Mike Leigh on Mike Leigh

in the same series

WOODY ALLEN ON WOODY ALLEN edited by Stig Björkman

ALMODÓVAR ON ALMODÓVAR edited by Frédéric Strauss

ALTMAN ON ALTMAN edited by David Thompson

BURTON ON BURTON edited by Mark Salisbury

CASSAVETES ON CASSAVETES edited by Ray Carney

CRONENBERG ON CRONENBERG edited by Chris Rodley

DE TOTH ON DE TOTH edited by Anthony Slide

FELLINI ON FELLINI edited by Costanzo Costantini

GILLIAM ON GILLIAM edited by Ian Christie

HAWKS ON HAWKS edited by Joseph McBride

HERZOG ON HERZOG edited by Paul Cronin

HITCHCOCK ON HITCHCOCK edited by Sidney Gottlieb

KIEŚLOWSKI ON KIEŚLOWSKI edited by Danusia Stok

LOACH ON LOACH edited by Graham Fuller

LYNCH ON LYNCH edited by Chris Rodley

MALLE ON MALLE edited by Philip French

MINGHELLA ON MINGHELLA edited by Timothy Bricknell

POTTER ON POTTER edited by Graham Fuller

SAYLES ON SAYLES edited by Gavin Smith

SCHRADER ON SCHRADER edited by Kevin Jackson

SCORSESE ON SCORSESE edited by David Thompson and Ian Christie

SIRK ON SIRK conversations with Jon Halliday

TRIER ON VON TRIER edited by Stig Björkman

Mike Leigh on Mike Leigh

Edited by Amy Raphael

faber and faber

First published in 2008
by Faber and Faber Limited
3 Queen Square London WCIN 3AU
Published in the United States by Faber and Faber Inc.
an affiliate of Farrar, Straus and Giroux LLC, New York

Typeset by Faber and Faber Ltd
Printed and bound in the UK by CPI Mackays, Chatham ME5 8TD

2 4 6 8 10 9 7 5 3 1

For Bonnie
(from AR)

Contents

Foreword ix
Introduction 1

Bleak Moments 45
Hard Labour 64
The Permissive Society 77
'The Five-Minute Films' 82
Nuts in May 88
The Kiss of Death 100
Abigail's Party 109
Who's Who 125
Grown-Ups 132
Home Sweet Home 146
Meantime 155

Four Days in July 169
The Short and Curlies 183
High Hopes 189
Life Is Sweet 205
A Sense of History 220
Naked 224
Secrets & Lies 250
Career Girls 277
Topsy-Turvy 288
All or Nothing 317
Vera Drake 338

Epilogue 371
Acknowledgements 380
Filmography 381
Stage Plays, with commentary by Mike Leigh 391
Index 425

1 Mike Leigh: 'It's about the joy of what you can do with a camera . . .'

Foreword
by Amy Raphael

It all starts with Timothy Spall. It's October 2001 and we've just finished talking – about acting, surviving cancer, and Mike Leigh. This is one of those rare interviews that I never want to end. The photographer is waiting, so we walk to a small park in central London. Between shots, Spall absently fishes a dozen crumpled bits of paper from his jacket pocket. He looks at them, frowns, and pushes them back deep into the pocket. He is concerned I might have seen something, a word even. These scraps are his notes from the film he had just finished making with Leigh over the summer. Secrecy is all to this director. I assure Spall that I have seen nothing, but I am consumed with curiosity.

A week later, I talk to Mike Leigh on the phone. I feel strangely nervous; I keep thinking about watching *Nuts in May* on television with my dad when I was nine years old. I ask him about working with Spall. We don't talk for long, but he makes me laugh. He is serious too. 'Tim's got this buzzing, alive, compassionate, enquiring sense of life; I think we share that. It's what makes us connect.'

Less than a year later, I interview Leigh in person at his sparse Soho office. It starts with an argument. There is some confusion about what we're supposed to be discussing: a magazine has briefed me to talk to Leigh about being a British man; he assumes we're here to talk about *All or Nothing*, the film about which Spall had been so guarded. Leigh says he doesn't see his work in terms of Britishness. He says a film such as *All or Nothing* is about 'how we live and relate and survive'.

I survive the argument and leave the Soho office with a heightened sense of curiosity. I am not sure what to make of Leigh: he is

intensely private and occasionally defensive. Yet this superficial judgement is just that. He is also, clearly, good company and a seasoned storyteller. He knows about a ridiculous number of things; it's always best to come clean with him and admit ignorance when necessary, because he also knows when you're bluffing. He is tough but kind; gruff but warm. I think.

At some point in 2005, Leigh asks if I'd like to work on this book with him. So I spend that winter watching twenty-two of his films. There would have been twenty-three, but the BBC, deciding to save space, wiped and lost for ever the half-hour studio play *Knock for Knock* (1976). It's a long winter, but also an absolute luxury to watch over three decades of films – from 1971's *Bleak Moments* to 2004's *Vera Drake* – in chronological order. As his 1971 debut suggests, some of Leigh's work is bleak – sad, desperate even. It can be excruciating: the bleak suburban embarrassment, the social solecism. Yet, ultimately, it's rewarding. You don't forget these films after leaving the cinema. They are films that stay with you, decade after decade.

Although he may not see them as his best films, even Leigh will concede that the language of the characters in *Abigail's Party* and *Nuts in May* has entered the vernacular. So, bleak perhaps, but also hugely funny. Ricky Gervais, Caroline Aherne and Julia Davis certainly think so – all have openly cited Leigh as an influence. Some critical viewers are uncomfortable with all this laughter: are we laughing with or at Beverly in *Abigail's Party*? If the latter, they ask, then surely Leigh is patronising his characters, many of whom are working or lower middle class. The charge, then, is that these characters are caricatures. It's tempting to ask the cynics whether it matters that we laugh with or at Gervais's David Brent.

In their commingling of bleakness and humour, Leigh's films recreate the tragi-comic world of people whose lives are far from glamorous. Although heroic at times, these people are not heroes in the Hollywood sense; they simply do their best to get by. Leigh's is a world where realism triumphs over hollow beauty. It's a world in which 'the done thing' prevails, where people behave as they are expected to rather than being themselves.

Although not overtly political in the manner of his peer Ken Loach, Leigh's films have certainly captured and even defined eras:

look no further than *Meantime*, the 1984 Channel 4 film that evokes perfectly the alienation and boredom of Thatcher's unemployed youths.

Above all, however, Leigh's films deal with universal themes: to have children or not; not being able to have children; the breakdown of relationships; family secrets. He is, by nature, a storyteller and a film-maker. Consequently, his films tell great stories – particularly his most recent offerings. Leigh often quotes Jean Renoir, who said that all film-makers make the same film over and over again. 'I know I return endlessly to the same preoccupations, but I'm not always aware of it initially.'

Once my viewing is complete, the talking begins. Between the start of May and the end of July 2006, Leigh and I spend nine days together in his Soho office. We always sit in the same places: he on an unforgiving armchair down which he slides as he talks, me on a soft corduroy sofa salvaged from the north London house he used to share with ex-wife Alison Steadman.

Talking to Leigh is rarely a breeze: like his films, you get back what you put in. He is notorious for not suffering fools gladly. During these long, intense days, there are awkward moments. At the start, he often says, 'Well, that's a question with no answer.' To which I have to brace myself and reply, 'Then this is a book with no content.' And, thankfully, we both laugh.

There will always be things that irritate Leigh no end. He dislikes being called an 'art-house' director. He gets prickly if you ask him why he's so good at making films about women: don't you know he makes films about *people*? He understands why his working process confuses, but his films are collaborative, he is the writer, the director, the *auteur*. And if Leigh is reluctant to discuss exactly how he makes his films, it's not only for fear of being misunderstood but also because he feels words don't do the whole process justice – though within these pages he speaks of his methods more openly than ever before.

For now, perhaps Lesley Manville, who first met him at the RSC in the late 1970s and who has appeared in six of his films, puts it best: 'People think it's a very complex, cerebral and complicated way of working; I love demystifying it. It's very, very straightforward.' The only significant change she has noted across the years

is the length of time allocated to the films: *Grown-Ups* was rehearsed for seven weeks and shot in five, whereas these days six months of improvisation, rehearsals and research are followed by a three-month shoot. 'There is no script,' Manville confirms, 'so you create a three-dimensional character from scratch, based on one or more people you know or have met. You then fill in all the bits of their lives. Slowly, slowly, through the rehearsal process, new aspects of this person's life will be introduced.' As the character's history evolves, they develop a voice: 'Because you've created such a thorough background for them, the process of dialogue forming and emotional exchanges taking place look after themselves. It's done very methodically and meticulously. The story – and then the film – starts to take form organically. It's a natural progression.'

At no time do any of the actors know what anyone else is up to, unless their paths cross as characters. After each improvisation, actors discuss their characters in the third person with Leigh. 'You talk about what you think was right or wrong,' says Manville. 'And after that, before you shoot it, you'll deconstruct it and put it back together in a dramatic order. The end product can't just ramble on, you can't be repetitive like the improvisations. Once the shooting starts you're often pinning dialogue down on a day-to-day basis. You need a lot of stamina. It's hard but it works.'

Manville – who casts Leigh as the mentor without whom she may never have discovered her talent to 'play people who are not like me' – explains why actors love working with him: 'It makes you feel intelligent, gifted, talented, empowered. It's the most fulfilling work you could ever hope to do as an actor.'

Leigh's regular performers – all of whom are proper old-fashioned actors rather than 'movie stars' – say similar things about working with him. It was a revelation; it changed their careers; it was fantastically hard work but tremendous fun; it was the most collaborative work they've ever done; their vocabulary and general knowledge increased threefold. All say unequivocally that they'd work with him again in an instant.

I realise some things over time: not only does Leigh have that peculiarly dry Mancunian wit, but he's also playful. He may sound stern, abrasive even, but watch for the glimpse of a smile. As he is

tough yet delights in teasing, so Leigh is touchy but passionate. The latter is by far his strongest trait. When talking about what turns him on – Pinter or Beckett, Peter Brook or Renoir, Vermeer or Ronald Searle – he sits up straight in his armchair and gesticulates. His voice becomes even more animated. He comes alive. Without doubt this passion helps elicit such great performances.

Alison Steadman, who first met Leigh as a student in the late 1960s when he came to direct a play at East 15 Acting School, thinks people often have a misguided notion of what it's like to work with him. 'They think it's like going into some kind of torture chamber where he's a little Hitler figure, whereas in fact it's quite the opposite.' She remembers observing her fellow students in Leigh's East 15 play *Individual Fruit Pies*. 'It was a revelation; it was very real and moving. When I chatted to Mike, he was the first person I'd ever met who made sense to me. We were on the same wavelength. We seemed to spend 80 per cent of our time at drama school improvising and I used to think a lot of it was either very silly or too difficult. Yet here was a person I felt I could work with.'

Steadman next bumped into Leigh around four years later, when he came to see her in a production of E. A. Whitehead's *The Foursome* at the Liverpool Everyman; she was 'chuffed' when he asked her to be in his first BBC 'Play for Today', *Hard Labour*. Initially puzzled by his working methods, she decided to trust him and go with it.

Soon after, Leigh and Steadman began to live together in London and married in 1973. 'We used to joke around a lot. I've impersonated everyone since I was a child, so I was always doing funny voices. I used to do this woman who eventually became Candice-Marie; Mike decided to put her in a play and pair her off with Roger Sloman's Keith. We did *Wholesome Glory* at the Upstairs Theatre at the Court, where the characters grew and blossomed.'

Candice-Marie and Keith are more famous, however, for their reincarnation in *Nuts in May* (1976). Steadman tells a wonderful story about the improvisations. 'Keith and Candice-Marie are on this camping holiday in Dorset. Roger Sloman, in character as Keith, worked out an itinerary. He had carefully planned a fifteen-mile hike from Lulworth Cove along the coastal path, with juice and biscuits at 11 a.m. So Mike said we had to experience it. As soon as we got in the car at 8 o'clock that morning, we went into

character.' As she talks, Steadman slips into character, moving effortlessly from Candice-Marie's girlie voice and soft 'R's to Keith's clipped, quasi-military tones. 'We are walking along this country lane, just the two of us. Candice-Marie says, "Look, Keith, look at that lovely bird. I wonder what it is?" Keith says, "Better check, Candice-Marie, better get the bird book out." His hands are up near his shoulders, as though he's holding the straps of a rucksack. Candice-Marie says, "Sorry, Keith, but you haven't got your rucksack on." He says, "Don't be so ridiculous, Candice-Marie. Get the bird book out and have a look!" Finally, he realises he's got nothing on his back.'

Steadman laughs. 'He was in character to such a degree that he couldn't believe he didn't have his rucksack. When we realised, we started laughing, and we had to sit down on the side of the road, tears rolling down our faces. We didn't move. We couldn't say anything. Then suddenly Roger became Keith again: "Come along, Candice-Marie." We stayed in character till 6 p.m. that evening. I was exhausted. Later, we reported back to Mike, told him how the day had gone . . .'

Though she has worked with Leigh countless times – continuing after their marriage broke down in 1995 – Steadman will always be best remembered for her role as Beverly in the BBC version of *Abigail's Party*. 'It was quite scary being in a television studio because we were so used to doing it in the theatre and getting a fantastic response. People used to scream with laughter. There was an electric atmosphere. And then suddenly we were in a dead studio. We had to take our performances down – especially Beverly, because she was such a dominant character. But it obviously worked, as it's endured over the years.'

Steadman talks about finding Beverly's voluminous dress in C&A Modes (she wore it on stage and screen, letting a panel out when filming the latter version to accommodate her pregnancy) and how, even when they were married, Leigh never discussed with her what the other characters were up to. 'What would be the point? It's much better not to know.'

She certainly didn't know at the start of the improvisations for *Abigail's Party* that the character of Laurence (Tim Stern) would end up as Beverly's husband. She explains that they got together in the usual way. 'A lot of it is common sense. Couples meet in a

work or public situation or by chance. The easiest situation in this case was a work environment: Beverly went to work as a temp in the office where Laurence worked as an estate agent. The rehearsals were held in a church hall and Mike set up an office. Tim was there pottering about – as Laurence, of course.'

Beverly turned up to work in a makeshift costume and a little make-up; Laurence only knew what the temping agency had told him, which is that she could type a bit. 'Neither of us knew for quite a long time that we were going to end up married and living in Chigwell.' Did Mike know they were going to get together? Steadman laughs. 'That's the $64,000 question! He could certainly engineer it in one way by calling me to one side and asking how Beverly enjoyed working in the office. What did she think of Laurence? Did she find him attractive?'

Next, Leigh asked if Beverly enjoyed temping – she hated it – and what she might enjoy doing instead. Steadman thought Beverly might quite like to get a job that had something to do with make-up. Leigh arranged for her to meet a Clarins make-up woman at Selfridges, to have a chat and see what sort of job Beverly might have done. 'Before we knew it, we had Beverly working as a beautician in Selfridges,' explains Steadman. 'All guided by Mike. The actors may feel they are in control, but they're not. Don't be fooled: he doesn't have a blank sheet of paper, get a group of actors together and wait to see what happens. No one knows what's going on his head, but it's certainly not a blank canvas.'

Leigh often describes what's in his head as a mere feeling or notion. When starting work on what would become *Vera Drake*, he at least had an idea that he wanted to make a film about abortion set in the 1950s. But, as usual, the cast knew only what was happening in their own lives. Imelda Staunton talks of the ten-hour improvisation that led to the police turning up to arrest Vera for performing illegal abortions as 'the most extraordinary experience of my working life'; more exciting even than the walk up the red carpet when she was nominated for an Oscar for the role.

'When I heard the knock at the door, I assumed it was Ruth Sheen's character Lily. When Vera's husband Stan said it was the police, I had a sudden pain in my chest. I felt as though I was going to have a heart attack. It was really frightening. Everything went

into soft focus . . .' Although she was happy to come out of character, go home and not say a word to her family about the film, Staunton found herself dreaming in character. 'I couldn't get away from Vera but I couldn't wait to get to work the next day. For two years afterwards I continued dreaming about the film.'

Phil Davis, who first worked with Leigh on *Who's Who* in 1979, played Stan. He still sounds surprised when he describes the police turning up. 'We arrived at rehearsal that morning and were whisked to our characters' flat at the rehearsal space. We were doing this long improvisation and then the police came. We didn't even know there were any actors playing policemen. We thought it must be a mistake. When we got down to the main hall, the whole place had been transformed into a police station. All these actors were being policemen and women, some doing tasks unrelated to us. It was fantastic.'

Davis remembers exactly how he – or rather Stan – felt when Vera whispered her terrible secret in his ear. 'Until that point he was convinced there had been some awful mistake. The whole family were assuming that something had been stolen from one of the houses in which Vera did the cleaning. He couldn't think of a plausible explanation. But when she told him, it was plausible. I don't think it was the morality of it that hit him, more the fact that they were in serious trouble.'

It's a devastating scene to watch; Davis felt pretty much the same acting it out. 'I can only describe it as a cocktail of emotions. It's not planned, it just happens. You're in the character's shoes, responding. At that point you're not monitoring yourself – you do that afterwards when you have an objective look back at it with Mike. I suppose, thinking about it, that the first feeling Stan had was for Vera: she looked so crushed and he loved her. But he was angry too.'

At the end of the improvisation, they sat around with cups of tea, feeling drained but exhilarated. 'Mike came in to say, "That was a great day. Well done everybody." He was obviously very excited. All these ideas had focused and suddenly we were off. One knew at that point – for the very first time – what the film was going to be about.'

Before working with Mike Leigh, Phil Davis had been a fan. He loved *Hard Labour* and *Nuts in May*. 'They made me laugh,

embarrassed me; all the things you want drama to do.' Timothy Spall remembers going into RADA the day after *The Kiss of Death* aired on the BBC. 'Everyone came in doing the characters. Mike was incredibly respected amongst young actors as someone who was doing interesting things. I was delighted when I got the call to go and see him. I did the audition for what was to become *Home Sweet Home* and he offered me the job the same day.'

Talking to Spall again is a revelation. Not only has he been working with Leigh for over twenty-five years, but he also counts the director as a good friend. 'He has the ability to hide the fact that he's a really nice bloke. I think he would find the prospect of being "nice" absolutely disgusting. But he is. He's also a very loyal friend. When I was in hospital [undergoing treatment for leukaemia], he was very, very lovely. He was upset.'

Spall was in hospital when *Secrets & Lies* won the Palme d'Or at Cannes. Leigh offered to bring the award in. 'I was having a blood transfusion and there was Mike with the Palme d'Or in this beautiful box. The nurse was having trouble finding the vein. I pointed out the Palme d'Or to her. "Ah yes, lovely box," she said. And carried on trying to find a bloody vein.'

Although there is a huge amount of mutual respect between Leigh and Spall, the actor has been known to push his luck. 'Tim can be very naughty,' says Leigh. 'Sometimes I want to throttle him. I want to tell him to stop fucking about. But he's a joy to be with. He's very, very funny.'

Spall explains that although he takes work very seriously, he doesn't take himself seriously at all. If the repetition on set proves too much, he can't help himself. 'When we were making *Secrets & Lies*, I used to pretend I had a little blue lobster on a lead called Bluey. Claire Rushbrook and I would walk it around outside while we were waiting to be called. It was childish nonsense but good fun. We were just passing time but Mike is always very focused: how is he going to cram a brontosaurus into an egg cup?'

When everyone was sitting around towards the end of rehearsals on *All or Nothing* in a group session, Spall fell asleep and started snoring. 'Mike's sonorous voice was going on. I woke up to James [Corden] pissing himself with laughter because I was making so much noise. He found it so amusing that Mike had to send him out. I had him sent out a couple of times for laughing.'

Spall likens acting to being a child, with Leigh as the parental figure taking on all the responsibility. 'Mike is serious but he also has a wonderful sense of humour. Not only that, but it's a silly sense of humour. And a vaudevillian sense of humour. Which we both share. He loves a bit of buffoonery. At the appropriate times, obviously.'

For all this talk of silliness, Spall has thought hard about Leigh's work. 'I've discovered over and over that he makes films at the centre of which he puts the sort of people who most other people are thankful not to be. He gives them nobility. Nobody makes the mundane more poetic than Mike. That is his genius. There are moments in *Secrets & Lies* when Brenda's character is almost heroic. It's not because I'm working class and automatically have an affinity with that kind of person; I'm actually an inverted snob, and lumpen working-class behaviour gets on my nerves.'

There's something about Leigh's working process that makes sense to Spall. So he doesn't ask many questions, he just gets on with it. Which is not to say he finds the work easy. He hardly knew the person on whom *Life Is Sweet*'s Aubrey is based. 'He was a man with no personality whatsoever – a nobody, a film financier or something. A man who felt duty-bound to be interesting but wasn't. I remember struggling with this character in rehearsal.'

At that point, Spall felt frightened. He thought he was sinking. 'Then we did an improvisation and it just clicked. This character came out of nowhere. I kept thinking about DJs: blokes who sit on their own talking to themselves for two hours, assuming everyone finds them fascinating.'

Over the years, Spall has noticed how Leigh's method has subtly changed. 'The last few characters I've done have been an amalgamation of three people instead of just the one person. I don't know why, but my instinct is that he wants more multifaceted characters. If you look at recent films, his characters are, on the whole, less idiosyncratic.'

Yet, despite working with Leigh for a quarter of a century, Spall still struggles to translate some aspects of the method into simple words. 'The moment where you turn it from a real-time improvisation to a scene is very difficult to explain. If anybody asks why we rehearse for six months, why we spend so much time talking, why it all takes so fucking long . . . I think it's because you're cre-

ating this parallel universe. It's a bit like working with Paul McKenna, who gets people to do things by auto-suggestion. Somehow this alchemy happens.'

By way of example he talks about the barbecue sequence in *Secrets & Lies*. 'Those five scenes are based on a twelve-hour improvisation done in real time. And this is where the alchemy comes into it . . . and it's probably why Mike doesn't like talking about it, because it's hard to encapsulate; I've never been able to define it properly, and I can talk for England. After the improvisation, you come back and talk privately about your character with Mike. Those moments are magically distilled. He doesn't really explain it, but twelve hours becomes twenty minutes. You distil, refine, distil, refine. And then you write it with him . . . it's amazing how it happens. But it's mind-blowingly hard work.'

Most challenging of all, says Spall, are the tactile improvisations. (Leigh later says that he got this idea from James Roose-Evans, 'the only person who taught me at RADA who was in any way inspiring'.) Spall explains how it all works: 'If you're exploring the sexual relationship of two characters, rather than getting into an improvisation and having a fuck – which would probably be deeply embarrassing and certainly crossing the line – you get into costume, get into character, kneel down in front of one another and make contact through your hands.'

He pauses. 'Through moving your hands, you express yourself to the other person. Mike watches quietly. You decode it afterwards. You're pretty certain when it's a fuck and when it's something else. It can be tentative or forceful or a mix of the two. You can understand why Mike avoids talking about it because it would sound like something from *Vision On* [the famous BBC children's programme for the deaf]. It works because Mike's tasteful and not into embarrassing people. It opens so much up. When Lesley and I were charting the breakdown of Penny and Phil's sexual relationship in *All or Nothing*, we did a few hand improvisations and it was pretty clear what was happening. You just have to go for it. I find it fucking painful but it's absolutely functional.'

Working with Mike Leigh is nothing if not a roller-coaster ride. Imelda Staunton once described making *Vera Drake* thus: 'Shocking, terrifying, exhilarating. It was rather like falling out of an

aeroplane with no parachute.' Sally Hawkins, who made her film debut in *All or Nothing*, is about to start filming 'Untitled '06' as I write. She is by turns excited and terrified. She talks of being lucky enough to have had dinner with *Naked* and *Career Girls* star Katrin Cartlidge before her untimely and sudden death in September 2002. 'She kept re-emphasising the fact that it was all about the experience. You just have to go with it. Or it will drive you mad.' Going with it means making yourself totally open, vulnerable, available. 'Improvising for "Untitled '06" was . . . life affirming one moment and hell the next. It's incredibly stimulating but draining. I can't imagine what it's like for Mike being at the centre of that. You can't really hide; he won't let you. He doesn't let himself hide either. He can see right through bullshit, and that's quite scary. He's a phenomenal director.'

Hawkins, it seems, is far from alone in her appraisal. When I ask Alison Steadman if she feels spoilt by working with Leigh, she shrugs at the apparent rhetorical nature of the question. 'Yeah, absolutely. There's nobody like Mike.'

<div align="right">

Amy Raphael
Brighton, April 2007

</div>

Introduction

AMY RAPHAEL: *Do you remember the first time you felt compelled to capture life on film?*

MIKE LEIGH: My grandpa's funeral when I was twelve. There was thick snow, the place was crammed with Jews, some guys were struggling downstairs with the coffin. One of them had a particularly long nose with a drip at the end of it. I remember standing there, thinking, 'This would make a great film.' At the age of twelve I didn't have the vocabulary to think, 'This is cinema!' But that was what I was experiencing.

Grandpa dying was a big deal for everybody. For reasons to do with who got what and that kind of rubbish, it caused endless family rifts. It never personally involved me, but it was traumatic if only because I was acutely aware of what was going on. People always said I was old for my age. I was clocking grown-up relationships from a very early age, and I think that's massively important. I very clearly remember being in my parents' flat in an old Victorian house in Manchester. We were only there till I was three: I was born in February 1943 and we moved in 1946. I certainly remember a lot of stuff from when my dad was in southern Africa during the war – I specifically remember him coming back, because he was quite late. At the end of the war all medical officers were shipped to Bombay, to process all the troops on their way back to the UK from the Far East. That was late 1945, early 1946.

Were you worried your father wouldn't come back?

No. But there was a kid in another flat whose dad wasn't coming

back. I didn't know what the war was. Nobody knew what anybody was doing in southern Africa. It so happened that it was safe.

My sister wasn't born until the end of 1945, so I spent a lot of time playing on my own. While I'm a perfectly gregarious person, I'm also a loner. My partner is away filming just now and I'm thoroughly enjoying being by myself. I am totally comfortable in that situation, and to some extent I thrive on it. In fact, it gets difficult if I don't have time alone.

As a child, in the 1940s, I used to get sent to stay with my maternal grandparents in Hertfordshire. They had moved there in 1940 after closing their butcher's shop in Finsbury Park. Grandpa used to breed chickens in the garden, which was, in a sense, going back to his rural Lithuanian roots. He used to take me around farms and to the cattle market at Hitchin. And when I went back to infant school at the end of the holidays, I was sometimes happy to be alone at play time: I was doing improvisations with animals and farms and cattle auctions . . .

Were you a keen reader in your childhood?

Absolutely. I read everything and anything, from *Just William* and *Molesworth* to Dickens. As a teenager my favourite H. G. Wells novel was *The Bulpington of Blup*; I found it fascinating because it's about this guy, Theodore Bulpington, who has a fantasy character called the Bulpington of Blup. He is one of the biggest wankers in literature (*laughs*). It's great. But also this whole thing of having a private, alternative, interior world is central to everything that I've made or done.

Some general truths about writers and film directors are unavoidable. Film directing is both gregarious and lonely. You do have to be bossy and you have to enjoy telling people what to do, to want to push people around and manipulate them. You have to be a control freak. You inevitably have to be both involved and detached. All of these things apply to me.

Paradoxically, the most solitary part of being a conventional writer is something I can't, ultimately, deal with. Being alone, ruminating, procrastinating and so on is essential to writing. But for me, when it comes to the crunch, being productive and creative

only flourishes in gregarious situations – but, if I'm honest, gregarious only if I'm in control (*laughs*).

Returning to your childhood for a moment, how did you respond to the formality of your education?

My journey through education went through quite different phases. North Grecian Street Primary School was really very encouraging of creative activity. I edited a newspaper and wrote and directed my first play, *Muddled Magic*. I then didn't manage to get into Manchester Grammar School, where my father and uncles had been, because I failed their exam (I didn't know the difference between stalactites and stalagmites). Instead, I attended Salford Grammar – Albert Finney had just left as I arrived – and there I became more of an anarchist. What was growing in me, quite unconsciously, was some instinctive sense of an illusive, organic, plastic thing about work and doing things that didn't square with anything one was being told to do.

I went through some really bad times, some to do with my father. Finally, I kind of screwed up all academic activities and decided – partly because you could do it without a full number of O-levels – to try for drama school. I was very young, only seventeen. By an amazing fluke I not only got into RADA, but they gave me a scholarship. It was very shocking, and not what my father or anyone else was expecting. In fact, my old man was outraged by the whole thing.

RADA was a continuation, in some ways, of the school experience. It was very prescriptive, very old-fashioned, set in its ways and mostly uncreative. But it was terrifically good news for me that I had that experience. On one level it kicked me off into the world of professional practice, but on another it left me questioning procedure on a daily basis. It wasn't till I took a foundation-year course at Camberwell Art School a little later that it dawned on me what the creative process is all about.

How did your father figure in the bad times you describe?

I have to say, with some mixed feelings, that my father was, for all kinds of understandable reasons, culpable of creating some of my problems, which, curiously, have mutated from problems into my

raison d'être. As a primary-school kid I was an avid reader, but as I went into my teens, pressure from my old man – to do homework all the time and not really have a social life at all, to only do academic work, to not 'waste time' drawing, to be sure that I'd go to university and be academic – made me become less and less able to do any of that.

Although I'm not at all dyslexic, the pressure seemed to create a short attention span when it came to reading. I still occasionally have lapses now. When I'm doing a project, I can't read novels, and when researchers give me material to read, I get someone to summarise it where I can.

Did you fall out with your father?

All the time. I have to say that, without wanting to rake out skeletons, I had the most fraught teenage years. It was desperate – extremely violent and extremely bad news. I was even sent to a psychiatrist, which turned out to be a pleasant experience. He merely concluded that there was nothing wrong with me at all . . .

At the same time, my old man was a great guy. I was devastated when he died prematurely in 1985. He was a fundamentalist NHS doctor. There were celebrations in my house when he got rid of his last inherited private patient. He was also a factory doctor. And he was a terrific doctor; I know because I've come across people he treated along the way. He was very direct and honest. He had great integrity.

You were a creative child, always drawing, painting, making things. Did your father fundamentally dislike your love of art?

The truth of it is that being an artist was anathema to my old man. His own father had been to art school in Russia and was a commercial artist who made his living colouring in photographs. He was a very good miniaturist. But during the Depression no one wanted photographs and Grandpa couldn't feed the family. Later, during the war, when everybody wanted framed pictures of sons killed on active service, he did very well.

I remember I used to be taken in the early 1950s to his little factory. These bohemian guys and women were all chain-smoking, talking ribald language and sitting at easels. They were known as

'The Artists'. I would be allowed to sit at an easel and bugger about. But for my father, being an artist was still associated with a lack of income, and he couldn't bear it. It frightened him to death. It has taken me a long time to realise all this, but it seems obvious now.

With or without your father's blessing, what did you like to draw as a child?

At a very early age I remember doing endless elaborate cartoons. I was influenced by Heath Robinson [best known for his drawings of eccentric contraptions], so there were lots of little men with bald heads and white coats, lots of machines and wheels and odd things happening. But if ever I was drawing – which was all the time – my old man would always walk into the room and say, 'You don't have to press on so hard.' Or, 'Haven't you got anything better to do?' One of the things that has completely informed my parenting is my own experience, as a result of which both my kids went to art school and are both creative. I learned from my experience, but it was painful.

There's a drawing that I've still got called *The Blowing of the Shofar*, a shofar being an instrument made from a ram's horn that they blow in the synagogue. This was a massive cartoon like something by H. M. Bateman [famous for cartoons depicting reactions to mishaps], with the rabbi blowing the horn and everybody going mad and putting things in their ears. There's a little door with a Star of David on it, and a mouse with a hat on coming out . . . I drew it because I wanted to enter a children's art competition run by the *Jewish Chronicle*. My old man was outraged. 'It's blasphemous! I forbid you to send it in!' But I did anyway. They wrote about it and gave it a commendation. He was shocked.

My folks never went to art exhibitions but they did regularly get their act together and go to the Shakespeare Memorial Theatre in Stratford. And my old man was very well read. Much later, long after he was dead, I found out that after his matriculation from Manchester Grammar, he wanted to read English at university. But it wasn't on – his family insisted he do medicine instead. In some ways he was a man embarrassed by art. And being 'arty' was always used in a pejorative way. This is a very provincial, subur-

ban, bourgeois world we're talking about. Of course, when I say my parents went to Stratford, to the theatre in Manchester or to the Hallé Orchestra, those were all middlebrow cultural events. They would go to a comic opera but not grand opera. They liked Mendelssohn, but not Bartók or Stravinsky. And we would have family trips to the cinema.

Would you say your parents – Abe and Phyllis – were snobby in any respect?

They were philistines in some respects. They were preoccupied with bourgeois values and aspirations. You certainly couldn't describe my old man as a snob, but on the other hand you couldn't give a detailed description of my mother without the word 'snob' coming into it at all!

Were you angry as a teenager?

I was angry with the establishment and with my folks. But teenagers in the 1950s were! Socially I was extremely active and gregarious. I was known early on as being a good laugh. I was a committed member of Habonim, the secular Jewish socialist-Zionist youth movement. I was very happy in that context. By about 1956 or 1957 – when I was thirteen or fourteen – I was leader of a team of younger kids. On a number of occasions I got kids together and put on plays with them. I got them doing things. A great Habonim tradition was the so-called 'zig', a kind of comedy sketch. It's no coincidence that other alumni include Sacha Baron Cohen, David Baddiel, Jonathan Freedland and Dan Patterson, who invented *Whose Line Is It Anyway?*, not to mention Arnold Wesker. We did a comedy about Nasser. Nothing was written down but it was all very structured. Having that leadership experience was great and has absolutely informed not only how I am but also how I've worked; everybody was open and democratic and working together towards a goal, the spirit of which goes right the way through my productions and the way I work.

Of course, this was all about the collective ideology of the kibbutz. Habonim's real objective was to get us young men and women to emigrate to Israel and be kibbutzniks. At sixteen you'd be taken there on a subsidised trip. I had this wonderful experience

6

in the summer of 1960. We sailed the Med in a rusty old ship, the *Artzah*, which like the *Exodus* had been used for smuggling Holocaust survivors a little over a decade earlier. We slept on the deck under the stars, sang and played guitars and made love. We picked figs and olives on a couple of kibbutzim founded by members of Habonim. In one we watched Wajda's *Kanal* projected onto a wall, with English and Hebrew subtitles. We visited Jerusalem – which was still divided then, so we didn't see the Wailing Wall – and we climbed Masada and swam in the Dead Sea.

Immediately after this I quit the movement, left home, went to RADA and walked away from Jewish life for ever. As Buñuel said, 'Thank God I'm an atheist!' I do maintain to this day very close friends – men and women – who date back to those days. And, of course, I deal with all this in *Two Thousand Years* (2005).

How long have you been an atheist?

For as long as I can remember. From a very early age religion just seemed to me like a game people play.

But do you feel Jewish in a cultural or even political way?

In *Two Thousand Years*, when Tammy is asked that particular question, she says, 'Well, I feel Jewish and I don't feel Jewish. I've never known what it is not to be Jewish.' Another question is, 'When do you feel Jewish?' Sometimes, by default, one feels very Jewish. Yet when I'm in a very Jewish situation, I feel decidedly un-Jewish. It depends.

It's very easy and comfortable at this stage of my life and of history to be Jewish and to be upfront about it. That's a far cry from being part of 'the Jewish scene'. As a result of *Two Thousand Years*, lots of Jewish organisations have wanted to involve me. That Jewish scene is an alien world to me, though. I've no desire to be any part of it.

But it would certainly be wrong to the point of being disingenuous to suggest that my life is devoid of anything manifestly Jewish. It isn't. Apart from anything else, a number of my very closest friends are not only Jewish but come from the Zionist youth movement I was in. And, of course, at some level I'm always preoccupied with Jewish cultural things. For example, I've read and

7

cherished Isaac Bashevis Singer enormously over the last thirty years or so.

How Jewish do you feel on a specifically political level?

I'm a signatory to Jews for Justice for Palestinians, but on the other hand I've mostly kept a low profile. I've been in the closet about it. Although you get a hint of these matters in *Hard Labour*, it hardly surfaces in my work. Deciding to do *Two Thousand Years* constituted a massive decision to come out and, in a certain sense, to stop hiding, if I'm honest; to gather together a group of kindred spirits and say, 'This is what we are.' Having agreed to make up a play at the National Theatre, I felt that there was simply no point in showing up and doing another version of *Abigail's Party*. I was just formulating the ideas that developed into *Two Thousand Years* when I went to see Kwame Kwei-Armah's play *Elmina's Kitchen*, which was set in Tottenham with a black cast. I remember thinking, 'I know what I've got to do. It's clear. I've been thinking about it for long enough.'

My sister came to see *Two Thousand Years* in a state of some apprehension. She hadn't picked up exactly what it was about, but she knew it was a play of a Jewish nature. So she came to London – and she doesn't come very much – specifically to see it. Afterwards, she thought it was great; she had been worrying that it was going to be all about our family in the 1950s. Of course, it was, but not literally. It is no more or less personal than any of my work. The ghetto mentality hang-up of hiding the fact that you're Jewish is my problem, no one else's. It's only us Jews who have the fear of a yellow star on our gabardines and want to have our noses fixed and change our names and be seen to be eating pork or bacon sandwiches. To pretend we're not Jewish.

How do your sons feel about you being Jewish?

Their mother, Alison Steadman, is not Jewish, so obviously they're not Jewish. But they've got a Jewish background. They know their relations in Manchester, their cousins and so on. When Toby was a young teenager, he used to go to Bobby Charlton's summer school at Manchester United and stay with his grandma. Then he went to Manchester Met University to do illustration, so he knows

the scene. They were at my mother's funeral. They're very relaxed about the Jewish thing – it's part of what they're about, but without really being involved with it in any way. They're not hung up about it like I am. Thinking about it, I've made a series of films that don't, as it were, have a Woody Allen factor – the little Jewish nerd syndrome.

Do you like Woody Allen?

It varies between blind adulation and deep loathing, depending on which film you're talking about. *Radio Days* would be on my desert island with me; if you wanted to subject me to excruciating torture, you'd send me there with a copy of *Match Point*. I wouldn't survive twenty-four hours. *Manhattan* infuriated me because I thought we could all make films like that if someone would just give us a chance. I love *Crimes and Misdemeanors* and *Bullets over Broadway*. I like *Annie Hall* but prefer *Hannah and her Sisters*. I loved *Zelig* but can't stand *The Purple Rose of Cairo*. But to me *Radio Days* stands head and shoulders above all the others. It's terrific. And he's a New Yorker, so it makes sense for him to make Jewish films.

How did your parents feel about you marrying a gentile?

They were finally OK about it, when it came to it. But throughout my twenties there was a massive stand-off. The phrase 'If she's not Jewish, I don't want to meet her' cropped up on more than one occasion. On two occasions very nice, respectable women said it made them feel like a whore. But when Alison came along, there was a sudden and swift turnaround. My parents weren't fundamentalist, Orthodox Jews. They decided that it was time for a rethink, to their credit.

Let's return to your influences: you may not have been particularly academic but it appears you were turned on by television and film during your formative years.

Very much so. People of my age will remember what a big deal it was at school when anyone came in and announced they had a telly. Gradually everyone got one, but it took some time. Then this

9

massive thing happened when the Coronation came along in 1953. It didn't mean everyone got a telly but, still, it was a big issue. What was known as 'viewing' became a major part of our lives. I don't want to lapse into nostalgia, but back then there was only one channel. You couldn't watch the telly on a bright day without drawing the curtains, and if you had it on for any length of time, it started to smell of burning valves. There were interludes between programmes, like *London to Brighton in Four Minutes*. More importantly, television was a window on the whole concept of people making live visual media. One became very aware of the difference between what was and wasn't on film. There used to be film shows at kids' parties. I had an uncle who shot a lot of stuff on 8mm, which I've recently acquired.

Another major part of one's culture was news theatres. They were fantastic. The programme would last an hour, but you could stay and watch it as many times as you liked. You'd get newsreels, Laurel and Hardy, the Three Stooges. Quirky little items about weird goings-on. Documentary items. Mickey Mouse and Donald Duck. A lot of film still kicking around in the late 1940s and early '50s was pre-war.

Did you also go to the cinema as often as you could?

It's very important that within walking distance of where I lived in Salford there were loads of cinemas. Some were flea pits and some were more respectable. In the holidays, if I had enough pocket money, I'd go all the time. There's a moment in *The Long Day Closes* (1992) where you see the kids outside the cinema asking grown-ups to take them into an A-rated film. We used to do exactly that: 'Will you take me in, mister?' Now an adult would be locked up for taking strange children into a cinema; then it was no big deal.

The independent flea pits would show whatever was kicking around, so you didn't only see the latest release but also old prints – all kinds of stuff, but always in English. There was a very active Manchester Film Society; I've no idea why I didn't join. If I had, I may have seen an Eisenstein. Instead, I only started reading about Eisenstein and De Sica towards the end of my time at school, after picking up a copy of *Film and the People* by Roger Manvell.

Even before wanting to capture your grandpa's funeral on film, did you always watch films and want to get behind the camera?

I don't know what chemistry happens to you when you watch a film, what makes it into a particular fascination for you. For all of us, at one level, it's the same thing: the film telling us a story and our involvement in that. For me – and I have to say the same is true with all art – it's bound up with a sense of wanting to *do* it, particularly with film and theatre, though more so with film.

I regard film as my natural habitat. It's about the joy of what you can do with a camera, with the medium . . . but even before that, it's about an exhilaration with people and places, with wanting to grab hold of life and do something with it – to somehow make it, even though it already exists. Despite my enjoyment of pen and brush, it's never been quite the same turn-on as making films. That's the ultimate turn-on.

A picture is being created of a young man who had quite a tough time at home, who was often a loner at school, who spent his free time creating other worlds by drawing or escaping from reality by sitting in the darkness of cinemas. But did you also like girls from an early age?

Yes, of course. But I didn't really have a proper girlfriend till I was seventeen.

What happened before then?

I had crushes. If there are all kinds of clumsy or unfulfilled relationships in my films, it certainly doesn't come from nowhere. But it's hard to talk about it without going into specifics . . . I think the same is true about sex in my films. Like everybody else, I've had some very good experiences and I've had some very unrewarding and disappointing experiences. If you take the kiss in *Bleak Moments*: I've said in the past that it's like a lot of kisses, which is to say awkward. There is no question that, ultimately, any two people are either sexually compatible or they're not. I think that underpins a lot of things that go on in my films – and in real life (*laughs*).

At seventeen you had your first proper relationship; you also left home.

And leaving home meant I had to grow up. Despite in one sense being a little old man, in other ways I was a pretty immature seventeen-year-old arriving in London in 1960. A proportion of the people on the course at RADA were considerably older because they had done national service. I missed it, fortunately, by about eighteen months.

Even though I was young, it was imperative for me to move down to London. I've since realised that there were some quite interesting things going on in Manchester in the 1950s, but I didn't know about them in my suburban existence. I would often go down to London with mates at weekends. You could get an overnight train for a fiver and sleep in the luggage racks.

Did you regret not having had a formal academic education at any point?

No. I don't regret anything. Although it would have been good to get to know about things that I either don't know about or have only come to understand in a roundabout way. What happened to me was in fact terribly good news, because I was catapulted into the world of RADA. And RADA got me questioning.

What sort of work were you interested in at the time? What got you excited?

As I've said, before I arrived in London in 1960 I'd virtually never seen a film that wasn't in English. Suddenly, here was world cinema – Eisenstein, Fellini, Bergman, Satyajit Ray, Buñuel, Ozu and Kurosawa. The French cinema entered my life. Renoir became a major influence, René Clair, Vigo . . . The Nouvelle Vague was just happening. *A Bout de Souffle* blew me away; *Les Quatre Cents Coups* inspired the autobiographical film I was never to make; and the first time I saw *Jules et Jim* I was in love with somebody who was in love with somebody else – and we all fell in love with Jeanne Moreau! Truffaut became a hero. I loved the fluidity of *Jules et Jim*, which is interesting when you consider the virtual absence of tracking shots in *Bleak Moments*.

Godard and Truffaut were definite influences, Truffaut for his humanity, Godard for his opening my eyes to the notion of film as film, the 'filmness' of film. Whereas the British New Wave – Karel Reisz, Tony Richardson, Lindsay Anderson – were more of an inspiration than an influence, really. Of course, I loved stuff like Richardson's wonderfully evocative bus ride round my native Manchester and Salford, or his hunt in *Tom Jones*, both beautifully photographed by Walter Lassally. It was great to see a real world one could relate to depicted on the big screen. I'd spent my childhood and teens loving British and Hollywood films but dreaming of a kind of movie where you'd see characters who were like you and me, warts and all.

Actually, just ahead of the New Wave proper came Jack Clayton's *Room at the Top*, which I saw at the Rialto in Great Cheetham Street, Salford 7. To walk out of the pictures into the real world you'd just been watching was a genuine breakthrough and very exciting. Though look at that film now, and it's pretty old-fashioned and stagey, certainly in the acting. Laurence Harvey's northern working-class lad is an embarrassment! (Incidentally, I really admire Clayton's work. *The Innocents*, which was cut by my recent editor Jim Clark, contains the most spine-chilling scene in all cinema.)

But the thing about the British New Wave was that every film was an adaptation of a book or a play, and, *Bleak Moments* and *Nuts in May* notwithstanding, I realised early on that somehow for me it was going to be all about making things up from scratch. In fact, one of the first films I saw in London was *Shadows* by John Cassavetes, another director I'd cite as more of an inspiration than an influence. We learned that his actors were improvising, that it had all been developed in a workshop situation. For me, this was particularly intriguing, as our RADA course was virtually devoid of improvisation work.

Over the years I've had mixed feelings about Cassavetes. Sometimes he was brilliant – I love *The Killing of a Chinese Bookie*, for example. But films like *Husbands* or, in particular, *Gloria* suffer from actors behaving like actors – improvising as themselves, so what pours out of them is actor behaviour, actor thoughts. Which doesn't work for me.

The other film that set me a-thinking in 1960 was *8½*. Nobody

13

on the shoot knew what the whole film was about or what Fellini was up to. He kept it to himself, which struck a deep chord with me!

All in all, going to movies of all kinds became my main activity. I now learned to understand Hollywood properly and more critically. I mean, as a kid I'd watched, say, John Ford westerns without knowing they were John Ford. I'd seen and loved *Some Like It Hot* in 1959 (my father was uncomfortable with cross-dressing . . .), but now, through *Sunset Boulevard* at the National Film Theatre, I discovered Billy Wilder. I even saw *Citizen Kane* and *The Third Man* for the first time. I'd only heard of them as I was growing up.

As important an educational discovery as any was the silent cinema, most of which was made up as they went along, of course! I was at all those first screenings of the newly discovered Buster Keaton masterpieces, when Raymond Rohauer would describe in detail how he'd tracked down long-lost, decomposed nitrate prints to the likes of James Mason's garage.

I've got a particularly fond memory of an all-night session at the NFT, when they showed all ten episodes of Feuillade's *Les Vampires* (1915–6). He extemporised like nobody else. He famously sacked his leading man halfway through the shoot for persistent lateness – but not before he'd first invented a scene where the unsuspecting thesp was shot dead! Those all-night screenings were great. I don't know why they don't do them now. Health and safety, I suppose. Five Marilyn Monroes, six Cagney gangster movies, *Batman* – the whole series . . .

When I was an actor briefly at Stoke-on-Trent in the mid-1960s, I spent the daytimes at a complete *Carry On* retrospective. Great fun, though obviously not a major inspiration. To be fair, given what I've been saying, they were actually original screenplays. Pure cinema. As were the Ealing comedies, which were most certainly an influence. And the Boulting Brothers . . . I love *Carlton-Browne of the F.O.*, though I would question the political morality of *I'm All Right, Jack*.

What films didn't you like?

Last Year in Marienbad bored me to death. And, although I liked early Antonioni, like *Il Grido*, *Il Deserto Rosso* irritated the shit

out of me and, later, I thought *Blow-Up* was total, unmitigated shite.

What about the theatre?

Well, my arrival in London coincided with the birth of Peter Hall's Royal Shakespeare Company. I'd already seen Shakespeare in Stratford at the old Memorial Theatre, and now they were in London as well, at the Aldwych and the Arts Theatre.

They became a major part of my life. I saw as much as I could. *The Wars of the Roses*, Gorki's *Lower Depths*, Rudkin's *Afore Night Come*, Michel St-Denis' production of *The Cherry Orchard* with Gielgud. And Beckett's *Endgame*, which I saw fourteen times, courtesy of my friend, the artist Paul Rowley, who was an usher. He used to let us in at the last minute, and we'd sit on the stairs.

Obviously the master at the RSC was Peter Brook, a major influence on me. Again, one knew about his experimental rehearsals, and I saw the results – *Lear*, with Scofield; the Theatre of Cruelty experiments, which introduced us to Grotowski and Artaud; and, later, the *Marat/Sade*. I was keen to be in the RSC and wrote to Peter Hall in 1964. By 1967 I was assisting him and others at Stratford, and I did my first major stage play, *Babies Grow Old*, at the Other Place in 1974, under Trevor Nunn's aegis.

But in all the time I was involved with the RSC I never met Brook, which was a disappointment. I've got to know him a little bit more recently. He's been very positive about my work, especially *Secrets & Lies* and *Vera Drake*, and he was most apologetic for coming to a preview of *Two Thousand Years* at the National (he had no choice: he happened to be over in London; he lives in Paris). I didn't mind, of course – though I'd rather he'd have come later! But he liked it, and the cast was chuffed.

I saw a lot of theatre, good and bad. Joan Littlewood at Stratford East was always interesting, and although I felt an obvious affinity with her spirit, her rough-and-ready folksy style wasn't exactly my thing. Then there was the Royal Court, with its Sunday night club performances, designed to get round the Lord Chamberlain's bans; and a lot of commercial stuff, courtesy of free tickets for RADA students.

When I arrived in London, Albert Finney was in *Saturday Night and Sunday Morning* in the cinema and in *Billy Liar* on stage in the West End. Ian McShane and I were in the same class at RADA, and we went round to introduce ourselves to Albert after the show. He was very friendly. I can't remember whether I told him I'd just left Salford Grammar. I suppose I must have. A decade later he was to back my first film.

The Caretaker was also running when I hit town. I saw it several times, and it was the first play I ever directed (at RADA in 1962). Pinter and Beckett are particular influences. The fusion of the word, the silence, the visual, the spatial, the comic, the tragic, the specific, the abstract, the transcendent, the ridiculous.

Apart from film and theatre, what else inspired you?

You name it. Of course, I've forgotten quite a lot of what I experienced. The great Picasso show at the Tate is one of my first London memories. Don't forget, I hadn't had that much experience of galleries before. And now here were the V&A, the British Museum, the National Gallery . . .

I started to discover the surrealists in 1959, pottering around Paris – but look, here's a random list of people who inspired me in the early 1960s: Paul Klee, Beckett's novels, Bartók, Brecht, Kurt Weill, Flann O'Brien, Saul Bellow, Kerouac, Ginsberg and co., Stanley Spencer, Scott Fitzgerald, Miles Davis, Alexander Calder, Thelonious Monk, Saul Steinberg, Lotte Lenya, Bessie Smith . . .

And that's before the Beatles and the Stones and Bob Dylan joined the party. Can I stop this answer now, please? It's doing my head in.

Of course, but before we move on can you say something about your cathartic experience in a life-drawing class?

Yes. As I said, RADA was, on the whole, a dead experience. We just learned the lines and applied our newly learned voice and movement techniques to the main task of 'not falling over the furniture'. There was no discussion. No research. We never asked questions beyond the immediate surface action of the play, questions about the characters, their world, the meaning of the play, how the play or the characters related to real life, to our lives, to

the world out there. Of course, I was dimly aware of this, but only in a half-conscious, naive, passive kind of way.

Then, a year or so after I'd left RADA and done a bit of acting, I enrolled on the foundation course at Camberwell Art School. One day I was in the life-drawing class. Drawing was a big thing at Camberwell. They were famous for it. At that time they'd taken over an old primary school in Peckham. Twenty or so of us sat quietly drawing the model – a real naked woman sitting on a chair. Bright sunlight beamed through the generous Victorian windows. There was total concentration; you could have heard a pin drop. I looked around and – ping! – it all came to me in a clairvoyant flash. This was what it was all about. This was what we had never experienced as drama students. Everybody was totally absorbed in making an organic discovery of something real, something meaningful to them. We were each investigating a unique personal experience. We were looking at the world and we were being creative. And I thought, 'Why can't rehearsals be like this? Why should they be unfocused, undisciplined affairs where people read newspapers in the corner of the room and take no notice of the work? This is a group of individuals each doing his or her own thing, yet this is more of an organic ensemble than many a rehearsal, because here each student is centred and secure, and not made insecure by other people's insecurities. Why should actors only practise interpretive service skills? Can't they be artists in their own right? And why, for that matter, should directing be an interpretive job? And why should writing and directing be forced to be separate skills? And couldn't writing and rehearsing be one and the same process, involving the actor in a truly creative way?' And a million thoughts . . .

It just suddenly all became clear at that moment.

So, after completing those courses in London by 1965 – RADA, the London Film School, Camberwell Art School, the Central School of Art and Design – you must have been very eager to start work.

By 1965 I felt as though I'd done the training, such as you might call it. I'd had a small acting part in a film called *Two Left Feet* (1963). I had directed, with great difficulty and no success artisti-

cally or otherwise, the original production of *Little Malcolm and his Struggle Against the Eunuchs*, written by and starring the late David Halliwell. It became a very successful play subsequently, but when we did the original it was a disaster, mostly because I derived no pleasure from directing it. It was a constant battle with Halliwell. He was very close to the material, and he used to say the director was just a chairman. I was very fond of Halliwell. He remained a close friend until his tragic death in 2006.

So I had a desire, a need to write, to make up plays and films – a conviction that I could and should direct. My most successful experience up till that time was, in fact, the first thing I directed: a production of *The Caretaker* at RADA. But a fascination with actors and acting contributed towards the idea of a practice where you get actors and make things happen in a collective way.

It didn't take too long for you to get going.

The first opportunity I got to carry out any of this stuff that was buzzing around in an unformed way was when, out of the blue, I was offered a job at the Midlands Arts Centre in Birmingham, which was a brand-new edifice built in the middle of Cannon Hill Park. When it opened, it had a state-of-the-art studio theatre. It was the brainchild of probably the most conservative and bourgeois person I've ever met, John English, who for years had run a children's theatre in a marquee in the park. He'd had an idea about increased leisure time in the future, and he'd gone out and raised vast amounts of money on that premise. He and his wife were really the most small-minded and anti-creative people you can imagine . . . but I was to be assistant director in the new set-up. My instructions were to 'do experimental things' with this arts club for older teenagers and young adults. Suddenly I was presented with an empty canvas to do just what I liked, just how I liked. That's where it all started.

I should say that just before I got offered the job in Birmingham, for £17 a week, I went with my portfolio to see the now-veteran animator Bob Godfrey, who had a company called Biographic Films in Dean Street. He said, 'We just make commercial films here. You'd get £10 a week and be a runner.' My work was very animation-orientated, so I was torn in half. I really wanted to do

something to do with film. I really wanted to stay in London. I hadn't lived in Birmingham previously, so I didn't know what a God-awful place it was going to be. I wanted to be carrying film cans around Dean Street and Wardour Street, and I thought it would lead in all sorts of interesting directions. It's impossible to imagine what would have happened had I taken that job at Biographic Films. Some instinct took me to Birmingham: I was properly spotting what I had to develop in the long term rather than a job that held an immediate attraction.

Did you manage to have a good time there?

Of course. The job was very good news; there was a bunch of highly intelligent and lively young people to do things with.

We did my first play in December 1965. *The Box Play* was undoubtedly a proto-'Mike Leigh play'. There was a family in a cage, and the rest of the world was going on outside. It was very stylised and cartoonish, lit in a heightened way, with jagged music. But its core was a sort of realness. It was also very funny.

The Box Play was conducted entirely through rehearsals in which everybody was there, all the time. But it took a couple of years to refine the way I worked, to spot what it was about. To start with, I was preoccupied with it being about the group experience, the ensemble – influenced by a hell of a lot of things that were going on at the time. What I had to learn – what has become a keystone in the whole operation – is that you can only build a proper ensemble when each individual participant is absolutely rock-solid and confident with what he or she is doing.

So in the first three plays at Birmingham, the characters were either very simple, stereotypical characters, or the young actors were sort of playing themselves. In 1967 I did a play at the RSC where I decided everyone would start individually with a character and I'd then bring them together. The stage manager and I filled a room with a massive number of vessels of all kinds. I told everyone to pick a vessel and to improvise a character suggested by it. Now that is about as far away in spirit from what it's actually about as I ever got. It was just a doodle device to get something off the ground.

When was the turning point?

In 1968, when I did my fourth play at East 15 Acting School, *Individual Fruit Pies* – the first proper 'Mike Leigh piece'. It was about a guy's mother dying in one room, while he lets out other rooms to various tenants. For the first time, the play came into existence by working very separately with the actors and building up very detailed, individual characters. The actors never knew anything about the rest of the work, other than what their character would know. The characters were originated, sourced and created from people the actors actually knew – which, basically, is how I've worked ever since.

Do the actors choose the characters themselves?

Of course not. The choice involves dramatic, thematic and aesthetic decisions. It can only be made by me.

Did you have a clear idea of the sort of characters you thought would come alive in your films?

When I started, in some way it seemed that you couldn't go beyond doing relatively inarticulate or non-communicative people. As much as anything else, it was creating a kind of anti-theatre or anti-cinema that was about the raw world of interior emotions: the way that people live in a state of complete suppression of what they really think or feel. I started to realise that you didn't have to be limited just because actors were improvising organically; they could be so much more than characters who bottled it all up.

I have mixed feelings about the fact that I didn't make a film when I was twenty-two. I could have done; I had the skills. At that age I would have made one of two films: either a completely autobiographical thing about a kid growing up, which would probably have been influenced very directly by *Les Quatre Cents Coups*, or – and thank goodness I didn't – a film about an abortion. I can even remember – and this shows what a journey I've made since then – thinking about filming it in a particular old, rambling house that belonged to somebody I knew in Liverpool. I even wondered if the great Peter Sellers would come and do a brief appearance as an abortionist because of an experience I had of a doctor showing

up, setting everything up and disappearing with the money, not to be seen again. That shows how little I knew. I was very young (and, incidentally, I was not personally involved with the pregnancy in question).

What sort of specific techniques were evolving at East 15?

I will happily talk about some of the techniques I use to get things to happen, but others I simply will not discuss in any circumstances, partly because they're a trade secret (*laughs*), but mostly because they involve elusive things like inspiration, intuition and telepathy.

In principle, I'll say, 'Let's start with this particular real person,' and then I ask the actor to start to act the character by him- or herself in a room, without making anything interesting happen – just to get him or her into the character.

If, as has evolved over the years, I do a character with an actor that is based on maybe three people or even more, then there are ways of going into character, going back and forth and mixing them together through acting, rather than just talking about it. It's about saying to the actors, 'Just do whatever you like – whatever your character would do. You're by yourself, you're not pretending you've got an imaginary friend.' So when the actor gets very used to being the character on his or her own, he or she can then go and inter-react with the other actors in character, who've been through the same preparation. With some solid basis: they know who they are, what they've been through and everything else about their character.

In the early days – and this certainly lasted as far as *Bleak Moments* – I would encourage the actor not just to be the person alone but also to talk to themselves. I was at least partly motivated by having dabbled around with Shakespeare and all his soliloquies, and also by the massively influential *Little Malcolm and his Struggle Against the Eunuchs*, in which the central character talks to himself relentlessly. Not forgetting that I was massively in love with Beckett, where there's all that stream-of-consciousness talk. I still use that device in certain circumstances to bring out certain things.

But I had to learn the patience and the understanding to negotiate the massive difference between something that I found attrac-

tive or interesting as an artefact and something that merely had to happen as part of the foundations of where we were going to wind up. In my early improvisations, I wanted to see the characters in evolution, to see the wheels going around. I wanted to enjoy the image of them talking to themselves. Somewhere along the line I spotted that this could be extremely counterproductive. In other words, I had to learn the difference between the foundations of the building and the building itself.

The generally received convention of what a director does with actors is that you start to manufacture the end product as soon as you commence rehearsals. What I had to learn – and it's the hardest thing to explain to people – is that a very large proportion of what I do is merely preparing the conditions in which the end product will eventually be created.

I don't think that I would have been able to do what I do at all had I not spent time, brief as it was, at art school. I have the ability to draw a character and the details of a character's face with a very fine pencil. When I went to Camberwell Art School, we'd sit around in the life class. There I'd be with a finely sharpened pencil, drawing the lines round the eye of the model. This wonderful teacher called Chris Chamberlain came up once and said, 'Give me your pencil.' He snapped it in half and told me to draw with the blunt end. 'Understand the structure of what you're doing,' he told me. 'Don't worry about the detail till you've got the bigger picture.' It was a major, major educational moment. Whether I'd have learned that if I'd done an English degree at Oxford or Cambridge . . . probably not.

All art is a synthesis of improvisation and order. That's what artists do. But I was lucky enough to have to learn to understand that. I'm now talking about the method of what I do. You can break down what goes on in the evolution of one of my films in terms of creating the characters, building up their history and their relationships, doing all kinds of research to inform the whole experience, then structuring it through rehearsal and finally shooting the material.

But built into all that is an exploration of the unknown, an investigation of things in a way and for reasons I don't necessarily know about when I initiate them. Things happen because actors are being spontaneous and creating in an organic way. So it's com-

pletely unpredictable. You're talking about things that could only happen because a very particular and special kind of rapport is constructed whereby everyone, including me, operates in completely free conditions, without being inhibited or driven or motivated by any sort of compromising or preconception about what it should be.

If you want to know why I am generally reluctant to talk about what I do, it's because you can't really describe it, you can't really do it justice, any more than Van Gogh could explain the sunflowers, other than by describing technically how he applied the paint.

What do you tell an actor working with you for the first time?

When I gather everyone together at the start of a film, the first thing I always say is, 'On such-and-such a date in six months' time, we're going to go out and make a film. Anything we do between now and then is merely preparation so that we can embark on that creative journey.' It's only much later, during the shoot – on *Naked*, say, when we're rehearsing at night in the office block with Johnny and Brian, knowing that we are going to shoot again in a few nights' time – it's only then that I can see the images and the event. Only then can I get down to defining it, to writing it.

The actor is going to experience the magical mystery tour when it happens. But I've rarely had to sell it to an actor. On the rare occasion I *have* sold it, I've wound up regretting it. There are people who don't get it: a few walk away; a few I've chucked out. So the trick is to make sure you get the right sort of folks in the first place. You might think that's no big deal; surely this is what actors do? But it's not. There are plenty of actors out there who wouldn't have a clue in hell what I was talking about. 'Acting' for them is carrying out a job; it's not about getting inside real people in the real world. The truth is, large proportions of actors aren't really pretending to be someone else in a make-believe situation; they're just being themselves in an actual situation, on a stage or in front of a camera. But I look for actors whose total immersion in their character and whose imaginative commitment allows them to know instinctively what to do when, for example, the police come round to arrest Vera Drake. That scene was the result of a ten-hour improvisation that took place three months before we shot it. To

ask grown-up people to dress up for ten hours and pretend to be somebody else, with all the commitment and willing suspension of disbelief of a group of little boys playing cowboys and Indians in the woods . . . it's a massive thing.

So how do you make sure you choose the right actors?

I interview people. I have meetings with them first, never for less than twenty minutes and with nobody else in the room. I don't think it's appropriate to have a casting committee. Auditions are frightening enough for actors as it is. Whoever I work with I finally have a very personal relationship with: that's what I'm looking out for. So I get people to talk about their lives and experiences – I chew the fat with them. If I feel they're any good and we get on, I get them back in. Then I spend an hour with them and get them to talk about somebody they know a bit and to 'do' them. How they talk about that person, how they act them, their response to my direction . . . you can tell a lot about their general philosophy. I also want to know if they've got a sense of humour or whether they can't get over a rather misplaced pious attitude to what we're doing. Certainly I've cast loads of people who I haven't seen working and, indeed, avoided lots of people I have!

Here's a story. In 1987, when I was seeing elderly ladies for *High Hopes*, a very old actress with white hair and round specs came to see me. As usual, I said, 'Tell me about your life.' It turned out that after the war she was very much around on the Fitzrovia scene. 'I knew Dylan Thomas,' she said. 'I knew him very well. We used to drink in the Fitzroy. In fact, the day before he went off on his fateful trip to America we went to the cinema together and I wanked him off . . .'

How much support do you offer your actors once they're on board?

I can't just expect people to do these extraordinary things without a massive and elaborate support system. As I've said, knowing not to put the icing on the cake before you put the cake in the oven is crucial to the whole thing. But all the time, even though my job is to set things up in order to explore and not to worry about where they go, I'm still cajoling and manipulating so that things are

pointing in the right direction. When I teach film students, I encourage them to think about what I call 'the film in your head'. It may change, expand, contract, evolve, but there does have to be a film in your head. You may never make a film that turns out anything like the film in your head; the concept may just be something that drives you. That doesn't matter.

If some regime put a gun to my head and said I had to put on paper exactly what my next film was going to be about or they'd kill me, I'd have to die. I could articulate a few possibilities but nothing more. Yet I've got a very clear sense of the film. I just couldn't tell you what it is in conventional narrative terms. If, as some people always assume, I always know exactly what I'm going to do in advance and I am merely keeping it a secret, then what would be the point of doing what I do? I could simply write it all down and get on with it. Why go to these elaborate lengths? Why give myself such a hard time? If you're going to invite people to come and make a creative contribution, there's got to be some point in it all. It's got to be for real. It makes for an unpredictable and adventurous and dangerous voyage of discovery.

Another way of decoding what I've been talking about is to understand what happens in the so-called rehearsals. They are really not rehearsals at all but the preparatory work out of which actual rehearsals will happen and define the action. I see it as the actors living the characters in a metaphorical dimension, in a non-literal mode. At a certain stage, it becomes much more literal.

Let's talk about *Secrets & Lies*. After three months of hard work involving all the actors playing the family, in which we'd gone through in painstaking detail everything that happened to all of them in their relationships and their lives, Brenda Blethyn said to me one day, 'When are we actually going to start doing some acting on this film? Will we ever get up and start playing these characters?' It's a standard worry. I should first of all tell you that when they did stand up to act those characters, they were brilliant. It was all there. It takes a little while to adjust to details.

So, how does it work? In principle, and in a nutshell, the world of the characters and their relationships is brought into existence by discussion and a great amount of improvisation – that is, improvising a character. And research into anything and everything that will fill out the authenticity of the character.

Gradually we build up the characters' lives, progressing chronologically through the years. Sometimes the actors are in character; a lot of the time they are talking *about* the character objectively; and sometimes I get them to work in ways that are halfway between the two.

Over the years I've developed a whole range of devices, techniques and procedures that make it possible to explore and experience every aspect of the character's existence, safely and with propriety, including sex, violence, travel to remote places and what happened when he or she was a small child, even a baby.

What are the techniques?

Oh, I can't tell you the details because it's a trade secret (*laughs*).

Well, can you give an example of an actor being a small child?

I remember Roxanne's fourth birthday party in *Secrets & Lies* going on for about ten days. It's all there in the foundations of the film. Everybody involved in the family was there.

Which meant that Claire Rushbrook, as Roxanne, had to be a four-year-old?

Yes. But she was able to do it through the methods I've referred to. To do it any other way, like pretending to be a four-year-old, would be embarrassing.

In *Two Thousand Years*, the grandmother dies during the play. We never actually meet her, but we learn she's poorly during the first act and then she snuffs it between the first and second act. During the whole evolution of the thing I 'played' her. I often do the off-screen characters. If I did actually have to play them, apart from anything else no one could get through rehearsal without collapsing with uncontrolled mirth. They'd be corpsed to death.

Now a whole lot of things go on while all this is happening. First of all, what I've just described – which happens while sitting around a table – is great fun. It can go on for ages. It's terrifically stimulating. It's often very funny. People make jokes. Then, in another moment, it can be serious, sad, moving. It's a wonderful way of building an ensemble.

If you have two actors whose characters are or become a couple, do the actors have to have some kind of chemistry between them to make it work?

If it were necessary for them to have that chemistry with each other, you'd also have to say that where a relationship became hostile, they'd really have to be hostile to each other. But neither is true, and both would be dangerous. That's the bottom line. If it ever goes wrong, it's because people can't draw a distinction between themselves and the character – the point at which it blurs. That's happened on occasion, and everything goes to pieces. Of course, people have to understand and empathise with their characters. They just don't have to *be* them.

We've only talked briefly about the fact that the actors take a character that's based on between one and three people they've met or know.

I encourage each actor to begin the whole proceedings by talking about a large number of people he or she knows. Depending on the actor and/or what I think we need, I may give some other specification, but quite often I don't. The list is as long as a piece of string; there are actors who can come up with thirty-five people and others who come up with a hundred and thirty-five. Often people assume we're going to create a character based on someone they know well. But it can be anybody, and it doesn't have to be somebody they like. A lot of time is spent on this. It's a massive part of the creative process for me. I'm imagining all kinds of characters. In the morning I'll be talking to actor A and in the afternoon actor B, so I'm constantly thinking creatively.

David Thewlis came up with over a hundred people before we arrived at Johnny. Stephen Rea, when we first worked together on *Ecstasy* at the Hampstead Theatre in 1979, talked about a large number of people in massive detail. I pushed him for more. One day he said, 'When I first came to London, there was a guy in an Irish pub on the Kilburn High Road, whose name I don't know, but he had a look in his eye and he used to wear a ring.' When I eventually picked this guy as our starting point, Stephen was *outraged*, in a good-humoured way. But we developed a great character: Mick McSweeney, Irishman, builder's labourer and drinker.

Where do the names of the characters come from?

I sit down with the actor and say, 'OK, we're going to name the character.' Then we make lists of all the possible first names and surnames the character could have. And we gradually whittle it down to what seems the best combination.

Obviously it's very much up to me. The actors can't just randomly choose by themselves, not least because a character's name is as essential an element of the poetic imagery of the film as the music or the title or the visual style. And, apart from anything else, they could all end up with the same name! Or names that didn't go together.

If the character is another character's offspring, I do a complicated piece of negotiation so that everybody has shared appropriately in contributing to the decision.

Once characters have been established and relationships are starting to evolve, what's the next stage?

(*Long pause.*) Let's just stand back from the rehearsal process. It's possible to be sidetracked by it and to forget that it's only a means to an end. All that matters is the final film.

On the whole, I don't really distinguish between my two jobs as writer and director, but it might be useful here to separate them and to look at their respective functions, as well as how they eclipse.

As writer, my job is obviously, like all writers, to think up the story. As director, the job is to tell it. So from the word go – long before I've cast a single actor – there's a conception, some notion, however vague; a tentative, putative film in my head. And that premise for the film we're eventually going to make – and don't forget, the one great bonus of working the way I do is that a film has to be made! – that film in my head changes and expands and contracts and evolves as I cast it, as I rehearse it and as I shoot it; and even, of course, in the editing, it being a fact of life that all films are made in the cutting room. All you do when you shoot is manufacture the raw material.

So there I am in rehearsal, a writer with an evolving film in his head and a director with the task of organising the proceedings so as to make them progress usefully. Every direction I give, every

question I ask, every answer I supply, every idea I introduce, every reaction I have, every feeling I experience, every juxtaposition I arrange is motivated by the film in my head.

It goes without saying that there'd be no point in going to all this trouble if my notional film was a fait accompli. Obviously it isn't. Some people think I know exactly what I'm going to do before I start; others insist I never have a clue. Well, in a way, neither is true – and both are! What's certainly true is that I'm only able 'to know what to do next' or 'to know where to take it' by two essential processes: using my imagination and taking from what's going on. I may have a clear notion that 'x' should happen. But then 'y' happens in an improvisation. What do I do? Well, sometimes I think, 'Great. That's much more interesting/makes more sense – let's go for it.' Or I might reject it because I know it must be 'x'. Or, as a result of being confronted by 'y', I realise it should be 'z'. Or, indeed, what often happens is that we explore and develop the thing, and the results are neither 'x' nor 'y' nor 'z' but something else altogether!

So as writer I'm imagining the film (I'm certainly not writing anything yet), and as director I'm responsible for organising the comfortable working conditions necessary for the actors to function freely and creatively, in a disciplined way. I never argue with actors. To move things in the direction I think they should go I have to make it work for the actor in terms of the character's motivation. It has to be feasible for him or her. I simply never dictate. That would be completely pointless.

Actually, as I say all this, I'm finding it immensely difficult to separate my two functions. They really do merge. And if you ask me how I arrive at my decisions – that is, where they come from – I'd have to say it's a combination of conviction, lateral thinking, logic, practical considerations, emotional recall, gut feeling, intuition, telepathy, imaginative leaps, blind panic and my sense of humour.

But even what I've just said could be easily misunderstood. It could sound too abstract. The thing is, we're talking about the *film* in my head. It's not a novel or a poem or an article. What I'm imagining are cinematic images. And this is important because, as I've said, I'm not just working with the actors. The cinematographer, the production designer, the locations manager, the costume and

make-up designers all need to access my ideas as they evolve.

To go back to your original question, what comes into existence during the rehearsals is a kind of three-dimensional metaphor, the imaginary world of the characters actually going on. From the actors' point of view, two things are important here. Firstly, that each of them not only knows all about his or her character but also that he or she knows how to play the character – what we call the characterisation. Secondly, that a believable organic experience is hard-wired into the actor's character memory, and indeed into the collective memory of groups of characters. This may involve events that will become scenes in the film, but frequently not: they just remain things that happened in the past. And, conversely, on location and during the shoot, scenes and moments are often invented that certainly never happened in the development rehearsals. But these can only be created because the character's experience actually exists and I fully understand him or her.

We keep talking about 'rehearsals', but rehearsing in the conventional sense never goes on. It's all about preparing us for going out on location to make up a film. At the end of the period, just before shooting begins, I write a scenario – a shooting script, I call it. It's a very short thing. Merely a structure. No dialogue. No detailed descriptions. From my point of view, the whole operation is designed to make it possible for me to be genuinely spontaneous and creative on the shoot – literally to make it all up with the team.

It's only when we get on location that for the first time we do real rehearsing – repeating it till it's right. This is really the writing stage. I never go away and write dialogue and come back with it on paper. In fact, the actors never see it on paper. I'll set up an improvisation, and when it's all over I'll analyse and discuss it. Then we'll do another, and I'll stop that at some point and start to fix what happens and who says what. And change and restructure, and suggest better lines, or try different ones, and cut and paste, and weld different bits together, and refine and refine . . . until the actors are word perfect and the actions and the dialogue are totally integrated.

Then we shoot it.

And all the time the actors are only aware of their own story . . .

The deal with any of the actors taking part in one of these opera-

tions is: come and be in the film; I can't and won't tell you what it's about. You will never know anything about anything except what your character knows. Interestingly, in passing, with hardly an exception actors love it. You might think they'd be inquisitive or they'd cheat or they'd be frustrated, but they never are. Each actor takes total possession of his or her character and has complete responsibility for him or her and is able, as in real life, to see his or her character at the centre of his or her universe. They don't see their character as being the fourteenth most important character; they don't know what the film's about or where it's going.

Anybody who does any sort of fully fledged character gets one-to-one time with me; I even spend a little bit of time with actors who come in later on to do tiny characters. I take responsibility for the evolution of their character. Of course, I am totally responsible for the pastoral care of the actor, but more importantly, the total-ity of the performance can't be compromised, because the small-part actor can't just learn the lines and come up with an instant characterisation, as in ordinary films. I have to make it all work, totally, for everybody.

There are constantly things for people to go and find out about, to fill out this whole life. People don't worry about what the film's about or what another actor might be up to. In fact, it becomes intriguing not to know – it becomes part of the fascination. They also understand they are holding onto something very private that they don't want anyone else to know about.

Do you encourage privacy across the board?

Yes. The issue of privacy goes beyond evolving a story: I'm very, very strict about actors being private about their own creative process and their own creative problems. Acting is a very vulnera-ble business, and what screws up so many actors in conventional films and plays is having to sort out problems in front of every-body. Don't forget, a problem may have to do with the acting or the character, or something technical or practical, or with the actor's own personal feelings or emotional experience. What becomes standard in my rehearsals and right through into the shoot is the use of the term 'pop out'. I can be working with a group of actors and something will come up, so I'll say, 'Everybody

pop out of the room except so-and-so.' Or the issue may concern just two people. Then we'll discuss it, and everybody else can come back in. Nobody ever talks about their motivation in front of anyone else, neither in rehearsals nor during the shoot.

As for having to talk about their character in the first person – I don't allow it. Nobody's allowed to do it. The actor is first person, the character is third person. I insist partly because I'd be embarrassed for them to be talking as the character and in the first person. But, more importantly, a distinction needs to exist between actor and character – and much acting elsewhere flounders because this principle is not understood.

I don't think it helps if one actor is party to another's acting problems. Sometimes I'll ask for someone to pop out so I can deal with something to do with the acting. Not everything works for everyone all the time. I've got to maintain a very clear, disciplined surveillance of what's going on that's to do with the actor and what's going on that's to do with the character. Sometimes characters start to go in a direction that's wrong . . . perhaps for some red-herring reason.

We therefore have to conduct these operations with a massive amount of elaborate security about who knows what, who is party to what. That's why, when I get people together on day one, it's invariably the only time some people meet till the wrap party.

I'm also excessively, obsessively strict about the actors not talking to anyone about any aspect of what they're doing – not even their partner, husband or wife – because the grapevine in a community of actors is massively efficient . . .

Do you always put up a copy of Fougasse's poster with its warning that 'careless talk costs lives'?

I used to. I had it up for a number of productions, then I had it up for one that went wrong. I decided it was bad karma. But then we stuck one up during *Vera Drake* because someone came back with it from the Imperial War Museum, where you can buy it. I worried it was tempting fate, but it was fine. I've got three originals up in my flat. I love Fougasse.

If you're doing a really emotional, difficult scene, such as that fol-

lowing Vera Drake's arrest, do you have to help the actor unwind afterwards?

Yes. But this is important even if it's not such an emotional situation. The actor needs time to come out of character, to come down, just as he or she needs to take time to warm up into character at the beginning of an improvisation or scene. I never jump in immediately and say, 'Right, let's discuss it!' I always leave time, absolutely.

People often suggest that I must love the rehearsals and find them very exciting; do I like the shoot as much? In some ways I hate the bloody rehearsals! They're a chore. At the end of the day you have nothing to show for it except, perhaps, a possibility. You haven't actually made anything. You're just endlessly buggering about with the foundations. At the end of six months, you've got fuck all, basically. Whereas I love filming. It's wonderful. And there are more people around.

Is it a simple matter to find the kind of space you need available for hire throughout these long rehearsals?

It isn't. We had huge hassles with 'Untitled '06', trying to find a space in London – we have to find a fairly big building with no one else there and with heat and light. If you want a space in the middle of London, as I currently do, it's very tough. It used to be easier: there were empty schools, churches, warehouses and so on, but they've all become real estate – fancy apartments made out of any and every kind of building.

Is it cheaper to work in London?

Overall it is, yes – cheaper than having to pay overnights to crew and cast. It's not cheaper to hire a disused building, though.

Do you enjoy the technical side of film-making?

Oh yes. But I don't regard it as technical; it's part of the joy of film-making. There are technical things I ignore, a lot of photographic mathematics that I don't have to worry about. But the actual application of these things I'm very excited by. I also get very much involved with the sound. I'm proactive and creative with it.

Of course, it's now possible with video playback to sit at a large monitor and direct the whole thing away from the action. It's possible to look at every take of every shot immediately after shooting it and for a whole committee of people to analyse it. I hate all that; I learned to make films the old-fashioned way. That's what it's about for me. So I don't sit glued to a monitor and I don't look at every take immediately after we've shot it; I think it's a massive waste of time and slows everything down. Also, I don't let actors see the rushes. Watching them is a menace for an actor. It can destroy a performance.

Is there a definite divide between cast and crew?

Yes and no. No, ultimately, because the crew are in on it; they are very much sharing it with the actors. And the input from costume and make-up, from the set designer and cinematographer is massive. I share everything with them.

But, on the other hand, the actors have been on this special journey with the characters. They have to spend a lot of time together and they have their own subculture. They're both separate and together.

The atmosphere on a film is core: if people aren't enjoying themselves, it's going to be a lousy film. And any suggestion of bad behaviour, bad vibes, rancour, neurotic stuff – I don't want to know about it. If you get the right people, you get a really good working atmosphere. People have a laugh on my films, there's no question about it. Often, both during rehearsals and the shoot, I'll walk into a room full of actors, and they'll be having such a good time telling stories and laughing so much that I'll feel very excluded from it. Which is very good news.

Don't forget that a large part of what I do is driven by my own paranoia and insecurity: paranoia about it not happening or it not gelling or it not being meaningful or it being awful. That keeps me going.

Has working with cinematographer Dick Pope changed the way you make films?

I started working with Dick on *Life Is Sweet* in 1990. We're still stringently resistant to being gratuitously flashy or letting the cam-

2 Mike Leigh seated on the dolly, in conference with director of photography Dick Pope (standing).

era do anything that isn't motivated. The work I did with Bahram Manocheri, Roger Pratt and Remi Adefarasin in the years preceding Dick was pretty sophisticated but perhaps more restrained. Dick and I have definitely become much more adventurous. I've allowed myself to ease up on some fairly fundamental and rigorous preconceptions about what the camera should and shouldn't do. If you look at the earlier films and where the camera is, what it's looking at is very specific, very strict. That principle has remained, but I've become more emancipated about the camera doing more dynamic, quirky things.

Is that because you've grown in confidence?

Partly, and it's also a case of simply becoming more mature with the medium. It reflects the more sophisticated subject matter and way of telling stories. Take the mother of all these films, *Bleak Moments*: it's defined in part by its severe, austere and for the most part static nature. But there are also two adventurous uses of the camera. The scene where they all sit round not saying anything at the tea party is a series of static shots; in order to achieve it – and since no one spoke and the eye-lines had to be so tight – we took

35

off the magazine and ran the film with no sound blimp at all. It was very noisy. The camera had to be as small as possible so that the actors could all see each other.

There's also a shot of Joolia Cappleman as Pat rushing to visit Sylvia, which was actually a shot done by drawing a very large, perfect circle in chalk on a wide piece of pavement with houses in the background. She rushed round in a circle while Bahram Manocheri handheld the camera and revolved on the spot in the middle.

The shot right at the start of *Naked* where the handheld camera rushes jaggedly down an alleyway towards Johnny and the woman: I actually suggested it to Dick Pope and he wasn't sure he could do it. But he gave it a try: he ran with the camera on his shoulder. I wanted it to be disjointed, and it worked.

On the whole people assume with my films that we're mainly talking about people and relationships. But one of the major elements of what preoccupies me is time and place. You could go through the films and isolate a whole compendium of shots where I am naturally drawn to just looking at and enjoying place for place's sake. In *Grown-Ups*, when the girls have a conversation about and experiment with folding brown doors, it's obviously consciously constructed. The camera stays static and enjoys the space and the dynamics of the scene. Another one that springs to mind is a moment in *Home Sweet Home* that I'm very fond of: at the back of the house, when Stan has brought his daughter back from the home. A static shot on the back of the house, in which they're talking about some television aerial she once brought home when she was a kid. It's about the environment and the space between them. *Meantime* is all about that too.

When it comes to the shoot, do you constantly discuss scenes with Dick Pope?

Everything I do in the preparatory period is only preparation for going out on location later and making up a film, defining things specifically in dramatic and cinematic imagery. That's where it counts and that's what it's about. Though it may draw from the preliminary rehearsals and may in some areas virtually replicate certain things that have happened, the film will also contain much

material which is only discovered and created during the shoot.

Part of what I have to do to change or modulate or dramatise a scene is to do with changing the motivation, and is often merely to do with changing the order of events. Improvising, pinning it down and fixing it, improvising again. We'll get to a rough version which we will then refine. We'll cut it down and change the action and words until we've got something that's very precise – which I can only do on location. I can only script it, as it were, through rehearsal and by seeing it at the same time. I'm also thinking about shooting it, as well as who says what.

As to the actual procedure of arriving at what shots to shoot, I can develop a scene without the crew there and the following morning we'll run the entire scene. I may then say to Dick Pope, 'Let's do this. This is how I've constructed it and the cameras are here.' He may say, 'Fantastic, of course.' He may also say, 'Well, yes, but I watched it from over there and it was really interesting. And the light was better.'

With longer sequences, such as the barbecue scene in *Secrets & Lies*, I will then share with Dick how we're going to shoot. My policy is that if it has to take two or three hours during shooting time for me and Dick to work out how to shoot a scene, then so be it. The actors will wait patiently and run the action as we need. We are looking for a way for the camera to serve the action, of course, but the actors are so solid in what they're doing that the action can and must also serve the camera.

What if you and Dick Pope really disagreed on something?

Even if we disagree, we know what we're doing. In the end it is down to me, but we are doing it together; it's a collaboration. What's interesting about Dick is that he didn't go to film school; he started in the industry as a lab technician in the processing room, then became a cameraman. He shot a lot of Granada's *World in Action* documentaries and brings huge experience to what we do. He also has feature-film sensibility. He loves to operate himself; I don't like working with a cinematographer and a separate operator. He even operated on *Topsy-Turvy*, a bigger canvas and the sort of film that usually demands that the cinematographer hasn't got time to operate as well as light.

There's more to it, of course, than just what the shots are: there's the whole conception of the film, the look of it, the palette. There's also what happens in post-production. The journey of discovery with Dick has been massive. I never made a film where we properly shot tests until *Naked*, although Roger Pratt shot experimental 8mm footage during the preparations for *Meantime*. There were *Plays for Today* where you never saw the cameraman until he showed up at the beginning of the shoot. The guys from Pebble Mill who shot *Nuts in May* spent most of their year shooting *Farming Today* and the occasional documentary. So the idea that you would be in communication with the cinematographer and you'd actually discuss the look, the feel, the spirit of the film and you'd go and shoot tests, I was very green about.

Let's return to the method. Timothy Spall says, 'The moment you go from the improvisation to words is almost impossible to explain.'

I agree. Next question?

Can the actors remember their lines?

Yes; their capacity to remember is amazing. It just goes straight into the brain box. That's because it's organic. They know and understand where it's all come from, and words and action are inseparable.

Is there a difference between actors you've worked with before and those who are new to the game?

Not really, apart from the obvious fact that anybody who does anything gets better at it the more they do it. First-timers are into it in no time. People who've done it before just get back into it. Without exception, this is what happens in my films. Sparks often say, 'I don't understand this film. There's no script, they all know their lines, they never fluff them, nobody gets into a right old state or rows with anyone. Every take is word perfect. I don't get it.' But it's just all there.

Can we talk about some examples of your method at work in the films?

Well, OK. Let's start with *Naked*. At some stage of the preliminary rehearsals of what was then 'Untitled '92', I set up a night-time improvisation where Johnny comes into an office block (our rehearsal space happened to be an office block). Brian was there, and they went into the building and walked around. They chatted. End of improvisation. It was a pointer in the direction of a putative scene. I also set up stuff where the woman was at the window. There was a configuration in the rehearsal space where you could do that.

However many weeks later we'd got a proper location and had dressed it. We then went into rehearsal mode – rehearsing, incidentally, at night for the full atmosphere. We did what is standard: we re-explored the improvisation, only this time with a real location. I then did what I always did: I stopped it, broke it down and built it up. Reconstructed it. In the case of that particular scene, we did a lot of improvisations and we also introduced a lot of stuff objectively by saying this or that could be in there. It's a very elaborate process which also involved sitting around and talking about what Johnny and Brian might say and sorting out all the ideas that were on the go.

But what also happened is that they simply improvised as they walked around the building, with Brian turning the lights on and off and so on. My job at that stage is just to watch and listen. At some point, I was in a particular spot where the lights came on through some interior windows dividing two offices and Brian had to walk right across the room to turn them off, which left me looking at Johnny silhouetted against light through the windows. Because he was in the dark, Johnny stayed where he was and was going on about things. I thought, 'Wow, how amazing, how cinematic! This is just fantastic!' So we used it, obviously. Then I took something we'd structured in another place – all the stuff Johnny says about bar codes – and reallocated it to this place. And, of course, the whole point of this is that I discovered this imagery by working three-dimensionally, by being there. I couldn't have thought it up at my desk.

How about the bathroom scene near the end of Naked *where Johnny and Louise sit on the floor talking?*

Interesting. The front end of *Naked*, when Johnny shows up at

Sophie and Louise's flat, had been investigated in the rehearsals. But the back end of the film didn't exist. It was explored and rendered at the same time, at the back end of the shoot, during a period where producer Simon Channing Williams – as he's done on a number of occasions – negotiated a week off with the crew so we could rehearse action.

We'd already shot everything to do with Johnny up till that point. So I set up an elaborate improvisation in which he came back to the house. We then distilled this down to the precise action we shot.

The scene in Meantime *where Tim Roth as Colin pulls his hood down after sleeping in his coat to reveal a newly shaved head.*

That's the real thing. We were waiting for Tim. He was having his head shaved. I knew, he knew, but, of course, none of the other actors in the improvisation knew. His mum, dad and brother didn't know where he'd been. They thought he'd been to do the painting job for his auntie. It was a very long improvisation in the flat – about seven hours. I remember it because I sat in one place and Chris Rose, who was the first AD, sat with me the entire time. It was a real fucking cliffhanger. He showed up and kept his hood up for hours. You could have burst waiting for him to pull it down! Eventually it came down when he was in his room with his brother Mark. So we dramatised that. Separately, we improvised and constructed all the stuff about 'Where have you been? Get yourself a proper job' and so on.

There's a constant distinction between what's happened in the rehearsals and stuff that can only be done in the actual situation. *Meantime* we rehearsed in an old warehouse on the Kingsland Road in Dalston. Barbara invites Colin round to help her with some painting. We did an improvisation, in a real house, with Barbara there in character with all the paint. We worked out that she had got out John's old pyjamas for Colin to put on while he was painting. The costume designer went to great lengths to get duplicates and triplicates of everything, because without a shadow of a doubt Colin was going to cover himself in paint, and there would be more than one take. Of course, when we investigated the situation, not a paintbrush was touched . . .

The scene where the sword falls on Gilbert's head in Topsy-Turvy.

That's more conventional: a reconstruction of a historic moment, a built set within the location. The sword had to fall off the wall at a certain moment. We filmed it 796 times hoping it would fall . . . No, seriously, a prop guy knocked the nail out from the other side on cue.

Gilbert's wife Kitty in bed towards the end of Topsy-Turvy, *talking to her husband about her surreal dreams.*

That's like the scene at the end of *Naked.* Some of what Gilbert says in that scene is a direct quote, such as, 'There's something inherently disappointing about success. I don't quite know how to take praise. It makes my eyes red.' But first of all we did the improvisations. I worked with them, putting in ideas, suggesting all the elements. Lesley Manville went away to think about it, and then we talked about it some more so she could get her head round it. I wanted to bring out Kitty's repressed creativity. This is an example of material throughout the films that represents my more obvious writing contribution: it's not all just organising what happened in the improvisations.

The scene where Cynthia discovers her daughter is black in Secrets & Lies.

At the start some of the actors knew each other and some didn't. They all assembled together for the one and only time in the upstairs room at Kettner's restaurant in Soho. You can read a more detailed description of this occasion in Michael Coveney's book *The World According to Mike Leigh.* One of the actresses there was Emma Amos; she was going to play the woman with a scar down her face who has had a terrible accident. Brenda Blethyn vaguely knew her.

When we decided to investigate Hortense phoning Cynthia, we did it with mobiles. Marianne Jean-Baptiste, who played Hortense, was tucked away somewhere near by. At no time had she and Brenda seen one another during the rehearsals. It was always organised so they'd never overlap, and everyone is under strict instructions never to show up unless they're called. So she phoned her up. It was a pretty devastating and accurate investigation of

what we eventually dramatised, although it didn't happen when she'd just had a row with Roxanne.

Brenda (not as Cynthia) told me subsequently that – outside the rules of engagement and in one tucked-away corner of her brain – on hearing the voice she decided it could only be Emma Amos. She assumed the baby she'd given away was white, since there weren't that many actors there and some of them were already in her family. She didn't even go as far as thinking it couldn't be one of the two black actresses – that simply wouldn't have occurred to her.

Her disbelief when she finally met Hortense must have been even greater.

Well, there she was, assuming it was Emma Amos. They arranged to meet. I decided they'd meet outside Abney Park cemetery in Stoke Newington, just because it was convenient; we were rehearsing in a disused school across the street. They met at dusk. I watched from the other side of the road. It was very powerful and tense. Of course, as always, I was watching the putative version of something that was going to be in a film, constantly checking it against the evolving story in my head.

Cynthia showed up and walked up and down. Hortense showed up and walked up and down. Neither knew who the other was. Not only did Brenda expect to see Emma Amos but there were also a lot of black people walking around. Brenda didn't recognise Marianne; it was twilight and she wasn't expecting her.

Marianne – Hortense – was on it and approached her. Brenda almost said, 'I can't talk to you, I'm doing an improvisation.' It was for real! So when she announced herself as Hortense Cumberbatch, the experience Cynthia had was as real as anyone can have in these situations.

Much later, we reinvestigated the dialogue and shot it outside Holborn tube station with the camera on a long lens on the other side of the road. We had rehearsed the main structure and dialogue of the scene, and then, on the day of the shoot, the great thing was that in one take this woman materialised. A big woman with a suitcase and specs. She was hanging around and then she walked towards Hortense, absolutely on cue. That was the take we used.

How did you deal with Sally Hawkins as Susan being date-raped in
Vera Drake?

Here we're in a very particular kind of territory. This rape had to
happen. Sam Troughton, who plays the chap, didn't know any
more than Sally did that we were in a film about abortion and that
the abortion was a foregone conclusion. But we explored the rela-
tionship through a tactile investigation. Then we stopped it. We
isolated a moment when the character might either force her to
have sex or back off. Sam said he'd back off. In many circum-
stances I'd think, 'OK, he backs off.' But in this particular circum-
stance it was the worst news I could've heard. I'd created this
character knowing exactly what his dramatic function was going
to be. Of course he bloody well could, and of course he did.

So occasionally there's a *deus ex machina* whereby I have to pro-
voke something to happen. I remember one particular circum-
stance in which there was a very interesting relationship on the go
between two people who were not getting on. It went on and on.
It was very important to me as part of the whole scheme of things
that they got married. This was for *Babies Grow Old*, the play I
did at the Other Place in Stratford in 1974. On that occasion the
two of them [Sheila Kelley and Eric Allan] came in on Monday
morning and I sat them down. 'The premise is', I told them, 'that
they get married.' They both looked shocked. They digested it,
thought about it in relation to the real world and agreed to go with
it. And it was great.

So, in *Vera Drake*, I had to tell Sam Troughton to do it. Of
course, I put pressure on him, but he knew it was entirely feasible
for that guy to be so beastly. He didn't agree at first; he was mak-
ing a moral choice, which was fair enough but not good enough.
We investigated it, left it alone until we came to shooting it and
then we simply set up an improvisation, constructed the scene and
shot it very simply.

This is the thing about it: for all its discipline and integrity, at the
end of the day the job is to make a fiction. There's nothing holy
about the improvisations. They are only a means to an end; they're
not an artefact in their own right. You have to remember in the
context of all this why it's important to have honest and intelligent
actors.

It must be tremendous when it all comes together.

I just get an enormous buzz when the whole thing takes off and actors start being brilliant. What happens on the journey with every actor and every character is that there's a certain moment when something clicks. Up to a certain point, we're both developing the story of the character and still working on how the actor plays the character. There's always a moment when it goes *Clunk!* and I can stop worrying about the acting. It settles, becomes three-dimensional and grows.

I mostly enjoy watching my films, but if ever I couldn't watch them for some reason, I do have fantastically glowing memories of sitting in rooms with people, watching them doing things without a camera even being there.

Can you imagine a life where you weren't making films?

On one level I'd be delighted not to have to do anything – just to lounge about and be lazy. But actually the buzz and excitement of making films is so colossal that it would be devastating not to do it all the time. For ever.

Bleak Moments (1971)

Sylvia (Annie Raitt) lives in a south London suburb with her mentally disabled sister Hilda (Sarah Stephenson). By day Sylvia works as a typist in an accountant's office with her friend Pat (Joolia Cappleman); by night she cares for her sister, drinks sherry and reads books. Her secret dream is to be a writer. Her lonely life is interrupted by two men: the first, Peter (Eric Allan), is an awkward, emotionally frigid teacher she vaguely knows who asks her out to dinner; the second, Norman (Mike Bradwell), is a hopelessly shy hippie who comes to do the printing when Sylvia rents her garage to an underground magazine.

Peter is nervous around women. He interrogates Norman about his education and criticises him for dropping out of school before A-levels. Peter takes Sylvia to a Chinese restaurant where there is only one other diner. The silence weighs heavy. Finally, they leave and return to Sylvia's house, where she offers Peter sherry and keeps topping up her own glass in an attempt to relax. There is more silence, yet the atmosphere is charged with unspoken desire. Sylvia desperately tries to lighten the mood by telling Peter that, in her head, she was telling him to take his trousers off. Peter refuses more coffee, pulls on his gloves and leaves.

Sylvia knocks on the garage door to see if Norman would like to come in the house for a drink, but he already has plans. At the office Pat tells Sylvia she wants to take Hilda to see a spiritualist; Sylvia is against the idea.

Peter is in the school staff room. When another teacher discusses next term's 'humour project', he says that he doesn't think teenagers have a sense of humour.

Sylvia and Hilda bump into each other outside the library. It's an awkward, tense moment. When the sisters return home, they discover that Norman is moving out. Pat comes round and gets upset about her mother. Sylvia doesn't respond. Pat and Hilda go to the cinema. Sylvia plays the piano in a half-hearted manner, alone.

* * *

AMY RAPHAEL: *When you made* Bleak Moments *you were just twenty-eight years old. Can you recall much of your world view at that time?*

MIKE LEIGH: Well, of course, I grew up in a socialist youth movement. At twelve and thirteen, when other kids were venturing into coffee bars, we spent our Saturday nights debating the likes of whether capital punishment should be abolished (my deep conviction was that it should). At fifteen, I went to hear Bertrand Russell at an early CND rally at the Free Trade Hall in Manchester. And we were on the Aldermaston march in 1960. At RADA I was once castigated by an elderly member of staff for wearing a CND badge. 'We all went through the war,' she cackled, piously, 'but we didn't need to wear badges. We just got on with it.' Remarkable, considering most people were in uniform and everybody was fighting fascism! But, in a way, that serves to illustrate the naive, apolitical climate of the established theatre in the early 1960s. And even for those of us who were politically on the left by instinct, it was somehow still OK to regard yourself as outside politics if you were an artist.

But for me, as for a whole generation, one became properly and totally politicised by the end of the decade. You can track this metamorphosis by looking at the evolution of the Beatles. Naughty provincial lads into flower-power exotics into active vocalisers on Vietnam. Vietnam woke us all up (incidentally, I was in Grosvenor Square in 1968). By the beginning of the 1970s everything seemed possible – and we certainly couldn't have imagined that the world thirty-five years later would be so terminally fucked up.

So *Bleak Moments* is an implicitly political film. It is rooted in a social-class context and looks at how we live. But it doesn't deal

with anything beyond personal and sexual politics. True, it touches on issues – care and responsibility, education, openness – but it doesn't do the kind of thing Ken Loach and Tony Garnett were up to on television. *Cathy Come Home*, which was shown by the BBC in 1966, had a direct effect on housing policy. *Bleak Moments* did no such thing. In that sense it is not an issue film.

Did you watch those BBC 'Wednesday Plays'?

Interestingly, I saw virtually none of them because I didn't have a television during that period. I didn't watch TV; I went to the movies. If anything, I initially felt isolated from the BBC. I had applied and been rejected three times to do the BBC directors' training course. A very frosty board plainly thought rehearsing and making up a film was just silly, really. I kept on being told to reapply, but the third time I was able to write back and say, 'Unfortunately I'm unable to apply this year as I'm actually directing a "Play for Today" for you.' Tony Garnett thought it was such a gas. Anyway, I finally hired a telly when I started to apply for the BBC course.

Bleak Moments *started life as a play in 1970. Where did the fundamental idea come from? Were you drawing on your own experience?*

The central frustrations and unfulfilled needs, aspirations and desires that afflict everyone in both the play and film were very personal. I was a deeply lonely person. In many ways I still am. Up to that time, I had had various relationships, but most of them hadn't got anywhere. I had some that did, but . . . a lot of it, particularly the central stuff between Sylvia and Peter, came in its essence out of my early experiences. The awkwardness and the whole thing about communicating – these were things I had experienced, yes. It was about being trapped. But the central premise of having to care for somebody, that just came out of my head. And, of course, the dead suburban world of my background has much to answer for.

It's very much a film about how we perceive ourselves, as opposed to how others perceive us.

One of the themes that runs right through my films is the whole business of received behaviour and how we are motivated or inhibited by our notion of how we want other people to see us. In a very raw state, that's what *Bleak Moments* is very much about. The tension between innocent, direct honesty and inhibited, indirect behaviour – inhibited by received notions of how you should be behaving – lies at the core of all five central characters.

Hilda is somehow more direct and straightforward than the others because she is innocent of all these mores. Although Norman and Pat are both inhibited and self-conscious in their respective ways, there is, at the same time, a directness and innocence in both of them. Then there's a directness in Sylvia which is simply completely inhibited by the company she keeps and the situations she finds herself in. And of Peter, no explanation is required.

You mustn't forget the influence of Beckett and Pinter on my work. I remember conceiving the basic dynamic and spirit and feeling of *Bleak Moments*, and it seemed very natural just to go into this very private microcosm and explore something in a real way. It was simply what was interesting to me. I don't know if I was conscious that what I was doing was particularly radical – though it was, actually. It was quite a unique film in a way, though all sorts of influences had gone in.

Bleak Moments *was certainly radical in the sense that you allowed silences to linger and people to emit strange noises or pull odd faces.*

I have always thought there was something missing in Antonioni's films. He seemed to be about something important, but it never really happened. It was a glossy, sexy, magazine world he was portraying. So, at some unconscious level, *Bleak Moments* is my natural reaction against that kind of perfect world; I wanted to look at people grunting and twitching, because it's what we do. As a non-gorgeous person myself, my motivation was almost to dramatise the rest of us in some way.

You asked before about world view. By the late 1960s I was in many ways absolutely onto what was happening. There was a guy called Tim Horrocks who was a teacher, thinker and film-maker and who sadly died young. He wrote a piece about *Bleak Moments*

in a magazine we produced at the London Film School. This was called *Sinic* and was edited by Roger Pratt, the cinematographer. Tim said, to paraphrase, 'This film sits on the cusp of the '60s and '70s. It sits on the cusp of the '60s with its protest and the '70s in which we are prone to self-absorbed introspection.' It was very perceptive to see that pretty much at the time.

One manifestation in *Bleak Moments* of what was happening in the world is Norman, the magazine and the world it represents. To me what's fascinating is to see the tip of the iceberg: this guy in this garage with an old-fashioned Gestetner machine and his guitar . . . No doubt some people would have no idea why he was there or what was going on, but a substantial number of people knew the world from which that came and everything it implied. You didn't really get much about who these alternative characters were. They were implied a bit by the clapped-out vans in which they dropped Norman off and picked him up.

It's a glimpse of another world, alien to the likes of Peter and even Sylvia.

Exactly. Whether it's the Jane Austen she's reading . . . There's very little that actually tells you much about the ins and outs of Peter, but you get a very clear idea of what kind of teacher he is. Partly through his interrogation of Norman, which is a key scene, and partly when you see him in the school. Education is discussed implicitly without the film being about a revolution in a comprehensive school.

Is Bleak Moments *a template for all that followed?*

In a way it is, yes. Don't forget that the stage version of *Bleak Moments* was the tenth improvised play, so in actual terms I'd already done quite a lot of work that paved the way. But what began to worry me hugely at this stage was the threat that working the way I did could only produce characters who were inarticulate or catatonic or introspective. By definition it made for non-communicative situations. This turned out to be total nonsense, of course. The breakthrough film, in this sense, was obviously *Nuts in May*.

How hard was it to transfer Bleak Moments *from play to film?*

Well, it was no big deal in broad terms. I've only ever done it with *Bleak Moments* and *Nuts in May*, although in these two cases I wasn't really turning a play into a film, rather making a film from some of the ingredients of a play. The only time I've actually pointed a camera at a stage piece was *Abigail's Party*. In *Bleak Moments* the characters were there, the dynamics of their relationships, their world. I simply had to go back and explore that world and then go off in another direction. But we had had a terribly rough ride with Charles Marowitz, who had agreed to put it on at his Open Space venue but then completely hated it. He had decadent, arty ideas about improvisation. Added to which, it played to empty houses. Yet I felt optimistic about the play.

Bahram Manocheri – who ending up shooting the film – came and took production stills of the play. Les Blair was at the London Film School with him and introduced us. We all sat around talking about how cinematic it could be. So right from the word go we were talking about making a film. Amazingly, when the play was still on, I got hold of Tony Garnett's number and, although I didn't know him, phoned him up. I said, 'I've got this play that's had bad reviews and I'd really love you to see it.' In retrospect it's remarkable that he came, because, as I soon learned, he hates theatre. He can't stand going to see plays.

But that night, after he saw *Bleak Moments*, I went back to Tony's flat with him and the writer Roger Smith. Apart from working on 'The Wednesday Play', both were very much involved with the Workers' Revolutionary Party at that time. I was there till about 3 a.m. talking about anything and everything. I remember saying how much I wanted to make a film of the play, and Tony saying, 'Well, how would you do it?' And we talked about the possibilities. Roger then reviewed *Bleak Moments* in the *Workers' Press*. He saw it as a fundamentally Marxist play.

You didn't work with Garnett until your second film, Hard Labour. *Instead, you formed your own company, Autumn Productions, with an old school friend, Les Blair. How instrumental was Blair in raising the money?*

Very. He said he'd like to produce and edit the film version of

Bleak Moments. In the meantime, I went off to do a disastrous production of *The Life of Galileo* in Bermuda. Albert Finney had taken a percentage rather than a fee on *Tom Jones*, which was very successful, and had decided to set up Memorial Films with Michael Medwin. So he put money into *Gumshoe*, which Memorial made, which Finney was in and which Stephen Frears directed. They made another film called *In Loving Memory*. Then they decided to take a gamble on *Bleak Moments*. They offered to put up £14,000. We ran out of money in post-production and they forked up the rest, taking the total to £18,500.

You've said in the past that this is the only time you've ever bene-fited directly from the BFI.

The BFI Production Board had this agreement with the ACTT, the old film union, where the crew could be paid way below union rates simply to ensure an experimental film can be made. This would make it an official BFI Production Board production. When I first came up with the idea of making *Bleak Moments* into a film, the director Bruce Beresford was head of the BFI board. He came to see the play and was very positive. But by the time it came to make the film, other people had taken over. Anyway, the BFI weren't very interested; the minimum they could give was £100, which they did. But, still, it became a BFI Production Board film, so we were licensed, as it were.

Did you earn any money from the film?

Not really. Everyone, myself included, was on £20 a week. The actors, who weren't covered by the ACTT agreement but by Equity, were on a minimum of £40 a week. They all invested half their wages back into the film. So while we were in production everybody was on £20 – just about enough to live on.

You said somewhere that shooting rumbled on for ever . . .

Well, it went on a bit. We shot for longer than was originally scheduled. Up to then my only film-making experience was acting in a film, *Two Left Feet*, as soon as I'd left RADA. I got the hang of how it happens because I used to go on set all the time, whether

they called me or not. I was also in some other bits, including Michael Winner's *West 11*. I went to the London Film School and did the night course, which was good but limited. I'd directed some shorts in Birmingham which are now lost. So I'd been around a bit of filming and later I'd taught how to direct actors at the Film School. But I hadn't really done the whole thing.

As a consequence, making the film was a massive learning curve. It was really my education in film-making. I hadn't directed a film with sound until that point. I remember that very early on in that shoot I lost my confidence. You've got to feel sure that people are behind you, and here it was so chaotic. We had very limited resources and manpower: a cinematographer, a sound recordist, a focus puller, a boom swinger and a fifth man, who was part of both crews. There was no catering. There were no sparks, so it took for ever to do anything.

But by the time shooting got into full swing, I was very freed up by it. I had the confidence, for example, to deal with the shots in the tea-party scene: you get all those tight shots and then a shot where you see the hatch, and Pat and Peter are right on the edge of the frame looking out. I remember everyone saying, 'You can't do that! They should be looking inwards or be within the frame.' But I knew I was right.

But another massively important thing I learned was that you have to have time with these films – more than an ordinary film – to develop and rehearse the action in the location, without the crew. Because we got ourselves into a real pickle. We did mad things like shooting all night. It was so undisciplined in a way. I wasn't giving myself time to get on top of the material. We'd be shooting things that hadn't really been digested. So we decided with Albert Finney and Michael Medwin's collusion and support to lay off the crew for a week to ten days in the middle of the shoot – just so I could engender a lot of material. And of course that was fantastic; it unlocked the film.

Then what made it special was other people's contributions, not least Bahram Manocheri's: he shot it on Eastman colour, 35mm, but he built home-made lights and lit it using bits of Aertex underpants. He had hardly any expensive stuff; it was all done on the cheap. But, as you can see, he actually got the quality.

I could go into a cutting room now and chop out twenty minutes

and it probably wouldn't suffer at all. It's got 'first film' scrawled all over it, but it still has a discipline and integrity. For all its faults and the ponderousness of its conception, I think I was motivated by a very strong sense of emotional purpose. And that holds it together.

How evolved was your 'method' at this point?

I think the real point is this: well before *Bleak Moments*, and certainly with *Bleak Moments*, there had come into existence a pretty sophisticated way of creating an inner world, a world with people in character that lay beyond merely acting out situations in a literal way. Everything that happened in the procedures that created *Bleak Moments* had already taken place in the previous productions. *Bleak Moments* wasn't the first improvised play I did with professional actors. I did one at the RSC that was very crude but interesting and another with drama students at East 15 Acting School. But in a sense, since the rest of them were with people of an amateur status, this was the most grown-up exploration. It was dealing with grown-up issues. There was something about getting together a gang of grown-up professional actors . . . part and parcel of that was the moving forward of the way of doing things.

Despite the fact that it was challenging, hard work and, at times, shambolic, did you have fun making Bleak Moments?

Yes. It was a very rich experience. But very, very tough. It was grindingly hard work; it always is, but we were particularly under-crewed.

How was the film received on its first release?

It was premiered at the London Film Festival, where it had a really good response. It ran at the Paris Pullman. It came out the same week as Hitchcock's *Frenzy*, and George Melly reviewing it in the *Observer* said something like, 'Alfred Hitchcock is famous for treating his actors like cattle and it shows. Mike Leigh, however, does no such thing . . .' And he went on to rave about the film. That was great, a shot in the arm. Other critics were supportive, notably Derek Malcolm in the *Guardian*. Eventually it won the

Golden Leopard at Locarno and the Golden Hugo at Chicago.

Roger Ebert, in the *Chicago Sun-Times*, raved, 'It is a first film by a young British director who exhibits in every scene a complete mastery of the kind of characterisation he is attempting.' Yet even he acknowledged that it wasn't entertaining in the conventional way. But there weren't many British films around at the time – which is why, of course, I didn't make another feature film for a hundred years.

One of the keys to making your films work seems to be your ability to keep empathy going, no matter how frustrating and hard to like the characters might prove to be.

I don't think about it as such. What motivates me – when I'm making all the choices in arriving at what you see in the moment on the screen – is what is interesting, and that can be for a whole variety of reasons. Part of the fundamental philosophy of my films is that everybody is interesting and, as in real life, every character is three-dimensional and rounded and at the centre of his or her universe. So, despite what some ridiculous people have said over the years, there are actually no stereotypes or ciphers. All the characters, even the minor ones, must be resonant. On that principle, the fact that a character may be unpleasant or hard to sympathise with would only be a problem if I didn't get them working or make them three-dimensional.

I suppose that even with a character as hopeless and difficult to empathise with as Peter you still watch the film shouting at the screen, 'For God's sake, man, pull yourself together! Just kiss Sylvia!'

'Get on with it!' Exactly. That's what it's about. The chemistry of how these films work – *Bleak Moments* not least – is exactly that. It's the audience constantly reacting to things in terms of how you know it should be, could be, ought to be. How you think it's wrong being the way it is. All of those things. And that's what this kind of story-telling is about.

There was a screening of *Bleak Moments*, early on, that I went to at Southampton University. It was shown at midnight and everyone had pints and it was very jolly. They were onto every gag, and it was

hilarious. Finally, when she says, 'I was thinking, take your trousers off,' there was a cheer, an explosion. Of course, I've also been to screenings of my films where I thought everyone had died.

How close was the final scene between Sylvia and Peter to the first improvised version of it?

Oh, that's a very complicated question. The following answer applies right across the board: you don't do an improvisation, just fix it up and shoot it. There were maybe a dozen to fifteen investigations – in other words, separate improvisations. When you then structure the thing, and you're drawing from things that have happened in improvisations, you still carry on reinvestigating it, even as part of the defining process. In fact, if you look at the scene in *Secrets & Lies* where the two women sit side by side at the table in the cafe, it's a clear descendant of the one from *Bleak Moments* you're talking about, in the sense that it's absolutely distilled and it's all going on, but it's drawn from a whole series of improvised explorations.

At this early stage in your career, how did you ascertain whether an actor would be capable of working in such a way?

I wasn't sure they could do it; I just hoped they could. I knew some of them could because I'd worked with them, but it was mostly shooting in the dark.

Did I have the choice of every actor in the world? Not at all. Often the people I cast were those I could persuade to take part. 'Sorry, what did you say? No script?' It was far out, barking mad. They'd say, 'Oh, you mean a happening? Oh, you mean a documentary?'

Anne Raitt I knew because I'd worked with her at Stoke, where we were both in *Twelfth Night*. Sarah Stephenson had been in *Individual Fruit Pies* at East 15. Eric Allan I knew vaguely from the RSC. He was a good sport. Mike Bradwell I taught at East 15 and he was a friend. Joolia Cappleman I was going out with, and she was original and off-beat. The famous George Coulouris, who was Thatcher the lawyer in *Citizen Kane*, started off in the early stage version – mad man, big eyes, long face, been in lots of movies, about seventy at the time – but he baled out after four days. He

55

thought it was bollocks. He'd been really enthusiastic to start with, saying he'd always wanted to do something experimental! He'd talk about Orson and the Mercury Theatre, and this was fantastic. But, in the end, it wasn't his cup of tea.

I then held auditions for the additional parts in the film, and out of that came Liz Smith, who came from nowhere and is now, of course, a national treasure, and Ronald Eng, who played the Chinese waiter. He was rather wonderful.

Bleak Moments *is an emotional roller coaster and yet not much at all really happens in it.*

'Not much happens' as defined by the general convention of things happening in films. Say that a man walks down a street, comes through a gate, walks up to a house, rings the doorbell. I would say that in a lot of movies that is a straightforward and uninteresting conjunction that has to happen merely by way of information. The second unit could go out and shoot it.

However, if you look again at the man walking down the street, there's a whole number goes on just getting through the gate. In *Bleak Moments*, this guy Peter is inhibited because he thinks Sylvia's watching him out of the window. There is complete silence in the street – and by the way, we never needed crowd or traffic control as it was that quiet. That's how it was in Tulse Hill in 1971.

I remember shooting Hilda coming back from the daycare centre, walking up the street with all those sawn-off trees, backlit. At one point in that sequence Hilda turns the corner of a street and a van goes past with 'Lambeth' written on it. That just happened. But you get a real buzz from the real world. Through the joy of looking at ordinary, banal things and finding what can be made interesting about them, it becomes something else, something meaningful, poetic.

It's interesting how the film documents an era quite specifically, from the quiet streets to Sylvia buying a bottle of sherry for fifty-nine pence . . .

Fifty-nine and a half pence. If you look very carefully behind the salesman there's a sign that says 'Decimalisation'. We shot that

3 *Bleak Moments*: the poetry of real streets.

scene just a few days before decimalisation. It's important that he says fifty-nine and a half pence; everybody feared that everything would become more expensive as prices would be rounded up. And, of course, that's exactly what happened. So fifty-nine and a half pence, which is a preposterously fussy sum, was an exact conversion of duodecimal to decimal. It would have been 12/6d or something. Within months it would have gone up to 60p.

To what extent is Sylvia anaesthetising herself from the reality of the world with her sherry drinking? Or is it simply a release from the mundane nature of her life?

Both. She's lonely. She's intelligent and perceptive and aware enough to know how bad this is and how unfulfilled her life is in relation to its potential. She's trapped in this situation. In the booze shop, when she buys the sherry, there's a certain level of self-conscious guilt about it. She's a lone boozer. And so when she gets a guy in the house, she wants to share it with him.

The fact that Sylvia is very beautiful somehow makes it all the

more tragic. You sense she has so much potential, yet she is being denied a Technicolor life. As a viewer you're desperate for someone to come and give her an opportunity to really live, but instead there are just these two hopeless men.

Totally. I've reflected on this a lot over the years: the film doesn't explicitly raise the question of Sylvia's choice as to whether to put Hilda in a home. It's implicit in the film that Sylvia has chosen to look after Hilda at home. And I remember thinking, 'Oh well, that's obvious.' Whether I should have dealt with it more explicitly, I wouldn't like to say. Certainly you know this is a woman who could make that choice and find another life for herself.

Because Sylvia doesn't discuss Hilda in that way, we immediately view her as a 'nice person', a selfless person who is looking after her difficult sister.

Absolutely.

Roger Ebert wrote, 'This is a new kind of suspense of real stories happening in real time.' The suspense is incredible: as well as not much really happening, the film moves very slowly, but you find yourself sitting on the edge of your seat.

As I said, I could go and remove a chunk out of it. But in a way one of its many subversions is that it's naughtily saying to the audience, 'Well, just be patient and take your time to get into it.' The other thing is that the bubble never bursts. There are four times which should be the climax; you think it's the end, but it carries on. Again, in subsequent films – mostly from *Nuts in May* onwards – you do get a kind of climax. In *Bleak Moments* it's very deliberate that it feels climactic, but there's never a climax. That's an important part of the subversion, of the treatment the audience is getting – forcing them to participate.

The humour, however, keeps us going. Its timing is very important. Like Sylvia's daft jokes: when Norman asks her what she does, she replies, 'I'm the president of Venezuela.' She's such a strong female character with a gentle sense of humour, to which the men have no idea how to respond.

I don't disagree with what you're saying, but I suggest you might want to distinguish between Peter's total lack of humour and Norman's . . . well, he gets it, but he's just a young, shy lad. But you mention the placing of the humour. I sometimes get asked, 'How do you decide when it should be funny?' The truth is that I don't ever really take time to ponder this. Humour is an organic, instinctive thing.

It's a bleak film, yet there is so much hope and possibility.

It's making the audience see those possibilities. The minute the audience aspires to things, or wishes for them, then the positive exists in their experience of the film.

With Bleak Moments *you set up an approach that you've pretty much stuck to with every subsequent film and play: you avoid moral judgement. You don't judge Peter's intellectual pretensions or emotional deficiencies, you just present them.*

Well, yes, it's a fundamental principle. Laying out ideological, didactic arguments and so on – I'd find that very hard. It's not a conscious choice of mine not to judge the characters morally; the fact is that I just don't. For me the most distressing line of criticism I get is precisely that – that I'm judgemental. But I never am. I simply reflect and lament on how we live our lives.

Might that criticism come, in part, from people feeling uncomfortable with the realness of your films? Perhaps they'd rather not contemplate the existence of Beverly in Abigail's Party *or Colin in* Meantime.

I think that's right. If you start with an awkward, slightly overweight, grubby guy with greasy long hair in an old black overcoat, people may say, 'Ah, you've made him like that so we can laugh at him,' as if he were inferior or degenerate.

Let's talk about the iconic nature of tea in your films. It's a constant in the whole body of work. Is that how you were brought up?

Everybody in these islands was brought up with tea. In *Vera Drake* Vera makes it all the time. The point, however, is not the cups of tea

themselves but the focus on the detail around. Throughout the films there are all kinds of moments to do with things – for example, the sudden presence of a dinosaur-shaped nutcracker in *Grown-Ups*.

I am endlessly fascinated by things. As a kid, I remember sitting in art class in primary school making electric irons out of clay and painting them, anticipating Claes Oldenburg by over a decade. I was always fascinated by Heath Robinson as a kid and Rowland Emmett, the railway cartoonist. Indeed, you will find in my library, perhaps surprisingly, books about old buses and cars and trams and railways.

Music is very important in your films, but the first film to have its own score is The Kiss of Death *in 1976. In* Bleak Moments *Sylvia hesitantly plays Chopin on the piano and Norman plays his three-chord 'Freight Train' on the guitar. Why didn't you have a music score for* Bleak Moments? *Was it a matter of money?*

No. I didn't want one. I thought it was absolutely wrong and unnecessary. In the original stage version, Norman sang Bob Dylan's 'She Belongs to Me'. Of course, we wanted that in the film but we couldn't for copyright reasons, so we used a couple of songs that Mike Bradwell wrote. Somebody told us they'd checked and 'Freight Train' was traditional and therefore out of copyright, but when the film came out in the States we received a bill for £900 because Elizabeth Cotton had written it in 1948.

Not having music was part of the deliberate radical policy of the film. I remember saying that all films have scores and often don't need them. In fact, I was quite militant and purist about it at that stage, which is why you don't get a music score till *The Kiss of Death*. Which is eccentric in one sense, because if someone had said to me, 'OK, name twenty films that you love, and love not least because of the music,' I could have done so easily. From *Jules et Jim* onwards.

It's fascinating to look in your films at how we perceive ourselves as opposed to how we are perceived by others: the notion that if there are two people in the room there are really six people in the room. Sylvia's boss wants to be smart, philosophical and funny but instead they're laughing at him . . .

I talk about this in the introduction to the script of *Two Thousand Years*. All my films have in one way or another dealt with identity, with the conflict between what we are and how we live, with what we believe in.

I've always thought I ought to do a film called 'The Done Thing'. I grew up in a world where you constantly heard that phrase: 'Don't do that, it's not the done thing.' What is the done thing, then? There was a lot of pressure in the 1950s to conform. We had ballroom-dance classes that were done jointly with the girls' school next door. Who the fuck wanted to learn ballroom dancing? My folks, bless them, actually got a guy to come round and give me bloody boxing lessons in my bedroom. I think my father worried that I was gay! There were layers and layers of received behaviour and having to conform . . .

Did that end with your generation?

It's a pertinent question. I never completely put all this into perspective until we were making *Vera Drake*. I realised, looking at that world, why people were conforming and 'behaving properly'. We who were teenagers in the 1950s couldn't wait to kick it all out in the '60s, which, of course, we did. What we knew but didn't really think about or realise was that between the 1930s and the early '50s, our folks had gone to hell and back in the Depression and the war. They'd been through shit. The whole awful respectability of the '50s and its effect on youth – encapsulated in everything from *The Catcher in the Rye* to *Rebel Without a Cause* – was about my parents' generation putting the world straight. They had gone through chaos.

A whole generation of us were fundamentally critical of this repressive world. So *Bleak Moments* is that very suburban world with this bubbling anarchy dying to get out. In a way, it's a metaphor for my own background.

Did your parents enjoy Bleak Moments?

They thought it was great. They were very surprised and bemused by it, of course. It hit the headlines. They had seen nothing of what I'd done in the 1960s. They didn't really know what I was doing till quite late on.

Did they think you ought to get a proper job?

Yeah.

And here was proof, finally, that you had a proper job.

Well, yes, except they thought it was great when I got a job as assistant director at the RSC. Then they were disappointed when that didn't last very long.

Let's talk about some specific scenes in the film. One of the most memorable is Sylvia and Peter in the Chinese restaurant. The excruciating portrayal of couples with nothing to say to one another over dinner is distilled to perfection.

We've all been on those dates, haven't we? I can think back to certain fledgling relationships that never happened. Why the hell didn't we just get on with it? What was the problem? There were these massive elephants in the drawing room. What were they? I don't know.

4 *Bleak Moments*: Sylvia (Anne Raitt) and Peter (Eric Allan).

The truth about this very public space they're in is that it's devoid of people, apart from this aggressive lone diner in the other corner. The emptiness makes it more oppressive. Then, of course, Peter and Sylvia go back to a very private place and it's just as bad, if not worse. The real issue at stake is how hard it is in societies where you're free to choose your own partner to find the right partner: someone with whom, on a very basic level, you can just communicate, quite apart from more complicated issues like sexual compatibility.

When they return from the restaurant, Pat is at home, having looked after Hilda. Peter and Pat stare at one another. They seem paralysed by their respective situations. It's sad watching Pat with Hilda. When she puts her to bed, Pat plays 'This Little Piggy'; for a moment she can pretend to be Hilda's mother.

In a way, Hilda is a child. Nevertheless, it is a loving relationship. Hilda is pleased to see Pat and to go home with her. I'm not sure that the scene with Pat's mother and the false teeth works completely. It might be slightly clumsy because it was filmed in a rush, all in one night.

Pat is so frustrated by living at home and by being defined as a daughter; with Hilda she can reverse the roles.

Totally. It's the only context in which Pat can be a controlling person.

The ghosts of the characters stay with you a long time after the film has come to an end.

For me, the most important thing with the chemistry of how my films work is that the audience is not let off the hook. They shouldn't be able to walk away without stuff to ponder and be haunted by, as you say. They should take responsibility. People often ask, 'What happened next?' I won't go there. That's up to you. I'll always remember a man in the Q&A at the New York Film Festival after the screening of *Naked*. 'Mr Leigh, do you think that within an hour of the end of the film Johnny is dead?' Which I thought was rather good.

Hard Labour
('Play for Today', 1973)

Set in Salford, Hard Labour *follows the life of Mrs Thornley (Liz Smith), a charlady who never seems to stop cleaning and looking after other people. Her husband Jim (Clifford Kershaw) looks on idly as she cleans their small terraced house, and later complains about the sandwiches she prepared for his night shift as a security guard. Her daughter Ann (Polly Hemingway) wonders why her shoes have not been taken to the cobblers. Jim is also dissatisfied with his footwear, asking the tallyman (Louis Raynes) to replace them as they are too tight.*

Taxi-firm owner Naseem (Ben Kingsley) asks Ann to the pictures. Later, he helps Ann's friend Julie (Linda Beckett) to arrange an abortion, telling her it is not only expensive but also dangerous. He tells Ann that he would not let her get into such a situation and would look after her.

While Jim is in the pub on Saturday night, Mrs Thornley retires to bed with a hot-water bottle and her rosary beads. When Jim gets home his wife is asleep. He throws the carefully placed hot-water bottle on the floor, tries to arouse her and then forces himself on her. She endures the sex as if she were a cadaver. Later, we see her rubbing Jim's hairy back when he complains about the rheumatism in his shoulders.

On Sunday morning, Jim and Ann bicker. She dislikes his table manners; he doesn't want her to smoke at the table. Mrs Thornley goes to visit her son Edward (Bernard Hill), who lives on a modern housing estate with his wife Veronica (Alison Steadman). Veronica criticises Edward's table manners. Mrs Thornley attempts to clear away the plates, but Veronica stops her. She looks bereft.

While Jim and Edward drink in the pub, Ann and Mrs Thornley discuss childbirth. Mrs Thornley – who had two difficult births with Ann and Edward – says that women must suffer to bring children into the world.

At confession she tells the priest, 'I just don't love people enough . . . It's my husband . . . I don't love him.' She accepts the priest's assertion that she feels guilty. While barely looking up from his football newspaper, the priest tells Mrs Thornley to pray and do penance. Back home, Mrs Thornley cleans her windows.

* * *

AMY RAPHAEL: *How did you set about following up* Bleak Moments?

MIKE LEIGH: Obviously, having made one film there was, of course, a very strong hunger to make another. Actually, after *Bleak Moments* I wasn't to make another feature film as such for seventeen years. As I've said, I had failed to get onto the BBC's directors' training course, so it's to Tony Garnett's credit that he had the imagination to phone up and ask me to come and do a film at the BBC. This turned out to be *Hard Labour*.

But Tony told me he had to justify the commission to management, so I needed to put something on paper. While we had been shooting *Bleak Moments* in London, my folks had moved from a house to a flat. I went up to Manchester to see them in their new home. After the war, when my old man set up his doctor's practice, we lived in the house, over the surgery. I remember a whole string of women staying at the top of the house: a combination of what in other contexts would have been called nannies or domestic helps. Quite a lot were unmarried women with babies. It was only later that I realised how enlightened it was of my folks to do that.

One of the early women was called Bridie Williams, who was actually married. She had come to Manchester to live with us from somewhere outside Dublin. She brought her baby daughter but temporarily left behind her husband and two boys. Later the family came over and they got a house down the road, so she moved out. But subsequently she was for many years my mother's cleaner. When I went to see my folks in their new flat, Bridie was there.

Having just shot *Bleak Moments*, I was looking at things very crisply. I suddenly saw these two women of a comparable age, who'd known each other for well over twenty years. My mother called Bridie by her first name; Bridie called my mother 'Mrs Leigh'. I thought somehow this could be a film. So when Tony needed something specific, that's what I suggested. What I actually gave him was a drawing of a woman and an Asian family and a Jewish family and a black family . . . it wasn't what the film became, but it was on that basis that Tony sold it.

What was your working relationship with Tony Garnett like?

The very serious and committed people who produced the BBC's series of 'Play for Today' films were concerned with the exploration and definition of ideas and with ideologies of various kinds. Tony Garnett was the king of those producers. So my debt to him is massive and my respect is huge. He completely appreciated the way I went about things; he enjoyed the way I worked. I think it would be true to say that as a result of discussions with him – of a type that I've never had before or since – the conception of the film expanded. One of the central points was that it would be an epic microcosm of different kinds of ethnicity, backgrounds and classes.

If I were completely honest, I'd have to admit that although nobody put any pressure on me to make a specific kind of film, somewhere along the line I was succumbing to a conception of a notion of style. I was trying to make it 'like a "Play for Today"' – as personified by Ken Loach films. So there's no question that I wasn't really doing my own thing completely in the way that I have done at all other times. But I must stress that this was all my own fault. I had absolute carte blanche, which Tony went to great lengths to protect.

Even the fact that you had to supply a working title . . .

Well, yes, I had to call it something. Right off the top of my head I came up with 'The Electric Weasel'. Which was a piece of surrealist nonsense. It turned out that on an old-fashioned northern factory loom there's a shuttle called the weasel. So people thought it must be about new technology in the cotton industry . . .

The next time the BBC demanded a working title it was for what turned out to be *The Permissive Society*. I thought it would be a wheeze to continue the style of the gag, so I called it 'The Clockwork Chipmunk'. This was followed by 'The Plastic Tadpole' (*Nuts in May*), 'The Elastic Peanut' (*Knock for Knock*), 'The Concrete Mongrel' (*The Kiss of Death*), 'The Porcelain Pig' (*Who's Who*), 'The Chocolate Chicken' (*Too Much of a Good Thing*, my only radio play), 'The Iron Frog' (*Grown-Ups*), 'The Wooden Egg' (*Home Sweet Home*) and 'The Hot Potato' (*Four Days in July*). Obviously the last of these was somewhat less random and surreal than its predecessors!

Later, when it came to making a film outside the BBC, it didn't seem right to continue the tradition of surreal names. So *Meantime* was called 'Smoke' and *High Hopes* was called 'Winter'. *Screen International* used to publish a weekly report of all the films that were being shot and at the end of the year they did a round-up, that particular year mentioning *High Hopes* and 'Winter' as two separate films. So I said to Simon Channing Williams, 'Hereafter we'll give our films names that no one can confuse.' So *Life Is Sweet* was 'Untitled '90', and thus we've continued.

Had you been a fan of Ken Loach's work?

Yes. I was a huge fan. And I got to know him. One has to remember that Tony Garnett had by this time pioneered all this work, particularly but not only with Ken, which was massive and hugely influential and significant. I was coming in with the privilege of being on the tide of that. What he was doing and continued to do with Ken and various writers was to be very much part of a team forging ideas and making them happen. In that context, my rather empirical, solo kind of operation wasn't something that Tony was used to.

Did ratings matter to the BBC then as now?

They were interested in them, certainly, but it wasn't a debilitating, inhibitive factor like it is now. There were only three channels, not three hundred. But a 'Play for Today' could get four, five, six or nine million viewers. I think around four million watched *Hard Labour*. They used to go out on the same night every week, at 9.25 p.m., just after the 9 p.m. news on BBC1.

Did you have a reasonable budget?

Yes. I remember saying to Tony that in an ideal world we'd go and make the film up in Manchester, but I presumed we couldn't. He immediately said, 'Why not? We can do whatever we like.' It was a revelation. Unfortunately, such freedom has been rare and I've made very few films outside London.

Did you discuss Tony Garnett's casting process too?

Yes. One of the things that Tony and Ken had pioneered in order to get away from actor-ish acting was to go up north and find variety people, performers, who had Equity cards. Ricky Tomlinson came out of that. So when we set about doing *Hard Labour*, I wanted real people. We put an advert in *The Stage* newspaper: 'Wanted: actors between 45 and 60. Who can improvise. Northern.' There were hundreds of replies. I sat in a room round the corner from here, on Oxford Street, seeing those people on and off for months.

I did the same thing up north. It was a massive operation. I saw around six hundred people.

Were you pleased with Hard Labour?

Hard Labour is not a complete failure, but I do feel that it was a film made, as it were, in a slightly different style to the rest of my films. It's less under control. Part of that is to do with the 'Play for Today' preoccupations I've already discussed. But it's also for another reason.

The house where Mrs Thornley and her family live is literally right on the doorstep of the area in which I grew up. Those characters in those streets were all my father's patients. The house that she goes cleaning in is next door but one to the house we moved to in Cavendish Road when I was twelve. I was making this autobiographical film in my head just because of the location alone. But I wasn't making that film at all, because I wasn't actually dealing with any autobiographical issues, other than something to do with mood and atmosphere.

What I was failing to do was to be really in control of creating a metaphor that gets to the essence of things. So *Bleak Moments* is a

much more accurate autobiographical film about growing up in suburban Manchester than *Hard Labour*.

Did you at least feel satisfied with some of the characters?

Some, but not all. Anyone trying to land me in the Old Bailey to prove that I wasn't being entirely honest on all those occasions when I've denied the existence of any caricature in any of my films would have to look no further than the nun who comes round to the Thornleys' house in *Hard Labour*. It's embarrassing. There's a sudden lapse into a sort of *Carry On* scene that you don't get anywhere else in my films. The Jewish women in *Hard Labour* are pretty awful too; their presence doesn't really get to the essence of anything . . . it only records surface behaviour, and not very well.

Having said all that, *Hard Labour* was ambitious. Interesting people worked on it, on both sides of the camera. It was a big opportunity. There was quite a lot of diverse reaction to it. There were people on the left at the time who thought it was a waste of an opportunity – as they later did with *Meantime*. Somebody said it was the view of 'working-class life as viewed by a middle-class aesthete'.

Did you feel under pressure to perform, given that this was your first film for the BBC?

Absolutely not. I think this applies to all the films I made at the BBC: everything was done to make it very comfortable. When you get into a project, you don't spend much time thinking about its profile. That comes later. The Head of Plays at that time was Christopher Morahan, also a director, and he along with Tony Garnett made it feel like a very positive experience.

Then I just got into the swing of doing BBC films. I used to be working on a bit of dialogue and I'd say to myself, 'Will they get this in John O'Groats and Land's End?' I had a very clear sense of these films being transmitted specifically around the British Isles.

Did you have a specific idea of how you wanted to portray Salford?

It's complicated. Just by being there I felt somehow as though I was depicting it. The strict answer to the question is no. Let's compare

it with, say, *Four Days in July*, which began with my never having set foot in Ireland – I was to discover Belfast and Derry for the first time. I had a really clear conception of the world I was depicting. Now I had that feeling about Salford and Manchester, but not with objective clarity.

There are also some oddities. The film opens with the shot of a derelict, isolated black building in a sort of Lowry-esque landscape which is right next to Strangeways prison. But that choice of location was completely fanciful, just a weird building on a bit of barren land.

I was motivated, undoubtedly, by a strong sense of going to film a world that I knew. But the question remains: was it a real world that I knew or a kind of fanciful world which varied to a greater or lesser extent in how organic it was? The one bit of the film where you really get an accurate sense of the social world I grew up in is when the Jewish tallyman comes around with Jim's boots. That actor, Louis Raynes, was very good; he'd captured something real and truthful.

Another thing in passing: notwithstanding that we were middle-class people in a bigger house, I had from an early age gone into houses like that lived in by the Thornleys for all kinds of reasons: delivering medicine or messages, notes, just visiting. I'd often be invited in for a cup of tea. It was very much a world I knew.

In this film, as in all your films, nothing is perfect in the world you create/recreate; it's the antithesis of Hollywood gloss and sheen. In Hard Labour there are unmade beds, belching after dinner, big fat bellies . . . It's the truth of people's worlds. Was anybody else doing what you were doing?

Not really – certainly not in England. But I'd been very inspired by the Czech directors a few years earlier, especially Milos Forman.

At the time did you feel like an innovator?

I did. And people saw me as such. There were also begrudgers. For example, some writers complained that the BBC had made a film without a writer, that they were denying writers a living. Fay Weldon was particularly aggressive.

Let's talk about how I credited myself on my films and my attitude to it. I made a massive mistake for a long time by not identifying myself as the writer of the thing, even though that is what I am. But out of respect for other writers and the conventional ways of doing things, I just put 'Devised and Directed by'. At the time of *Hard Labour* I was very angry about the complaints but I just put up with it.

Mrs Thornley's life is a desperately sad one in many ways. No one seems to appreciate her, her sex life is cold – she lies almost as a cadaver while her husband does his thing. How much hope is there for her? She seems more trapped than many of your other characters, more alienated.

She is. There is no apparent escape route for her. Her husband may die, which would relieve some of the pain. Obviously what the film also raises – and this was contentious to some degree – is the question of faith, what it does for people, and the deceptive nature of religion. There was also quite a lot of stick about the priest reading football pinks . . . When I did a play called *Epilogue* with Catholic students in Manchester, one of the priests we wheeled in

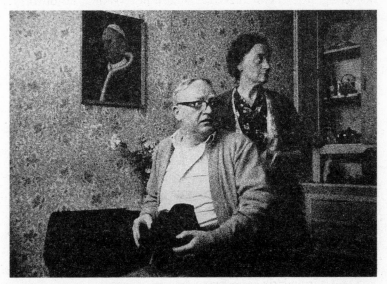

5 *Hard Labour*: Mr and Mrs Thornley (Clifford Kershaw and Liz Smith).

to check things out asked us where the priest's football pinks were, and, later, when we went to a Catholic church in Salford to shoot the confession scene, there they were . . .

Why is Jim Thornley so angry?

He's frustrated and unfulfilled. He's not comfortable in his own skin. It's a desperately boring job he does. I worked for Securicor in the early 1960s for a stretch. (At that time you didn't have to be a burly guy.) I guarded various buildings in London. Of course, this is recycled much more significantly in *Naked*. It is very, very bleak being in an empty building all night. For people like me doing it in the '60s, you could find ways of making it interesting. You could read books, as Brian does in *Naked* . . . but for a guy like Jim Thornley, it's desperate.

Mrs Thornley tells the priest during confession, 'I just don't love people enough . . . Well, Father, it's my husband . . . I don't love him.' Obviously the film comes out of improvisation, but did you know it would reach that point?

Her predicament is that she's riddled with guilt. She's trying to find out what she feels guilty about. She feels as though she's not being Christian enough in some way. For her the objective fact that she doesn't love her husband is a sin.

By contrast, one of the most uplifting scenes is between Mrs Thornley's daughter Ann and the taxi driver Naseem, played by Ben Kingsley. It provides the only real moment of emotional honesty in the entire film.

Yes. The daughter is a character who you do feel will get on with it and break out. She is upfront. More than her brother, who's trapped with this awful wife who is, I suppose, the mother of a whole load of my subsequent characters: the original version of various suburban, upwardly mobile types . . . some of whom are played by Alison Steadman, some not (*laughs*).

Let's talk about Alison Steadman.

As you know, we'd met at East 15 Acting School some four years

before. Then I was casting *Hard Labour* up in Manchester and I went over to the Everyman in Liverpool to see her in *The Four-some*, by E. A. Whitehead, about two couples on the beach, played by her and Polly Hemingway – who plays Ann in *Hard Labour* – and Jonathan Pryce and Michael Angelis.

When did you and Alison Steadman start having a relationship?

While we were doing *Hard Labour*. It was a busy time. There was a lot going on (*laughs*). If we're going to be completely honest, it may be that not being completely in control of the film had some-thing to do with embarking on a major relationship. It was slightly distracting, yes.

Of course, there was Liz Smith as Mrs Thornley.

I'd worked with her on *Bleak Moments*. She was very good news. Having agreed with Tony Garnett on the central idea for the film, it occurred to me that it was an opportunity to work with her again – she was a starting point.

And you knew Ben Kingsley from the RSC?

Yes. I assisted Trevor Nunn on *The Taming of the Shrew*, which was a very good experience, and Ben was the First Huntsman. I saw him do other stuff too, culminating in Peter Brook's *Midsum-mer Night's Dream*. An important thing about *Bleak Moments* and *Hard Labour* was that I'd been around. I'd had a lot of expe-rience of actors.

How would you compare working on Bleak Moments *to* Hard Labour?

Bleak Moments was a skeleton crew, a very scratch team, working with very limited resources. For *Hard Labour* I was being given the full monty to work with: a full crew, proper state-of-the-art caterers. I even had my own assistant, a very experienced woman called Irene East.

The other thing is that for the first time I was properly paid, and very substantially by the standards of the time. I think I was on £100 a week, which was fantastic. On top of that, Irene would

continually give me envelopes stuffed with massive amounts of cash. She'd pull off all kinds of stunts to get expenses. This was standard BBC procedure. My car packed up; no problem, here's a hire car. Basically, it was a proper, grown-up, funded real deal.

Did you use a shooting script?

Before I start shooting every film I write a shooting script. These are skeletons from which to build the film. They are printed, and everyone has a copy. *Hard Labour* is the only film for which I didn't really have one. I just had big sheets of lining paper covered with lots of notes and doodles. Nothing was printed or given out. So there's a sort of looseness to it. Which may in some ways be part of its charm, but it's also the reason why I think it's less successful.

You keep referring to Hard Labour *as being 'less successful' or 'undisciplined'. But you must have learned so much from those mistakes?*

Totally. It was a seminal experience. Don't forget, we shot it over the course of spring and summer 1972, and it went out in 1973. Then I didn't make the next film for another two years, because no one was interested. It was only through a fluke that the next one happened. It was always tough to get those BBC 'Play for Today's. But if *Hard Labour* hadn't happened, I doubt I'd ever have got any. I just don't know what would have happened, I really don't. Thank goodness for Tony Garnett.

Would you still have been working in the theatre?

Yes and no. I would certainly have persevered with getting films made. But I don't think I'd have been in a position to produce the continuous body of work I did at the BBC and develop the way I did. So, by the time I was making feature films again, I had a port-folio that made it possible to be taken seriously. And don't forget, it was only because of the popularity of my TV work that theatres allowed me to do bigger and more expensive productions.

What did you do in those two years before The Permissive Society *was made?*

Well, *The Permissive Society* was done at the end of 1974 into 1975. We did *Hard Labour* followed by some plays: *Wholesome Glory* at the Theatre Upstairs at the Royal Court, which was the prototype for *Nuts in May*. Then I did a play in Edinburgh and another one at the Court. The first proper piece of major work following *Hard Labour* was *Babies Grow Old*, a play at the Other Place at Stratford. And that really was a breakthrough in many ways, a very solid piece of work.

How useful was your work in the theatre when it came to returning to film?

To some extent, the quality of the writing and the conception of the films was helped by my work on plays, which were by their nature more sustained. One could never mount a stage play as undisciplined as *Hard Labour*. By the time I did *Babies Grow Old*, which opened at the end of August 1974, it was two years since *Hard Labour* and no one was interested in a film. I was very pissed off about it. The main outlets for films were the BBC in London, the BBC in Birmingham and some of the independents, like Granada. To this day I cannot explain why I couldn't get a gig at Granada. Maybe they didn't like *Hard Labour* . . .

There was a producer called Tara Prem who was working at the BBC in Birmingham as a script editor. By the mid-1970s she was producing a series of half-hour plays called 'Second City Firsts' and she got me in; *The Permissive Society* was the end result. While I was there, rehearsing at Pebble Mill, I got invited to a Christmas drinks party in David Rose's office. He was head of BBC English regions drama. He said they'd had a very good year and the following year they were going to make four films. He had commissioned three but was on the lookout for a fourth. My only obsession in life at that point was making my next film. So I talked to him after the party, and he kept saying, 'How do we know what it'll be about? You have to give me some indication.'

We'd done *Wholesome Glory* at the Royal Court the previous year. Once Keith and Candice-Marie had been born, it became obvious it would be great to do a film about these two, get them out into the open country. So I mentioned this idea to David Rose. He said he was from Dorset, yet all the films he was commission-

ing were set up north in urban environments; he suggested I went down to Dorset to have a look round the Isle of Purbeck, which I found a very inspiring experience.

Of course, *Nuts in May* ended up as nothing if not a deeply urban film about urban people behaving in an urban manner. For them to be in the middle of nowhere is a complete technicality, really. And, of course, the irony is that it became one of the most famous and successful of the films to come out of Pebble Mill.

The Permissive Society
(BBC 'Second City Firsts', 1975)

Les (Bob Mason) has been dating Carol (Veronica Roberts) for five weeks. Before a night out he invites her to his family's flat. He wants to be out before 9 p.m., when his mother and stepfather will return from work. They watch a television programme about nudists; Carol says she could never be a nudist, while Les argues that we are all born naked. Les's older sister Yvonne (Rachel Davies) comes in. Les wants some tea, even though he's arranged to eat out with Carol. Yvonne warms up some food his mother left ready, which Les then eats lying flat out on the sofa.

Les quizzes Yvonne on her relationships; she talks about her former husband treating her badly before leaving her. Les is berated by both girlfriend and sister for being a slob. Carol warns Les he might get indigestion, but he remembers seeing a television programme which explained that people can eat in any position – swallowing has nothing to do with gravity and is all about the throat muscles. Carol has learned in biology the principles of 'peristalsis'.

Carol helps Yvonne to do the washing up. Carol reveals she is an only child because her mother had a few miscarriages. Les pushes Yvonne to get ready and go out. Carol has a go at Les for neither eating at the table nor offering to clean up. He tells her to shut up, and she threatens to leave if he says it again. He tells her to shut up; she puts her coat on and asks him to come to the pub. He wants to wait till 8.30 p.m.

Carol and Les finally have a proper conversation. He admits he's never had a girlfriend before and is a virgin. She wondered why he hadn't pushed her into having sex. He is serious for a

moment: he says sex is everywhere but it shouldn't be like that.
Carol wanders into Les's bedroom, where he apologises for his
earlier behaviour. He plays 'Leaning on a Lamp Post' on his
ukulele. She kisses him.
* Yvonne returns home early, having been stood up. Les asks if*
she'd like to come to the pub with them, but she refuses. Les and
Carol leave; Yvonne stands alone in the kitchen.

* * *

AMY RAPHAEL: *What was it like working within the confines of a*
studio?

MIKE LEIGH: At that time a lot of drama was made in the studio
with five cameras. It was an awful convention, because it had such
a definite studio feel – that static, airless, literal quality. And shoot-
ing with five cameras simultaneously meant each shot was inhib-
ited by the other four. There was a very definite divide between
pro-studio and pro-film people and non-partisans who didn't give
a shit either way as long as they were working. So I was very resist-
ant to studio, but this gig came up. It was an opportunity, and Tara
Prem was very supportive.

How did you make the best of the studio situation?

Having done loads of stage plays really helped: between *Hard
Labour* and *The Permissive Society*, I'd actually staged *Wholesome
Glory, The Jaws of Death, The Silent Majority, Babies Grow Old*
and *Dick Whittington and His Cat.* I was getting more and more
experience.
 The basic construction of a studio play is common sense. And it
wasn't actually the first time I'd been in a studio: I'd directed a
thing about gambling called *A Mug's Game* for BBC schools tele-
vision. In fact, the earliest work I did in the theatre was episodic,
with scenes being chopped and changed. They really were like
films on the stage. Things would stop in the middle, black out, cut
to other scenes. Certainly the more I got to do films, the more com-
fortable I felt with the kind of stage situation I prefer – where you
really settle down and don't allow the audience to be distracted by
boring theatrical devices like scene changes.

78

What is important about the studio aspect of it is this: because it was a studio play as opposed to a film, it had to be constructed properly as a play. You couldn't do it in a filmic way. On balance, the result is positive: it's a well-constructed piece, very tight. *Bleak Moments* and *Hard Labour* would have much to learn in that respect.

How was it working with just three actors?

I'd have to say there's a continual conflict between the delight I get from working with small groups of people and the desire to people a canvas with all sorts of characters. But it's always tempting every time I start a project, including now, to say let's only have a few actors; the only two times I actually did was with *Grown-Ups* and *Career Girls.*

How did the budget compare to what you were allocated for Hard Labour?

I've no idea. One was a full-length film that was shot on location and the other was a half-hour studio play. We shot in a day, I think. Maybe two days. We rehearsed for three weeks or something. *Bleak Moments* was probably rehearsed for about six or seven weeks. *Hard Labour* rehearsed for eight weeks and shot in about five. *Nuts in May* was actually shot in sixteen days . . . all those BBC films were rehearsed in five to seven weeks and shot in no more than five weeks. Now we rehearse for six months and I get the hump because I only get ten or twelve weeks to shoot. *Topsy-Turvy* was an exception; we shot for twenty weeks.

The Permissive Society *is a concise vignette of family relationships alongside sexual expectations and tensions.*

I like the way there's sex hanging in the air. All three of them have sex on the mind, yet no one's openly referring to it.

Was it an observation on society at the time or was it autobiographical?

Well, it's always autobiographical in a sense. Sure. And at the same time it was observing what was around me. It remains a reality

that even now, when we're living in this fantastically liberated twenty-first century, sex is not easy or straightforward.

Les says that sex is everywhere, but he wants it to be special. I don't imagine it was very common at the time, the idea of saving yourself for someone?

In 1974 we were living in the age of 'the permissive society'. The phrase was much in use. Compared with now things were tame, but it was still intimidating for guys like Les.

There's the sexual awkwardness going on between Les and Carol but there's also a class issue going on.

And again it's in the context of 'the done thing'. Carol wants to be a respectable girl. She thinks everything should be done properly. She doesn't like it when Les slobs around – she takes it personally.

Does Les try to emote through music, by playing the ukulele for Carol?

It's a way of communicating with her, yes. And the fact that Bob Mason had musical skills – I always like to tap into such skills when actors have them. I love it when you've got music coming out of action. I also love George Formby.

I first saw Bob Mason's gangling genius in a play he wrote at Rochdale Youth Theatre in 1969, before he went to drama school. *The Permissive Society* was one of his first jobs. For some years he stopped acting to write stage plays and TV, including seven years on *Coronation Street*. He returned to acting and was in *Secrets & Lies* as the father in a long sequence about a wedding Maurice photographs. Sadly, we cut it because it was a red herring. Even more sadly, Bob died of throat cancer a few years ago. He was very talented and a delightful guy.

It's interesting how much you learn about the characters in just thirty minutes: you feel as though you have a strong idea of Yvonne's bad luck in love and Carol's status as an only child after her mother suffered miscarriages. Often this information is gar-nered from muttered half-sentences.

I think that's right. That's what I always try to do. I was pleased when Trevor Griffiths told me he thought it was the perfect TV play.

Again there's the notion of learning to watch without making judgements; thus, we shouldn't judge Les as a slob who doesn't care.

That's true, but at the same time – this is important too – what I'm doing is trying to work on those very expectations on the audience's part. So you see Les and think, 'Slob.' At that moment that's exactly what he is. The thing I try to do constantly is in a subtle and subversive way to shift the audience from the slob assertion to thinking instead that they like the guy. You have to earn that with the audience. In a way, my job is to build a route for the audience to follow.

'The Five-Minute Films'
(1975; broadcast 1982)

THE BIRTH OF THE 2001 FA CUP FINAL GOALIE

An amateur goalkeeper (Richard Ireson) concedes five goals and arrives at hospital too late to see his wife (Celia Quicke) give birth. Six years on, the goalie and his son are kicking a ball around on a scrap of land near some council flats. In a reversal of stereotypical gender roles, the goalkeeper had urged his wife to come off the Pill and get pregnant. He had also hoped for a girl.

OLD CHUMS

Two old school friends meet but are as strangers. Disabled Brian (Tim Stern) sits in his invalid car, while Terry (Robert Putt) boasts about sexual conquests. Their short conversation ends and we see Brian drive off to the cinema to see The Blazing Inferno, *as he inadvertently describes it, while Terry strides off into the distance.*

PROBATION

A black lad (Herbert Norville) who didn't pay for a cup of tea and then got into a mild fight with a copper is up for probation. He goes to a probation office. There is a suggestion of racism from the officer (Anthony Carrick) who is preparing the lad's court appearance report. As he leaves him to make a cup of tea, the officer says, 'Don't nick anything!'

A LIGHT SNACK

A middle-class woman (Margaret Heery) gives the window cleaner

(Richard Griffiths) a sausage roll; in the sausage-roll factory a Scouser (Alan Gaunt) talks non-stop drivel till his colleague (David Casey) tells him to 'Just shut up!' and 'Leave it alone.'

AFTERNOON

Two young women – one the hostess (Rachel Davies), the other her teacher friend (Pauline Moran) – sit around drinking whisky and smoking as the hostess's child sleeps. They are cynical and jaded about men. The teacher says she'd like kids; she didn't spend all those years in a classroom for nothing. A younger woman (Julie North) turns up, still in her honeymoon period and apparently oblivious to the other women's 'all men are bastards' criticisms. 'Don't you love your husband?' she asks the hostess. Her naive reply makes the others explode with laughter. Outside, we see children coming home from school.

* * *

AMY RAPHAEL: *Whose idea was it to make a collection of short films?*

MIKE LEIGH: Mine. I had this notion that was quite specific, personal and idiosyncratic. There would be some forty or fifty five-minute films that would pop up on television either regularly at the same time or randomly all over the place.

Each film would stand up individually, but all of them viewed as a whole would create a microcosm. You might see a character for a moment in one film who would be a central character in another. Or you might see one character just once, and another lots of times. They'd all be self-contained feature films lasting five minutes, so to speak. I was very pleased with the idea and I still am, for all that it failed. It was a pure television idea that lent itself to the way people watch TV. But the truth is that this was a project that never really saw the light of day because these five were just a pilot.

To cut a long story short, Christopher Morahan, head of plays at the BBC, took me to see Brian Wenham, who was the rather splenetic controller of BBC1. He suggested I make five pilot films and then they'd decide where to go from there. So we made them and Morahan liked them a lot. He went away. I was really up for

doing it. If the whole concept had been properly realised, with the full back-up, we'd have done better than the five we made; they just served to illustrate the principle.

Morahan came back to me and said, 'It's a very good idea, we want to do it, but how would you feel if I commissioned other directors and writers – like Jack Gold or Harold Pinter – to do some?' I was extremely cross and put out because the whole point of it was to create one homogeneous, personal piece of work. I left him in no doubt that I would not participate and that I was deeply offended. So that was the end of that.

My view is that it was deeply stupid. They could have done it very easily had they costed it at the regular price of two hundred minutes of television. The five we made weren't shown for seven years – till 1982. There was an *Arena* special on my work and they were used as curtain-raisers, for fun. In the end, the whole thing was treated like a slightly eccentric idea that the BBC would have to tolerate. I actually think that if I'd done it properly and been able to do it justice, it would have been immensely successful, a great television event.

Did you enjoy the discipline of making five-minute films?

Oh yes! *The Birth of the 2001 FA Cup Final Goalie* was terrific fun to make. And to have those girls getting drunk in *Afternoon* . . . Just the thing of being able to do what I do anyway – it doesn't matter who you look at or what you deal with, it's interesting. *Probation* is the least interesting; it's a bit obvious and not very significant. I'm very fond of *Old Chums*. There's this big bloke bragging on to this poor handicapped guy who's clearly never had the opportunity to get it on in the back of a car. *A Light Snack* is good fun, though awful technically because it was shot in a hurry in fading light. But I've always meant to deal with its theme properly, the whole relationship between all the legions of workers who have slaved away manufacturing what you're wearing, who made the paper you're using. It's fascinating. Who makes all those sausage rolls?

A measure of the improvised, spontaneous pilot nature of the thing is the title music. I pulled a few musical phrases off an old Harry Lauder LP and bunged them on. Also, it's important to say

that they wouldn't have been called 'The Five-Minute Films' had there been more. They'd have had a proper name.

Did you have ideas for the remaining bunch of films?

Absolutely. Even now it would be a gift. Films like *Short Cuts* or *It's a Mad, Mad, Mad, Mad World* that burst with character are the sort of films that I've inched towards but never quite pulled off. Or I've never had the opportunity to pull off. Maybe *Topsy-Turvy* is the closest.

The only other thing to say about 'The Five-Minute Films' is that at that time I'd never made any commercials. Having done these short films, I felt very well set up to make commercials. But no one asked straight away. It eventually did happen, but it was hardly a creative process.

What generally happens?

Well, tragically, no one has come along and said, 'Here's the commodity, go away and think something up. Be inventive, do what you do. Suggest a commercial in your own style.' Given the great tradition in this country of giving creative freedom to artists to do certain campaigns – like, for example, the way different artists have worked for Guinness – it never ceases to amaze me that most people aren't given the chance to be really creative. Even Alan Parker, who has made famous commercials, can't understand why I've never been given this freedom.

On the half dozen occasions I've made commercials, this happens: you go in, they tell you how much they love what you do, how much they want to see evidence of your individual, unique style. And then they hand you the script! They want the quality but, of course, they don't ever quite get it because I can't work in my usual way.

Did you hesitate on principle the first time you were asked to do a commercial?

I wouldn't do them for years. I used to say it was out of the question. I was finally persuaded to go and talk to a particular company who made commercials. They said, 'We understand your

misgivings, but Ken Loach does them. Phone him up and see what he says.' So I did. He said, 'Everything you think will be bad about doing commercials is. But you've got mouths to feed. Somebody is going to take money off those capitalists, it might as well be you.' That was good enough for me.

Who did you make commercials for?

I did some for Kleenex, where I cast the original three girls. I was supposed to do the whole series, but they sacked me after the first three because they weren't as funny as they'd hoped. But they weren't my scripts, so there you go.

We did some for McDonald's that were actually rather good. This was before the McLibel case. Obviously I wouldn't work for them now. Although I used to take my boys there in the early days, when they first opened, I would never eat there now either: they closed a branch for a day while we shot the ad, and when I walked through the kitchen I saw all this congealed fat everywhere. I thought, 'Never again!'

In one of the scripts it said 'old lady crocheting'. There's a knock on the door. She opens it to find her grandson on a skateboard who has been to McDonald's. He's got himself a Big Mac, and a Filet O'Fish for her. They sit there munching. End of commercial. We read the script. Both the designer, Eve Stewart, and I had the idea independently of how much more fun it would be if the old lady was playing on a Game Boy instead of crocheting. Tetris. I'd got the idea because when my boys first got their Game Boys there was no way of getting them off their grandmother in Liverpool.

We went to a meeting with the McDonald's people. We said to the head of McDonald's UK that we thought it would be a good idea if, instead of crocheting, the old lady was on a Game Boy. He said, 'That's ridiculous, you wouldn't get an old lady on a Game Boy.' We left, wondering, 'Who is their target audience? People who know what crocheting is, or kids who have Game Boys?' When we were shooting it, the word came through: the client has asked the agency to ask you to shoot both versions. Of course, they used the Game Boy version. That's the kind of crap you have to put up with.

86

Was it worth it for the money?

Absolutely. I did it only for the bread . . . When I did *It's a Great Big Shame!* at Stratford East in 1993, I worked on it for four months and was paid £1,500 in total. The next job was the McDonald's gig, for which I was paid £10,000 a day (the kind of money I've never had for a movie, by the way). That's why one does commercials, and I've done very few.

As we get older I suppose there's a realisation that we can't be so pure about these things.

Especially when you've got kids to feed. There's no getting round it. The bonus of doing commercials is that you can get your chums out to do some filming. For many people, me not least, the gap between films is always a bit of an issue. We begin shooting our next film in April 2007. The last time I stood next to a camera and said 'Cut!' was at the end of *Vera Drake*, just before Christmas 2003. In the interim, if you get a commercial it's a bonus. And also you can go and experiment with things. Back on the Kleenex commercial, I'd never worked with rain machines. It was lovely weather, so out came these very expensive machines, which was a very interesting experience. I also did quite a nice one for the Mayor of London's office to persuade girls to only go in licensed black taxis and not any old minicab.

I like doing shorts, although I've done very few. It's a form in its own right. I wish I could do more, but they are never practical because they hold up the main projects.

Nuts in May
('Play for Today', 1976)

Keith and Candice-Marie (Roger Sloman and Alison Steadman) go camping in Dorset for ten nights. Keith has organised everything meticulously and as a result expects everything to go to plan. He likes to be in control, refusing even to let Candice-Marie look at the guide book and instead reading edited highlights out to her in a loud, pompous voice. Candice-Marie chews her food seventy-two times and tells Keith she is 'very happy'.

Ray (Anthony O'Donnell) arrives and, in a big empty field, pitches his tent not far away from Keith and Candice-Marie. He lies around smoking and listening to music on his radio. Keith confronts him, insisting he turn the radio down. When Ray refuses, Keith moves their tent further away. Candice-Marie befriends Ray; Keith is jealous but invites him over for a cup of tea. When Candice-Marie and Keith start playing guitar and banjo, Ray is forced to sing along to a song they have made up about going to the zoo.

Finger (Stephen Bill) and Honky (Sheila Kelley) roar into the field on their motorbike. The couple, from Birmingham, are out for a good time; they pay little attention to Keith's advice on the country code. Keith reads the Guinness Book of Records *in his tent; Finger and Honky invite Ray to the pub.*

They return in good spirits and wake up Keith and Candice-Marie. When Finger starts to light a fire, Keith loses his temper. He says it's against campsite rules and threatens to make a citizen's arrest. Keith then attacks Finger with a stick. When he realises that he's gone too far, Keith announces he's 'going for a walk' and runs into the woods crying.

When he finally emerges from the trees, Keith tells Candice-Marie that they are leaving. While looking for another campsite, they're stopped by a policeman, who warns Keith that he has a bald tyre. They get permission from a farmer to camp on his land and settle for the night. Only a barbed-wire fence separates them from a herd of dangerous free-range pigs.

* * *

AMY RAPHAEL: *The Pratts started life in your play* Wholesome Glory. *What were they like on stage?*

MIKE LEIGH: As characters they were as you see them in the film. The action of the play was pretty much Keith's brother Dennis – played by Geoffrey Hutchings – coming round one Sunday afternoon. He occupied the same situation as Ray, only it was Dennis they made sing in the play. It was a one-act, seventy-five-minute piece staged at the Theatre Upstairs at the Royal Court in February 1973.

Keith and Candice-Marie didn't develop as such. When we were working on the play, we did the improvisation where they went to the zoo then came back and wrote the song in character. Which was fun. Again, that's using a couple of actors who have basic guitar skills. As with *Bleak Moments*, the characters weren't especially developed as a function of making the film. It simply opened up what happened to them. Of course, they experience greater emotional depths: the play contained no confrontations of the Honky and Finger kind. Geoffrey Hutchings couldn't be in the film because he was in the RSC at Stratford so wasn't free; he was particularly pissed off because he actually comes from Dorset.

All the obsessive stuff with food was commented on in the play but obviously made sense in the context of camping. It's very strange now if you look at it to remember how eccentric and far-fetched it was back then for people to be concerning themselves with organic milk and eggs. If you'd said at that time that in years to come there'd be organic sections in supermarkets and you'd be able to buy all these things as a matter of course, it would've seemed surreal, absurd.

Nuts in May feels like a departure: you seem to be moving onto another level, another stage in your career. It's more sophisticated and ambitious.

Somewhere along the line I twigged onto – and digested – what I'd been feeling about *Hard Labour*. I felt the need to do something that was a return to my own sense of style, form and content. And to move on. Also, having done two films with names such as *Bleak Moments* and *Hard Labour*, I wanted to do something funny. There's no question in my mind that *Hard Labour* was weighed down by, and perhaps inhibited by, a sense of being a 'Play for Today'. It was trying too hard to be a 'Play for Today', i.e. gritty, urban, northern, improvised, semi-documentary. *Nuts in May* was completely liberated from all of that. I was more confident generally. I also felt the freedom and the strength to do this comic realism, these simple juxtapositions of people.

With the possible exception of *Naked*, *Nuts in May* is more linear in its narrative than anything else I've done. Keith and Candice-Marie are not in their status quo situation, where we'd be looking at how their life normally is. Holidays are by definition linear: each day is different. That gives the film a certain spirit – the ability to have a cartoon-strip quality that the other films don't quite have.

Apart from offering a different way of working, was Nuts in May *more fun to make simply because of the 'comic realism'?*

It wasn't a different way of working, rather a different kind of story. And there isn't a correlation between something being funny and being more fun to make. It was, though, yes.

As with many of your characters, it's easy to feel intolerant initially towards Keith and Candice-Marie. You find yourself mocking Candice-Marie, before realising that we all behave strangely in our relationships. It's as if you need to be honest with yourself in order to get the most out of a Mike Leigh film.

I hope that's right, which is why a lot of people come up with dubious and suspect reactions to them. To go back to *Hard Labour* again – which may at this point be getting too harsh a press, but

there you go – it maybe failed because it didn't look at a clear spectrum of people, all of whom could be you. Whereas in *Nuts in May* there's a spare simplicity about the two couples – the 'goodies' who behave badly because they don't know how to behave, and the 'baddies' who have hearts of gold – and a guy who is lonely but perfectly gregarious, who is just getting on with it. There's your dynamic.

Keith has to be in control of everything. Are you like that?

Yeah, totally (*laughs*).

He's also typical of a certain sort of weak man in your films.

And in the world. Again, we are back in the culture of received behaviour. This is a guy who has rigid, fixed ideas of his role and what is required of him, both in his social role and his role in his relationship. He has fixed ideas of how men ought to behave, who's in charge, all that stuff. In many ways, he's not equipped for it. But this is a universal condition for us men. You know exactly what kind of parent he's going to be . . . He's a man who thinks he's liberated and alternative, but is actually a complete reproduction of his repressive father and grandfather.

No matter how many times one sees the film, the moment where Keith takes off and runs into the woods, crying, is always a shock. In that moment does he realise what he is or might be, i.e. weak, human, vulnerable? Or does he just feel bullied?

Well, my normal policy is to say, 'That's up to you to decide.' But I think what you're looking at there is a man who has been unhinged and derailed by the anarchic abandonment of rules, by the breaking of his own mask and by the knowledge of his emotional frailty. The fact is, he can't handle it. The only way he can deal with it is to say, 'Right, that's it, we're going.' He can only assert himself by trying to leave a threatening situation.

Keith now seems such a perfect name for his character. How did you decide on the equally appropriate Candice-Marie?

I was in Manchester in the late 1960s and I went out on a couple

of dates with a young woman who lived next door and was a radiographer. She wasn't interested, and nor was I. I remember her saying she'd been to Wales to see her cousin's new baby, whom they'd christened Candice-Marie. For some reason it made me laugh; I thought it was a ridiculous name. So four years later I recycled it. Presumably there is in existence a woman of about thirty-seven called Candice-Marie who grew up in north Wales. I don't know if she's even heard of *Nuts in May*, but I guess she'd be astonished to discover that the character was named after her.

Alison Steadman has a very particular way of talking as Candice-Marie that makes her sound even more subservient to Keith. Did it evolve early on in rehearsals for the play?

Oh yeah. The characters were formed for the play and, once formed, that's how they were in the film – the standard procedure. Alison and I had a private running gag about that sort of talking, which we decided to use.

Keith and Candice-Marie are so busy thinking they have to enjoy nature and be at one with it that they can't be in any way spontaneous about it.

Candice-Marie is naturally spiritual in a way; Keith knows that and yet fails to understand it.

Again, it's this sense of an urban setting being transposed to a field.

Totally. They are urban people. They don't know how to behave in the countryside. When Keith says, 'This is called Stair Hole. There's a stair there and a hole here. You're standing on sedimentary limestone,' he's actually seeing the rock formation as a diagram in a book. The joy of that stuff is the interface between character and place, as in all the films, but here it's liberated to go onto another level.

Does Keith have any saving graces? Or are we right to mock him?

Well, there are people in life who set themselves up to be shot down, people whom you do laugh at because they make prats of themselves. And he is one such Pratt. Because he's a figure of

authority and takes himself seriously; you just know he resonates with everyone's uncle or father or teacher. At the same time, you're looking at a couple whose hearts are in the right place. They really do believe in things that are important. They are trying to live out some very legitimate ideal. Where the fascist comes out in Keith is when he can't tolerate other people enjoying themselves.

By the time Keith goes for a shit in the woods at the end, it's so awful. He looks so lonely and vulnerable.

I wanted to call the film *Eaten by a Pig*, but the BBC wouldn't let me. I don't think I was completely serious but it would've been a good wheeze. Those free-range pigs are quite dangerous. When you see Keith clambering through the barbed wire with bits of toilet paper getting stuck, in the actual shot Roger had to get out of the way pretty fast because this pig charged after him.

At one point in the rehearsals Sloman and Steadman had to go into character and go on the fifteen-mile hike. Is that fairly standard?

Yes, it happens on every film. Like in *High Hopes*, when Cyril and Shirley went to Highgate Cemetery, which became an integral part of the film. In *Nuts in May* Keith and Candice-Marie went to Lulworth Cove as part of an improvisation. They ran into Ray, and it was pissing down. But when we came to shoot the scene a few weeks later, the weather was gorgeous. We had to hang about and wait for it to rain.

Did you make the cast go camping as part of the rehearsals?

Well, yes – it's a film about camping! For weeks we had long days of improvising in a field and around the area.

For *Secrets & Lies*, Timothy Spall learned how to take photographs; in *The Kiss of Death* David Threlfall and Clifford Kershaw visited proper undertakers, and so on.

Despite there being vast amounts of space, they all put their tents up close to one another – as people always seem to put their towels right next to someone else's on an empty beach.

If you look at that campsite, there are other tents off in the dis-

tance. But I've always known, deep down, that it's a slightly more unpopulated campsite than it would have been in reality. We shot it in March, ahead of the season, so we had the run of the place. The point is that under dramatic licence they're all in close proximity to each other, otherwise there'd be no story. What you say is nevertheless true. People do strangely lack spatial awareness. I was at the cinema last night and it was completely empty, and a couple came and sat right in front of us . . .

As Ray, Finger and Honky go off to the pub it's hard to imagine Keith and Candice-Marie ever really letting go and enjoying themselves.

They would never go to a pub. It's complicated: it's partly snobbery, partly the fact they'd want organic beer or think alcohol is bad for you. There's a bit of puritanism going on there too. But also fear. They are insular people.

Candice-Marie says to Keith she's 'very happy' after he announces they're having raw mushrooms for lunch. He says, 'So am I.' Are they happy?

They think they are happy, yes. I think she means, 'This is what we planned in order to be happy, all the details of our holiday, and now here we are and we're carrying out those plans, *ergo* we're happy.'

Keith and Candice-Marie's relationship is father–daughter/teacher–student. She's ethereal in one sense, but childish and girly in another, which allows him to control her. But why would she have chosen a man like that?

You've put your finger on it. He has a kind of strength. He's secure and safe. She will gravitate towards that. And without being specific, they do, like a lot of these characters, resonate with people I know.

Keith works for the social services. You often seem to be down on the social services in your films . . .

Not at all. I just want them to be properly run. I was very put out

94

at a screening of *Secrets & Lies* in west London when a woman asked, 'Why is the social worker such a caricature?' I don't think she is any such thing; she's a woman who's very efficient and sympathetic but obviously hassled. There was also a lot of arguing about the social workers in *Home Sweet Home*. But I'm certainly not down on them. Like everybody, I'd be down on any public-service institution that was run by people like Keith.

Meanwhile, Candice-Marie works in a toy shop.

And they will have children. I wonder how that went!

One of the more excruciating scenes in the film is when they force Ray to sing along to the zoo song. Why does he allow himself to be coerced?

He's a nice guy, he doesn't want any trouble. There he is in the middle of nowhere, free to move around, and he's stuck in this front parlour. Don't you love Honky and Finger? They kick the ball around and shout a lot.

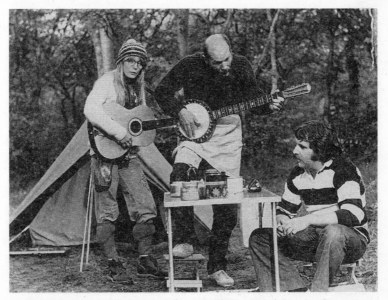

6 *Nuts in May*: Candice-Marie (Alison Steadman), Keith (Roger Sloman) and Ray (Anthony O'Donnell).

And Keith says, 'Get back to your tenements!' Honky and Finger have a sexual relationship, while Candice-Marie is all zipped up in her sleeping bag with her hot-water bottle to cuddle.

Absolutely. She tells Keith to 'kiss Prudence'. And Honky and Finger fart and fuck. I like it when, after the conflict of the night before, Candice-Marie and Honky both go to the loo and there's this unspoken moment of sisterly solidarity.

Yet, despite everything we're talking about, it's not a depressing film.

It's not, you're right. I suppose, if I'm honest – notwithstanding the pig at the end, although you shouldn't decode that by what I've told you – we sort of let the audience off the hook at the end. You see the Pratts as being self-absorbed and slightly ludicrous but benign. She gets into this whole thing about the wind in the silk scarf . . . hippy stuff.

Did you mean to let the audience off the hook? Do you regret it?

Sure I meant it; no regrets. Anything I do, I mean to do.

It wasn't an issue of time or money?

No. I created the end of the film in a very spontaneous way, which is how I always work. There is one scene I would have loved to have shot if we'd had the budget: I really wanted Keith and Candice-Marie to visit the great giant at Cerne Abbas, the chalk figure with a very large penis and balls. They should've gone there, but you could only have filmed it with an aerial shot or you wouldn't have got any visual mileage out of it. We couldn't afford a helicopter. We tried to work out if we could do it with a balloon, but that was impossible. So we never explored it, but it would have put them on the spot – it is primeval, fertile, organic, deeply spiritual. And rude. It would've been very funny.

Did you feel generally as well as specifically restricted by the budget?

I always do. After we'd shot the film, we went back to BBC Birm-

ingham with it and realised we needed more footage. We did two things: we got Keith and Candice-Marie together and shot some additional camping action in the Lickey Hills near Redditch. Then, without the actors but with a cameraman and two production assistants, we returned to Dorset and shot some more bits. So when, for example, you see Keith and Candice-Marie walking on the Dorset coastal path, you're actually looking at my feet and the production assistant's feet. You hear them talking as you see shots of the ancient church; we recorded the voice-overs when we shot the stuff in Redditch, and also at Pebble Mill studios. The shot of their car driving over a traffic bump near a caravan site – Keith and Candice-Marie weren't actually in the car. Ordinary filming tricks, really.

You said earlier that Nuts in May *was particularly good fun to make; any anecdotes you're willing to share?*

We all stayed in the Corrie Hotel at Swanage. We were making this film about an obsession for organic food, while ironically we were eating this quite classy, old-fashioned hotel food. One of those places where they couldn't just serve up omelettes: they had to be 'omelettes limousine'.

One day, Tony O'Donnell and Eric Allan, who plays the quarry-man, went for a drink in Swanage. They ran into two of the girls who were working in the hotel. They had a drink and suggested going back to the hotel bar, but the girls weren't allowed to drink at the bar because they worked there. Tony and Eric said it would be fine, they could be their guests. So they went back, the manager wouldn't let them in and there was a row. Eric is an extremely nice man but has a very deep rage. He'd had a few drinks, punched the guy but missed slightly . . . anyway, there was a big stand-off and they chucked him out of the hotel.

I tell this story because Eric was and remains very much a real organic, outdoor person himself. He had a camper van. So he said, 'Fine, I don't want to stay in the hotel. I'll go and stay at the quarry.' It had been fixed up for him to work at the quarry but they were very circumspect – they expected an actor to turn up in a smoking jacket with a gold lamé cigarette holder, a Noel Coward figure. Of course, this guy shows up and is very down to earth.

They didn't want to let him touch anything. It was a family quarry, and they were very close.

Then, the day after Eric arrived at the quarry, the owner died. As a result of which they were suddenly thrown into having to do the funeral and they were short-handed. So Eric just got on with it. They were dressing the stone out of which the new post office was going to be built at Corfe. And he went to the funeral . . . he suddenly got access to the whole esoteric social culture of this strange, timeless, Hardyesque world.

So, by the time you get to filming, you've got this very sophisticated actor who'd been in *Bleak Moments* and who'd been at the RSC but who was really into being a quarryman. He's really integrated. He's become part of the environment. I love that scene.

And they found a real dinosaur print?

Of course, but it's not a big deal. They do that all the time. It's a place where dinosaurs walked. For real.

Were you happy with the way Nuts in May *is shot? It looks as though more than three years has elapsed between a grim-looking* Hard Labour *and this colourful, lively film.*

I think what's important from a stylistic point of view is that *Hard Labour*, *Nuts in May*, *The Kiss of Death* and *Who's Who* were all shot with a zoom lens on the camera all the time. Looking back, I'd say that only *Nuts in May* benefited from this, because of its fluid, strip-cartoon narrative.

All the films from *Grown-Ups* onwards were shot with a range of fixed lenses, as *Bleak Moments* had been. I much prefer this discipline. The choice of a lens is as stimulating a part of building the story as the choice of a word or a prop or a sound effect. And the Distagon lenses Dick Pope has used for the more recent films are a joy – such clarity.

Of course, although what I'm talking about is shooting without a zoom lens, all cinematographers carry one on board for special occasions. There are moments when they are a decided bonus, especially when the action demands shooting spontaneously in a documentary mode: like the little kids dancing with Alison Steadman at the beginning of *Life Is Sweet* or the shots of mourners at

the funeral in *Secrets & Lies*. In these situations, Dick was able to work very quickly, picking up a whole range of close-ups and wider shots. The trick is to edit out the zooms, so that the footage you use is consistent with the style of the film.

There are actual zooms in the early films, like the shot of Mrs Thornley reading a newspaper in *Hard Labour*, that I find vulgar and distracting.

Did you have any notion Nuts in May *could – or would – become a TV classic?*

No, of course not. You never know. It was popular at the time. But the thing about doing TV was that although critics may review your work, it wasn't the same as a film coming out with its attendant publicity machine.

What was your reputation in the UK at this point?

Cor blimey . . . Well, some people would know who I was to a degree, but not very widely. I'd just done a play at the RSC that was reviewed by all the serious theatre critics, but that doesn't mean popularity. Quite recently I was in a taxi and the driver said, 'What do you do?' 'Well, I make films.' 'What's your name then?' 'Mike Leigh.' 'I'm sorry, mate, means fuck-all to me.' Whereas in France, after getting the Palme d'Or, it was like winning the World Cup. I was a celebrity everywhere.

I think *Nuts in May* made a difference. It was certainly more of a breakthrough than *Hard Labour*. But the real breakthrough nationally probably came with *Abigail's Party*.

The Kiss of Death
('Play for Today', 1977)

Trevor (David Threlfall) is an undertaker's apprentice in Oldham, Lancashire. He wears flares, his shirts have round collars and there's always a paperback stuffed in his jacket pocket. He meets his friend Ronnie (John Wheatley) down the pub with two young women, Ronnie's girlfriend Sandra (Angela Curran) and her friend Linda (Kay Adshead). One of the young women asks what he's reading; he simply shrugs and says, 'A book.'

Linda, with her constant gum-chewing, makes it clear that she would like to take things further with Trevor. He responds to her flirtatious behaviour but he's clearly not interested in a straightforward way; he seems to be amused by the whole ritual of courtship. One afternoon they sit side by side on the sofa. 'You can kiss me if you like,' offers Linda. Trevor smirks, giggles, bursts out laughing. He grabs her face and kisses her hard on the mouth. The kiss of death. She asks if he's coming upstairs. When he starts giggling again, she asks him to leave.

At work, Trevor chats to his boss, Mr Garside (Clifford Kershaw), as they dress a corpse. Death is everyday for him; it's part of his life. Yet he is irrevocably affected by the death of a baby. He goes with Mr Garside to the house of a middle-class couple and finds the dead baby still in its cot. He wraps the baby and, later, puts it into the mortuary fridge. He returns home, lies on his bed and reflects on life.

Trevor goes to a disco with Ronnie, Sandra and Linda. He is clearly uncomfortable in such an environment. He refuses to dance with Linda, so she dances with Ronnie. In a taxi on the way home, Linda chats away about nothing much. Trevor loses his

temper. He yells 'Shut up!' at her with enough venom to keep her temporarily quiet.

We see Trevor hanging around outside a church – Mr Garside's car is also used for weddings – talking to a very young bridesmaid who denounces boys and marriage. Trevor drives round to Ronnie's and suggests a trip to Blackpool. They drive off in the car.

* * *

AMY RAPHAEL: *Is this still a favourite among your own films?*

MIKE LEIGH: It is, yes. I've already kind of said this about *Nuts in May*, but perhaps *The Kiss of Death* is the first piece of total filmmaking. *The Permissive Society* is not a film. *Hard Labour* suffers from all the problems we've discussed, while *Bleak Moments* and *Nuts in May* came out of plays. *The Kiss of Death* starts afresh and deals with the problem of making a film in an urban environment. It was also the first film I made without saying anything to the producer (David Rose again) about its content.

It's not insignificant that it's going back up north again. In a way it solves the problems that *Hard Labour* didn't solve. As far as I'm concerned, there's a much clearer conception of a northern town, and of course it was liberating for me because it wasn't so familiar. It wasn't like shooting in north Salford; we were down the road in Oldham. It was able to be a metaphorical place, with that sense of control and freedom. And, of course, it was four years after *Hard Labour*.

For me, *The Kiss of Death* is a film about youth. In some ways it's already dealt with in the earlier films and in *The Permissive Society*. And again, Norman, Les and Trevor are all bedfellows, all non-conformists being asked to conform. Their descendants are Cyril, Johnny, Phil – and, I guess, W. S. Gilbert! The whole central conflict and argument of *The Kiss of Death* is this slightly offbeat guy – I discovered that guys who work for undertakers often are offbeat – and his relationship with the opposite sex. There's a lot of pressure from these young ladies, who again have received notions about what is respectable behaviour, how guys should behave, and so on. You get, in a way you haven't had previously in my work, the predatory female syndrome.

How autobiographical is Trevor?

To a degree, of course he is. He's an outsider and he laughs at life. He sees through bullshit. The whole thing of funerals and death is important to me. Of course, there's the story of my grandfather's funeral, the point at which it occurred to me to be a film-maker. I quite often think of having funerals in my films, but so far there's only this one and the one at the start of *Secrets & Lies*. I like funerals, and I can't stand weddings.

As a young man, were you like Trevor when it came to women?

In 1966, when I was about twenty-three, I put an advert in the lonely hearts section of *Time Out*, which had only been going for a short time then. It read: 'Where is the girl of my dreams?' I got maybe four or five replies. I met three, I think. I remember meeting this girl in Waterloo station who actually turned out to be Jewish, which I hadn't spotted at all. She was straight in with criticising how I was dressed, how I was deluding myself about my aspirations. It was completely absurd. Needless to say, it was a short interview. I mention that in the context of this film. Both the girls in *The Kiss of Death* are out for a good time, but with judgemental notions of how guys should behave.

The Kiss of Death was shown on the BBC in 1977, the year of punk and the Queen's Silver Jubilee. In the film you've got these microcosms of life, and there's very little hint of what's really going on in the wider world. At the same time you seem to want to reflect different eras in your films.

I think I do. To me what's usually interesting is the world that's going on despite the fashions and trends. Mostly, you don't get state-of-the-art trends going on in my films, but I suppose that's a reflection of how I am. Having said that, I do quietly absorb and take the temperature of the world and depict it.

The film is all about possibility, which, of course, was punk's central remit. Trevor is quite a punk character in some ways, in that he does his own thing and isn't interested in what you would call 'the done thing'. He's not pretending or acting up, he's just responding

naturally and instinctively to situations. When Linda tries to grab him for the kiss, he can only giggle.

Absolutely! That's really central to what the film is about, definitely. He's naturally amused by the absurdity of the rules of etiquette and courtship and all that crap. So, in a way, to compare it with Peter and Sylvia in *Bleak Moments*, the difference is that Trevor is sussed.

Trevor and Linda's kiss – the kiss of death – is very real and awkward. Thirty years on, there still aren't enough of those moments in film.

This is about the politics of how films are made. There's no question that if you put down a treatment for *The Kiss of Death* – or any of these films – it wouldn't get made. But because my films aren't subjected to committees of people prescribing what they will be before they ever happen I'm free to explore in the moment, and there's no agenda in that sense. I'm free to explore those idiosyncratic things that are about the texture of life and how we are.

When Trevor and Linda are in the pub, she's chewing gum and he's affecting nonchalance. The tension and awkwardness remind me of the Chinese restaurant scene in Bleak Moments.

Yes. It would also remind you of the scene in *The Permissive Society* where Les doesn't really know how to talk to Carol. The big difference being, apart from anything else, that ultimately Trevor has a sense of humour and he knows where he's at. Unlike Peter, who is simply out of his depth, Trevor thinks it's all nonsense.

One regret I have with this film is that a coda was never shot; we had it lined up that two alternative, informal girls in duffel coats and jeans would be picked up as hitch-hikers by Trevor and his mate, and they'd drive off to Blackpool. We just ran out of time. The girls and the car were all lined up. It was a tragedy, really, because you know Trevor will be fine when he stops messing around with the likes of Linda.

Let's move on to one of the most disturbing scenes in any of your films: the dead baby that is collected by Trevor and Mr Garside.

Every undertaker we talked to said they can handle their job. Nothing fazes them. They've taken down people who have strung themselves up, found people who have gassed themselves, dealt with bodies half-eaten by rats. They can deal with all of that. The one thing they can't cope with, which is really tough, is cot deaths.

But I can't tell you how disappointed I was at people's reactions when the film came out. Obviously we had to decide how much of the baby you'd get to see. Of course, we weren't going to have a real dead baby. This brilliant production designer, Jim Clay, clandestinely managed to arrange to have this tiny cadaver made for us. But the big piss-off is that a huge number of people over the years have asked, 'Why was it a doll? Was it symbolic?'

I can see why people thought it looked like a doll. We shot it in a very simple, unaffected, clear way. To us it was very real. Everyone on the shoot was affected by it. It was very disturbing. Yet the way we shot it left a more than useful number of people thinking it was a doll. I wanted to go back and reshoot it.

Maybe it's easier for some people to see it as a doll because to think of a dead baby is so appalling. Did Trevor have any idea he was going to find a dead baby in that house?

Go back to the film and you'll see what happens. Trevor shows up, he's late. You can tell Mr Garside knows where he's going and Trevor doesn't. He must have told him in the car on the way there. You can tell it's a fresh experience for Trevor.

On a different level, the other thing about that scene is this: we were very strapped for cash. We had to find a house that was already dressed. We found this neo-Georgian estate house. We filmed a shot in the living room, and on the wall of the living room and on the wall in the hall were two identical reproductions of the same Lowry painting. I remember saying to Jim Clay, 'You can't use this, we've already seen it. You can't put the same picture in two shots.' Jim said, 'I haven't touched a thing – honestly.' The guys who owned the house came back a bit later to watch what was happening, and we pointed out the two Lowrys. 'Oh yes,' they said, 'we've never noticed.'

And it's worth pointing out that David Rose, the producer, was the innovative genius who started *Z Cars*. So when the police car leaves the house, followed by Mr Garside's car – which is, incidentally, my car, also seen in *Who's Who*, a silver Ford Escort estate – for a moment Carl Davis's music gives you the *Z Cars* theme as they drive off. An in-joke. It's allowed sometimes.

After Trevor deals with his first dead baby, he goes home and lies on his bed, staring at the ceiling. It's a coming-of-age moment: he's reflective in a way you maybe wouldn't expect of a young guy.

It may be a growing-up moment. It certainly motivates him to go and do something. Which is why he goes round to see Linda, to confront things full on.

Doesn't he also go round to see her because he's lonely?

He likes her, he fancies her. Basically he wants to fuck her and all the rest of it. The baby's death makes him think about life . . . but don't try to be too logical about it.

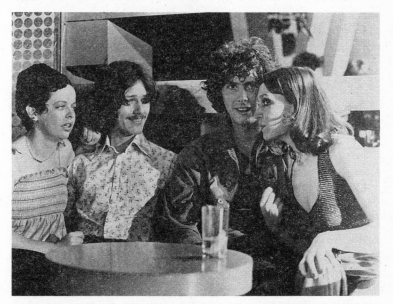

7 *The Kiss of Death*: Sandra (Angela Curran), Ronnie (John Wheatley), Trevor (David Threlfall), Linda (Kay Adshead).

He fancies her, yet he can't stand her. In the final scene, on the way home from the disco, it's surprising to witness Trevor's venom as he screams at Linda to shut up.

Well, he's had enough. In a way, it's all part of the fact that he's not a softie. He's not a pushover. He's unfulfilled and he knows there's far more to get out of life. Which is why I wish to hell we'd shot that end. Why we didn't get it together to do it . . . I don't know. It's just one of those things. At the time I rationalised it out of existence, but we should have gone back and done it somehow.

Where did you discover David Threlfall?

He was in a production of *A Winter's Tale* that Manchester Youth Theatre were doing when I was up there rehearsing *Hard Labour*. When I was casting around for actors in the north of England to do what turned out to be *The Kiss of Death*, he was just coming out of Manchester Polytechnic acting course. I saw him doing stuff there. So I got him in straight from drama school. Lately he's been rediscovered, has he not? I love him in *Shameless*.

And you had worked with Clifford Kershaw previously on Hard Labour.

Indeed I did. He was an extraordinarily good actor. He was a Tory councillor and a stallholder in Oldham market. He was a Granada extra. He'd been an actor at some point, but hardly worked. I took a gamble on him. It more than paid off. He died some years ago. He was a really nice bloke.

Can you tell the story of the corpse corpsing?

First of all I asked the First AD – who will remain nameless – to get a very old man, given that we couldn't have a corpse. Straightforward. On the day I arrive at the location, he says, 'Come and meet Ronnie the corpse.' We go to this little morgue, where the make-up designer is painting this guy to look as though he's dead. The First AD introduces us. Ronnie says, 'Very nice to meet you' – with an incredible twitch. Perfect for a dead person . . .

We worked out that if he kept his eyes open, he could keep still.

We were shooting in an actual room where they clean bodies, a pseudo-Gothic morgue, very tight, a tiny space. I tell Ronnie that when I say 'Action', he's to stop breathing; when I say 'Cut', he's to start again. I was shouting 'Cut!' and he carried on holding his breath. Turned out he was stone deaf. So that got people giggling. Then Clifford Kershaw's character Mr Garside starts telling his gag about the Queen. There are lots of shots, lots of close-ups. Ronnie was told this joke so many times it eventually got through his deafness barrier. He started to snigger, and then somebody said, 'Don't corpse!' And that finished everyone off. It was a nightmare. Luckily, we had a very good editor, Oliver White, who managed to extract the scene from the footage.

There's a footnote to the story. A writer had been commissioned by the BBC to write and direct his first TV film. He'd gone up to Scotland to a cottage to write. I'd been asked by David Rose if this chap could come and visit us on location, on his way back to London, as part of being educated in film-making. So he dropped in on the corpse corpsing day. He was in the room when all that happened. He is Sir David Hare, who subsequently came to my house, where I gave him film-directing lessons in the kitchen.

Going back to Carl Davis's music: this was the first time you used a score in a film. Did you give him specific direction?

Carl and I had actually worked together before on a little title sequence I'd done for Thames Television. I did what I've always done, which is to look at the film, discuss it and arrive at a notion of what kind of sound would work best. I remember we started talking about Janáček, but finally we arrived at this unlikely line-up. Some people at the time thought it was incongruous, but I think it really works.

What's interesting in terms of the march of technological progress is that this was the only film I made where the music was worked on without access to video, the old-fashioned way. We didn't do what is now standard procedure – to work on a piano with a machine and a tape. It was done blind, as it was with all movies till the invention of the video in the late 1970s. So we looked at the film in a projection room and then we did it all

theoretically at Carl's house. Once, we hired a room at the Wigmore Hall with a piano in it and we talked it through there. In the old-fashioned way. The next time I made a film with music, again with Carl, was *Home Sweet Home*. But by now we had the full technology.

Abigail's Party
('Play for Today', 1977)

Beverly (Alison Steadman) is getting ready for a small drinks party in her suburban house. Laurence (Tim Stern), her estate-agent husband, comes home later than expected and is distracted by work. The first guests arrive: Angela (Janine Duvitski), a nurse, and her husband Tony (John Salthouse), a computer operator. They moved into a neighbouring house two weeks ago. Laurence leaves to pick up the keys to a house and Tony helps him start the car. Unprompted, Beverly tells Angela how she could make better use of lipstick.

Another neighbour, Susan (Harriet Reynolds), arrives; she has been divorced for three years and wants to escape her own house while her fifteen-year-old daughter Abigail is having a party. Beverly is gregarious, confident, sociable; Angela is chatty but mousey; Susan is introverted. Beverly is determined to be an exemplary hostess, swishing around the small living room in her voluminous dress, filling up glasses and offering cheese and pineapple on cocktail sticks.

Ignoring Laurence's preference for classical music, Beverly is determined to play records by Tom Jones and Demis Roussos. He is clearly angry with Beverly for being manipulative. He complains of indigestion.

Beverly asks Susan about her divorce. Angela mentions an ill child at hospital before revealing that Tony, who is a withdrawn and hostile husband, used to be a professional footballer with Crystal Palace. There are more drinks, more nibbles, some idle chit-chat and several awkward silences.

The tension becomes increasingly tangible. Beverly turns the music up and starts dancing. Laurence, furious, turns it off and dis-

appears with Tony to check on Abigail's party. Sue, who has drunk too much, throws up in the downstairs toilet. Angela talks of Tony's temper. Laurence, back from the party, makes a sandwich, turns the music down and tries to turn the conversation to more highbrow subjects.

Beverly slow-dances with Tony, with whom she has been flirting all evening. Laurence is distressed but dances awkwardly first with Angela, then with Susan. Everyone sits down. Laurence asks Susan if she likes real art. An argument ensues over the relative merits of a reproduction of van Gogh's Yellow Chair at Arles *and an erotic painting upstairs that Beverly admires, which she goes and gets, telling Laurence to drop dead.*

In a state, Laurence puts Beethoven's Fifth on the record player. He suffers a heart attack. Angela takes control. She puts him in the recovery position and gives him the kiss of life. Tony phones for an ambulance. Beverly flicks cigarette ash over Laurence, shouts at Susan and orders Tony to ring the emergency services again.

Laurence dies. Beverly sobs. Susan tries to phone Abigail and get her to turn down the party music. Angela gets cramp. Abigail's music gets louder.

* * *

AMY RAPHAEL: *How would you introduce* Abigail's Party *at a film festival or a retrospective?*

MIKE LEIGH: The first thing I'd say is, this is not a film. And not only that: for a film-maker, it's a work of deep embarrassment and pain. There is no piece of work for which I have been responsible as director by which I'm embarrassed, apart from *Abigail's Party*. Not for the play or its content, which we'll come to. It is a stage play that was wheeled into a television studio. It's slightly compromised as a play, but not too seriously. However, as a piece of craft, it's simply appalling.

The original set was adapted and modified – the BBC wouldn't credit the original designer, by the way – although the costumes were on the whole intact. When we'd done it, I swore I'd never set foot in a television studio again – from now on it would all be film, film, film. I remember having a discussion bordering on an argu-

ment to that effect with television boffins at the BBC, who said, 'Film is dying. By 1990 it will be over.' In 1977 one did not reply by saying 'Rubbish': it really did look as though that might happen. Cinemas were shutting down. Of course, the opposite has turned out to be the case. It was studio-based plays that went out of fashion. But at the time they were very much the mode.

What do you see when you watch it again now?

It is appallingly lit, it is sloppily shot. There are boom shadows all over it. You can actually see the boom come into the shot on more than one occasion. It's bland and slick in the worst sense . . . I'm a film-maker for whom the film is all about the precision of moments, and for me it's a disaster. I actually can't watch it. Having said that, when we did it in the studio it was after a hundred and four performances in the theatre and it was dynamite. The performances were rock solid. Those actors sustain those performances in spite of the inherent problems with the television studio.

From a technical point of view, was it one nightmare after another?

To say it was warmly received by the television crew would be an understatement; they could've pulled the plugs at 10 p.m. irrespective of whether or not we'd finished the play because they had very strict regulations. But they didn't; they kept going till we'd finished because they dug it to pieces. When the recording came back after the supper break, proceedings were held up – at that time there was an incredible disease of theft inside the BBC and somebody had nicked the Beaujolais from the prop cage, and we had to wait for a replacement.

And there was, of course, the issue of the music.

When it came to the television version, the BBC insisted certain pieces of music that appeared in the play were unacceptable for copyright reasons. The BBC had an all-in deal for all British record labels but not for most American labels, so we couldn't have Elvis Presley, who appeared in the definitive version of the stage play. We couldn't have José Feliciano either. With great pain we hunted through British possibilities and finally decided that Elvis should

be replaced by Tom Jones, which is ridiculous, and José Feliciano should be replaced, even more ridiculously, by Demis Roussos.

That Beverly puts on Tom Jones in the television version seems to have passed unnoticed by anyone who's ever seen it, but when the BBC did a programme to celebrate the twentieth anniversary of *Abigail's Party* – in which, significantly, I wasn't invited to take part – they wittily rounded up all kinds of 'actresses' who'd played Beverly in amateur productions. They also went to interview Demis Roussos in Greece to ask his feelings about being associated with *Abigail's Party*. Of course, he'd never heard of it.

When there was the excellent revival of *Abigail's Party* recently at the Hampstead Theatre in Swiss Cottage – where, of course, it had started life in April 1977 – and then in the West End, the production was absolutely faithful to the original stage play, except I allowed the director David Grindley to use Demis Roussos instead of José Feliciano. The feeling was that people would be so disappointed otherwise.

Apart from that, of minor interest is the fact that there are one or two cuts and time-jumps within it, but it is generally the play as seen in the theatre.

Why did you agree to it becoming a BBC 'Play for Today'?

At first I was completely resistant to the idea of it being done in the television studio. It was a massive success on the stage, and half a dozen West End theatre managers wanted to move it into town. Alison Steadman turned out to be pregnant and we went to see the doctor, who suggested she could only continue for a further five weeks. At that point in the game, there was a play about the Diplock trials in Belfast by Caryl Churchill, which was pulled for 'political reasons'. So Margaret Matheson – with whom I was already in collusion because she was going to produce the next film, which turned out to be *Who's Who* – was left with an empty television studio on her hands. She suggested filming *Abigail's Party*, and I said, 'No way. It's a play. It won't work on television.' I was sat on by everyone, from every angle. Quite rightly. Finally, we wheeled it into the studio and the rest is history. But it is a stage play. It's certainly not a film. When it's described or discussed as a film, it pisses me off.

But, as it turned out, quite a lot of people watched it. Particularly the second repeat.

Yeah. It went out in November 1977, and it was very popular. They repeated it. Then the second time they repeated it, in August 1979, there was an ITV strike on. Channel 4 hadn't started yet. There was a highbrow programme presented by Jonathan Miller on BBC2. Massive storms were raging throughout Britain. And sixteen million people watched *Abigail's Party* on BBC1. That's a lot of people. So it became a legend.

The irony that in a way underpins the entire story is that originally I had no intention of doing a stage play at all. I was starting to think about the next film, *Who's Who*. David Aukin and Michael Rudman had taken over Hampstead Theatre and they took me out for lunch. They'd got some money, so they could offer a ten-week rehearsal. The only major stage play I'd done was *Babies Grow Old* at the RSC. Hampstead had previously been very sniffy about my stuff, and here were the new boys asking me to make a decision over lunch. They were very jolly, very funny. I said, 'OK, all right.' But I was really reluctant. I remember thinking it was just a stopgap, something I'd just get out of the way that would sink without trace.

Not knowing it would become something of an albatross.

Well, not bad for an albatross! But if I'm here to talk to you about my films, that's all I have to say about *Abigail's Party* really. However, I suspect you'd like to talk some more.

Indeed. I can see how deeply frustrating it must be that Abigail's Party *is the piece of work that's become most synonymous with your name.*

It's complicated. What's frustrating is that there are other plays and films that haven't enjoyed the profile of *Abigail's Party*. In its own right it's fine, I'm very pleased with it – as a stage play. It's a very durable piece that has stood up to hundreds of productions all over the world. It was off-Broadway in 2005, where it was very good and very original, completely its own thing. I've seen the play in Dutch, and it's been performed in Germany and France. It's been

done Down Under a few times. I've seen some very good productions and some ridiculously bad versions.

Can you pinpoint why it was so successful?

That's to do with the play. Certainly at the time it tapped into a nerve. It's probably interesting that it was first broadcast some eighteen months before Margaret Thatcher came to power, and the repeat that was broadcast to 16 million people in 1979 was a few months after that election. Why does it continue to talk to people? The fact is that 'Beverly Culture', if you want to call it that, is dripping and groaning on every TV channel. There are whole stations about house make-overs and fuck knows what.

People utterly relate to the horrors of what it's about. We've talked about 'the done thing'. There's also the disaster of that terribly common anomaly, the mismatched relationship. Beverly would be great with the right guy, and so would Laurence with the right woman. He needs to be with someone who shares his taste. They are all in the wrong place at the wrong time really.

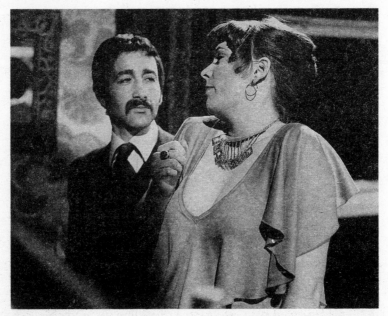

8 *Abigail's Party*: Laurence (Tim Stern) and Beverly (Alison Steadman).

You do spend most of the play wondering why the hell they got together . . .

'Is it autobiographical?' you may ask. You usually do. It is – though not in any literal sense. But by that stage I was living in north London and getting to know neighbours who were, on the whole, incompatible. It was part of my existence. It started to get worse when my children were born, when you'd spend a lot of time with people with whom you had very little in common. You were very lucky if you found like-minded, kindred spirits to be parents with.

Notwithstanding that, life's battle has been about trying to escape from people, situations, worlds that I didn't want anything to do with. Unfortunately, this still goes on. It's very hard to live a 'normal existence' without having to make those compromises. Finally, persons such as yourself or myself can and do just walk away from things. We have choices. But this is a world in which it's not so easy. The only person in *Abigail's Party* who actually walks away is Laurence. And he walks away on the grand scale – he kicks the bucket.

Yet, despite your talk of 'escaping from people', I've never really thought of it as a misanthropic play.

Actually, what we're talking about now is whether you have the luxury of choice. It's nothing to do with being misanthropic or anti-social; it's about being able to walk away. Why does *Abigail's Party* talk to such a wide spectrum of people? Because it's about most people's experience of not having such choices.

And so the characters seem stuck in their insular worlds, with people they may love in some way but don't necessarily get along with.

The general social and sociable principle of inviting people around to make new friends is perfectly healthy. It's great. But people aren't always well matched. Or there are too many other factors that motivate what people are and how people are, what their aspirations are and all that.

Abigail's Party is particularly about 'the done thing', in that Beverly has – though she would deny it – a very strict agenda of what you talk about and how you behave. Very important you should

have a drink! And be happy! If a host or hostess offers a guest another drink and the guest declines, but the hostess then shouts, 'Come on! Drink up!' instead of accepting the response – that actually indicates the fascism of being obliged to 'enjoy yourself' and have a 'good time'.

Isn't it often the case that people who have a drink problem try to chivvy you along to keep up with their drinking simply to disguise the problem?

That's true . . . but *Abigail's Party* isn't a play about alcoholics. However, to talk about the amount of alcohol consumed in the play – the play is not naturalistic, it's very heightened. The amount they drink in the play is far in excess of what's feasible. Like everything else in the play, it's larger than life in a devious way. Reports came to me years ago from actors who'd taken part in a production in Hornchurch Rep. At one rehearsal they ran the play with real drinks. Only they couldn't get through the second act because they were so drunk.

So vomiting in the toilet actually became a reality at Hornchurch Rep?

Yeah (*laughs*). You just can't work with that amount of booze.

Consumption of alcohol aside, it's a tragic play.

It works *because of* the reality, the tragedy of it. Bernard Levin's famous reaction to it in the *Sunday Times* read: 'One of the most horrible plays I have ever seen (though meant to be), and in some ways one of the most remarkable too . . . a study of the *mores,* attitudes, conduct and speech of Affluent-Yobbonia, a large delegation from which dread land appeared to be in the first-night audience, to judge from the vacant braying which punctuated it throughout.'

What he saw was an audience braying and barking at this spectacle of grossness. While that review was culturally high-minded and therefore in some ways snobbish, on the other hand what he experienced was the very chemistry that makes it work. From start to finish, it's raw, visceral and in your face.

What makes people stop and look through those small holes in hoardings outside building sites? Or stop and watch an accident? It's the pure, raw theatre of life. You're not looking at anything that has any pretension of intellectual meaning; it just is what it is. One of the things my work is about is operating at that level. The audience live through the detail of the behaviour and, in *Abigail's Party*, the horror of it – the pain and pleasure of the horror of the event.

As onlookers, as viewers, do we then become voyeurs?

People quite often ask if they are voyeurs. If so, is it in some way immoral? As far as I'm concerned, the audience of any film or any play is a voyeur, as is the reader of any novel. I haven't really got any time for a discussion of the moralities and immoralities of being a voyeur. That's what it's about: you're looking in on some-body's life in some shape or form.

Abigail's Party proved to be a turning point for you in all sorts of ways: this was, for example, the first time you agreed to turn a play or film into a published script. Were you reluctant?

This is complicated. For me, a play or a film script is not a piece of literature in the same way a book is. Which isn't to say the literary elements in a play or film of mine aren't massively important. For all the stage plays prior to *Abigail's Party*, inherent in the philoso-phy of the operation was the fact that it only existed in its organic, before-your-very-eyes form and it ceased to exist after the last per-formance. Unlike my films. But, thinking back, I regret that those works weren't written down, but at the time I celebrated the fact that if you didn't see them in performance, that was it. Come 1977, everyone started saying I should 'write *Abigail's Party* down'. It was provoked, in part, because the *Plays of the Year* anthology wanted to include it. So they published it and then Pen-guin picked it up.

So in the end you were happy to 'write Abigail's Party *down'?*

The truth is that not only did it turn out to be a good idea for all the obvious reasons, but the minute I sit down and write a play, I

thoroughly enjoy doing it, because I love writing on paper and expressing things in words. I enjoy writing the stage directions. I'm a stationery and pen freak, and a book freak too. I love it when a book comes out in print and you can smell it.

The script, of course, doesn't mention where Abigail's Party *is set, referring only to things such as the ornamental fibre-light and the onyx coffee table on the ground floor of Beverly and Laurence's house. But in* The World According to Mike Leigh, *you talk to Michael Coveney about it being set in 'theatrical Romford'.*

In our heads it was indeed somewhere like Romford, Essex, somewhere in a London satellite suburb. At one point Angela says she's at Saint Mary's Hospital in Walthamstow, and people always think they know it. But I made it up! My films are full of places, streets I've made up. Like most of my work, *Abigail's Party* could be anywhere. When people from Manchester or Birmingham watch it, they're not registering that it's down south; it's part of their world too.

One of the most visually memorable aspects of the film is Beverly's voluminous dress. It's almost become iconic.

In this play I suppose there's a general heightening of the set and costumes, consistent with the heightening of the action. Beverly is in real-life terms a person who is over the top. So she dresses over the top. When we did it on television, Alison was several months pregnant. This did allow a certain rotundity in the character and therefore the dress heightened that. I have to say that dressing the characters is of massive importance right across the spectrum.

How is a character's costume chosen?

It's a collaboration between the costume designer, the actor and myself. In other films, input can be very random, so the costume designer has to make arbitrary decisions about the character. The massive difference with my productions is that by the time the costume designer joins in, the characters are already rock solid. The actors know what their whole character background is, et cetera, and the costume designers love it. So by the time Alison Steadman

went shopping with costume designer Lindy Hemming, she was able to talk a language of complete understanding of the character.

The real Beverly seems hidden inside that dress. So we see Beverly playing at being a hostess, commenting on Angela's lipstick, being outrageously aspirational . . .

But everyone is aspirational. Inherent in what motivates mankind is working to get what you want. It's important that Beverly has been a beauty consultant in a department store. She's concerned with looks, appearances. But she obviously eschews other qualities of life. She says, 'We're not here to have a conversation, we're here to enjoy ourselves.' She doesn't want to know about ideas. You could, of course, say she's frightened. She wouldn't like to have a discussion about the existence of God. It's frightening and it's outside the parameters of what's safe. She doesn't feel bright enough.

It has, as you say, talked to people for the past thirty years but, still, it wasn't without its critics.

When the play was on its run at Hampstead, it was the toast of London. You couldn't get tickets. Everyone in show business came. Everybody loved it. Except one person. There, at a performance I went to, dressed in black and with a face as long as a fiddle, was Kenneth Williams. He left at the interval. He writes about it in his published diary. He thought it was awful. He saw it as sneering and braying at suburban people. But he already had a face as long as a fiddle before the show started. Then Dennis Potter reviewed it when it was on television. He loathed it. He famously accused it of being one big sneer.

Occasionally I get asked to go on BBC2's *Late Review*. I haven't reviewed anything since I was a student. I think we should shut up and get on with what we do. Of course, there are people who do work that you think is a load of bollocks, and privately you may say so. But ultimately we're all having a go and we're all doing our best.

Did Dennis Potter's comments really get to you?

If someone like Dennis Potter is going to decide to be a critic, then

at least he should do so without a trace of *Schadenfreude* or bitterness. It is inconceivable to me that Dennis Potter could have failed to see the merits of *Abigail's Party*. There's no way a man who wrote what he wrote failed to get it. And therefore it's deeply suspect and deeply offensive.

When my play *Ecstasy* was reviewed on Radio 3, this very posh critic said, 'These are Hampstead people sneering at working-class people.' That remark couldn't be less accurate if it tried. The play is so in love with the characters. We were not Hampstead people at all; we were people doing a play in Hampstead. But there's a presupposition that the artist sees himself as a superior, middle-class person – a judge of society. *Abigail's Party* is not a play about 'them', it's a play about *us*. Which is why it works for the audience.

How did the cast research their roles?

As they did with all the other productions. Janine Duvitski went off and looked at nursing. Alison Steadman hung around stores in Oxford Street watching those girls at the make-up counters giving

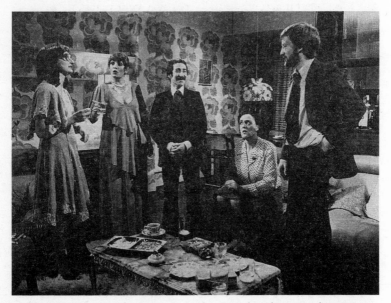

9 *Abigail's Party*: Angela (Janine Duvitski), Beverly (Alison Steadman), Laurence (Tim Stern), Susan (Harriet Reynolds) and Tony (John Salthouse).

demonstrations, though she had reference from previous experience in that territory. Tim Stern spent time with estate agents. John Salthouse had played for Crystal Palace juniors when he was a kid, so we used that – something I don't often do. Alison and Tim went to the Ideal Home Exhibition in character. They were jumped on by a guy who gave them a form to fill in to apply for a mortgage. Tim filled in his name and occupation, and as he wrote down 'estate agent' he realised it was a howler because he wouldn't be applying for a mortgage there if he really was an estate agent.

We discussed the way Alison Steadman talked as Candice-Marie in Nuts in May. *A lot of what Beverly says sounds funny or has pathos simply because of the way she talks.*

People have talked about my characters as a collection of tics, but that's reductive. The voice doesn't exist by itself in a vacuum. It is how some people talk, specifically people from certain places in the Thames Estuary. But so many different things on so many different levels are organically on the go that you can't quite put your finger on what it actually is that provokes your reaction.

A fundamental misunderstanding about my work – or certainly a reductive view of it – is that by collaborating with an actor I arrive at what I could otherwise have arrived at if I'd sat in a room and written a script and then cast the actor. That somehow it's just another way of arriving at the same goal. But this is fundamentally not the case. The philosophy of the thing is to create characters who are like people actually are, with all the attendant complexities. Those complexities operate on a whole range of levels. One can't separate out how Beverly talks, how she walks, how she behaves towards other people from who she is, what her class, cultural, educational, socio-economic background is, what her life experience is, where she's been on holiday, what she eats, what she watches on the box – everything! What her world view is, what her politics might be, how her parents were, how she was treated as a kid. All of which is there. You get stuff about her father and what a bastard he was. It's all going on in what she is. All these things are inexorably bound up, and because we do explore all of those things in the birth, growth and evolution of each character, they are all earning their keep.

Although Abigail's Party *is relentlessly funny, it's also a play about a room full of dissatisfied people who feel life is in some way letting them down. Susan is divorced, while Beverly and Laurence want different things. Tony seems the most unhappy, trapped in his marriage to Angela.*

The play is about aspirations and fulfilment, and in some ways Tony is this young man who's got lost and isn't or wasn't fulfilled and doesn't want to talk about it. But I think in the grander scheme of things or in real-world terms he is getting on with it. I'm never disposed to talk about what happens after the play, but just for the sake of discussion I would say this: anyone who says – and some people do – that now Laurence has kicked the bucket Beverly will be straight in and having it off with Tony is wrong.

What's happening between Tony and Beverly in the hothouse moment of that Saturday evening when they've had a few drinks and it's all getting a bit out of hand is one thing. But I'm quite sure Tony and Angela went on to have kids and got on with it and found a way of coping. People do. For Tony, the frustration and the nostalgia for his youth will have disappeared. Obviously he'd have been in his element in the changing room with the lads, but he'll learn to move on.

And also, this occasion – the drinks party – is hard work. For us it's a metaphor for life, but for them, for the characters, it's just this occasion.

When Beverly's dancing with Tony and she's urging Angela to dance with Laurence, she says, 'Don't worry, Ang, you'll be safe with him, he won't rape you.'

It's funny because it's inappropriate. On one level – and I don't like to use this phrase – it is a comedy of manners. A comedy of bad manners. We've all been in situations where people drop clangers and you have to stuff a hanky in your mouth to stop yourself laughing. Well, the chemistry of *Abigail's Party* is just that really. Except we're allowed to laugh.

How open are you to other people's comments on your work in progress? I ask because I understand that in an early version of the play Laurence had a heart attack totally out of the blue. Then

someone suggested you hint about him having indigestion and feeling unwell in the build-up to the heart-attack scene.

It isn't true that it came out of the blue. Laurence's running condition throughout the play is very much a man heading for a heart attack. But Michael Rudman, who's a very good director and is very good at working with his writers, came to watch it and his only real note was the need to make a bit more of the pointers in the build-up to Laurence's demise. It wasn't that the pointers weren't there. It's just a standard thing on any piece of work that you need to go back to another draft and pull out certain themes. And as for taking suggestions on board, it's always useful at a certain stage of the work.

Didn't Jonathan Miller get involved too?

Yes. We were in the theatre finally putting the play together over Easter, and I said I'd like to get a doctor in to check the heart attack. The stage manager said, 'Well, I know Rachel Miller because she lives round the corner.' They phoned her up and she was away, so Jonathan Miller came instead. I'd never actually met him at that time.

We ran a whole section for him to see what he thought about the heart attack. It goes without saying that although I was asking him to comment on the technical aspect of the heart attack, I also expected him to be amused by the play. But he looked at it and, to our amazement and horror, he was completely impassive. He didn't even laugh or say, 'That was great.' Then he said nobody just drops dead of a heart attack just like that. And he gave a long speech about the principle of doing heart attacks on stage and talked about some attack somebody had in a Chekhov production he did. Then he left.

It was absurd, because it just isn't true that people don't instantly drop dead of heart attacks. Alison had actually seen a man do so in Euston station about six weeks previously. I suspect it slightly falls into the same category as what we were saying earlier about Mr Potter.

Did you have alternative endings in mind?

No, it was always going to be a play about a man who dies of a

heart attack. The only development was the detail of the cramp. There were a couple of performances in preview in the theatre before I had the brainwave of putting in the cramp. I suffer terribly from cramp and I think I got it one night around that time. I suddenly twigged: I knew it needed something else that was about somebody else's problem. So I added that element after a few previews.

Where did the initial idea for Abigail's Party *come from?*

To begin with, Aukin and Rudman at Hampstead said, 'It's absolutely up to you what you do. There will be no interference, but we'll just say one thing: plays do transfer from here to the West End and it would be great to have a piece that could achieve that.' I took that on board, although of course it never got to the West End, as we know.

From the outset, I decided to subvert the traditional French-windows, cigarette-smoking 'boulevard play'. That was one conception. The other was a 1908 drama cartoon called *Drama Amongst Puppets*, where the characters are drawn in chalk. This is a very private conception: I always have lots going on at a subliminal level, so the notion of subversive high drama happening amongst the puppets of a boulevard play was something going on in my head when putting together *Abigail's Party*. I mean, people don't die of heart attacks in graphic detail in West End-type boulevard plays. But they do in this one.

One of the things that always motivates me from piece to piece is how I'm going to contrast it to its predecessor. Clearly, *Naked*, for instance, was deliberately dishing up something that nobody was expecting at all because it wasn't the least bit like its predecessors. And *Secrets & Lies* confounded everyone who thought I'd now only make films like *Naked*. *Topsy-Turvy* ranks very high on the list of big surprises all round. *Ecstasy*, while it has lots of humour and warmth, is set in a bleak Kilburn bedsit and it's what I dished up at Hampstead after *Abigail's Party*. Everyone expected another *Abigail's Party*.

Who's Who
('Play for Today', 1979)

Alan Dixon (Richard Kane) has a desk job at a City stockbrokers. Obsequiously humble whenever he comes into contact with his superiors, he is essentially a dull and quasi-invisible presence. He shares an office with a cheeky young man called Kevin (Philip Davis), whom he clearly bores by wittering on about the famous autographs he collects: a signed postcard from the late television presenter Russell Harty, a letter from the Prime Minister's secretary. 'Mrs Thatcher was delighted to hear from you and is delighted to send you a photograph . . . with her warmest wishes,' he reads with pride at one point.

Alan lives his life vicariously through celebrities, while his wife April (Joolia Cappleman) breeds cats instead of children. She is eccentric, neurotic, remote, distracted. Their house is overrun with long-haired white chinchilla cats and decorated with pictures of the royal family and Mrs Thatcher. The couple struggle to communicate at even the most basic of levels.

Meanwhile, a partner at the stockbrokers (Jeffrey Wickham) has a meeting with rich clients in Kensington. Lord and Lady Crouchurst (David Neville and Richenda Carey) check their diaries, which include their appointments at the Savoy and at Windsor. The nanny (Lavinia Bertram) lurks in the background, making sure their young daughter is neither seen nor heard.

Two of the younger upper-class stockbrokers go to a yuppie dinner party hosted by their friend Nigel (Simon Chandler). It's not an entirely successful evening, with loud guffaws, awkward silences and misunderstood comments. Overindulging in alcohol fails to loosen them up.

April invites an animal photographer, Mr Shakespeare (Sam Kelly), round to the house. Chaos ensues as he tries to capture the naughty, indulged cats on film. A posh, self-absorbed woman called Miss Hunt (Geraldine James) perches uncomfortably on the edge of the sofa hoping to buy a cat – Harrods has just let her down. Alan, putting on his best accent, asks her daft, inappropriate questions about her family tree.

* * *

AMY RAPHAEL: *Who's Who is not one of your best pieces. There are some farcical moments, but essentially it's loose and disjointed.*

MIKE LEIGH: You just have to look at it for what it is. It is unquestionably full of ideas and notions of various kinds. I would say, looking at it now, that it was potentially a really interesting, original satirical film. Incidentally, people sometimes talk about my work as satire, but this and *High Hopes* are the nearest I get to it. Its central flaw is that it doesn't go anywhere. It has a beginning and a middle but not an end. It sort of disappears up its own arse. Which is a shame.

The truth is that halfway through the rehearsals, on 3 February 1978, my first son Toby was born. That's the same child whose earlier manifestation prevented *Abigail's Party* from going into the West End. We rehearsed *Who's Who* in a basement in Maida Vale with no air and no light. We ate our lunches in the Maida Vale canteen of the BBC studios, which also had no windows. It was winter. I developed a headache just after Toby's birth which just would not go away. It got worse and worse. I started to take analgesics. The doctor kept giving me stronger doses. Then I got dozy. I fell asleep in the rehearsals. The whole thing became a nightmare. Finally, I had to stop going to work for a while. They sent me to the BBC doctor but nothing worked until one of the production assistants took me to see his osteopath dad in Greenwich. He put me on a table and beat the shit out of me. The headache disappeared immediately and things got back to normal.

None of this is necessarily of any interest to anybody, but because of all those factors the whole thing didn't turn out as it might have done.

Do you find it hard to watch now?

I don't think it's completely without merit. This total snob who's a lower-middle-class clerk who sends for autographs and whose wife breeds pedigree chinchilla cats – it's all great fun. Of course, there are comic roots manifesting themselves all over the place in my work, but in a way the Ealing comedy roots of *Who's Who* are closer to the surface than most. And, coincidentally, some of it was shot in Ealing.

You were supposed to be starting work on Who's Who *when you were commissioned by the Hampstead Theatre to do what became* Abigail's Party.

Margaret Matheson was someone I worked with on and off over a period of time. Later she was in charge of drama at Central Television when we made *Meantime* in 1983. We get on very well. Before I started work on *Who's Who*, she just had one suggestion: 'You always do working-class and lower-middle-class life.' She said that she would love to see me have a go at upper-middle-class life. So I agreed. But being naturally drawn to a dialectic view of the world, it seemed more interesting to look at the upper middle class through the prism of Alan and his preoccupations. So this central conceit of *Who's Who* allowed or encouraged or afforded an abandon in the heightening of things.

You ran out of time because of the various distractions you listed. What direct effect did that have?

Because we ran out of time, much of the dinner-party scene was improvised on camera, within a clear structure. With another week I'd have got it word-for-word precise, which is, of course, my preferred style. Still, looking at it now, I do think it has a certain charm.

There have been improvised scenes here and there throughout the films. Mrs Thornley and Ann at the market: awful. Keith and Candice-Marie discussing war as they pass military camps: delightful. Keith and Finger fighting: good. Trevor meeting Linda for the first time, and later in the disco – shot with two cameras because one packed up, then decided to start working again when

a second one was sent out: interesting. Billy and Lorraine and the lads on the piss at the bonfires on the night of 11 July: natural, and the only way to achieve it. Barbara and Mark in the car looking for Colin: very funny. Wendy and her dancing class: lovely.

Obviously if you've got actors who can improvise totally in character, truthfully, organically, it sometimes makes absolute sense to use those skills if there's a reason. Like Barbara and Mark in the car, responding to the real world. But, for me, that isn't mainly what it's all about. Distilling, structuring, good writing: that's my preference. I prefer to do my script editing in the rehearsal beforehand, not in the cutting room afterwards. Virtually all the scenes I've just listed would have been better had I had the time to rehearse them extensively. Yes, there are some moments of inspired improvisation here and there in the films. But they're the exception. It's no coincidence that there are no improvised moments at all in *Grown-Ups*, *Naked*, *Topsy-Turvy* or *Vera Drake*.

Are there any characters in Who's Who *that are appealing in any way? I struggle to find anyone even vaguely sympathetic.*

Well, that's as may be. I don't feel that about any of the characters. Look at Alan and April: you could say they are ludicrous and pathetic, you could say that you may not even want them as neighbours. But they're not offensive in any way. It's another one of those dysfunctional relationships, except they find some way of coping, although things rumble under the surface. They obviously share some kind of passion for various forms of lineage, both human and feline.

As for the young men . . . over the years I've looked at all kinds of posh people. I've even had relationships with a couple of upper-class women. Still, in the context of doing this film, I remember doing various kinds of research, including one night when we somehow fetched up at a Kensington & Chelsea Conservative Association reception with the then MP, Sir Nicholas Scott. I did all kinds of research. I even went down to Gosport and hung around on yachts.

And you reported on the world you found.

In a way, removed from the overall context and perspective of the

film, the little study of Sloanes having a dinner party was quite an accurate picture of that world. Within that, you see these kids who are again victims of received notions of behaviour and all the rest of it. You've got a girl who is basically a gorgeous sweetie, dressed up like a cake, who just wants to be nice. You can't find her offensive. There's another one who understandably wants to break away, so she's trying to be a punk. Even Nigel, the rather officious host who does the cooking, is quite vulnerable.

So I don't take as beastly a view of them as you, I have to say. I think it's quite sympathetic in a sense. Since you posit this notion, I would say that nowhere in *Who's Who* is there actually a character that is as offensive as the landlord in *Naked* or the expectant father at the end of *Four Days in July* – that life-hating person.

Actually, if pushed, I don't mind Phil Davis's character Kevin.

Absolutely. He's just taking the piss out of Alan, and you can't blame him for that. He's a goodie. The important thing about the posh kids is that you then see them in a more rounded way in a social situation. Even the boss, Francis – played by Jeffrey Wickham, who goes on to play the prosecution barrister in *Vera Drake* – goes to see Lord Crouchurst and is just a man saying it like it is.

To talk about it on another level, it's a film that goes off into not completely successful realms of high comedy and surrealism. I think the Sloane turning up to buy a cat is probably implausible. A woman like that wouldn't go to a piss-pot house in Ealing to find a cat. The explanation given – as you know – is that Harrods ran out of them. But hey . . . It contains a howler too. She is obviously a hunting person yet she seems ignorant about the reproductive functions of cats.

I assume the cats are simply replacement children?

Yes. But you don't need a degree in psychology to work that one out. April is a vulnerable person. Nutty, but a perfectly nice woman.

With a house overrun by fluffy white cats.

You try filming the bastards. That was for real. They were a night-

mare. This woman arrived with her assistant in a Volvo full of these bloody neurotic moggies.

The other very interesting and funny aspect of the making of *Who's Who* is that Richard Kane wrote to all sorts of real people in character and got real replies. So when you see those replies, including the letter from Margaret Thatcher, they are all for real. We had a lot of fun, because he wrote to actors we knew and never told them.

April has cats instead of children. Would it be fair to say that Alan is living his life vicariously through famous people?

Those things are the central premise of the film. That conversation he has with his boss in the lift – he's not just enquiring how his family is, he's having some fantasy that he's in that life.

At one point, as he's wandering around London looking at the residences of these famous people, you see Alan walk past 10 Downing Street and then you see him looking through the railings of Buckingham Palace from the Queen's implied point of view. In 1978 you could still walk up and down Downing Street; there was no security. The cops were very cool. We did various takes of him walking back and forth and they didn't bat an eyelid. You couldn't do that now.

We wanted to do that shot through the railings of Buckingham Palace, but you're only allowed to shoot outside. *Who's Who* was designed by a brilliant production designer, Austen Spriggs, who solved the problem by wheeling down a lump of railings that more or less matched those at the palace. Because you had the Victoria memorial in soft focus in the background, it gave the impression that the camera was inside the grounds looking out, from the Queen's point of view, as it were.

The dinner-party scene ends with a single shot of Simon Chandler on the sofa, with everyone else coming and going. 'Your Tiny Hand Is Frozen' from *La Bohème* is playing. We ran out of time; we literally had nine minutes to get out and that was the end of that location. I set it up quickly and made it all happen in one shot. Which, of course, you can do when you've got actors who are so familiar with their characters.

Had you worked with many members of the cast before?

The first thing I ever directed was Pinter's *The Caretaker* at RADA, and Richard Kane played the tramp. He's a good actor. Joolia Cappleman we know about because she was in *Bleak Moments*. This was the first time I worked with Phil Davis. I'd met him some years previously when I was auditioning for a theatre thing. I like him hugely. He's a great actor.

When you come across an actor like Phil Davis and he goes on to appear in several of your other films, is there a specific quality that you find attractive or is he just a versatile actor who understands your method of working?

Well, all of those things. Of course, they're good actors, we get on and become friends. They love what we do. You ask if there's a specific quality and there is: each of these actors has his or her own *particular* quality.

Grown-Ups (1980)

Dick (Phil Davis) and Mandy (Lesley Manville), a young couple who have been dating since school, move into a council house in Canterbury. Mandy's older sister Gloria (Brenda Blethyn), an anxious woman in outsize glasses, comes round to see them within hours of their move and is suitably impressed. Dick later walks her to the bus stop. The following day we see Dick working at the local hospital, cleaning the kitchen, Mandy waitressing in a cafe, and

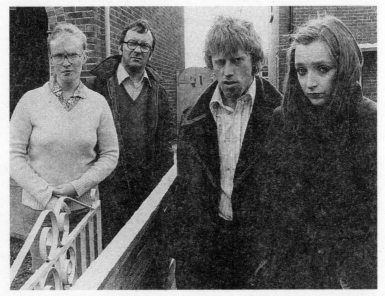

10 *Grown-Ups*: Christine (Lindsay Duncan), Ralph (Sam Kelly), Dick (Phil Davis) and Mandy (Lesley Manville).

Gloria at the office, where she is a typist. That evening Gloria visits again. Dick eats his fry-up lying on the sofa. Mandy is reluctant to feed Gloria as she doesn't want to encourage her, but she still stays.

Dick and Mandy discover that their new next-door neighbours, who live in a private house, are their old religious-knowledge teacher Ralph Butcher (Sam Kelly) and his wife Christine (Lindsay Duncan). Dick reminisces, 'I hated him . . . he used to go on about my teeth.' But Mr Butcher doesn't recognise his old pupils.

Sharon (Janine Duvitski), an old school friend of Mandy's, comes to see the house. She tells them it needs doing up and is 'filthy'. Gloria appears with a vacuum cleaner as a gift and makes herself some toast.

Christine comes home from school to find Ralph asleep on the sofa. They talk about the Loch Ness monster, then argue about religion; a pious Ralph accuses his wife of lacking faith. Dick returns from the pub drunk; Mandy is fed up with him for not helping with the unpacking, but they fall asleep holding one another. Next door, Ralph lies in bed reading school essays to his dozing wife.

Gloria is unable to stay away from Dick and Mandy's house. At one point she sees Ralph and introduces herself; at another she goes to the pub with the young couple, then bursts into tears. She doesn't want to go home, where she lives with her mother.

Dick and Mandy go to the pub another night. They lie in bed and argue about having children. Mandy warns him that she isn't going to keep taking the Pill. Dick angrily proposes they talk about it 'next year'. He adds, 'We'll have kids when I say so,' belches and falls asleep.

Mandy tells Christine that she is planning to get pregnant. Christine, who is childless, looks sad, bereft.

Mandy and Sharon return from the shops to find Gloria in the house and Dick fed up with her continuous presence. They ask Gloria to leave. She refuses. They force her out, but she tries to come in by the back door. She runs into Ralph and Christine's house – Christine has left the door ajar as she washes the car – and locks herself in the bathroom. Ralph wants her out. He protests, 'This is a decent Christian household.' Christine manages to coax a hysterical Gloria out of the bathroom. As she reaches the front door she turns, sees Dick, Mandy and Sharon, and bolts back up the stairs.

Everyone – Christine, Ralph, Dick, Mandy and Sharon – tries to grab her. They collapse in a heap on the stairs. Gloria is wet with tears and snot. Dick, Mandy and Sharon leave, while Christine makes Gloria a cup of tea. While Gloria is having a snooze, Christine goes next door to collude with Mandy and Dick. Finally, Mandy and Sharon take Gloria home in a taxi.

Ralph lies in bed reading Life Before Man. *Christine, unable to contain herself any longer, exclaims, 'I want sex. I want love. I want a family.' Ralph simply offers his usual grunt in response. Next door, Dick and Mandy cuddle up in bed. Dick seems to be changing his mind in favour of starting a family.*

Christmas, a few months later. We see Gloria happily listening to the baby in Mandy's swollen womb.

* * *

AMY RAPHAEL: *Was* Grown-Ups *something of a departure for you?*

MIKE LEIGH: By the time I did *Grown-Ups*, I'd made five films. I would say, taking everything into consideration, that *Grown-Ups* was the first really thorough, completely organic, properly structured, perfectly written, absolutely controlled piece of film work. And it was the first totally organic fusion of comic and tragic in a real and heightened way. It was nine or ten years after *Bleak Moments*; there's a decade of experience going on, including the fact that it was preceded by a couple of stage plays.

Grown-Ups is a massively complex film in many ways, particularly when it reaches the climax. We're not talking *Apocalypse Now* or *Ben Hur*, but in its own way it's an operation. Which is why I feel so positive about it having come after all those other films: you really see me absolutely on top of the material. It's constantly inventive and there's all sorts of stuff going on.

Did the fact that you'd been distracted during the making of Who's Who *have an impact on* Grown-Ups, *in the sense that you wanted to create a stronger piece of work?*

Yes, that's true. There are other circumstantial factors that made it possible for that to happen in *Grown-Ups*. But yes, you're right.

As with all of us, each piece of work to some degree defines where you go next. The thing about *Grown-Ups* is that the eye is always sharp and I know what I'm looking at.

What's the genesis of Grown-Ups?

I was in the house with my two-year-old son for the day. My agent phoned to say that Louis Marks at the BBC wanted to see me for a possible film. He wanted me to go in there and then. So I found somebody to look after Toby and went into White City. Louis is a delightful old communist who by this time was only really doing classics in the studio. A film he'd been working on had been axed; he was left with half a budget and did I want to make a film? Of course I did.

I thought that instead of casting a lot of actors I'd have a small, concentrated microcosm. Apart from anything else, Louis said that he'd seen a young actress who'd played a maid in a classic adaptation. She was called Brenda Blethyn. That's where she came from. I'd worked with all the other actors before, apart from Lindsay Duncan, who I knew from around town. I thought I'd film somewhere out of London, since I could, since there was a budget. You then had to be a certain distance from London. I randomly chose Canterbury, even though I'd never been there. In the event, there are references to Canterbury, but it's not really central to the film. You could tell the story just as well if it wasn't Canterbury. It's just a place where those people happen to live.

On a very basic level, why do you think Grown-Ups *works?*

There are a number of factors. First of all, there were only six actors, so it's very concentrated. Secondly, it was the first of three collaborations with the great cameraman Remi Adefarasin, who's gone on to shoot films such as *Elizabeth* and *About a Boy*. But *Grown-Ups* gave him his break as a cameraman in the BBC. He and I really were on the same wavelength.

It was also the first time you encountered Simon Channing Williams.

He came on board as first assistant director – or 'production assistant', as they were called. Several other people were supposed to be

doing the job before he turned up, the first of whom fairly quickly got a directing job. He was then replaced by somebody else who I didn't even properly meet. I was in the legendary BBC club, in the section where all the drama people stood, drinking themselves to death. Behind me, I heard a conversation between two men. One said to the other, 'What are you working on?' To which he replied, 'Oh God, I'm doing one of these fucking Mike Leigh films. There's no script. I tell you, they are such wankers.' By lunchtime the next day he was no longer working on the fucking Mike Leigh film.

Quite late in the day, the third person who was going to do the job, who'd been around during rehearsals, got quite seriously ill and ended up in hospital. By this point we'd been in Canterbury for weeks and it was quite late in the day. It was a Friday and I was told this guy was coming down from London to be the production assistant. I asked his name, and was told 'Simon Channing Williams'. I thought, 'Fuck! Another bone-headed, upper-crust, toff idiot.' So I was working with all the actors that day and I was a bit down about having to go off and meet this guy. He turned out to be a huge, ebullient character, and he seemed very nice. I asked him if he'd ever been to Canterbury before, and he'd never set foot in the place.

What did the actors make of him?

There were only a few of us, cast and crew, so it was really quite a close-knit gang and every Friday, during the rehearsals, we used to go to a restaurant and have a very fine dinner. So we thought we'd sussed out all the good restaurants in Canterbury and chucked out the crap. As this was a Friday, Lindsay Duncan suggested we invite Simon to join us. 'Oh yes,' he said, 'I'd thought of that and I've booked somewhere.' We were a bit startled. There was a general feeling this was a bit pushy.

He mentioned a pub nobody had heard of. We offered to pick him up, but he'd arranged transport for us. We met at this pub and really we were all still a bit miffed. We go in, and the landlord says, 'Hello, Simon!' No tables, nothing, and we're all standing round having a drink, wondering where the dinner is. Suddenly we're led through to this extraordinarily good restaurant, hidden away behind a curtain. It turned out to be the best meal we'd had in

Canterbury. At which point I twigged that this man was the ultimate organisational genius – which, of course, he really is. Basically, he enabled me to make such a good film.

To the point where you wish you'd met him earlier?

In a way, yes. The key to a film is how well it's 'firsted' or organised. I could say some very rude things about some of the people who did some of the earlier films, though not all of them by any means. Simon was just fantastic. He could anticipate forty moves ahead. He was on the case with everything and he could make everything work together, so no time was wasted. He sussed pretty quickly the principle of what I would need. He could see, for example, that I'd done the broad structure of *Grown-Ups* but needed time to work on the climax.

The schedule included Easter, and Simon did massive negotiations with the crew, trading Sundays here and there, all in order to give them time off for the whole of Easter week. This allowed me to spend time with the actors working out the climax, so that we didn't have to waste shooting time to work on it.

I assume he was instrumental in securing the two houses.

Prior to his arrival I'd said we'd need two houses side by side: a council house and some kind of semi-detached house. I knew this was a tall order, but it's what was needed. We were looking around Canterbury, which is not a very big place. There had been occasions in the past where I'd asked for stuff and it hadn't really materialised. I'd always been in a right old flap. But, finally, up came these houses. You couldn't have built a better set. So a deal was done with the inhabitants of the private house, who happened to be teachers. They were going to move out and we were going to do the place up. And a deal was done with Canterbury council for the house next door.

Then, all of a sudden, some fascist Tory councillor got a bee in his bonnet about the 'Play for Today' series and imagined reds under the bed. He couldn't be shifted. The council was no longer playing ball and was walking away from the agreement. At this point Simon joined the production, and after a couple of days we got the house back. Afterwards I found out that he got on the case

and did some esoteric homework that only he knows how to do. He found some ex-public schoolboy who knew someone else who knew someone else who had a mole in the council. And it was sorted.

It might have been a reasonable film anyway. It was a good, clear idea, but Simon's presence was so incredibly liberating. He created real time and space for everything to work. He's a big bugger and he won't take any shit from anybody: you want silence, you get it. But also he's got a great sense of humour. He's great with actors.

You were lucky to find someone on exactly the same wavelength.

Indeed. Simon only had one fault on that film. Sam Kelly is probably the most excruciatingly funny person I know. He is agony to be with. If you're filming in a very small room you can feel people's alimentary canals turning themselves into knots so as not to laugh during the take. Especially as Ralph is always making that odd kind of clearing of his throat.

We shot one scene where Christine and Ralph are having supper and she's talking about playing netball. Simon was standing there next to me, and I had to send him out because this great heaving, giggling barrel was in the room and it was displacing the space.

A last word on Simon for now: we obviously got on very well and we asked him to first *Meantime*, but he was doing something else. I insisted he be brought in on *High Hopes*, and in fact he became co-producer. We made that for Portman Productions – by that point, people were making independent productions for Channel 4. We then decided that we should work for ourselves, so we formed our own company, Thin Man Films. The rest is history.

What did you bring from your own background to the film?

Well, here's another story, about the late film director Maurice Hatton, whose most famous off-beat film, *Praise Marx and Pass the Ammunition*, was made in the 1960s. Maurice was Jewish, Mancunian, a very nice guy. He came to a screening of *Grown-Ups* at the London Film Festival. It was, incidentally, the very first time a television film was screened at the LFF; they broke their convention for this film and it opened up the possibility for telly films.

Anyway, at the Q&A after the film, Maurice put up his hand and very naughtily said, 'Is this film autobiographical?' To which I replied, 'Absolutely not. No way.' He said, 'I don't accept that, thank you.' Because, of course, the world in which people shout and scream and carp at one another in that way is very much evidence of an ordinary Jewish background.

Again, it's another film about what's going on behind the twitching lace curtains, so to speak. And about class division. Ralph and Christine are obviously descendants of Keith and Candice-Marie. Again, you've got all the same old stuff happening: people just trying to be themselves, people aspiring to be something else; people not able to deal with their emotions and being disingenuous; people trying to care for people. And all the rest of it. People trying to get out and get away. Whether you have children or not. It's all there.

Was your Auntie Janey a source of inspiration for Gloria?

I come from a family – and I'm certainly not the only Jewish person who can say this – where whole branches of the family wore thick specs. My father's Auntie Janey was the widow of my grandmother's eldest brother, Uncle Sid Blain. He went down in a ship in the North Sea in the first week of the First World War. He was killed before anyone had got used to the idea of the war. By the time I remember Auntie Janey, in the 1940s and 1950s, she was a little old lady who wore these big lenses but still could hardly see.

The house we eventually lived in was the one in which my grandparents had lived previously. They always used to come in the back door. Then my folks rebuilt the back, so everyone had to use the front door instead. Except Auntie Janey. You'd look in the back garden, and because she had bad sight, she'd come right up to the window and you'd suddenly see this face peering in. You'd say, 'Auntie Janey's here, go and let her in.' It's not a portrait really; it's just the specs looking through the window.

There are rather a lot of outsize glasses in your films.

The number of characters in my films with glasses can undoubtedly be traced back to the autobiographical fact I just logged. I never wore specs till 1992, because I take after my mother's side of the family. I love it when we get to the specs bit of a film. There

were at least two fantastic pairs of period specs in *Vera Drake*: one worn by Ruth Sheen and the other by Allan Corduner. Of course, specs are a cinematographer's nightmare, reflections being what they are. There's a moment in *Who's Who* when Sam Kelly takes off his specs and rubs his eyes in a very tight close-up because we were shooting in a tiny room, and Remi couldn't light him without showing a double reflection of the whole crew.

To return to Gloria and her specs: the unwanted relation who keeps giving you gifts and wanting to be in your life is, of course, a central theme of this film. But Auntie Janey wasn't the least bit like Gloria. She was a quiet, gentle soul.

And, as usual with your characters, the viewer is vacillating between embracing and rejecting such characters. As a viewer you are forced to think very hard about why you like or don't like a character. When we first meet Sharon, for example, it's hard to understand why Mandy puts up with her negative comments on the house.

I think she's just somebody who's disposed to be critical about things. She's a nark, as they say. I don't think she's jealous of their set-up; it's not that complicated. Dick more or less says, 'Oh, she's come to cheer the place up.' He banters with her. These are people who've grown up with each other, who know each other well enough to say what they like. They are being themselves.

The physical appearance of Dick, with his jutting jaw and goofy teeth, verges on the grotesque – which is how people are. It's not about the light relief of looking at pretty, airbrushed faces all the time. He remembers Ralph thus: 'I hated him, he used to go on about my teeth.'

As is often the case with my films, we went back in time, so that some time in rehearsals we did a few improvisations where they were kids in class and Ralph was the teacher. So Dick is referring back to something that has actually taken place.

At the start Dick and Mandy seem to be bickering all the time, but then the viewer realises that that is how they communicate and there's tenderness in the relationship.

140

The thing about Dick and Mandy is that they're fine. They are obviously in conflict about whether or not to have kids yet.

Whereas Ralph and Christine seem to have stayed together only through habit. Finally, she shows her frustration with him. 'I want sex. I want love. I want a family. That's what I want.'

The great thing about Lindsay Duncan's performance is the progression of our view of Christine as a dowd to a woman with real passion, a proper person with needs. Yet when she tells him what she wants it's shocking. The way we shot that scene is important: it's very straight on, at two people together in bed but separated by the lies between them.

He's reading Life Before Man, *but with no passion. He's almost robotic . . .*

It's so important to see them both teaching, to see how appalling he is at it. There are always lots of references in these things – for me – all kinds of sources on the go. In 1966 I made this little documentary about a kid in a secondary school in Birmingham. There was an art teacher who was slightly my source for Ralph. He was completely impervious to the kids' creative possibilities and needs. As much as anything it's a film about education. If you look at Ralph and Christine as purveyors of education and you see the others as the recipients, it gives you a lot to think about.

At least Christine has a degree of sensitivity; Ralph is not aware of anyone's needs, least of all his own. He simply uses religion as an emotional crutch.

Well, I subscribe to the old-fashioned view that religion is the opiate of the masses. I've got no time for it at all. But in this film, I say, 'OK, this is Canterbury. This is the centre of Anglicanism. This is a place of God. This is about Christians.' But, of course, the received notion of Christian behaviour is what is at stake when the shit hits the fan with Gloria and she ends up in Ralph and Christine's house. He who endlessly spouts things about God is completely un-Christian, whereas Christine displays proper Christian values.

The scene where Gloria is on the stairs sobbing and having a near-breakdown: how do you point the action of such a scene in a certain direction?

My job is to negotiate into existence what happens. When it came to that scene, the main structural idea I had was that Gloria had to run next door. We had to do a lot of improvisations where we would test possibilities. I seem to remember that Brenda Blethyn's instinct was to rush next door, but she worried that I wouldn't want her to do that. Which is, of course, ridiculous. It's outside the rules of engagement: she should have done it because it's what she knew Gloria would do. In fact, it was the only thing that dramatically would give the film any meaning. Everything has to be organic, which is to say it has to make sense for the actor playing the character. I will never say, 'Just do what I tell you.' It's against the rules. That's not just a vaguely pious, cultish position; it's a practical necessity because it's got to be completely truthful within its own terms of reference.

This particular sequence – which starts when the girls arrive back from the shop and ends when the front door is slammed and they go back to their own house next door – happens in continuous real time. But to arrive at that was a very elaborate process that went on for a week. The problem with doing an improvised scene like this is that you have always, always got to return to the beginning and run through it all again to get to the next bit, otherwise it's not motivated. With all the shouting and hollering and screaming going on, it takes a lot out of the actors' voice boxes. If we were working from a script, we'd probably be tempted just to move on to the next scene.

And it must be emotionally exhausting.

It is, very. But those batteries are easier to repair than a fucked-up voice box. It's an occupational hazard given that you can't just pick it up in the middle. It has to be motivated to enable everyone to explore the uncharted territory of the next bit. Improvise it, pin it down and then test it out at full throttle. It does involve emotional, physical commitment and patience from everybody and it's very, very tough.

How do you know when you've got it right?

You just do. Also, what I do is this: I get to the point where a piece of action is constructed, and that's on rehearsal day. I then convene with the whole crew and we'll run through the scene, primarily for the cameraman and others to check out what we've been doing. Next we have to discuss how we're going to shoot it, which can be quite an elaborate process. It has to be lit and everything has to be put in place – all of which takes a long time. While that's happening, we'll go somewhere else – perhaps to a hall or the dining bus or a dressing room – and I'll refine the dialogue and the detail with the actors, bringing the scene to performance pitch.

This, of course, is the first screen appearance in one of my films of Lesley Manville, although I'd worked with her before on a BBC Radio 3 play, *Too Much of a Good Thing*, and she had been in the failed play at the RSC. Her versatility is phenomenal. She grew up in Brighton with girls like Mandy, so she really knows them.

How did you get on with the extras in this film?

In *Grown-Ups* my story-telling motivation is very clear and controlled, so that the use of the extras in the brief pub scenes is very tight. You see a burst of guys cheering at the pot of a ball. It's very clear and graphic and distilled; there's no sense of being weighed down by having to show long shots. Not like in *Hard Labour*, which is clumsy and clunky and dissipated and bland. Or there's a scene in a clothes shop with girls trying things on. Or scenes where you see Gloria typing in her office and wide-shot close-ups. Or Mandy in her cafe . . . it's all very controlled and there's no wastage.

Some directors are really good with extras; as we've touched on before, it's not really my bag. It's partly because being confronted by people that look and behave like extras is off-putting. Sometimes I'll agree to take twenty extras, but when it comes to looking at the scene, I start getting rid of them straight away. In *Secrets & Lies*, when Maurice is having a drink on his own in the pub, I stripped away all the extras until it was just a man sitting by himself in a pub. In theory, you say we've got a pub scene, we need people. But when you look at it, it's like a homage to Edward Hopper.

The film on which there was the biggest issue with extras, which I've already mentioned, was *The Kiss of Death*. The same AD who was responsible for the bungle with the corpsing corpse – who will continue to remain nameless, though you can see his name on the credits – did another ridiculous goof. The scene in the disco was shot during Wakes Week – a term that dates back to Lancashire's industrial era but is now used to describe the annual summer holiday. There were a lot of people around, so we used non-extras to populate the disco. As they weren't in Equity we couldn't pay them, which was OK. They simply got free food and drink and very minimal expenses. But when it came to giving out the expenses, our famous AD was overtaken by an unhealthy attack of philanthropy and handed out bigger chunks of money to everyone. We had shot a lot of wild footage that day, and when we were in the cutting room in Birmingham weeks later to look and listen to it, you kept hearing this voice saying, 'I'm an Equity member, I'm going to report this!' The Equity person shopped the film, there was a big fuss and we had to pay a fine. I was very embarrassed because I'm obviously a union person and a committed member of Equity. The bottom line was that £300 had to be paid into the Equity fund. For the rest of the film we had to have Equity members from Manchester.

So, when it came to the pub scene where Trevor and Linda meet, there were all these official extras hanging around, tanned and tinted folk who didn't look anything like real people. So we did a long shot, paid them and sent them home. We then got in some real people and shot them instead. I tell this story with a completely clear conscience because that's what you have to do to get the right effect.

If you detect a certain degree of friendly antipathy towards extras, it derives from my experience of *Two Left Feet* in 1962. Because I was playing a minor character I spent a lot of time with extras, twisting again, like we did last summer.

You're probably not alone in your antipathy.

Indeed. Alison Steadman tells a story. She was in a 'Play for Today' in a television studio, playing a central character. It was a serious piece and the character was in a serious crisis – and Alison was giv-

ing it her all. During a scene in a pub with some extras – all on set – she had to go to the bar, get some drinks and sit back down. Every time she got to the bar in the middle of this highly emotional scene, the barman would say things like, 'How's this take going for you, Alison? Is it all right?' He couldn't stop himself. Every bloody time . . .

Home Sweet Home
('Play for Today', 1982)

Three postmen – Gordon (Timothy Spall), Stan (Eric Richard) and Harold (Tim Barker) – chat in their sorting office early one morning. Stan is spotted on his rounds by Gordon's flirtatious wife Hazel (Kay Stonham), and she invites him in for a cup of tea. A seemingly stoical Stan explains how his wife ran off with another man, leaving behind their six-year-old daughter. Tina (Lorraine Brunning), now fourteen, lives in a care home. Hazel gives Stan a tour of the

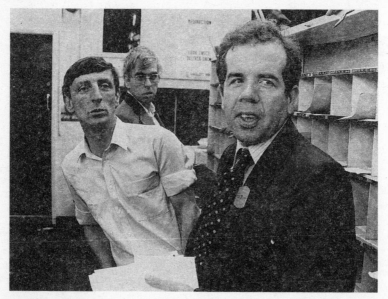

11 *Home Sweet Home*: Stan (Eric Richard), Gordon (Timothy Spall) and Harold (Tim Barker).

house and invites him over for Sunday lunch one weekend.

Harold, who is always telling unfunny jokes and reciting fragments of lyrics from songs, goes home to his wife June (Su Elliott). They sit around after lunch drinking tea. Fed up with Harold's endless quipping, June transports herself to a different world by reading romantic novels. Gordon, who lounges around in his own home belching like a slob, appears to be equally incapable of expressing affection for his wife. He complains about the tightness of his trousers, only for Hazel to suggest he lose weight.

Stan is visited by an earnest but inexperienced social worker called Melody (Frances Barber), who talks about herself before remembering to point out that he has only managed to see Tina four times in the past year. She reminds him to go and visit his daughter on Sunday. Yet when the time comes he goes instead to the laundrette, picks up a lonely, simple-minded woman (Sheila Kelley), buys her a drink and then takes her home. After they have had sex, Stan has no interest in her, but she leaves cheerfully.

Hazel invites Stan in for another cup of tea. She flirts with him, reminds him of the invitation for Sunday lunch. Stan goes home and takes a phone call from Melody asking why he failed to visit his daughter the previous day. He goes round to see June, with whom he is having an affair. They bicker, then go upstairs. When Harold comes home from work, June is lying in bed with a headache. She snaps at him, telling him he is annoying – not least because he doesn't realise how desirable she is.

Stan visits Tina in the home with Melody. It's an awkward meeting, with neither father nor daughter knowing what to talk about. Melody suggests Tina spends the upcoming weekend with Stan. He agrees, but with little conviction. This time, however, he keeps his word: we see them standing in Stan's desolate back garden, talking about her childhood, attempting to re-establish a connection. On Sunday Tina helps Hazel prepare Sunday lunch while Stan and Gordon are in the pub. Gordon is drunk, and when they go for a postprandial walk, he struggles to keep up with the others.

After the walk they all go to Stan's house for tea. He plays Frank Sinatra's 'My Way', joins Hazel in the kitchen and kisses her as Tina looks on. Tina goes upstairs to pack; Stan, clumsy in his attempts to bond with her, offers some money. Downstairs, June comes round to talk to Stan but soon leaves. Gordon shouts at

*Hazel for mothering – and smothering – Tina, before storming out
of the house. Stan drives Tina back to the home, while Gordon and
Hazel exchange insults in the street.*

*In bed that night, June tells Harold about her affair with Stan.
He is shocked, then baffled; he thinks she must be joking. Finally
realising she's not, he asks her to end it, but she says nothing.*

*Stan is visited by a second social worker, Dave (Lloyd Peters).
Dave starts talking about the importance of Stan's relationship
with Tina but soon drifts off at tangents, discussing Marxism along
the way, as Stan looks on, bewildered.*

* * *

AMY RAPHAEL: *This is another of your favourite films.*

MIKE LEIGH: It is indeed. I think it works very well. The juxtaposition of disparate elements, I guess, in the way that many of these
films are at some level subverting some other form. This takes the
kind of women's romantic stories June reads and subverts them.
Don't take this too seriously, but it is nevertheless true.

It's a very emotional film.

It is. And I think that's what's important about it, even in relation
to *Grown-Ups*. Although it has comic and heightened elements, it
is at heart a serious, emotional look at needs and love and comfort.
Parenting. The needs of children. Also it has the most amazing
score by Carl Davis – it is, literally, four double basses and nothing
else. Carl and I were struggling to find the right voice for the film,
and he suddenly said, 'I've just thought of something. I had a post-
card yesterday from a group calling themselves the London Dou-
ble Bass Ensemble. The lead bassists in the four London orchestras
have got together – maybe we should consider them.' They were
just fantastic.

With Grown-Ups *you had a tightly knit cast, whereas with* Home
Sweet Home *it's more disparate.*

Well, it's bigger and the story is more disparate, as I've said. It's
partly that, as ever, I wanted to do something that was very differ-

ent to *Grown-Ups*. At the same time, the two films have things in common, such as their dramatic, cinematic narrative economy. They are a pair if only because they were shot with the same producer and the same team, one after the other. The good news with both films is that I'd come on a long way from *Hard Labour*. Now I was really doing my own thing with comfort and, dare I say it, grace.

Home Sweet Home has panache, but it's also yet another Mike Leigh film offering a depressing view on relationships and the lack of communication in them. Harold constantly tells jokes and recites song lyrics instead of really talking, while June immerses herself in romantic novels. Both are avoiding reality. Is there anybody in the film who's living in the real world?

Well, there's the kid, Tina.

Is this the point at which you say all the men are weak and admit that the film is autobiographical?

Of course. Yes. Yes. Yes.

So were the marriages ever loving?

What do you think?

Possibly, briefly, in one form or another.

Yes, on the wedding day. Maybe.

Despite everything, I rather like Stan.

He's a straightforward guy. You've quite often pointed out that certain characters in my films have no self-awareness and therefore aren't aware of their behaviour. Well, Stan knows what he's like. He knows his weaknesses and his vulnerabilities. He knows when he's being dishonest. He even knows when he's being disingenuous, so in that sense he's not actually being disingenuous. But he can't help it and life is tough. He's getting on with it. He just wants to sit and listen to Ol' Blue Eyes really. Talking of which . . .

After the debacle with *Abigail's Party* – with the BBC insisting

that we use Demis Roussos and Tom Jones instead of José Feliciano and Elvis for copyright reasons – my assistant checked about Sinatra and was told we couldn't use him. But I decided I would anyway. I didn't care what anyone said. I thought they could even refuse to air the film if they wanted, I was just going to do it. Of course, nobody ever batted an eyelid. And the Beeb certainly never sold the film in the States.

It had to be Frank Sinatra. It couldn't be anyone else.

Well, exactly! What are you going to do? Not hear his music, just listen to Stan talking about him? He's a total fan.

For someone who seems to like nothing better than sitting alone listening to Sinatra, Stan is very good at finding sex.

One of the strongest parts of the film is Stan's scene with Janice; I think Sheila Kelley's acting is one of the best aspects of the film. She wasn't even going to be in the film at all to begin with, but often I wheel in additional actors. Eric Richard and I had invented the story that he didn't go and see Tina on this particular Sunday when he was supposed to because he'd picked up a woman in the laundrette. Obviously we weren't going to see this, but I thought it was essential dramatically, so I changed it. Sheila came down and we cobbled that character together in an hour or so – and it's actually one of the best bits of the film. It's terrifyingly moving, sad and real.

Did you wheel in anyone else in a similar fashion?

I also wanted to have somebody having their post delivered. Paul Jesson – as 'man in dressing gown' – came and did that. We just lifted his disgusting character, Irving, straight out of my play *Goose-Pimples*, which was running in the West End at the time. We had him receiving what was plainly something filthy through the post and bunging it in the back of his car before his wife could see it. Paul couldn't bear not to be in the film because he's from Hitchin and that's where we were shooting it. But he wasn't able to be in it properly because he was in the play.

Why did you choose Hitchin?

In the same random way I picked Canterbury for *Grown-Ups*. I was also drawn to it because as a small child I would often go and stay with my grandparents in Letchworth in Hertfordshire, and Grandpa used to take me to the cattle market at Hitchin. And finally I chose it because it was easily accessible from north London. Alison Steadman was pregnant again, so I couldn't be too far away. Leo Leigh was born during the rehearsals of *Home Sweet Home*. His birth didn't affect the film as Toby's arrival had done during *Who's Who* – which isn't to say I love Leo any the less!

As an aside, Leo was born in North Middlesex Hospital. Just before he was born, I was driving up to Hitchin early one Monday morning and I suddenly thought, 'I've had this car a long time and it could clap out at any moment.' It was the same clapped-out grey Ford Escort estate which appears in both *The Kiss of Death* and *Who's Who*. I always drove past a second-hand car dealer's, and on the forecourt that day was a gleaming, bright red-orange, second-hand version of the same car. So I bought it to make sure I wouldn't break down on the way to my son's birth.

This was the second time you worked with Remi Adefarasin; his cinematography gives Home Sweet Home *a cinematic element, even though it was shot for the small screen.*

I was very aware during the shoot that this wasn't a feature film. By now it was ten years since *Bleak Moments* and I was beside myself with frustration. I'd recently had a conversation with John Schlesinger, who'd said he loved what I did but, given the way I worked, it would be impossible for me ever to make a film for the cinema. I kept wondering whether we'd ever get back onto 35mm and the big screen. When Stan and Tina are at the back of the house in a wide shot, and she's talking about when she's a kid, I remember thinking, 'This is a film shot. We should really get to make a proper movie. But I never will . . . it's just not going to happen now.'

It's a lovely moment in the garden between the semi-estranged father and his teenage daughter. The discipline of the scene allows

them just to stand there, not saying or doing much, just being together.

Totally. It's all going on in the space between them.

Is Stan scared of loving Tina or incapable?

He does love her. I don't think it's about being incapable. It's more about not being able to accommodate her in his life. It's about the practicalities of his life and how he lives. It's about not being cut out to be a single parent. He's a loner who wants the freedom to pick up women. I think it's wrong to think he can't love her or is incapable of loving her.

They seem physically estranged more than anything.

That's because they've been apart. She doesn't know how to deal with him. She's sensitive enough to know that when he asks her questions or offers her money, he's doing it because he thinks he ought to, but she can't respond directly.

When June tells Harold about her affair with Stan, he seems genuinely puzzled; apparently Tim Barker had no idea what his screen wife was about to reveal to him.

Of course. That's the way it works in my films. Maybe the actor was even more puzzled, angry and shocked than the character. That's the joy of this method of developing material. If you sat down and wrote it, you'd be more economical with it in one sense and you'd probably get there quicker. But you'd never get such performances.

When Stan takes Tina round to Gordon and Hazel's house for Sunday lunch, it's hard, at times, to watch. Hazel is clumsy in her efforts to mother Tina. We wonder if Hazel and Gordon's relationship would improve or deteriorate if they were to have children; we wonder if, indeed, they will have children.

She obviously desperately wants kids. She's not like June or some of the other characters we've talked about. She's definitely going to have children in the normal course of events. If they're boys, she'll

bully them; if they're girls, they'll all gang up against Gordon.

Back at Stan's house, Stan talks briefly about his mother's coffin fitting down the narrow stairway. It provides a glimpse of his humanity, of his hidden pain.

But also in that moment he doesn't want to talk about intimate stuff. Of course, as before, I'm fascinated by the whole thing of houses and coffins.

I walk up and down Tin Pan Alley (Denmark Street, central London) all the time, and I quite often remember this guy called Morgan Jones who lived and worked – and, I suspect, was immured – in a small room on the top floor at the St Giles end of the street. He was a music copyist. At the time I was living in a pad in Tottenham Street with a lot of jazz musicians. I went with them to see him a few times on the way to a greasy spoon, this hugely, grossly overweight Welshman. Skin the colour of faded parchment. He sat there endlessly copying and chain-smoking, while people brought him pies and chips. He never went anywhere; he just sat around in this cesspit. When he died, so the story goes, they couldn't get him out and had to lower him through the window. Fascinating.

All the rituals and events around death?

Yes.

Did you set out to make a film about postmen or relationships?

I wanted to get round to doing postmen at some stage. I don't know any more than that. I couldn't tell you now how much of an idea I had in my head when I cast the film.

This is Timothy Spall's first appearance in a Mike Leigh film; where did you come across him?

In the usual way of agents suggesting actors. It was just a routine suggestion. I'd seen him in William Boyd's TV play *Good and Bad at Games*, which Roger Pratt shot.

Timothy Spall says he's been married to you for twenty-five years now – as long as to his wife.

It's long, yes, but some things seem longer. Like real marriages (*laughs*).

You often talk about enjoying your own films. Is that the case with all your films or just certain ones?

Well, there are one or two I'm not very disposed to watch. But yes, on the whole. It would seem that I'm unusual in enjoying watching my own films. If you can't enjoy your own films, then why the bloody hell should you expect anyone else to? But I'm lucky because I only put on the screen what I want to. I make films I'd like to see. And I like watching my work with audiences. I suppose there are people who are eclectic and who are hired to make all kinds of films. They can be forgiven for not enjoying watching a lot of their work. As I say, I'm just lucky.

Meantime
(Channel 4, 1983)

Barbara (Marion Bailey) lives with her husband John (Alfred Molina) in a spotlessly clean house on a new suburban estate. They have a shiny red car in the drive and a set of nesting tables in the living room. Barbara's sister Mavis (Pam Ferris) has brought her family round for a Sunday visit; John makes it clear he hasn't got much time for them. He refers to Mavis's son Colin (Tim Roth) as 'retarded', which Barbara rejects. Time passes slowly.

Mavis and Frank (Jeff Robert) live in a council flat in the East End of London with their two sons Mark (Phil Daniels) and Colin. The three men of the family are unemployed and spend a great deal of time at home irritating one another. Mark – smart, witty, switched on – passes the time wandering around the desolate estate, nipping in and out of betting shops and pubs. Occasionally he spends time with Coxy (Gary Oldman), an aggressive, hostile skinhead, ultimately prone to self-destruction.

Colin is slow, shy, withdrawn, a boy not quite able to become a man. His glasses are taped together, his trousers too short. His brother refers to him as 'Muppet' or 'Kermit', but Colin, apparently drifting through life, still tries to follow him everywhere. Hanging around with Mark in the local pub one afternoon, Colin plays a decent game of pool and exchanges words with Coxy. The skinhead takes Colin to see Hayley (Tilly Vosburgh) in her flat. He jeers and mocks Hayley and later locks Colin in a cupboard. Mark is concerned about Colin spending time with Coxy.

Barbara comes to Mavis's flat while the estate manager (Peter Wight) is looking at a broken window. She offers to pay Colin to decorate her house. Later, we see Colin slowly making his way to

the house. *Mark takes a short cut, arrives first and says that his brother is lost. Barbara and Mark drive around looking for him and on their return find him waiting by the front door. Inside, Mark asks, 'How come you never had no kids, Auntie Barbara?' After a pregnant pause, she says, 'In case they turned out like you.' Mark asks Colin to come home with him. Colin is angry; he thinks Mark wants his job. He leaves and goes straight to Hayley's flat, but she refuses to let him in.*

When John gets home from work he finds Barbara drunk and angry. Unspoken words – about their relationship, about having no children – hang in the air. Mark and Colin are back home. Colin sits on his bed, the furry hood of his parka pulled up. Mavis and Frank are angry with him for walking out on the job. Usually reticent and withdrawn, Colin yells at his dad, tells him to be quiet and to leave the room. Mark tells Colin that he loves him and that they should consider leaving home.

Colin sleeps with his parka on, the hood up. In the morning he shows Mark his shaven head. He insists the £1.20 haircut had nothing to do with Coxy. Mark asks if he regrets it. 'Dunno. Yes,' admits Colin. Mark calls his brother 'Kojak'. Colin grins. In the background we hear Mavis and Frank arguing.

* * *

AMY RAPHAEL: *I believe the genesis of* Meantime *occurred in the bath.*

MIKE LEIGH: While shooting *Home Sweet Home*, I had a flat in a desolate, strange, remote place over some shops in the middle of nowhere in the Bedfordshire countryside. I was lying in the bath, listening to a report about two kids in Warrington or Wigan who had committed suicide together because of unemployment. When I'm in the middle of a film, I invariably worry that what I'm doing is trivial and not about anything much. I heard this report and thought, quite literally, 'I'm wasting my time. That is what I should be making films about.'

What stuck with me was the spirit of that story, which lurks somewhere in *Meantime*. Actually, to be honest, apart from anything else I've always struggled, from *Bleak Moments* onwards –

with that film's deliberate refusal to hit a catharsis – to deal with the whole question of letting the audience off the hook. What happens in *Meantime* is more interesting than the story of two kids depressed enough by unemployment to top themselves. Moving and tragic though that would be, it doesn't engage in a debate; it's black and white. There's no scope for reflection or speculation about it.

It's important to talk about the political background at the time: by this point, Thatcher had been in power for four years. I imagine you felt completely disillusioned with 'Thatcher's Britain'.

I've fallen into the habit retrospectively – and quite legitimately – of saying that *Meantime*, *Four Days in July* and *High Hopes* are in some way a trilogy of Thatcher-motivated films. That is not untrue, but looking at it in detail and more precisely, as we are in this context, I'd say that that connection can only really be made with hindsight.

Whereas *High Hopes* is motivated by an angry and frustrated reaction to Thatcherism, *Meantime* is more specifically motivated by the huge rise in unemployment and the superficial, palliative, gestural schemes the government was introducing to deal with the problem, of which Barbara's scheme for Colin is a kind of parody.

Four Days in July is, of course, about the Thatcher government getting it wrong in Northern Ireland, just as everybody from Wilson onwards had. But it's about Northern Ireland and not Thatcher's government as such.

But I suppose, having said all that, what's significant is that *Meantime* was the first film to be motivated by identifiable, specific, politics-related issues.

And yet you're not a political film-maker.

Rubbish. Of course I'm a political film-maker. We're talking about *Meantime* (*laughs*)! I may not be the left-wing guerrilla I've been called (rather bizarrely), and I certainly don't make the sort of didactic films from which you walk away with a single conclusion. But I'm obviously concerned with stimulating the audience to care about life and how we live it.

The film about two guys committing suicide because of un-

employment would in crude and basic terms have been a more obvious political statement than *Meantime*, but that doesn't make *Meantime* apolitical. Just more complex, subtle. Some quarters on the far left severely criticised it for not tackling issues and, ultimately, not having anything to say. Once, at a Q&A at the Rio cinema in Dalston – in the age when extreme political factions were still kicking around – and another time at the Academy cinema in Sydney, I was heckled viciously by people from the far left who were absolutely furious with the film for being so wishy-washy and soppy.

They thought it was a cop-out?

Totally. I also got attacked by Karl Francis, the Welsh film-maker, at a public screening in Cardiff. One of the things that bugged people – and it certainly bugged him – was the profligate waste of the opportunity, when one has got hold of the tools of propaganda and communication. The fact is, however, that it is without question a political film. To stick with that discussion for a moment, which of my films is not a political film? *Topsy-Turvy? Nuts in May?* Both political films. There are factions and issues that are about society and power and economics; class and dignity; conformity.

Do you remember feeling at the time that the idea of Labour regaining power was a remote possibility? Did you feel depressed by the improbability of such a notion?

Well, Thatcher was into her second term by now. Actually, that's the other thing about the history of *Meantime*. It's very easy to look back at that period armed with an overview of Thatcher. At the time it was undeniably frustrating, and I do remember feeling that she seemed unstoppable. But the general feeling in 1983, when we made *Meantime*, was massively different to when we made *High Hopes* five years later, by which time she was obviously an epidemic . . .

I watched Meantime *again just the other day and it seems to have caught a moment in time; but, simultaneously, given the disenfranchised youth of today, their malaise and simmering anger, it could have been made last week.*

Having also watched it again recently, I'd say this: what you've just said is true, except that, if anything, the depressing fact is that for all the violence around the neighbourhood in *Meantime*, there's nevertheless an innocence about that world that is in stark contrast to today's state of affairs. For example, the government recently introduced a knife amnesty. The world is an infinitely more dangerous and screwed-up place than it was twenty-five years ago.

When it was first broadcast, did Meantime *immediately become an underground film?*

Well, no, not at first. It's complicated. *Meantime*'s status is very interesting. First of all, it was only the second or third Channel 4 film. David Rose, the new head of drama, had spent many years at the BBC. As we know, *The Permissive Society*, *Knock for Knock*, *Nuts in May* and *The Kiss of Death* were all under his aegis. Now the thing we'd all been asking for years was why couldn't we make these films on 35mm? Why couldn't they get a theatrical release and then be shown on TV? The BBC used to say it was a ridiculous notion – union agreements and so on.

In fact, as soon as Channel 4 started, Jeremy Isaacs – who, of course, had also come from the BBC – was on the case, as was David Rose, who worked with him from the beginning. They were there to do co-productions with independents, so companies popped up all over the place. I got together with Graham Benson, an independent producer. There was talk of doing a film on 35mm and having a theatrical release.

When we went to David, who was always very supportive, and asked to shoot what was to become *Meantime* on 35mm and make it as a feature, the simple answer was, 'We're not there yet.' Six or nine months later it would have been feasible. Had *Meantime* been made as a feature, it would have been exactly the same film, but its subsequent history would have undoubtedly been quite different.

So you had to continue using 16mm?

Yes, *Meantime* was shot on 16mm, shown on Channel 4 twice, and to all intents and purposes sank without trace. In its capacity as a film on the new Channel 4, it could in no way be classified as an underground film. But for the next few years – the years of its

total obscurity – I would regularly get letters from people who were permanently unemployed and who'd seen the film. It turned out that it was circulating on off-air video copies. So it gradually acquired underground status. Of course, there was no other way of seeing it, although it has now been released on DVD.

I would say – and this is a relatively new thought long after the event – that the fact of nobody particularly picking up on *Meantime* was as much to do with what was about to happen in British cinema. You'd had things like *The Long Good Friday* (1980), and you were about to get Neil Jordan films like *Mona Lisa* (1986), and so on – films which were glitzy and sexy. There was this new wave of a reborn British cinema, and *Meantime* was eclipsed.

This was the first of your films shot by Roger Pratt.

He'd been a student at the film school when I taught there in the 1970s. He was the focus puller on *Bleak Moments*. He'd served his apprenticeship as focus puller on a lot of Monty Python films by this time, and had shot one American movie too. He's a great cinematographer. His contribution to the film is huge.

Every film I'd made previously, apart from *Bleak Moments*, had been for the BBC. Which meant that they were made within BBC institutional parameters. Although there were very good people in the BBC, you didn't put together a hand-picked crew from the film industry. To some degree it was in the lap of the gods how good or efficient people would be.

Here, for the first time, we were making a feature film – which is why it's so frustrating that in the end it wasn't actually a theatrical release. As I keep saying, the only thing that distinguished it from feature-film status was the fact that it was shot on 16mm. Everything else about it suggested a proper film – including the fact that it was edited by the great Lesley Walker, who subsequently cut *All or Nothing* and is very distinguished and has only ever worked in feature films.

But, ultimately, the experience of doing *Meantime* was very different because it was really like a proper movie. Not to castigate the BBC, but it was made to higher specifications than my previous films. And Roger Pratt would hang around rehearsals and tune into what was going on. He had the time that his BBC predecessors

would never have had because they'd have been working on other jobs. Roger had his 8mm camera and he pottered around the area – up and down the canal, for example. He was inputting visual conception, which reflected in the film.

It must have been a liberating experience.

Yes. We didn't have all the time in the world to make the film; it was still very tight and low-budget, but we had complete control over everything. That made the real difference.

Was it easy to find the estate?

It was in Haggerston, round the back of where we were rehearsing – an empty rag-trade warehouse on the Kingsland Road. Anticipating the *All or Nothing* experience of a thousand years later, the estate had been condemned, so we were free to do as we chose, although there were still people living there. There are scenes, like when Mark comes out of the betting shop, where you see people wandering around for real. Diana Charnley, a very good designer who did *High Hopes* as well, created the labour exchange where the Pollocks go to sign on in the back of the Metropolitan hospital, which was just up the road and was empty.

Of course, it's now recognised that Meantime *was a breakthrough film for Gary Oldman, Tim Roth and even, to an extent, Phil Daniels, who'd already been in* Quadrophenia *and* Scum.

Roth had just been in Alan Clarke's *Made in Britain*. That's where I got him from; the late lamented Alan told me about this good guy he'd used.

A digression: across the road from my office, on the corner of Greek Street and Soho Square, there used to be a 1930s office block, where now stands a bank. Central TV had some offices in there. In 1983 Ken Loach, Alan Clarke and I were all in there preparing films: *Meantime*, *Made in Britain* and a series of documentaries about the trade unions [*Questions of Leadership*] that Ken was doing. The three of us would eat sandwiches together in Soho Square.

Years later, when we started researching *Topsy-Turvy*, we dis-

covered that Richard D'Oyly Carte had been born in Greek Street, in a house on that same site.

Do you have a rule that most of your actors shouldn't be too well-known when you first use them?

There's nothing inherently wrong with an actor being well-known; if you think about some of the actors I've worked with over the years, you'll find some were already established. However, less well-known actors are certainly cheaper. They are more available. There are also high-profile actors who can't or won't be able to deal with not knowing what the story is and going with it. In a way, that's less of an issue now than it used to be. As my profile has grown, so people have accepted my working methods.

Nobody in *Meantime* was that well known, but there were plenty of members of the cast who'd done quite a lot of things. Marion Bailey had already been in my play *Goose-Pimples* in the West End; Fred Molina was to become famous, but at that point he was a relative newcomer; Gary Oldman had never done a film, just theatre. They were all tuned into the world in question. Pam Ferris is a middle-class New Zealander whose work I knew from the theatre. She had to make quite a leap to get Mavis, as did Jeff Robert, who played the dad.

Without apology, I would particularly celebrate Marion Bailey's performance. I've worked with her a few times and she's extraordinarily bright and sharp and subtle. Her storyline is pretty unpredictable and unchartable. It's both elusive and real.

The other great discovery was Peter Wight as the dippy hippy man from the council who comes to see the broken window in the Pollocks' flat. He's fascinating as an actor. He's given three mindblowing performances in my films: as the estate manager in *Meantime*, as Brian in *Naked* and as the Detective Inspector in *Vera Drake*. Although the received wisdom and official ground rules for these works is that the actor plays a character, he manages to have this kind of personal spiritual dimension going on as well. He's very open – a profound and interesting guy.

And he takes his roles terribly seriously, does he not, carrying on the research long after his part is finished?

Yes! The message came on *Naked* that he wanted to continue the research. Could he claim expenses? I had to say no. He'd already finished his part!

When he turns up at the flat, it becomes a complicated scene, with all sorts of agendas going on.

Well, in the parallel-universe version of the film, which is about two kids committing suicide, you'd have got a bog-standard 'Play for Today' scenario. But here we have a scene where Barbara has come round to see her sister and to offer Colin work. The fact that both characters turn up simultaneously is obviously a narrative decision on my part. It was important to see Barbara and Peter Wight's character talking in the Pollock flat. The fact that they're talking about economics . . . well, you could hardly call it an apolitical scene (*laughs*), though some people would simply see it as trivial – maybe the same people who see anything that has a joke in it as ceasing to be effective propaganda.

The very same people who accuse you of caricature?

Absolutely.

Some people think you're too defensive of your work, that you're unable to accept criticism.

It just isn't true. Honest. But anybody could be forgiven for being irritated by the kind of reactions we've just referred to.

OK. In the opening scene we initially don't know who anyone is, nor how they are related to one another. Is that to make the viewers work from the first moments of the film?

It's a given that the viewer of any film needs something to motivate them to pay attention. The joy of screening *Vera Drake* very early on, when no one knew what it was about, was fantastic. Sadly, most people subsequently went to see it knowing it was about an abortionist. When you don't know and suddenly find out, it's deeply shocking.

I love the whole thing of setting up what are sometimes deliberate diversionary devices. For example, when *High Hopes* starts

you see a street with thousands of people and traffic – and then there's a shot that isolates this one guy, and you would be forgiven at this point for thinking the film was about him. But it turns out he's an incidental character.

In *Meantime*, the idea is that it's an urban film about unemployment, but the first thing you see is a lyrical, rural, idyllic place. It's just that juxtaposition that I find interesting. It's good to set up an expectation from which the audience can then be moved on.

Although Alfred Molina's John is quite cruel and the brothers are drifting through life, it is really only Coxy who is a lost cause.

I think you're right; not a lot happens that makes him particularly redeemable. He's a fairly terminally screwed-up case; the last time we see him he's completely lost it and is going berserk in a barrel.

What separates Mark and Coxy in terms of racism?

Mark's not racist. Why is he racist? When he's in the pub and he calls the guy a 'black bastard', he's just being ironic. Whereas Coxy is really a life-hating kind of guy. The point about Mark, obviously, is that he's a proper person and a good egg. He's bright. My feeling, which is clear enough, is that we should walk away from

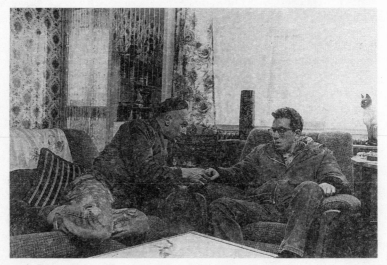

12 *Meantime*: Coxy (Gary Oldman) and Colin (Tim Roth).

164

the film knowing Mark will move on and be all right and look out for his family. The scene where he's winding up the other boy . . . he's not even winding him up, he's just gagging when he calls him a 'black bastard'. If he was being racist, he wouldn't say, 'Do you want a drink, you black bastard?'

How do you see Colin?

He's not too bright, really. I think that's his main problem in life.

At the end of the film you see that perhaps Mark can be some kind of positive role model for Colin. They'll be OK because they'll look after one another. It's the redeeming moment in the film . . .

Definitely. It's incredibly important. And when he says, 'I love you,' it's a great moment. In that scene, which is a two-shot, I just kept the camera rolling at the end, and quite spontaneously Mark pulled out a couple of fags. Somehow it's so meaningful and moving.

Mark is going to move on, move out and get on with it. It's not insignificant that you see him walk across Trafalgar Square, which is why we went to the trouble of shooting there. It's a really important moment because you place him in a familiar worldly environment, away from that stifling flat.

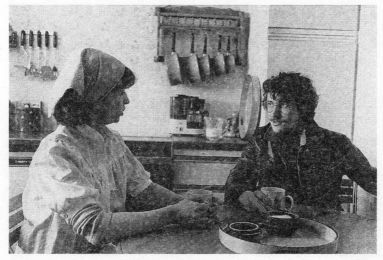

13 *Meantime*: Barbara (Marion Bailey) and Mark (Phil Daniels).

Why do you think Mark follows Colin to Barbara's house?

I prefer to leave this one to the audience, but if I'm forced to answer: he's on her case and he wants to protect Colin from what he basically sees as bullshit.

When Colin and Mark have both left, we see Barbara turn to the bottle and break down in the spare room. She's trapped in her situation, in that house, with her husband out at work and with no children.

Yes, and it's hard to believe it will change, other than internally. You can decode their relationship from the beginning of the film, when they are going upstairs and her husband says something bossy to her, something defensive.

It's important to see Barbara break down, even though little is resolved. It's a contrast to Mark and Colin making progress in their cramped bedroom.

I remember being very aware of – satisfied or pleased about, I suppose – the distilled, clear narrative development of *Meantime*. What I am also pleased with is that it finally tells a story in a very implicit and elliptical way but with a very clear narrative. The elliptical bit is obviously what happens at Barbara's, but finally it all becomes clear, and the end is very satisfactory and graphic. You know where you are with it.

It's as important as it is at the end of *Naked*, where the ending is open to all sorts of discussion. At the end of *Meantime* you know what you're feeling and what's happened and that something is moving forward between these guys. They are, apart from anything else, dealing with inadequate parenting – for which the parents themselves are not to blame because society itself has given them a lot of raw deals.

Part of the film's enduring strength lies also in the costumes: Colin's slightly too short trousers, the glasses and parka have all become an iconic part of the film.

It was the first time I worked on film with Lindy Hemming, who would ultimately get an Oscar for her costumes in *Topsy-Turvy*. I

think it was her second film; she had previously done *Laughter-house*, directed by Richard Eyre. She came out of the theatre, and had done the costumes for *Abigail's Party* and *Ecstasy* at Hampstead. So we pulled her in. She's an amazing costume designer because she's got a strong sense of the real world. In fact, I went and sat in skinhead pubs with her when we were getting it together, right round the corner from where she still lives in Islington.

Although other people have done costume design on my films – now I work with her old assistant Jacqueline Durran – Lindy has done the vast majority and she's one of the great geniuses at tuning into what we're doing and getting a sense of the whole character.

It was also the first time you worked with Andrew Dickson, who composed the music.

Yes, and what a good experience it was. I'd been to see a production by my friend Sarah Pia Anderson of *The Caucasian Chalk Circle* at Sheffield, with Sheila Kelley as Grusha, and it had this extraordinary balalaika music played by the guys on stage. He's not a conventional composer, Andrew; he's a theatre person who's been a performer. He was very much involved with *The People Show*. Anyway, I tracked him down to Bridport in Dorset – he hides out there, so you have to keep trekking down there to work with him.

Some people loathe the score for *Meantime*, but I adore it. Whereas in *Home Sweet Home* we had Carl Davis and the London Double Bass Ensemble doing this classical-based style, here was a score that evolved from Andrew playing around on his clapped-out old piano in his rented cottage in Dorset. He suggested a tack piano, where you stick drawing pins in the hammers to create a tinny sound. Ultimately a proper grown-up piano in a studio was prepared in this way and he played it. But it came out of this raw, improvised, emotional, un-classical sound, with one tenor sax thrown in. It's great.

When I hear the theme tune, it evokes all kinds of stuff that was happening in my life at that moment; it goes beyond just the film. I'd say that music is more personally evocative to me than any music in any of my other films. It's so . . . unique.

A final question: how did Tim Roth almost blind Gary Oldman?

We were rehearsing in this very big industrial warehouse that had dozens of strip lights. Tim and Gary were in character, doing an improvisation to develop the relationship between Colin and Coxy. So they were both fully in costume and Gary's head was shaved for real. He had the full monty on, boots and everything. They were chucking this milk bottle about and suddenly Tim, in character, chucked it upwards rather clumsily and it hit one of the fluorescents. I remember seeing red splodges spouting all over Gary's head. We rushed out, and I drove him to the local hospital in my car.

As we ran in, he screamed, 'For fuck's sake, tell them I'm an actor so I don't get a rough ride!' They removed glass from all over his head. In any close-up of him now or if you meet him you can still see a scar between his eyes. It was terrifying, because he could have lost one or both eyes. The thought that he could have been blinded at that point was shocking and terrifying, and somewhat destabilising. But he was OK in a day or two.

These things happen. It was one of those moments where you go to the wire with making characters really real. But it can be dangerous.

Four Days in July
(BBC, 1984)

The action takes place in Belfast from 10–13 July, in the build-up to the Loyalist marches on 12 July, when the Orangemen celebrate the victory of the Protestant William of Orange over his father-in-law, the Catholic King James II, at the Battle of the Boyne in 1690. While the British Army patrols the streets of Belfast, two couples prepare to have their first child. Collette (Bríd Brennan) and Eugene (Des McAleer) are Catholics from west Belfast, while in the east Lorraine (Paula Hamilton) and Billy (Charles Lawson) are Protestants.

Eugene has been injured and spends his time with his wife at home; Billy, a soldier in the Ulster Defence Regiment, enjoys a few cans with the boys. On 11 July, as the celebrations and bonfires are being prepared, Brendan (Shane Connaughton) fixes Collette and Eugene's toilet, while Dixie (Stephen Rea), who has been cleaning the windows, stops for a beer. Brendan and Dixie are Republican ex-prisoners. They tell jokes and describe their time in the Maze prison. They briefly mention the marches that will take place the following day. Eugene talks about being accidentally injured on three different occasions by the British army. Lorraine, heavily pregnant, accompanies Billy to the bonfires, where the atmosphere is drunken and aggressive.

The next morning, both women go into labour. Billy hears about Lorraine while he is on military duty at the parade. He and Eugene sit in the waiting room with a third expectant father, Mr Roper (John Hewitt). Eugene, a kind, warm man who has put on a jacket and smart trousers for the occasion, tries to make conversation with the gruff, taciturn Billy. Collette and Lorraine lie in adjacent

beds with their new babies. They attempt to make small talk but an invisible sectarian wall sits between the two beds – and between the two newborn babies.

* * *

AMY RAPHAEL: *This was to be your last film for the BBC and your first to be shot outside England. Why did you decide to make a film about the Troubles?*

MIKE LEIGH: Before I answer the question directly, I'd like to discuss certain aspects of my background that are significant. First of all, I grew up in Salford, which is a Catholic city. When I was a kid, we lived across the road, literally, from a big Catholic church, St Thomas of Canterbury. On Easter and Whit Mondays they had the old Easter and Whit walks with banners and effigies of the Virgin Mary. On those days I'd wake up to hundreds of people assembling in the street, with drums beating right outside the house. So I grew up aware of the Catholic world – although there were virtually no Catholics at my school because, of course, they all went to Catholic school.

I was also aware of Protestants: in one of my classes at Salford Grammar School the register began with Aaronson and ended with Zuckerbrod (10 per cent of us were Jews), and in the middle came Ledsham, Leigh, Malpass and then a clutch of McCabes, McCanns and McQuaids. They were from very Proddy families. So one was very aware of it. The lady that I've talked about as being the source character for *Hard Labour* was, of course, very Irish.

And you also taught at some Catholic colleges in the late 1960s.

In 1968–9 I was a drama lecturer at two Catholic teacher-training colleges in Manchester. Sedgley Park College, the women's college, was Faithful Companions of Jesus and the men's college was De La Salle. Drama was very oversubscribed because it was the only joint course between these colleges. They wanted to get on the course to meet students of the opposite sex. There were a lot of students from Northern Ireland.

So ideas were lurking about . . . but I'd never been to Ireland.

The more tangible beginning of the history of *Four Days in July* came about when we were doing my play *Ecstasy*. Stephen Rea simply said one day, 'You should make a film in Belfast.' It was something I'd thought about from time to time, with all the Troubles going on. Then I went to a swanky dinner at the Café Royal to celebrate another early Channel 4 drama – a Jack Rosenthal piece called *P'Tang Yang Kipperbang*, which Alison Steadman was in – and I found myself sitting next to Kenith Trodd, the eccentric BBC producer.

Here's a digression. Often, when people ask me what my next film is about, I say, 'It starts off with a shot of a dog walking across the road and it pans round and you see all this meat in an abattoir.' Some years prior to the dinner, Ken Trodd had asked me to go into the BBC for a chat. I was, as usual, vague about what I wanted to do for my next film. He was very persistent, saying that I must have some idea. Eventually I said, 'Well, I've always thought it would be interesting to make a film about an abattoir.' At that moment the actor and screenwriter Colin Welland – a famously less than sensitive person – walked in and sat down. He was very cheeky. 'I asked who was here, and she said it was only you, so I thought I'd join you. But take no notice of me – I'll sit here quietly and just listen.' It was truly remarkable that Trodd didn't chuck him out, but he didn't. He said, 'So, you were talking about an abattoir.' At which point Welland interjected, shouting, 'Great! Great! I can just see it now. A shot of a dog walking across the road and it pans to all this meat!' I just got up and walked out.

So that was the history of my relationship with Mr Trodd up till that time. Then we were sitting at this dinner and I told him I really wanted to make a film about Northern Ireland. I said what I'd really like would be to have six months on a contract, just researching, before casting, because I didn't know anything about Ireland except what I'd learned in school (Gladstone put down his axe and said, 'My mission is to pacify Ireland'). Ken took the idea to his BBC masters the next day, and they agreed.

Did they put any restrictions on the project?

At no stage in the proceedings did anyone interfere with the film, its form or its content, its politics or its polemics. When it was

broadcast, there were questions asked in the House of Commons about it. In the end it was only ever shown once. Apart from an argument about its length, which I won – it went out at ninety-six minutes as opposed to ninety minutes – there was never any interference. I had the full BBC facilities: I could hire cars, drop into offices in Belfast, run up bills at the Forum hotel.

What were the basic preparations?

I read a lot of books. I boned up on everything. I watched a lot of footage. Incidentally, I watched every single television film that had been made about Northern Ireland, not least the drama ones, just to define what the territory was.

I assume you particularly enjoy that stage of the job, given that it's almost like an academic project?

Oh yes, I love doing research. And, of course, then I travelled all over Ireland, north and south, just talking to people. And getting into the occasional tight corner, the details of which will remain a secret!

Did you always come clean about the fact that you were making a film?

Generally speaking I'd tell people. If I was taken to see people by other people then I'd explain very little. Stephen Rea had by this time started the Field Day Company and was touring *Boesman and Lena* by Athol Fugard. So from time to time I'd go and catch up with him and his gang. It was a good excuse to have a drink with him. Unfortunately, the entire experience of researching this particular film was, inevitably, in view of the culture of Northern Ireland and the Republic, the most alcoholic experience I've ever had. I'd have all these pints of Guinness with whiskey chasers and have to get out of bed at 9 a.m. the next morning to do more research. A lot of brain cells were destroyed that year, but it was very interesting.

Did things get seriously difficult at any point?

I'll go this far: I was taken to see a man in a house several hundred

metres from the Fermanagh border with the Republic. An Orangeman with a long beard whose house was festooned with Loyalist paraphernalia and insignia. Whose back shed was a workshop in which he painted the union flag on all types of artefacts and little effigies of Churchill. A man to whom I said, 'What do you feel about the Republic?' It was walking distance from his house but he replied, 'What Republic?'

I then went to an extraordinary stock-car track in the middle of nowhere where this race was going on – I have a sneaking regard for stock-car racing as I like old cars – and everything that was going on around the track was totally sectarian. At a certain moment I thought, 'This is the film.' But obviously it wasn't.

Throughout the project there were lots of useful liaisons with Republicans. But at some later stage the production manager said we had to go and see the head of the extreme Loyalist UDA, which was fairly frightening, as in big guys and being in a room famous for being where people were kneecapped – that type of thing.

Did the BBC provide any useful contacts?

One day this BBC guy said, 'OK, I'll take you on a trip. I'm going to visit an artist in Donegal. Just string along and see what happens.' So we drove across Northern Ireland, through Derry and into Donegal – which is very beautiful – and went to visit this guy. The housekeeper in this old, slightly bohemian house said, 'I'll bake some scones.' I went for a walk while the BBC man did some recording. I returned to discover this fantastic smell. In the kitchen was an enormous bookshelf that was full of the works of Elizabeth David, and it turned out she'd often stayed in this house. The scones were the best I'd ever tasted.

Then we went to visit Paddy Tunney, who wrote a book about Irish folk song called *The Stone Fiddle*. We were in his house till 1 a.m., listening to him singing and drinking a great deal – of tea.

The next day we were having breakfast in the hotel when the news came that a bomb had gone off at Strabane, which was famous at the time for having the highest unemployment in Europe. I asked if we could go and have a look on the way back to Belfast. There were these little houses, one of which had been completely gutted. Suddenly it became clear that it had been a pub.

There was a group of old men and women standing around, so I asked them if it had indeed been a pub. One old lady replied, 'Aye, 'tis a pub with no ale.'

Eventually, to cut a short story long, I started casting. I auditioned in London, Belfast and Dublin. I always knew Stephen Rea would be in the film, but he was working on another project, which is why he has a relatively small part. Des McAleer was Stephen's co-actor in the Field Day Company. That great actress Bríd Brennan had been in a series of 'Plays for Today' called *The Billy Trilogies*, directed by Paul Seed and starring Kenneth Branagh. I saw actors in all three places but ultimately cast them all from London and Belfast.

How was it working with both Catholic and Protestant actors?

Fine, although we rehearsed in a couple of halls that were part of a convent, which a couple of the Protestant actors weren't too pleased about. It's the only time I've worked with actors some of whom I'd be identifiably at loggerheads with politically; the guys who played those soldiers were not a zillion miles away from being in sympathy with their characters. They were nice guys but there was some bad behaviour . . .

Did you go to many Catholic and Protestant church services?

I stayed back in Belfast one weekend so I could do a bit of church-going! I went to the Clonard Monastery, which is the big Catholic cathedral in the Lower Falls. It was around St Patrick's Day. It was very informal: you could smell alcohol in the air, it was packed and people were standing. Kids were on the altar with guitars. There was a lovely atmosphere.

I then jumped in my car, sped across the bridge and went to Ian Paisley's church, which was a very different experience. First of all it was this modern, soulless, crisp place. Families were scrubbed up and suited; girls were compressed into these constraining frocks. A guy jumped on me asking me to sign a visitor's book, which I did, in scrawling handwriting – I just wrote 'London'. I was quite nervous. Paisley is the whole show; he conducts the whole service. At some point he was welcoming people and said, 'And we have a visitor from London!' Terrifying.

174

Anyway, during the year that I spent doing the research, the cast, the rehearsals and the shoot, I never actually found myself in the presence of an actual incident. It was a quiet year in Northern Ireland.

So obviously there was an underlying feeling of the potential for trouble, unrest, violence?

Oh God, yes. On one occasion, just before we started shooting, Bríd Brennan, Des McAleer and I were driving to the Lower Falls to see this little house, which was to be their characters' home. We were stopped, as one frequently was, by a patrol of very, very young, nervous Scottish squaddies. They were only eighteen. This kid asked where we were going. I told him we were with the BBC, making a film. He immediately asked if there was a rape in it. I said there wasn't. It just shows you the mindset of a kid who's in the British army, with all sorts of porn in his locker and around his bed. The rape would be stimulating for him. As we drove away, Bríd, who is an extremely droll lady, said she had to work very hard not to say, 'Only the rape of Ireland!' Which would have got us into very deep water.

You must have felt very self-conscious being English.

Well, before going to Belfast for the first time in 1983, I read a lot and I was very apprehensive. But when I arrived in the early autumn I remember thinking, 'This is all right. It's just Manchester and Salford in the 1950s. Terraced housing and the smoke coming out of chimneys.' Gradually I started to realise there's a whole lot of stuff going on under the surface. There are always questions. So, yes, of course, the fact that I was English was there for all to see. People wanted to know if I was Protestant or Catholic, and, of course, I could say Jewish and it was fine. It actually solved a lot of problems.

I reached a point where I was thoroughly fucking sick of the place and I wanted to get out, but finally I broke through and got to the end of the shoot. In the end it was delightful and people on both sides were very helpful. But at the same time it was kind of crazy.

Did any of the improvisations get the actors into trouble?

Funny things certainly happened in the rehearsals. We decided that there'd be an improvisation where Des McAleer's Eugene and Shane Connaughton's Brendan would take a cab and go to a bar or two in the Republican area of west Belfast. We'd kept a massively low profile and there was huge security, as there always is on my films anyway, and huge secrecy about what we were doing and why we were doing it. Here it was even more rigorous and cautious. So they're in the bar and the barman comes over straight away and says, 'How's the fillum?' Everyone knows what's going on! People are snooping and spying and know your business.

How did you deal with the issue of firearms?

A very good guy called Mervyn Dougherty was production manager and he had to deal with it. There's a scene where the UDR guy [Charles Lawson] comes back from work, takes his gun off, dismantles it and puts it in a biscuit tin. He obviously had to have a real gun. So we had some sent over from Bapty, the theatrical props people. When they arrived, they were made out of balsa wood, painted black, and useless for the scene we're talking about.

It turned out you couldn't have a gun in a film on the territory of Northern Ireland, which is why some films supposedly set there were actually shot in other cities, such as Leeds. We were already filming and we needed to get special permission. Mervyn went off to the Royal Ulster Constabulary to sort this out. He was promptly banged up for an hour in a cell – while we were shooting! That's how crazy it was!

The other thing is that you were, under no circumstances, to point the camera at troops or helicopters. Or installations. So when Bríd Brennan's Collette draws the curtains and you see squaddies walking past, they are extras.

But you also managed to shoot a real patrol of squaddies too.

We were filming one day, and suddenly Mervyn rushed in and shouted, 'Stop shooting! Take the camera outside! Line up a shot, there's a patrol of squaddies coming past in a few moments and you're allowed to film them this once. Just don't ask any ques-

tions!' We rush out there, these guys come past and we get a shot of them. Suddenly they jump over the wall, run back and come past again – for us to do another take. Then they do it a third time and leave. All without saying a word.

How did you tackle shooting the actual Orange parade on 12 July?

It was very difficult. The RUC would only allow us to shoot on one street corner. Everything is shot from there. Given that, it's not too bad, but we didn't leap about much. It so happened that the schedule included the marching season. It was Friday 13 July for real in 1984 – we didn't make that up. The fact that filming fell around the middle of July became central to the film.

For all the film's narrative discipline, the 11 and 12 July scenes are, of course, shot ad lib. On the twelfth, with the parade going past, we constructed the tiny bit of action during which the news that Lorraine's gone into labour comes through. Otherwise it's shot on the hoof in a documentary way.

The more complicated shoot was the previous night, which was shot for real in Sandy Row in the middle of Belfast, in this very Proddy enclave where they build these enormous bonfires. I think what we extracted from it in the cutting room is respectable, but it was quite a hazardous thing to shoot, not least because we had a black cinematographer in what was a very aggressive atmosphere. When we looked at the footage there was a lot of abusive, racist stuff ranted into the camera lens at Remi Adefarasin.

Did the march and the bonfire scenes feel quite threatening?

No, because by the time we'd got to them I'd been around. They are only threatening in the sense that this desperate, barbaric, otherworldly fascism is implicit. But it was never actually threatening in any manifest way. We'd all been at it for weeks by then and we were steaming round everywhere. In any case, we were accompanied by our own heavyweight bodyguards.

I think the film's quite a remarkable achievement, on a lot of people's parts.

What was the reaction to the film in Northern Ireland and England?

Stephen Rea is really the best person on this. He says that it was extremely popular in Belfast. People on both sides felt it had captured something . . . There had been a great clutch of stuff previously but it was always simplistic or romantic in some way. Generally speaking it was treated with serious respect, but I'd have to say that, like a lot of these television things, it was no big deal, it didn't cause massive waves.

How was it brought up in the House of Commons?

Probably foolishly, I did an interview in the *Radio Times* in which I acknowledged a Republican bias. Without having seen it, a couple of Tories asked questions about whether it should be going out on the BBC. It was a storm in a tea cup.

Let's talk about the conceit of the film: at what point did you decide to use the juxtaposition of two families and two pregnant wives?

It became clear to me that my job was somehow to express the spirit of the two sides. As I experienced it – and obviously I've missed out many experiences of many things – the spirit of republicanism would seem to me to be positive, life-loving, passionate and creative, while the spirit of the Loyalists was a stark contrast. Loyalism, as has been proven, is an ideology in retreat. So it seemed a natural device.

Eugene and Collette are easier to warm to, partly because they seem to be getting on with life.

They are thinking very much about the future and about politics. But what they are not doing, of course, is sitting around being mouthpieces and talking about all kinds of implausible things. It's there; there's no way they're not thinking about the politics. They are, as you say, getting on with life. Collette is more concerned with finding a pram and getting some decent sleep. She's going to have to deal with two kids because Eugene is a handful in his handicapped condition. She's got a lot to cope with.

At least they have a relationship; with Lorraine and Billy it's very

hard to tell how much love is involved because he's such a cold,
hard-drinking guy.

When the three guys are in his house drinking and telling the story
about being out on a manoeuvre and slaughtering and barbecuing
a cow, that is a real story thrown up by research. Over and above
their identity as Ulstermen and squaddies, in their official capacity
as characters in a Mike Leigh film they are receptacles of received
behaviour.

Did you try at any point to make it less obvious which couple you
felt more compassionate towards?

No. I think Billy is a pretty unsympathetic sort of character, with a
quite nice wife who's rather put upon. Both Billy and Eugene are
frightened, in different ways, of their impending brats. That cen-
tral dynamic of the story – fundamental and important though it is
– is the most straightforward to decode. Finally, at the end of the
film, when the two babies are born, it's pretty clear what's going
on.

To me, the more elliptical elements are the way the film is book-
ended by these two manic Loyalist nutcases: the eccentric (played
by John Keegan) at the beginning, with his van and his completely
convoluted and confused view of Protestant and Irish history, and
then later John Hewitt's glorious Mr Roper, a life-hating impend-
ing father, balefully waiting for his child to be born at the end of
the film. I rather relish him. He's a great comic character bringing
up the rear. He's a distant ancestor of Sandra, who shows up at the
end of *Naked*. Though plainly a different spirit, he has a similar
kind of function.

The other huge gag in the film is Mickey, Collette's cousin, who's
played by David Coyle. I thought it would be great fun to have a
character who talked in that totally and utterly impenetrable
dialect.

It lends the film an air of authenticity; it's bloody hard to decipher
the Belfast accent sometimes, especially when alcohol thickens it.

You do sometimes think, 'What are they talking about?' It's
another place – a foreign country.

You just mentioned Mr Roper waiting for his child to be born: maybe Eugene's kid will be OK, but as for the other two . . .

Of course, we know that something has gone terribly wrong with baby Roper. But in the context of the ideology and philosophy of the film, as viewed from the point of view of 1984, Collette's and Lorraine's babies are being born innocently into a world that will have them in no time perpetuating the sectarian divide.

In that sense it's a depressing, negative ending. Even given the recent changes in Northern Ireland, you wonder how baby Billy would escape his Loyalist background.

Absolutely. That is what the film is saying. So on one level it is a reflection on the spirits of the two sides and an evocation of those worlds; on another, it simply laments the way things are.

Yet there's a glimpse of what might have been: when you see the two new mothers cradling their babies in their adjacent beds, you truly believe the wall is down and they'll bond over the simple fact of having babies at the same time. Within seconds, however, the wall has sprung up again.

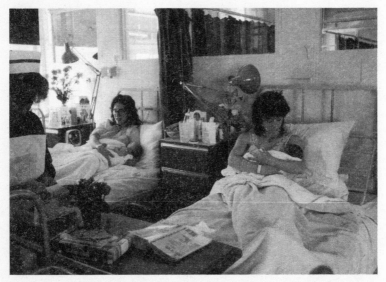

14 *Four Days in July*: Collette (Bríd Brennan) and Lorraine (Paula Hamilton).

Completely. And don't forget it goes up from the right-hand side, from Lorraine's side; Collette is far more willing to be friendly.

Does Lorraine instinctively behave so coldly or is she scared of her husband's reaction?

She is indoctrinated. It's not about her husband at all.

While Billy is a menacing character, Eugene appears to be easy-going. His condition, though tragic, is also funny.

I decided he should be a guy who's been injured through being in the wrong place at the wrong time on three occasions. The scene where he describes with great piety and self-pity what happened to him at great length – and you know many people have heard it many times – cannot help but be funny for all its sadness.

What did Shane Connaughton bring to the film?

Shane is a brilliant actor, and of course he's also the man who's written some extraordinary prose, not to mention the screenplay for *My Left Foot*. He's a very bright and original guy. He brings a perceptive and dry view of the world – a wonderfully lugubrious character. There are certain moments that are a delight, like when Eugene reports meeting a 106-year-old nun who survives on bread and jam – 'It shows how little you need to get by.' This came out of research – Shane visited a local convent with a Republican plumber.

Although Stephen Rea wasn't available for a long stint of rehearsing and filming, he still succeeds in making Dixie a memorably three-dimensional character.

The research threw up the fact that these guys spent a lot of time sitting around with a continuous quiz on the go. And so you get these two jokers in Eugene's house winding each other up. I love all that stuff, I have to say.

Are you happy with the film when you watch it now? With hindsight is there anything you'd change?

The only thing I can't stand – which is stupid on my part and a serious piece of ill-conceived crap – is the preposterous gag of having three guys called Billy. It doesn't make any sense. It's not dealt with, it only exists in the credits and it's a bollocks. I am embarrassed by it. I only did it because there are so many Billys in Northern Ireland. Beyond that, no. Frankly, I think the achievement of making the bloody film was colossal.

It's interesting that it was my last BBC film. In a way I'm very pleased with that; it was followed by a gap, after which I moved into a different gear. It has a kind of coming-of-age maturity about it, so it feels very right coming at the end of the cycle of films that began with *Hard Labour*.

This is a film I like talking about, so perhaps we should stop.

OK. One last question: what was the inspiration for Rachel Portman's music?

There's a kind of Irishness about the score, but of course it's not really Irish at all. There was talk of getting Irish music and Irish composers, but it's more sophisticated than that. I'd been to hear for the first time Carl Davis's live score for the restored edition of Abel Gance's *Napoléon*. At a certain point in the proceedings there's a sequence where you hear a hurdy-gurdy, so I suggested this notion to Rachel Portman. Carl Davis put us onto an interesting but eccentric lady and her husband who played the organistrum, which is a kind of hurdy-gurdy. It's an extraordinary sound; it gives the score a remarkable quality. It has the sense of being Irish or Celtic, without really being either.

The Short and Curlies
(Channel 4, 1987)

Betty (Alison Steadman) is a chatty, gossipy hairdresser who strug-
gles to communicate with her reticent and difficult daughter Char-
lene (Wendy Nottingham). One of Betty's customers, Joy (Sylvestra
Le Touzel), works in a chemist's shop, where she is chatted up by
Clive (David Thewlis). He peers at her over the counter and tells
bad jokes.

Betty is excited by the news that Clive and Joy are to marry,
while almost overlooking her daughter's pregnancy. As Charlene
mopes around at home, Betty provides a never-ending list of her
own ailments.

* * *

AMY RAPHAEL: *You had a kind of enforced break after making*
Four Days in July.

MIKE LEIGH: The only real gap in my output in the years from
1965 to the present is in this period we've now hit. A feature film
was set up to be shot in the summer of 1986 but it went down
because I had a kind of crack-up. For a variety of personal reasons
I wasn't on form and I couldn't get it together.

When the film was abandoned I was told unequivocally that if I
was ever going to get medical insurance for a film again, I'd have
to get some therapy, which I did. And I stayed at home looking
after the boys, which was great.

How did you get back on track?

David Rose at Channel 4, who had been involved in the film that never happened, called me in. He was planning a series of eleven-minute cinema films and asked if I'd like to do one. He thought making a short would prove I was OK and I could then go on to make a feature film. So we did *The Short and Curlies* for that reason. In fact, it's eighteen minutes because I persuaded them to keep it that length. My objective was to make a short film that had all the elements of a full-length feature, like the 'Five-Minute Films'.

And you shot it on 35mm.

When we went out to shoot the film, again with Roger Pratt as cinematographer and Diana Charnley in charge of design, it was the first time I'd been out with a 35mm camera since *Bleak Moments*. So it was made as a cinema short. There was a great sense of new hope that shorts could now be shown in the cinema. That didn't really happen in the end, but *The Short and Curlies* did get some kind of release theatrically. In fact, David Rose eventually phoned me up and asked if the whole season could be called 'Short and Curlies'. I said no, that's ridiculous. But he called it that anyway!

This was the first time in three years you were back behind a camera. How much did you miss working?

Of course I missed it, but I'd been doing various other things in that period: I went to Australia, taught and travelled, went around south-east Asia and China. And my father died after a long illness, when I was in Sydney, which was traumatic. But yeah, absolutely, I missed it. I didn't do anything creative at all throughout the whole of 1985, then in 1986 I embarked on doing the film that didn't materialise. *The Short and Curlies* was made in 1987, so it was less than three years, but it was still a long time. And what I'd been through at that point was about far more than not standing next to a camera: it was a negative black hole. I actually went through a phase of thinking I'd dried up completely and would never do anything else. At the age of forty-three, I'd entered, dare I say it, into the condition of middle-aged crisis. It's as simple as that.

So shooting *The Short and Curlies* was liberating and fun. It was creative. It went very well and was advantaged by being very quick

– around three weeks of rehearsal and a week shooting – and containable.

Did your confidence return quickly?

Absolutely. You can see from the film. It's liberated and inventive, both visually and dramatically.

This was the first time you'd worked with David Thewlis.

Well, Thewlis and Wendy Nottingham were fugitives from the film that was cancelled. It's the only time I've worked with Sylvestra Le Touzel, but she is going to be in 'Untitled '06'. She's terribly good. And as for Alison Steadman, what can I say?

Where did you find David Thewlis?

In the ordinary run of auditions. This is also the first appearance of the remarkable Wendy Nottingham, with whom I've now worked

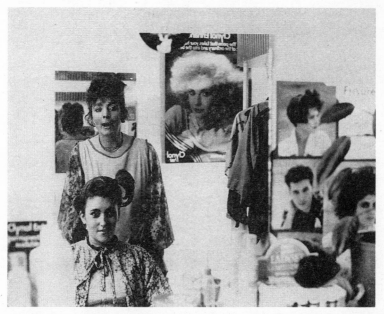

15 *The Short and Curlies*: Betty (Alison Steadman) and Joy (Sylvestra Le Touzel).

a number of times; each time she does something completely different. The most extraordinary thing she did was in my play *It's a Great Big Shame!* Then, of course, she played Helen Lenoir in *Topsy-Turvy* and was remarkable again. She's very smart, very versatile.

Naked came six years later, but even at this stage did you feel there was something special about Thewlis?

He seemed like a good, interesting, intelligent northern actor. He'd had a very small part with Alison in a railway-carriage scene playing a soldier in *The Singing Detective*. If you're asking could I tell what a genius he was at that early stage, then I'd have to say not especially. But once he got into *The Short and Curlies*, it became obvious that he was a clever guy.

He seems very hot on bad jokes.

Oh, I have an enormous collection of joke books. I gave him boxes of them and he went away to consume them. I already had the bad jokes in *Home Sweet Home*. *Two Thousand Years*, of course, involves a dentist who tells Jewish jokes compulsively.

Once again we have the issues with women and babies: in this case Charlene, who has a very awkward relationship with her mother, is not quite able to embrace her pregnancy. It's sad, yet not without humour.

It's a tragi-comic work. At the comic level it's continuously comic, it's constructed in a comic way and the juxtapositions are very comic. Betty's itching is sad but you can't help laughing at it somehow. Underpinning it all are these needs, yearnings and disappointments. And, of course, sadness.

Why are things so bad between Betty and Charlene?

They are lonely and frustrated. She would say that there's no man in their lives. We could debate that . . . It's hard work, surviving and working. Charlene is failing to be the gorgeous girl Betty would love to have had as a daughter.

Joy and Clive have a conversation about having protected sex and using Durex 'for AIDS'. Wasn't 1986 quite early to be concerned about AIDS?

Yes, it was. But it's there; it was clearly an issue. I don't think we'd known people who'd died. The idea that we should use protection because of AIDS was a new idea.

Is there a possibility that Joy and Clive will make their relationship work?

I'm totally fascinated by that most hilarious of all human phenomena, the person with no sense of humour at all. Not least because I had a mother who definitely manifested this particular characteristic. What is hilarious and in some way tragic about Joy is just that, really. She is part of my grand investigation of suburban young ladies who have a very clear, fixed idea of 'the done thing'.

So do they have a future together?

I suppose I'd like to say I hope not, but I suppose they have. They are quite believable as a suburban couple, aren't they? If they'd lived in a particular street ten years earlier, they might have been invited round to watch Laurence have his heart attack. Which is to say they are distant relations.

In contrast to the tightly constructed scenes in which the rest of the cast appear, David Thewlis is so casual on camera that it stops the action from feeling rushed.

That's right. Although what Thewlis is doing is just as tightly constructed as the rest of it. And it works in counterpoint to the breathless, nervous energy of Betty. Also, I wanted this film to be multilayered and densely packed, to have a lot of brief scenes that were packed solid.

How was it, after such a wait, shooting on 35mm?

I was wildly turned on by the whole 35mm big-screen thing. The style of the piece lent itself to bold, graphic images, like the shot of

Joy's house when Clive walks her home or that shot when Betty arrives at her house, when you pan round to the front door and then track back at great speed – that's the sort of shot Roger very much egged me on to do. It wasn't the sort of shot I'd used much previously, a counter-track like that, a camera moving on its own volition.

You wouldn't have wanted to do it before, or you wouldn't have felt comfortable?

Both. And the fact is that as you progress from *Bleak Moments* through all the television films, you can see they're all shot in a very disciplined and controlled way. By the time, for example, you get to the opening shot of *Naked* . . . the journey certainly from *The Short and Curlies* to *Naked* was important in terms of being adventurous. But still, my taste is for unobtrusive, controlled shots.

High Hopes (1988)

Wayne (Jason Watkins) arrives in London with a small suitcase and a scrap of paper detailing his sister's address. Clearly lost, he sees motorcycle courier Cyril (Phil Davis) tinkering with his motorbike outside a small block of flats in King's Cross and asks for directions. Cyril doesn't recognise the address and invites Wayne into his flat so he can look it up in the A–Z. Shirley (Ruth Sheen), Cyril's partner, is kind to the helpless Wayne. There's passing reference to a cactus called Thatcher because it's 'a pain in the arse'.

Cyril and Shirley visit Cyril's mother, Mrs Bender (Edna Doré), in her dark, quiet house and sit close to one another on the sofa. She is a lonely widow prone to complaining about everything, including her son's scruffiness; Cyril is simply fulfilling his duty and has little to say to her other than inappropriate comments about gunning down the royal family. He is anxious to leave. Cyril tells Shirley that the street was very different when he was growing up. She thinks his mother may be the only council tenant left in a gentrified street. They look through the letterbox of Mrs Bender's posh next-door neighbours, who are in the country.

Shirley talks about having children and the option of going back to work. Cyril thinks the world is already overpopulated. Wayne turns up again with nowhere to go and is offered a bed. He watches wide-eyed as Cyril builds a joint, and lets Shirley zip him up in a sleeping bag as though he were a child.

Cyril's sister Valerie (Heather Tobias) is highly strung, neurotic and aspirational. Her dog is her baby, her marriage is in trouble and her house is a garish clash of styles. She visits her mother from time to time but is even less interested than Cyril.

When Mrs Bender locks herself out of her home, her snobby upper-class neighbour Laetitia Boothe-Braine (Lesley Manville) is unsympathetic and initially reluctant to let her wait in her house. When Laetitia's husband Rupert (David Bamber) comes home, he suggests she smarten up her house, fails to hear when she says her husband is dead and talks of his £150 seats for the opera. Valerie comes to pick her mother up but has forgotten the key. Then Cyril and Shirley arrive. Brother and sister rarely have contact and it's a desperately awkward moment.

Later, while Valerie tries to initiate sex with her husband Martin (Philip Jackson), we see Cyril and Shirley returning from the pub, giggling. Shirley soon becomes serious: she doesn't want to use her cap when they have sex. Cyril counters that families are out of date and concludes that 'two's company'. We also see the Boothe-Braines engaging in playful, slightly strange sex which involves a teddy bear.

Cyril and Shirley visit Highgate Cemetery. Cyril contemplates Karl Marx's tomb and announces that without him 'there wouldn't have been nothing'. He berates Shirley, who works for the council as a gardener, for looking at some flowers instead of showing more interest in Marx.

Shirley's friend Suzi (Judith Scott) visits the King's Cross flat. She wonders why they don't have a baby, given that there's a spare room. There is talk of politics, of meetings, of revolutions. Later, Cyril tells Shirley he wants everyone to have enough to eat before having a baby. He declares himself a dead loss and wonders why Shirley doesn't 'clear off'. She says she would if she didn't love him.

Valerie has organised a surprise party for Mrs Bender's seventieth birthday. Martin picks his mother-in-law up, leaving her in the car while he pops in to see his lover (Cheryl Prime). The party is a showcase for Valerie to display her relative wealth and for Cyril in turn to wonder how they can be related. Valerie, a woman on the verge of a nervous breakdown, tells her mother to shut up, swigs from a bottle of champagne and has a huge row with her husband. The camera lingers on the old woman's expressionless face as things fall apart. Shirley asks Mrs Bender if she's all right. 'I'm still alive,' she says.

Shirley takes Mrs Bender to their flat, where she comes to life – although it is increasingly clear that she is suffering from prema-

ture senile dementia. In bed that night, Shirley tells Cyril she hasn't got her cap in, and he only jokingly protests.

The next morning, Cyril, Shirley and Mrs Bender stand on the roof of their King's Cross flat looking out across London. 'It's the top of the world,' exclaims Mrs Bender.

* * *

AMY RAPHAEL: *Where does* High Hopes *sit in your canon of work? Is it a favourite?*

MIKE LEIGH: No. I've got a soft spot for aspects of it. *High Hopes* and *Life Is Sweet* sit together in a separate section from that which went before and that which follows. It would be wrong of me to say that any real pressure has ever been put on any film I've made, including those two. However, because of the glitch of 1986's abandoned film, I felt as though things had changed by the time I made *High Hopes*. There seemed to be a received expectation of the commercial possibilities of a film I might make.

What displeases you about the film?

When people criticise my work for caricature, or when satire is talked about, *High Hopes* is the only legitimate target in my view, apart from *Who's Who*. It's the only film I've made that (a) involves anything that you could really call satire, (b) is culpable of carica-ture, and (c), most importantly, is certainly the only film where the deliberate device is employed of heightening in a comic way some characters against others in order to make an implicit statement. That said, it still works within the conventions of what I do.

When I was in Hollywood promoting it, the *LA Times* review talked about a 'mixture of acting styles'. I was vehement at the time – and I remain so – that there's not a mixture of acting styles. In fact, it's perfectly consistent – more so than many a film. The sophisticated and rigorous discipline and the choices that have gone into how actors play characters are consistent across the board. However, it may well be possible to criticise the choice of behavioural characteristics and the way those are heightened or brought out.

Why do you mention High Hopes *in conjunction with* Life Is Sweet?

With both films there's a distinction between the question of per-
formances and the choices of what goes on. Of the two films, I'm
less comfortable with *Life Is Sweet*. In fact, in some ways I'm least
comfortable with that film. All the stuff about the Regret Rien
restaurant and Aubrey is inherently funny and plainly has some-
thing to say about entrepreneurial activity – apart from all the
other stuff about individuals and isolation – but if I'm honest
there's a degree of strain on my part in the rendering of that side of
the story. I suppose, looking at the two films from a post-*Naked*
perspective, I find the construction and the narrative on the clumsy
side. More so in *Life Is Sweet*. It's difficult because *High Hopes* –
taken on its own terms, where it came from and where I was at –
is fine, and I don't really have a problem with it.

High Hopes *has some strong performances – notably by Phil
Davis, Ruth Sheen and Edna Doré – and some memorable scenes.
I love the King's Cross setting and the very real parts of London
that are shown. The yuppies are pretty unbearable, but I like the
dynamic between Cyril and Shirley and the possibilities their rela-
tionship offers. Which is not to say I value it as a complete film
like, say,* Secrets & Lies.

What you've just said absolutely squares with what I've been try-
ing to say. Incidentally, just as a sociological quibble, I don't think
the neighbours are yuppies. They're certainly not upwardly
mobile, on the way up. They're already there. They're posh.

*Unlike Valerie, who is desperate to show how well she's doing and
how fabulous her life is.*

Absolutely. That's the whole point. You need that contrast. You
say the posh people are pretty unbearable, and, of course, they are.
Nevertheless, Lesley Manville's performance and characterisation
are totally accurate. She researched those women and she gets it
spot on. The scene where she takes in Mrs Bender, plays *Così fan
Tutte* and bullies the old lady about moving away from the street
is, for all its awfulness and appalling behaviour, actually rather
real, which, of course, owes much to Lesley's brilliance.

Let's return to your 'world view': it's seventeen years on from Bleak Moments. *You are now forty-five and living with your young family in Thatcher's Britain. How had things changed?*

Ever get the feeling that you are going to fail your GCEs again? God, that's a tough question! It's easier to talk about world views at twenty-eight. First of all, since you mention the young family, the films do divide up and fall on the pre- and post-parent phases of my existence.

But were you still an angry young man?

Of course. I still am. There's anger on the go in *High Hopes*, of course there is. But it's an obvious anger really. The sense of disappointment at the notion of socialism . . .

I went to Poland with the film in 1989. In a way, this experience defines the historical moment. There was a British film week in Warsaw and Kraków, organised by the British Council. In each city the mini-season kicked off with *High Hopes*; in Warsaw there was a gala screening with a Q&A. It was the week at the end of which Lech Wałęsa was going to be elected – the great events at Gdansk with Solidarity had been going on while we were making the film. In other words, the film came out at the time the Berlin Wall came down. You ask about my world view: well, I stood up in Warsaw at the end of this screening in a state of what I can only describe as deeply stupid western insular naivety and smugness. I was used to Q&As where I'd be asked, 'What was the budget?' and 'Is it true there isn't a script?' The first question was, 'Are you a Christian?' Which came whacking out of nowhere like an Exocet missile.

Some of the audience were passionately moved by the film, but many others were deeply offended and thought it was obscene to see the good guys go to Highgate Cemetery and genuflect at the shrine of Karl Marx. They thought it was absolutely filthy. There was a serious row in the audience. It was chaos. It wasn't wanky intellectuals like those who stood up at the Rio in Dalston or in Sydney and castigated *Meantime* for not being heavier or not containing more obvious propaganda. This was serious: these people had lived through it. They were on the front line.

When we went to Kraków a few days later, there was another

such battle in the audience after the screening. It went on long after the public transport had stopped, even though, as it was the middle of winter, there was thick snow everywhere.

Now, what *High Hopes* is about – at the level of Cyril's frustration about being a socialist – is these changes that were taking place. At that time it also seemed impossible to imagine how the Tories would ever be voted out, although it proved to be only eighteen months away from Thatcher's demise. If you'd told me in 1988, when we made *High Hopes*, that the celebratory champagne moment when Labour finally swept to victory wouldn't be until 1997, I'd have been horrified. But not as horrified as I would've been had I known what Labour were to do – or, more precisely, fail to do – in the subsequent ten years.

Returning to British Film Week in Poland for a moment, did you feel you had to defend High Hopes?

No, I didn't at all actually, because it wasn't about that. I did grab several opportunities to do live radio interviews where I was extremely rude – as I always was – about Thatcher, which shocked some people. But you can't argue with people who are on the front line. And besides, their arguments weren't actually with me or the film.

That said, a Polish person asked me, with complete seriousness, something along these lines: 'We are fed propaganda about homeless people sleeping rough on the streets of London; will you confirm that this is a lie?' Of course, I wouldn't and didn't. It is totally true, I explained, come to London and see for yourself. Stefan Laudyn, a Polish film journalist who later went on to direct the Warsaw Film Festival, was subsequently at the London Film Festival at the NFT, and we had a similar conversation. He wouldn't believe there were homeless people, so I showed him cardboard city, just a few metres away, on the site where the BFI Imax cinema now stands. He was shocked.

What provoked debate about *High Hopes* in Poland was the way in which it warms to socialism, when they wanted to embrace a liberal society. Socialism was a dirty word for many Poles, and the political culture gap between our perspective and theirs is not one you can glibly argue across.

At its most serious and intelligent level, *High Hopes* sits on what turns out to be a historic cusp and moment of change, but more because of my intuition than any political nous. My instinctive sense of what was rumbling and going on.

How far did you feel you had travelled at this point in your film-making career?

I had, by that time, directed a dozen films for television; I'd had a pretty rigorous and sophisticated training. I'd obviously improved as a film-maker and was able to be more adventurous. But it's easy to forget that *High Hopes* was my first proper feature film. The only films that would qualify prior to this would be *Bleak Moments* and *Meantime*, but neither were regular feature films. When *High Hopes* was screened for distributors in London, it got a lot of negative response and it took a while for Palace to pick it up. So in many respects it was made in a state of innocence. It didn't feel particularly different on the ground, just that the scale was bigger and therefore the disciplines greater.

One mustn't forget that, from *Meantime* onwards, my assumption was that Roger Pratt was going to shoot all my films. But in fact *High Hopes* proved to be our final collaboration. When it came to what turned out to be *Life Is Sweet*, Roger had to choose between it and *The Fisher King*. He knew Terry Gilliam because he'd worked on all the Python films and they were close friends. So he chose *The Fisher King*.

I'd heard about Dick Pope over the years, and he has actually gone on to shoot everything else I've done. Still, I think it's a great shame that I stopped working with Roger because you develop a private language with a cinematographer. You do with other crew members and actors, of course, but with the cinematographer it's a particularly special relationship. Roger's experience of feature films was crucial to *High Hopes* because it was experience I hadn't had.

Does the title of the film refer in any way to the Frank Sinatra song?

No, not consciously. I have a lot of trouble with the titles of my films and I'm pretty relentless about it. I often go right up to the deadline with it. I invariably wind up going to bed with *Roget's*

Thesaurus, which is how I came up with *High Hopes*. But within days everyone was saying, 'Oh yes, the Sinatra song . . .'

You changed your credit at this point from 'devised and directed' to 'written and directed'.

Well . . . look at the poster for *Bleak Moments*: it says 'written and directed by Mike Leigh'. Way back when I started these projects in the fringe-theatre context – before I really understood what I was doing – I'd always had aspirations to write but did the film-making 'thing' instead. So, out of respect to 'proper' writers, a feeling that I wasn't really writing – which is rubbish, but there you go – I started to use 'devised and directed by'. I kept it when I started to work for television. I talked about all this earlier, when we were discussing *Hard Labour*. Before I got to the end of that period it became abundantly obvious that the plays I made in the theatre were by me and, more importantly, that auteur films are written and directed by the auteur. So, at the time of *High Hopes*, I decided once and for all to fix this thing that had been bugging me for years. The notion that I changed it is not at all accurate; it's more a case of finally fixing it up properly.

High Hopes is similar in many ways to Grown-Ups: *council house next to private house, girlfriend trying to convince boyfriend to get on with having first baby. These are obviously recurring themes, but did you want specifically to revisit and expand upon them?*

I didn't think twice about it. It is and has been a running theme. Things related to having or not having babies, baby substitutes, families or lack of families have run all the way down the line from *Bleak Moments*. If I did stop to think, 'Hang on! I've already dealt with that!' I'd become extremely cramped. I don't quite know what I'd be doing. I think I'd suffer serious block – and block is very much denying what you really want to do.

In terms of a biographical element to High Hopes, *I presume growing old was on your mind following your father's death?*

Yeah, it was. The new issue in my life was my widowed mother and my responsibility for her. In 1988 she would have been about

16 *High Hopes*: council house and private house, cheek-by-jowl.

seventy-two and she was fine. It so happens that the actual issues raised in the film, in terms of looking after an ageing geriatric mother, became real some years later, before she finally died.

Did you feel a sense of guilt and duty towards your mother?

Yeah, definitely.

Did your mother see High Hopes?

She saw all the films. It was *Naked* she had the hardest time with, not surprisingly. What did she think of *High Hopes*? Along with her friends, who were also over seventy, she thought the old lady seemed much older than seventy. Retrospectively, I think they might have been right. We created a character with Alzheimer's disease. The true explanation is that my father was in fact only seventy-one when he died in 1985, but between sixty-five – hardly older than I am now – and his death he became a very old man. He could have passed for eighty-nine. Thus, my perception of an old person around seventy was very much reflected in Mrs Bender.

Your father died while you were in Australia. Was High Hopes *a direct response to his death?*

Very much so. It was my first serious piece of work since his death. My deep grief lies at the emotional core of the film.

How did Edna Doré research the role of Mrs Bender? She was, after all, just sixty-six at the time.

Edna Doré was and remains one of the fittest, healthiest actors around. She'll outlive all of us. She is a famous allotment queen. The only research that's of any interest is that we wheeled in a geriatrician. The rest is standard.

A measure of how much more sophisticated the research becomes as time goes by is that on *Vera Drake* there were two guys at the Imperial War Museum to help everyone fill in their character's background and to work out the experiences they would have had during the Second World War. Edna and I put together Mrs Bender's history during that period, but we didn't go down to the Imperial War Museum. Post-*Topsy-Turvy* our research has become more sophisticated and thorough. I think this is also partly to do with the birth of the internet, which makes research so much quicker and easier.

Cyril doesn't have much in common with his mother, particularly

17 *High Hopes*: Mrs Bender (Edna Doré).

when it comes to politics; as Shirley says at one point, 'I bet your
mum did vote Tory.' Yet he seems to be terribly idealistic.

He has ideals and aspirations. He has reached a place where he is
realistic. Actually, I think it's more complex than being realistic or
idealistic. He's both of those things, but he's also disappointed.

How much does he really understand the theories of Karl Marx?
Or is Marx more of an icon?

I think he understands Marx and Marxism in basic terms. I don't
think he's overly susceptible to iconography.

When they go to Highgate Cemetery and Cyril becomes exasperated
with what he sees as Shirley's lack of interest, is he disappointed?

It's a mistake to decode what's happening in that scene exclusively
in terms of what's happening between them politically. There are,
of course, some tensions on the go in the relationship. So when he
accuses her of not being interested, it's because she's also interested
in the flowers; he's irritated she's not paying complete attention to
his analysis of Marx. It's not true to say she's not interested in
Marx; she's just looking at the flowers as well – she's a professional
gardener!

 You could imagine – in a parallel universe or in the hands of a
different kind of writer – another version of *High Hopes* where
everything was exclusively motivated by the political meaning of
the discussion. For me it doesn't matter what's happening on the
surface. The characters are like real people, and other stuff is going
on that isn't directly related to the main theme in an obvious way.

When they do talk about having a child, Cyril insists the world
needs to be a better place first. But he's also scared . . .

. . . about being a parent. Absolutely. We talked earlier about him
being an idealist; this is a perfect example.

When the couple are back in their flat, after Suzi's visit Cyril says
to Shirley, 'I'm a dead loss, I don't know why you don't clear off.'
Is he deeply insecure? Does he lack the confidence to believe he can
make her happy or be a good dad?

18, 19 *High Hopes*: Shirley (Ruth Sheen) and Cyril (Phil Davis).

He feels all those things at that moment. Because he's a real person, the fact that he says that in the desperate heat of that moment doesn't actually mean that it's what he totally thinks.

As a couple they are saved, to a degree, by their shared sense of humour.

This is the running theme. Nothing is more dispiriting in life than when you feel you and your partner are divided by a lack of humorous communion.

The contrast between Cyril and Valerie is stark. Would it be fair to say that she's a grotesque reminiscent of Beverly in Abigail's Party, *only with even fewer redeeming qualities?*

It would be difficult to disagree with that. The point about Beverly is that for all her vulgarity and selfishness, part of her culture is the notion of being nice to people. She has a conception of generosity, whereas I don't think that word actually exists in Valerie's vocabulary. I think she's probably deeply repugnant. But also very sad, lonely and unfulfilled. That would be her defence.

How did she end up being so different to Cyril?

Valerie is, once again, a victim of the received notions of how you should be. Working-class background, upwardly mobile, aspirational. She sees it all in terms of material gain. You ask how she differs from her brother: well, she's not bright enough to spot the spiritual truth in life.

You have said earlier that the film is not about three couples, yet at one stage you show three couples in their bedrooms.

Indeed. You've got one couple whose sexual proclivities seem to include a third party – a teddy bear with a gastronomic name. You've got a woman in another couple who seems to need to indulge in fantasy in order to make love, while the guy isn't interested because he's bonking an unfortunate young lady in a rather dingy flat somewhere. And another couple who are entirely wholesome and proper who really have love on the go and who are struggling with their care for the world. Whatever I've said about

it, the juxtaposition of those scenes is interesting. I do hope that whatever else happens in my films they are always interesting. You can't not be interested by what goes on in those bedrooms.

By the way, I love it when the Boothe-Braines return from their night out and Rupert fails to recognise what he's just heard in the opera house. He asks if Laetitia sang it at school. For goodness' sake . . .

When Valerie gasps to her disinterested husband in the throes of passion, 'You're Michael Douglas and I'm a virgin,' it's almost unbearable.

Indeed. She enjoys inventing these fantasies. Somewhere along the line she may be a distant relation of June in *Home Sweet Home*, who reads all those romantic novels.

In fact, most scenes in which Valerie appears are unbearable, as we discussed earlier. Are you prepared to talk about the improvisations that led to Valerie's party for her mother's seventieth birthday, notably the scene in which we only see Mrs Bender's face?

Only to say that Heather Tobias failed to maintain that clear distinction between herself and the character that I always encourage. So she took personal umbrage, walked out of the improvisation and went home in a huff – the only actor ever to do such a thing, incidentally. This left us with no time to prepare the structured scene, so I set up the single tracking shot of the old lady and recorded wild tracks of the others improvising out of vision. Which we edited later.

When we were shooting that shot of Edna, Roger Pratt asked how we were ever going to explain our way out of it. I said, 'Don't be ridiculous. People will write theses about it, it will be regarded as a masterly cinematic stroke.' In fact, I rather suspect that this little scene is more interesting and poignant than it would have been had I done it as I'd intended. And it's perfectly well structured.

After the horrors of Valerie's party it feels at least as if there's an uplifting ending, with Cyril, Shirley and Mrs Bender standing on the roof.

Sure it's a positive ending. But these are people who've got their feet on the ground. It's not the end of their problems, but they're dealing with them within the parameters of what's possible. But don't forget that when Cyril and Shirley go round to see Mrs Bender at the start of the film, Cyril does what we all spend all our lives doing – behaving towards our parents as though we are still disgruntled teenagers.

Somewhere along the line he goes through some sort of change – maybe an epiphany. Or maybe he grows up. It makes him stop having a go at her and feel some responsibility. At the same time, Shirley, having been exposed to Valerie's appalling behaviour, appreciates her own situation. She also has a wobble.

At this point you'd been working with Phil Davis for almost a decade.

The fascinating thing about Phil is that we've worked through from him being a naughty youth to a middle-aged man. He's a really extraordinary actor. He's completely rigorous, intelligent, rooted and with a sense of the real world. He's up for trying anything. Completely creative. And a very nice bloke. The interesting thing about him, however, is this: he's an actor of immense scope and versatility, but don't ask him to do an accent. And Ruth Sheen is the same. She's fantastic; there's nothing she can't do – except accents!

Ruth Sheen's one of the people who wrote to me. I had a very strong instinct about her. She joined in a bit later than the rest of the cast, as I knew I was going to deal with the Bender family first. Of course, she was voted best actress at the European film awards, with Edna Doré getting best supporting actress.

I think I've underused Ruth over the years. She was also in *It's a Great Big Shame!* and *All or Nothing* playing goodies, so when it came to *Vera Drake* I suggested we do a baddie. And she does a rather good baddie. At that time she was doing an Open University general arts degree. She's an expert on Humphrey Jennings and the propaganda cinema of the Second World War, and comes from a working-class East End background.

The bottom line is that the chemistry between Cyril and Shirley is very special, and it was good to get that working on the screen.

What happened with the extras on High Hopes?

The second AD was actually Marc Munden, who's now a very distinguished director in his own right. I'd been to China three years previously, and every time I went to Highgate Cemetery to think about the scene where Cyril and Shirley visit Marx's tomb, there were several groups of people from the People's Republic of China. I wanted a gang of these people to be in the cemetery at the same time as the characters.

So Marc arranges for me to 'audition' some Chinese extras. We're shooting in the East End, and a minibus arrives and out get all these Cantonese-speaking guys who've been Chinamen in any number of movies. They've all peeled rice for decades in the basements of Chinatown restaurants. One even had a little suitcase with a *Chu Chin Chow* costume in it. They didn't look like comrades from the People's Republic of China, and they'd certainly never been to Highgate Cemetery. It was a complete waste of time. In the end, we broke the rule book, went to London University and found a group of people from the PRC, so the group you see in the film had all been to Highgate, they'd all paid homage to Karl Marx. It was organic, for real and kosher.

Life Is Sweet (1990)

Wendy (Alison Steadman), cheerful and energetic, leads a children's dance class. When she returns home her husband Andy (Jim Broadbent), affable but prone to procrastination, is waiting for her. Her twin daughters Natalie (Claire Skinner) and Nicola (Jane Horrocks) are polar opposites: Natalie, a plumber dressed in a bloke's shirt, gets on with life; Nicola, in a baggy Smiths T-shirt and with a cigarette always to hand, is neurotic, angry, sulky and full of self-loathing. She sits around reading Diet Lifestyle, *screeching 'Bollocks' and complaining to her chirpy mother, 'Your sandwiches stink . . . I'm going . . . in a minute.'*

Andy's friend Patsy (Stephen Rea) takes him to see a ramshackle burger van and talks him into buying it. Wendy and Andy's friend Aubrey (Timothy Spall) arrives at their house in an old red convertible Triumph Spitfire. Dressed up in a baseball cap, Giants baseball jacket and outsize glasses, he chats to Nicola while nervously juggling a pineapple.

As she sits punching her fists inside a 'Bollocks to the Poll Tax' T-shirt, Aubrey tells Nicola that she's an attractive girl, but she immediately insists she's too fat. He talks to Wendy with pride about the opening of his new nouvelle-cuisine restaurant, the Regret Rien. When Andy arrives home with the Hot Snacks van, Wendy is not impressed.

Wendy and Andy visit the Regret Rien. Aubrey tells them a typical dish will be 'jam blended with orange juice, yogurt and one king prawn'. The waitress rings and announces that she can't make it as she is on her way to Prague. Wendy offers to stand in.

At home, Aubrey drums like a maniac and later falls dramati-

cally out of his bed. Andy and Wendy lie in their bed. Andy explains his plan for the burger van – to be used initially at week-ends until business is strong enough for him to give up his day job – and Wendy calls him a 'big softie'. She talks of her concern for Nicola and her guilt for shouting at her. In her room, Nicola opens a suitcase stuffed with chocolate and crisps, gorges herself and vomits into a carrier bag. She is clearly anorexic. Natalie, back from an evening in the pub, lies listening in her bedroom next door.

It turns out that Andy is the head chef in an industrial kitchen. Wendy has a second job as an assistant at a children's clothes shop. Natalie is installing central heating in a house. Nicola is at home. When her lover (David Thewlis) shows up, she calls him a 'middle-class wanker' and then instructs him to tie her up and smear chocolate over her naked body. She calls him a 'sexist pig', and he asks her why she never wants him to stay. She doesn't reply.

Andy is in the pub with Patsy, who tries to sell him a pocket tel-evision. Aubrey opens the restaurant but has forgotten to advertise. Not a single customer turns up. Drunk, he stands in the street try-ing to attract people. He makes a pass at Wendy – 'I love you . . . I want to fuck you' – takes his suit off, turns over all the tables, smashes the glassware and collapses on the floor in his underwear. Paula (Moya Brady), an odd, quiet girl who has been helping Aubrey in the restaurant and who Aubrey tried to seduce earlier by teaching her how to play his drums, is disappointed they'll no longer be going to get chips together. When Wendy arrives home from the restaurant, Andy has passed out in the van with his feet sticking out of the door. He claims he's been tidying up.

The next morning, Nicola's lover comes round and tries to talk to her. She claims to be a feminist, but he accuses her of being a 'bit vacant' and a fake. Wendy decides to talk to Nicola in her bed-room. She tells her daughter, 'Dr Harry told us you had two weeks to live . . . life's not easy.' Nicola says she didn't ask to be born. With great sadness, Wendy observes, 'Something inside you has died.' Her mother says they all love her, and Nicola starts to cry.

Andy breaks his leg at work. Wendy brings him home. The spoon on which he slipped is hung on the living-room wall. Wendy talks to Nicola again. Natalie plans to go travelling in North Amer-ica. Natalie and Nicola sit side by side in the back garden, chatting

in the late-afternoon sunlight. Natalie says she knows about her sister's problem and wants to help.

* * *

AMY RAPHAEL: Life Is Sweet *was the first film made by Thin Man Films, the production company you set up with Simon Channing Williams.*

MIKE LEIGH: The unmade film of 1986, *The Short and Curlies* and *High Hopes* were all made for Portman Productions, a company that had been going for many years. Simon Channing Williams and Victor Glynn were co-producers on *The Short and Curlies* and *High Hopes*. While we were doing *High Hopes*, Simon and I started to talk and wondered why we were working for another company. At which point we decided to start our own company. So yes, *Life Is Sweet* was the first production of Thin Man Films. Nothing to do with the famous series of films: the 'thin man' in question is, in fact, an ironical reflection on the fact that both Simon and I are given to a certain degree of portliness. He is rather larger, both horizontally and vertically, than I am.

Did forming Thin Man make you feel more secure, give you a base from which to work?

It's not about feeling secure; it's about the means of production. I've always said that the only way to make things happen in show business is to make them happen yourself. The roots of all this are in the early 1960s, which is very much to do with finding ways to challenge the status quo and get stuff on against all the odds. Les Blair and I formed our own company to make *Bleak Moments*, and, long before that, I formed a company with David Halliwell to put on the original production of *Little Malcom and his Struggle Against the Eunuchs*. It was a natural and logical thing to do, particularly with Channel 4 stimulating, encouraging and promoting independent companies to make programmes for them. I just felt we should be in control as much as possible. Of course, it still means we have to go with the begging bowl for each movie, but when we get the money we're in control of how we make the film.

Was it any easier to get funding by this stage?

We started going to Channel 4 for meetings about this next film, at that point known simply as 'Untitled '90'. We had meetings with David Rose and Simon Relph, who was head of British Screen, the main funders. We said we've got Jim Broadbent, Timothy Spall and Alison Steadman. We don't know what the film's about but they're signed up. They asked for another meeting, during which Simon Relph wanted to know if I'd thought about using Bob Hoskins. I told him it was out of the question: he's not my sort of actor – no disrespect to him.

So then we had another meeting in which Lenny Henry and Victoria Wood were suggested. Simon Relph wanted it to be a comedy. At the next meeting he said that American distribution was important and had I thought about Dustin Hoffman and Meryl Streep? 'They're really good, they're character actors and they're bright, but that's not the point,' I replied. In the final meeting he said, 'The word is that Robert De Niro is very keen to do a low-budget British movie.' I told him he had to be joking.

It would be quite wrong and disingenuous to suggest that these conversations translated into real pressure, because at the end of the day they gave us complete freedom. It was all talk. I'm not complaining, and Simon, like David, was friendly and supportive. It's just part of the background to what went on.

So, at a certain point, you could basically get on with the film?

Oh yes, with complete freedom. I had a slight wobble in preparing 'Untitled '90' because I got hit by some kind of flu bug and was laid out in the middle of rehearsals. I suddenly recalled the complete collapse and lack of confidence I had which led to the cancelling of the film in 1986. And this was only four years later. I had a real panic attack and thought I couldn't continue with the film. But they filled me with vitamin B12 injections, and Alison, who, of course, was also in the film, fed me smoked salmon and avocado pears, and it was all right in the end.

During every project I have a wobble and think it's not going to happen. It's terrifying. But that's probably the last time I had a wobble that felt so serious, or at least felt that I wasn't able to deal with it.

This is the first time you worked with Dick Pope, who replaced Roger Pratt as cinematographer. In The World According to Mike Leigh, *Pope tells Michael Coveney that on the first day he set a shot up and was feeling pleased with himself, when you 'tore it to pieces, questioning why the camera was cutting to certain shots and from whose point of view . . . I didn't know then how nervous he was.'*

We were all wandering about the estate in Enfield looking for the right opening shot, and all it came down to was a static exterior shot of the house. At first we simply weren't talking the same language, but that lasted for less than an hour.

The cast was a mix of old favourites and new discoveries. You already had Jim Broadbent, Timothy Spall and Alison Steadman lined up; what about the newer names?

Well, David Thewlis we knew about from *The Short and Curlies*. Moya Brady came on the scene because for a long time she had been Thewlis's partner from up north, from Blackpool. This funny little character was always skulking about, so I got her in the film. I love what she does. I suppose the main discussion is about Claire Skinner and Jane Horrocks. They are two very different kinds of actor, though the chemistry between Nicola and Natalie is really good in the film. They were both in their mid-twenties at the time; they're both mothers now.

Somebody recently wrote to me saying his wife was the model for Jane Horrocks's character in *Life Is Sweet*. It's an agreed rule that nobody ever says what the sources are for their character. I wrote back saying it was a myth. He wrote back again saying I should watch a *Parkinson* show from a particular date – apparently Jane actually talked about it on his show . . .

Jane Horrocks has a great deal of wit but she's very much a personality in her own right. What she did on *Life Is Sweet* is fine and she really went for it. She researched the anorexic-bulimic side of things. She's a very different kettle of fish to Claire Skinner, who brings a certain profundity, serenity, panache and humour. Witness the extraordinary contribution she makes at the end of *Naked*. It's one of the best performances I've been associated with.

20 *Life Is Sweet*: Nicola (Jane Horrocks).

This was the first time you'd worked with Jim Broadbent on screen.

Yes. He'd already been in two of my plays, *Ecstasy* and *Goose-Pimples*. He does a great thing in *Life Is Sweet*; it's very subtle. And very funny. This was only the second time I'd worked with Mr Spall. Aubrey is a fairly outrageous character, although he resonates with a lot of people I've come across. He is the worst example of received-behaviour characters in my whole canon. Gordon, Tim's character in *Home Sweet Home*, and Aubrey are both over-the-top characters. I love it when he's shouting, 'I ain't fat!' When you get to the next three contributions – Maurice in *Secrets & Lies*, Richard Temple in *Topsy-Turvy* and Phil in *All or Nothing* – we hit his sensitivity and deep pools of emotional reserve.

I think what Alison does is another of her extraordinary contributions. What's great is that, from my point of view, part of the device of the film is the way your assumptions about people are challenged. The big hoax with *Life Is Sweet* is that you meet this guy who just doesn't get it together at all; he spends all his time procrastinating, and then you discover he's a serious pro in the kitchen. What we're up to with Wendy is precisely that. You think she's a dickhead, but when it comes to it she's not: she's a proper

person with real emotional reserves. She has an interesting background that at a certain point is revealed.

Of course, *Life Is Sweet* is the last film on which I worked with Alison before we split up, which was around the time of *Secrets & Lies*. There's nothing I have to say about that apart from the fact that the investigation of family life on which we collaborated in *Life Is Sweet* came at a time when our family life, to all intents and purposes, was intact.

David Thewlis was apparently disappointed by having only a relatively small part.

Of course he was, and rightly so! We had a whole thing on the go but dramatically it became obvious to me that you only needed to see him twice. He hung on in there because I kept trying to invent ways of bringing him back at the end. I thought it might be quite interesting if he came round at the end with none of the others knowing who he was. He'd just show up. Eventually I decided it was irrelevant to what the film was about.

So yes, Thewlis was in some ways short-changed because there wasn't very much of him in the film. He was disappointed, but people always are. It happens all the time, especially in my films. He was fine about it; he just didn't want to do it again. Especially for a man of undoubted star quality. Therefore, when I asked him some time later if he'd be in the next one, he wanted reassurance that the same thing wouldn't happen again. I promised him he'd have a fair slice of the pie. And of all the promises I've made in my life, I'd have to say that was the best kept!

Stephen Rea isn't in the film much either, but he is in that lovely scene in the pub with Andy.

I'd arranged that scene in a quite different way. With a normal film you write a scene, then go and shoot it. With me it was a case of find a pub and let's see what happens. We got there, and the first assistant asked how many extras we'd need. I asked for forty people to cover us. We showed up in the pub, and there were the people.

Sometimes, when I'm not on top of the material, I get subsumed by some kind of misplaced sense of responsibility. I kept thinking

21 *Life Is Sweet*: Wendy (Alison Steadman), Andy (Jim Broadbent), Natalie (Claire Skinner), Patsy (Stephen Rea) and Aubrey (Timothy Spall).

we had to show the pub and all the people simply because they were there. I constructed a scene around that notion. I knew in my belly it wasn't a real turn-on like it should be. I was doing it for the wrong reasons. When we showed up to shoot the scene – and this is something I battled with every time I'd made a film – I'd been persuaded to allow a TV crew to film us filming. I've learned to deal with it now. I say no. I hate having people filming us. It's the worst thing in the world, really inhibitive.

On this occasion it completely threw me. We were shooting bland wide shots. So I tumbled into a room somewhere with Jim and Stephen and rethought the scene completely. As I've had to do on a number of occasions, I took a grip of myself and said, 'Fuck the location, fuck all the extras, let's just tell the story in a way that's appropriate: intimate, close and, therefore, interesting.' There are extras but they're seen incidentally within this static two-shot. It's an object lesson in what it's all about, similar to what I talked about in respect of the pub that was lined up with a whole load of people for *Secrets & Lies*, and I gradually got rid of the extras one by one until it was just Tim sitting there all by himself.

Stephen Rea had to betray his real football team for the scene.

Yeah, it was very difficult for him, in a not very serious way, because he's an Arsenal fan and there he was talking about supporting Tottenham. Patsy's a great character and obviously a distant relation of Dixie from *Four Days in July*. Dixie is probably brighter than Patsy.

The scene provides a good insight into male relationships: Andy's just been ripped off by Patsy, yet they still go for a good-natured pint together. Because Wendy puts up with and laughs about the caravan, it doesn't really matter.

Absolutely. But I had terrible trouble with that scene when Andy and Patsy show the caravan to Wendy and the twins. It was a classic case of finding your cinema eye: I was really perplexed till I realised the camera should be inside the caravan. It all made sense. It's not an obvious place for the camera to be, but it works.

The films you made either side of Life Is Sweet – Meantime *and* High Hopes *before,* Naked *after – focus on frustrated, disenfranchised, unemployed youth. In a less direct way, this is also a film about unemployment.*

In 1990, when we made the film, it was still an issue, and it remains one today. Obviously the difference between *Meantime* and *Life Is Sweet* is this: in *Meantime* the premise is that everyone is unemployed, so it's simply the status quo; in *Life Is Sweet*, they are all busy. Wendy's got several jobs, Andy's a pro, Natalie's getting on with it. It's only Nicola and her boyfriend who have the problem. It's a different take on unemployment, a different set of assumptions.

On another level, *Life Is Sweet* follows on from *High Hopes* in the context of Thatcherism and entrepreneurialism. Having discussed those things very explicitly in both films, I certainly had a strong feeling of wanting to move on. But it's still important to see *Life Is Sweet* in those terms.

I just realised a few moments ago that there's a certain irony in the fact that when discussing this film in the context of being the first Thin Man film, I made a speech about taking control of the means of distribution and exhibition, as it were. And, of course, that's just what Andy is doing with his caravan and Aubrey is

doing with his restaurant – branching out on their own. So it is, at some level, a film about entrepreneurialism – which, of course, is also discussed in the scene in *High Hopes* when Martin attempts to offer Cyril advice.

Natalie is non-conformist in a very different way to Nicola: working as a plumber, wearing tomboy clothes, ignoring the notion of female identity.

By the way, I didn't initially plan for Natalie and Nicola to be twins; I just thought they'd be sisters. But at an early stage of getting the characters on the go, it suddenly dawned on me that we could make them look like twins. Anyway, I think the key line in a study of Natalie is when the two sisters are talking and she says she wants children. We didn't think she was gay, as a matter of interest. I also reject the theory that she's in some way sexless. It's not true. She's challenging the status quo, making things happen, questioning things. Actually, she's a kind of young woman who's really come into existence more recently.

There's one sister sitting around the house with her bedroom poli-

22 *Life Is Sweet*: Nicola (Jane Horrocks), Aubrey (Timothy Spall) and Natalie (Claire Skinner).

tics, *in need of love but unable to accept it, and there's the self-suf-ficient sister who's challenging perceived notions of being a woman. By being a plumber and wearing a bloke's shirt she is being political in her own small way. She's happy with herself and her parents are happy with her; they don't moan at her. She is doing more than Nicola, who sits in her room feeling sorry for her-self, yelping, 'Fuck the poll tax!' every now and again but achiev-ing very little except self-hatred.*

I couldn't have put it better myself. Can you re-ascribe that speech to me?

The scenes of Nicola in her bedroom are incredibly intimate and verge on the voyeuristic; at times it feels as though we are peeking at her diary. It's easy to laugh at her, but, of course, it feels wrong, cruel.

Well, some of the time you can laugh at her. Mostly I don't think it's funny.

Whose idea was it for Nicola to wear the poll tax T-shirt?

I'd imagine it was Lindy Hemmings'.

Were you aware the chocolate and fucking scene would go from being controversial to iconic?

I know it's much talked about and discussed. It allows journalists to rework the 'this film did for chocolate what *Last Tango in Paris* did for butter' gag. That kind of journalistic bollocks. When you're making a film you never know what's going to become famous or celebrated. If you stop to think about it you might, but in truth you don't.

Did you consider how far to take it?

Of course.

Did we have to see Nicola actually vomiting, for example, or could Natalie just have heard it through the bedroom wall?

You had to see it. You don't want to alienate the audience to the

extent that you can no longer suspend their disbelief. On the other hand, you want to confront the audience with the visceral experience of something. So to let Natalie just hear it through the wall wouldn't have worked – in fact, it never occurred to me. There would have been the risk of it not being clear for a start. You have to show things as they are. Where you draw lines is a matter of taste.

If the principle of a film is that things happen and the audience is a fly on the wall who has to see those things happening, you can't mess around with that notion.

One of the most powerful scenes in the film is that between Wendy and Nicola; when we discover the daughter almost died, it's an incredibly emotional, raw and memorable moment.

It's a good scene. Those are the kind of scenes where the back story – although it's erroneous ever to call it a back story really – is really earning its keep.

How do you stop such a scene from being sentimental?

I am sentimentality-proof. I'm so resistant to it in any form. When we're constructing scenes which could easily be sentimental, I just

23 *Life Is Sweet*: Nicola (Jane Horrocks) and Wendy (Alison Steadman).

jump on it – so it at least stops feeling sentimental to me. There are endless scenes in these films that could have been loathsomely sentimental. The point really is this: what is going on is not sentimental. It's real and truthful. Given that the motivating participator in that scene was Alison, I doubt whether the question of sentimentality could ever have come into it.

We return to the subject of child-bearing once more: Wendy was pregnant at sixteen and gave up studying, while Andy worked all hours at catering college. She struggles to communicate with Nicola, telling Andy about her guilt at shouting at Nicola. Has she managed to be a good mother?

Yes, I think she has. And motherhood isn't easy. Saying anything to Nicola, let alone those things, is almost impossible.

Aubrey, meanwhile, is self-deluded to the extreme, obsessed with sex and with being sophisticated. Are we to empathise or just laugh at him when he falls off his 'orthopaedic, five 'undred quid, you know' bed or passes out, pissed, on the restaurant's opening night?

There are two different things here. On the one level he's a comic character, it's a comic idea and there's a whole line of gags. Tim and I sat down one evening and invented all those preposterous recipes. We then got in a professional cook and asked her to reject anything on the list that was technically impossible to make. So what's left is all feasible, gross as it all sounds. It's basically a joke about pretentious menus in restaurants . . . so we're laughing at that, no question. One of my favourite reads every week is Matthew Fort's restaurant review in the *Guardian Weekend*. When he takes the piss it's a scream.

However, sympathising or empathising with Aubrey the character is a whole different matter. There is an Aubrey in all of us. He is desperately sad. He really has all these aspirations, but his fear renders him dysfunctional. The only moment, paradoxically, when he knows what he's doing and is in focus in some way is when he's seducing Paula with the drums. Which is not a moment when you particularly love him. Most of the time he doesn't know what he's doing. People say, 'He's a caricature! There's nobody like that in the world!' – sorry, I've got news for you.

Did you intend to make a film with a happy ending or did the film need some optimism by the end?

The film's got a positive ending, so obviously I wanted one. Mostly these films arrive at natural conclusions, although there are always complexities. *Life Is Sweet* may have a positive end but that doesn't mean everything will be hunky-dory from now on and you can walk away and then forget about it. There's no way it could have a negative or pessimistic ending. It's a film about a girl coming out of a nightmare, about connections being made through things going wrong.

How did the film do in the UK, Europe and America?

It premiered at the London Film Festival. The festival director Sheila Whitaker said afterwards it was so popular it should've opened the festival. She said the next film would open it instead, but then changed her mind because it was *Naked*. It wasn't till *Vera Drake* that a film of ours opened the LFF.

Before we agreed that *Life Is Sweet* would be in the LFF, we checked with the Berlin Film Festival that this would not disqualify it from competition there. We were promised it didn't matter, so we screened it in London. Then Moritz de Hadeln, who ran Berlin, said this disqualified it.

But didn't Life Is Sweet *go to Berlin in the end?*

Yes, but out of competition. It was very well received. Alison and I also went to the Norwegian Film Festival, a long way north, in Haugesund. It was a big thing to do because our boys were little. We were on a plane flying across the North Sea and I suddenly thought, 'Fuck, if this plane went down the boys would become instant orphans.' So when we then went to the States on a promotional tour shortly afterwards we never flew on the same planes for the whole trip – much to the inconvenience of the distributors.

We committed a massive gaffe in New York. There are groups of adults there who get together every week and discuss a movie. The film-makers then come and talk to them. We went to this particular group that was full of middle-aged blue-rinsed women. We arrived some way through the film and sat at the back. People were

leaving. But there was still a substantial number of women left at the end. The reception was deeply frosty. The whole thing was summed up by a woman who asked why I made 'that poor girl eat all that chocolate'. They loathed the film, thought it was absolutely repulsive and reprehensible.

We were devastated. We then made a massive mistake which horrified the distributors. The next day we were interviewed by a guy who innocently asked how the film had been received. We told him the story and the next day it was all over the paper. Never tell a bloody journalist the truth!

It did particularly well in Australia. That was also the time I broke a self-imposed lifetime's ban and agreed to go to the Jerusalem Film Festival. It was very popular, as my films always are in that little country. The visit was very traumatic because I'd refused to go near the State of Israel for thirty years. But it was interesting. I'm glad I went that one time.

A Sense of History (1992)

This confessional memoir of the fictional twenty-third Earl of Leete (Jim Broadbent) is a short but shocking history of his estate. With his tweed suit, bald head and controlled upper-class voice, the earl tells the camera how his father committed suicide when he was barely a teenager, how he went on to kill his own brother at point-blank range and how, when the war came, he wasn't inclined to fight Hitler. Instead, he fell in love with a stable girl and drowned his wife in a lake on the estate. When he suspected his two young sons were witnesses, he drowned them too. Leete stands waist deep in the lake, re-enacting the scene for camera. Naturally, he never saw the stable girl again. He has remarried and now has two more children, who appear briefly by the lake.

At the end, the earl disappears inside the house, only to reappear a moment later with the rather prescient statement: 'If anything happens to me, I do want this film to be shown.'

* * *

AMY RAPHAEL: *How did you end up directing Jim Broadbent's script when you're usually so fiercely autonomous?*

MIKE LEIGH: Jim Broadbent has a cottage in Lincolnshire, and one day in the early 1990s when he was out on a walk in the Fens he improvised this monologue to himself, then went home and wrote it down. He took it to the BBC and they dithered. He then told me about it, asked if I wanted to read it – he knew I wouldn't direct someone else's script. But I read it and thought, 'Well, actually, this will be really good fun to do.'

I showed it to Simon Channing Williams, and we decided we'd like to do it. Meanwhile, the BBC were procrastinating about it. The whole conceit of it was that it was a mock documentary. Apparently Alan Yentob was considering it, so I phoned him, and he was worried that everyone would know it was Jim and therefore it wouldn't work as a mock documentary. So while they were procrastinating, we went round the corner to Channel 4 to see David Aukin, who immediately said, 'Yeah, we'll do it.'

It must be strange directing a film with a script in place, written by someone else. For a start, you had to relinquish your usual control . . .

Yes. That aspect of it is worth discussing. Previously I had never even remotely considered the idea of directing someone else's script, but for a variety of reasons this felt right; it wasn't a case of not being in tune with it or not liking everything in it. Part of the trick of what I do is that, having engendered my own material, I understand everything I shoot. It's linked to the juices of my own body, as it were, rather than not knowing if you'll really get or even like someone else's script. With *A Sense of History* that wasn't an issue anywhere along the line. It was completely up my street as a gag.

One of the other things that pretty much rules out the possibility of directing anyone else's material is that you have to cast it and then find a way of making it work for actors. Again, in this film it wasn't an issue as it came ready cast, and the actor wasn't an issue as he wrote it. In that sense, it had some of the characteristics of my own work. It was ready-made, organic.

Far from being an alien or strained experience, it was actually very liberating. Jim's brilliant comic writing was right up my street, like *Augustus Carp, Esq., by Himself* or *The Diary of a Nobody*. I very much directed it. I was as responsible for its visualisation as usual. It was a brilliant experience. I'm proud of it as a piece of film-making, despite the minor fact that it wasn't engendered or written by me.

It looks freezing in every shot.

That's because we shot in the third week of January in Newbury,

in the depths of freezing winter. It was as cold as it looks (*laughs*). The running gag while we were shooting it for Channel 4 was everyone walking around saying, 'Do you think the BBC are going to do this?'

During one of the takes this idea suddenly popped into my head that Jim could play W. S. Gilbert. But we'll come to that later.

Anyway, we were very disciplined. Jim's script didn't need much editing. Simon was living in Newbury at that time and he knew Lord Carnarvon, so we got to shoot it at Highclere Castle. We went down there a few times, paced around, worked it out, rehearsed it. All very disciplined. We pulled in Stephen Bill, who was Finger in *Nuts in May*. He's a close friend of both Jim's and mine. He plays the estate worker on the tractor.

Did Jim Broadbent manage not to corpse during filming?

Just about. It's hilarious. But he didn't find it very funny when he was in the seriously low-temperature water. That scene is totally for real (*laughs*).

You worked with your usual team: photography by Dick Pope, design by Alison Chitty, music by Carl Davis.

Alison designed this wonderful little house by the lake out of an upturned boat. Of course, we got posh kids in to be the kids. Carl Davis put the music together in about an hour; he was very busy, off on a conducting tour in Germany or something. He came to the cutting room and watched it a few times, and then went away, wrote it and recorded it – all within less than forty-eight hours. It's a great little score.

Can you imagine doing a similar project in the future, given similar circumstances?

Why not? It's not what I normally do, and life gets shorter. But everything's possible.

Were you thinking of your next feature film at the time?

We were in an agreement with a company called Mayfair to make a film for which Channel 4 and British Screen were putting in a

minor part of the budget. It was a film that I talked about long before and long afterwards, about flight attendants crossing the Atlantic. It had a budget of £3 million. It was in the planning stage when we made *A Sense of History*. In the weeks that followed *A Sense of History*, it became abundantly obvious to us that the amount of money that was available to make this film was ridiculous given what the project was. Also, the backers were being inflexible about when we could make it – they wanted it in time for Cannes the following year.

There came a point where it was obvious the film couldn't be made for the budget and within the time frame. So we went to British Screen and Channel 4 and said we'd love to walk away from this film and make an unspecified film with the remaining amount of money. They thought it was a good idea. We pulled out of that deal and instead made *Naked*. It wasn't what I had been premeditating at all, although the preoccupations of *Naked* had been going on. Probably more than issues of air travel!

Naked (1993)

Down a dark alleyway in Manchester, Johnny (David Thewlis) is having rough sex with a woman. It's hard to see exactly what is going on, but it's clear she is starting to object, to struggle. Johnny runs off. He steals a car and drives overnight down the motorway to London.

In the morning he turns up at the flat where his ex-girlfriend, Louise (Lesley Sharp), rents a room. Louise is out at work, so he talks to her flatmate Sophie (Katrin Cartlidge), a needy, desperate young woman who, like Johnny, is dressed in black. They drink tea and smoke a spliff together. While Sophie talks without moving her mouth much, Johnny spits his words out thick and fast. He is expressive and articulate, well-read and opinionated, disillusioned and nihilistic. Edgy, restless, humorous. An end-of-the-century street philosopher.

He shares his world view with Sophie: 'Have you ever thought you've already had the happiest moment in your whole fucking life and all you've got left to look forward to is sickness and purgatory?' She frowns: 'Oh shit.' When Louise returns from work, Johnny is rude and mocking, ridiculing her for being straight and responsible. Louise lies in her single bed listening to Johnny and Sophie having sex.

In the early morning Johnny talks aggressively to Louise. Later in the day Sophie shadows him round the flat, telling him how much she likes – and then loves – him. He is untouched. They have sex on the sofa. He grabs her hair and pulls it, fucks her violently, smashes her head on the arm of the sofa. Later that day he winds both Louise and Sophie up and then storms out of the flat.

Johnny wanders round Soho. He meets Archie (Ewen Bremner), a Scottish youth with a serious twitch who repeatedly shouts his girlfriend's name, 'Maggie!' When Archie wanders off to find Maggie, Johnny bumps into her, and they go off to find something to eat. 'Do you know that wherever you are in London, you're only 30 feet away from a rat?' asks Johnny. 'Does that freak you out?'

At a tea stall Maggie (Susan Vidler) suggests Johnny is 'about forty'; he says he's only twenty-seven. Johnny is surprisingly gentle and protective. Archie is reunited with Maggie on some waste ground and the couple go off into the night, shouting at one another. Johnny is left alone in the misty night.

Johnny finds shelter in the doorway of an empty office block. The security guard, Brian (Peter Wight), invites him in. They take a tour of the building. 'You could steal all the space and no one would notice,' observes Johnny. Once he starts talking, Johnny seems unable to stop. He shares his apocalyptic, nihilistic views with Brian, telling him, 'I don't have a future. Nobody has a future. The party's over, man.'

The two men look out at a woman (Deborah Maclaren) in the window of the flat opposite. Johnny teases Brian for spying on her. He leaves the building and goes to her flat. She is high on vodka and happy to let him in; like Sophie, she wants to be kissed, touched, loved. Johnny pulls her hair, taunts her, glancing out of the window in case Brian is watching. He tells her he can't fuck her as she looks like his mother. He sleeps in her armchair and then steals her novels.

He meets Brian again and they have breakfast in a nearby cafe. Brian shows him a photo of a dilapidated cottage in Ireland where he hopes to live once he retires. He warns Johnny with grave seriousness not to waste his life.

Johnny wanders the streets, then returns to the cafe. The young waitress (Gina McKee) invites him home. He looks through the books left on display by the absent gay owners of the flat and declares he's read most of them. She asks if he has a photo of his mum. 'I think you might find one over at the newsagent on the top shelf,' he spits. The conversation deteriorates and she tells him to 'just fuck off'.

Meanwhile, the landlord of the girls' flat, an obnoxious upper-class character calling himself Sebastian (Greg Cruttwell), has let

himself in before Sophie gets home. He has appeared earlier in the film, calling himself Jeremy, picking up a waitress in a restaurant and forcing her to have sex. Now he rips off her tights, buggers and rapes her. Louise comes back from work to find Sophie a gibbering wreck. The two women go to the pub to escape Jeremy/ Sebastian.

The same night, Johnny is kicked to the ground by a man putting up posters and then beaten up by a gang of youths in a random attack in an alleyway. He returns to the flat with a bloody face and a damaged leg. The third flatmate, Sandra (Claire Skinner), returns from a disastrous safari in Zimbabwe and is appalled by the messy flat. Jeremy/Sebastian makes a pass at Louise but she ironically threatens him with castration; Sandra, who has an undisclosed history with him, is also angered by his presence. He finally leaves.

Louise and Johnny lock themselves in the bathroom and talk; Sophie sits on the stairs crying. Louise offers to hand in her notice and go to Manchester with Johnny. He agrees. It's only a few days since he arrived in London; the next day, while Louise is at work, he steals the money left by Jeremy, leaves the flat and hobbles slowly down the road.

* * *

AMY RAPHAEL: *You may insist that all your films differ, but* Naked *is without doubt a departure both in terms of its truly epic nature and its move away from the intimate environs of the family home.*

MIKE LEIGH: I tend to talk about *Naked* in terms of the apocalypse, the end of the century and impending doom, all of which are absolutely part of the very essence of the film. As I have said before, I have a general tendency or instinct to dish up something that's different to what went before. On that level, *Naked* is obviously as different to *Life Is Sweet* as *Topsy-Turvy* is to *Career Girls*. Indeed, you can find that in earlier sequences of films too.

On top of that, I was – and remain – very aware of the inevitable correlation between the fixed domestic environment and the risk of the narrow view of a limited domestic film. With *Naked* I was embracing the notion of a film that by its very nature was going to be peripatetic or picaresque. It was a very deliberate, conscious

device to get away from being locked in another street with another bloody family and another domestic situation. Not that *Naked* isn't about families, because it is in some ways; after all, the characters are in retreat from their families or on the run from family situations. But in terms of consciously liberating myself to paint a bigger canvas, that was part and parcel of it.

Did you feel as though your work was becoming too easy to label, perhaps even homogeneous?

In a way I did, yes. In that sense, I thought it really important to break away from the perception of what a Mike Leigh film was. Even Michael Coveney, in his excellent book *The World According to Mike Leigh*, acknowledges how people talk about 'a Mike Leigh situation' or 'a Mike Leigh character'. It's fair enough and I don't in any way disagree or object to it, but even now, after a very long journey, when people say such things they still mean situations or characters in *Abigail's Party* and *Nuts in May*, while actually I've moved on and on.

So in the early 1990s I was really keen to shed those shackles. Having shed them in *Naked*, I returned to a domestic world in *Secrets & Lies*. But the epic dimensions of *Naked* had liberated me, and they are there in *Secrets & Lies* too. Without *Naked* before it, I don't think *Secrets & Lies* would have had the same sense of scale in terms of emotions and dynamics.

Did you have a sense of the journey you'd made from Bleak Moments *to* Naked?

Absolutely. When I made *Bleak Moments* it seemed a given that there was an inevitable correlation between my way of working and catatonic or non-communicative characters. The fact is, that's rubbish and there's no correlation in any shape or form. There are garrulous characters much earlier on – Keith and Candice-Marie have something to say in *Nuts in May* – but, of course, *Naked* is a very deliberate attempt to go beyond that. It's a conscious decision on my part to investigate a character who not only has a great deal to say but also has actual ideas on the go, which in themselves are extraordinary enough to explore.

So you wouldn't have been ready to make this film any earlier?

No. I don't think so. If you look at Cyril and Shirley in *High Hopes*, you can see that I'm already looking at the way people express ideas and views. Which is a far cry from some of the earlier films. You could argue that Sylvia in *Bleak Moments* is capable of expressing ideas, but she doesn't actually do so.

But no, I don't think I could have made *Naked* any earlier. And also, given what I've been talking about, it's by no means insignificant that *Naked* was the first film to go to Cannes. It won two prizes; it was the breakthrough film.

I keep returning to the political backdrop in Britain as you were making the last half-dozen films, and it's just as relevant in Naked.

None of my films is particularly about Britain, and *Naked* especially is not. There are references to the fact that Johnny comes from Manchester and travels to London, but they could be any cities; it's a universal landscape. The preoccupations of *Naked* are much wider than the state of John Major's Britain. There's a reference to Margaret Thatcher, but only a minor one.

Yet this was the era of the infamous Sun *headline 'If Kinnock Wins Today, Will the Last Person in Britain Please Turn Out the Lights?' (April 1992). And homelessness was a big issue.*

When we made *Life Is Sweet*, I disappeared from the West End for nine months while we rehearsed and shot the film. When I returned to do the post-production, there was suddenly a proliferation of people sleeping on the streets. When I started thinking about *Naked*, I absolutely had it in mind to make a film about homelessness. That was definitely an objective. But as I pursued it – and once again I discovered the film through making it – it became abundantly clear that it wasn't about homelessness as such.

Although some people have seen it or remembered it as being about Johnny the homeless person, he's not homeless: at the beginning of the film you see him go back to his house in Manchester and pick up his luggage. The last time you see him is only a few days later. The film strays across the main road of the subject of

homelessness but it's not really about that at all. It merely evokes its spirit. You could argue that Archie and Maggie are not homeless yet, although that will happen. For now, though, it's just the insecurity of having just arrived in London.

Johnny may not be homeless, but watching the film one feels he may become so very quickly.

Sure. From the perspective of the chauffeur of the Rolls-Royce who briefly thinks Johnny's the client he's been waiting to pick up, he is either a pop star or a vagrant.

Why do you think people found Naked *so hard to watch when it first came out?*

Anyone that criticised it in that way wasn't getting the film. If you dig out the reviews, you'll find questions such as this: why does every woman in the film allow herself to be a victim, to be a doormat? And it's just not true. It's not true of Louise, for a start. It's a far more complex film than those questions suggest, but there were certain kinds of old-fashioned 1980s quasi-left-wing reactionary attitudes on the go.

I saw a BBC programme the other night about feminists in the

24 *Naked*: Johnny (David Thewlis) and Sophie (Katrin Cartlidge).

1970s. There were even crèches in Camden where they wouldn't allow boy children! That was the spirit of the criticism of *Naked* at the time. When the film came out, there was a Q&A at the Screen on the Green in Islington and a 'feminist' started attacking it. What she didn't know was that Katrin Cartlidge, Lesley Sharp, Deborah Maclaren and Claire Skinner were all in the audience. They had this woman for breakfast. They weren't having it. No woman involved in the film is the type who would allow herself to be a doormat. We'd never have got the film made. They'd have cut my balls off first. They were nothing if not feminists.

You were clearly disappointed by accusations of misogyny.

No one could have anticipated some of the nonsense that the film would endure at first, nor the flak it would get from so-called feminist quarters. But when we talk about the early fate of *Naked* – and I say early because you'd never hear those kinds of comments or criticisms from young feminist women now – it's vital to discuss the spirit of the shoot. It was a very smart, mixed crew. There was a female designer, art director, boom swinger.

We made a point always that when we shot the scenes which were tough going from an actress's point of view – such as the scene in which Sophie is raped by Jeremy/Sebastian – there wasn't a room full of blokes like there would've been in the old days. And Heather Storr, who always works with me as script supervisor, was around. Having said that, the following is true: the film was shot from the autumn into the winter and it was, at times, a tough experience.

It's also important to remember, I think, that guys like Johnny are very charismatic. There's obviously never an excuse for violent behaviour, but such men exist and women seem to fall time and again for men who they think they can help or mother or whatever.

Absolutely. Of course these men exist.

If I'm honest, David Thewlis is oddly attractive in Naked. *He's dirty and out of control and angry, but he's also fiercely bright and he has ideas.*

25 *Naked*: Johnny (David Thewlis).

I agree. And life is never straightforward; people are complicated.

*I also don't feel as though the scenes where Johnny initiates sex –
either with Sophie or the woman in the window – are in any way
glamorous or glossy. They are raw and uncomfortable.*

All of that is absolutely right. The film is in no way a celebration
of male sadism. The other character that Greg Crutwell gives us –
Jeremy/Sebastian or whatever he's really called – is there to offset
Johnny. I thought it was important to see somebody who actually
is a rapist.

But whatever I say, the perceived wisdom in some quarters is
that *Naked* is a misogynistic film. And a cynical film. It's absolutely
not a misogynistic film because it's in no way a celebration of
misogyny; it's a criticism of it. Many critics have asserted that
Johnny is a cynic. On the contrary, Johnny is a frustrated, disap-
pointed, embittered idealist. The very opposite of a cynic. He
believes in real values. He's entirely disillusioned about the way
people and things are. Having said that, *Naked* survived in all
sorts of places and contexts as a voice of the time. Particularly for
young people. And it has remained immensely popular.

You just alluded to it being a tough film to make for both cast and crew.

Absolutely. The mood of the film really took us over. Not really in any negative way, given that people were very behind it and very committed to it, but it was very pervasive and powerful. The way it was lit and the concentration . . . when a film's really organic it gets to people.

You mention the way the film was lit: the look of Naked is particularly important, creating as it does an edgy, bleak and chilling atmosphere. Did cinematographer Dick Pope decide to use the 'bleach bypass process' that makes it look as though it's washed out in black and blue? Or did you decide together?

What happened is what always happens. The various artists or heads of departments who collaborate with me knowingly – as opposed to the actors who are unknowing – sit and wait till I'm able to give them a clue. One day during these rehearsals I was able to have lunch with Dick Pope and Alison Chitty – the production designer – and talk about a nocturnal journey, a sense of doom. A solo guy on this journey, et cetera. Out of that we started to talk about tone, mood, colour palette.

Then we did what we've subsequently done more regularly, which is to shoot tests of an entirely visual nature, using stand-ins to represent the actors who were going to be the central protagonists. Dick Pope, Alison Chitty, Lindy Hemming the costume designer, Christine Blundell the make-up designer and myself met up and talked again about tone, palette, film stocks. Dick mentioned the possibility of using bleach bypass, so we sat down in a preview theatre and looked at reels from a whole lot of different films that had been shot using that process, including *Nineteen Eighty-Four*. It seemed obvious that it was what we should use.

When it came to the shoot, the colour control was obsessive on Alison Chitty's part, to the extent that in Brian's office block you actually see a fire bell that is dark grey because she'd had it painted. When we did a shot in the street, there was a red car and no one could locate a driver; the guys finally had to bounce it out of the way.

Just to dwell on the subject of Alison Chitty for a moment, who

remains a very close friend: until *Life Is Sweet* she hadn't designed films. In the end she only did three, including *Secrets & Lies*. She has never designed a film with me since, because fundamentally she doesn't like it. She is very much a play and opera designer, and although she appreciates film, she doesn't like the fact that as a designer you design the whole thing, hand it over to the director and cinematographer, and they then decide on the images. Which is obviously not how it works in the theatre – at least, that's her argument. She's not in the least bit aggressive about it; it's just the path she's chosen to tread. I think her achievement on *Naked* is extraordinary. But the decision to carry the campaign against red to its end is operatic to say the least. Of course, more recently Alison designed my play, *Two Thousand Years*, at the National Theatre.

I presume you and Alison decided on Brian's office together.

I thought Brian should be in a working office block because my experience of working for Securicor in the 1960s was of guarding people's offices. One day Alison came back very excited and announced she had a great idea: what if it's an empty office block with just space that's not yet been let? I thought it was fantastic. A great idea, absolutely relevant to the central ideas that were evolving. Much better than my idea, much more inspired.

The house that you finally found for the girls in Dalston was perfect.

There were lots of feasible flats but none was very interesting. I had a real resistance to using just another ordinary domestic house in a street. It had to have an edge. Alison kept asking me to explain more. Then one day she ran in with the location manager, shouting, 'We've got it! We've got it! It's in Dalston! We must go there immediately.' Which we did. And, of course, it was fantastic, an extraordinary Gothic house. Not only is it interesting in itself, but what made it special – and absolutely squared with what I wanted – is that it's not just a house in a straight line in a street. It had an epic feel: you could look at it from a hundred and one different angles, and – witness the end of the film – you could see it from about half a mile down the street. Of course, finding the house absolutely liberated us. We'd found that edge I was looking for.

Did you also have problems finding a rehearsal space?

I wanted to film *Naked* in the West End, so we needed to find a place that was central. We eventually found a disused office block that had belonged to the ILEA, just off Marylebone Lane. And that's where the film was developed.

You'll no doubt argue that you could say the same for all your films, but it's hard to imagine any other actors playing the central parts in Naked, *especially when one thinks of David Thewlis's extraordinary performance.*

I agree about Thewlis. But it's hard to make any generalisations. Greg Crutwell has come in for an unnecessary and unfortunate amount of flak for his Jeremy/Sebastian character, for creating a caricature. I don't think it's true. I was in a pub in Poland Street last night with some friends and there were a whole load of people baying. Someone came up to me and asked if I was Mike Leigh. They bought me a bottle of wine. They were only in their early to mid-thirties and they were Jeremy/Sebastian types, basically.

The meat and bones of *Naked* were, of course, David Thewlis, Lesley Sharp and Katrin Cartlidge. Here's an interesting, convoluted bit of background to this film that shows it's important to bend your own rules sometimes. The accepted etiquette when casting is this: you check an actor's availability and make it clear it's a serious request. If the agent then phones back and says another project has come up, you have to make a decision: let it go or agree to ask the actor to be in the film. In the case of Claire Skinner, we had checked her availability and later decided she should play a central character. When we called the agent to make the offer, we were told she wasn't available as she was doing a series with Lenny Henry. I phoned her up and found out they'd forgotten to tell her or us. It's just what many agents are like. So I asked if she'd join us late, when she'd finished the TV series, as Stephen Rea had done in *Four Days in July*, and bring up the rear. I had no idea what that meant or what she might be doing, but she agreed. If you think about the logic of it, that's complicated because she plays a character whose flat the girls live in. What happened was this: I invented a nurse called Sandra, a practical, down-to-earth woman who was always conveniently on ward duty and therefore not around. The

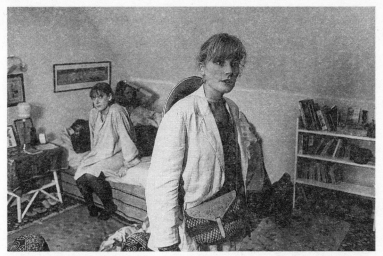

26 *Naked*: Sandra (Claire Skinner), with Louise (Lesley Sharp) and Sophie (Katrin Cartlidge) on the bed

other actors can't do improvisations with a character who isn't played by an actor. She was a standard off-screen character.

When Claire was due to join in, I decided to put in her version of Sandra retrospectively, as it were. Of course, the Sandra she and I invented was an altogether nuttier lady than the first version, but still practical and down to earth underneath it all. And we went back and re-explored – or explored in greater depth – all her relationships. So, with the appropriate adjustments, we integrated her into the world of the story, including the liaison she'd obviously had at some stage with the landlord.

So we'd done it back to front. I'd broken my own rules. I often do. Rules are there to be broken. It's all about telling a dramatic story, not playing a sport.

Going back to Thewlis for a moment: is it true that you have a theory about everybody seeing a dead body at least once and you wanted him to see one?

I think everybody should experience a whole number of things. I certainly think all artists, all actors should see a dead body and should be confronted by all manner of experiences. Like seeing a baby being born. It is certainly obvious in the context of what we

were doing in *Naked* that it would make sense for David to go and have the experience of seeing a dead body. Sometimes I get actors to do things that the characters wouldn't necessarily do. Things often work in a lateral, more Zen kind of way.

Here's another sideline anecdote. During the rehearsals of *Naked*, one of the big stories that hit the papers was the vexed question of the 'Squidgy tapes'. The question was whether they were real, if it really was Princess Diana and James Hewitt or if it was actors. The *Guardian* paid me £100 to listen to them. I came to the very quick and easy conclusion that there was no way it could be actors. It was for real, because I know what actors improvising sound like and I could have detected it. For actors to have arrived at what was on that tape would have been a very long operation, and not many actors have those specific skills, let alone directors to make it happen.

We talked earlier of the criticisms levelled at Naked, *but when you watch it now what stands out?*

The section of the film that is most interesting to discuss is this: Johnny has escaped, he's come down to London. For the first passage of the film after that it's fairly claustrophobic and he's mostly in the flat with the two women. There's a sense of being trapped which finally manifests itself in the scene where Louise is watching the box and Johnny is prowling around, followed by Sophie. They go from the living room to the kitchen to the stairs and back to the living room.

From a technical or *mise-en-scène* point of view it's an interesting scene because I've constructed the action to serve the shot. I wanted to get the feel of Johnny prowling around like an animal in a cage, so I decided to use a continuous panning shot, from the kitchen to the living room, to and fro. That scene is lit in a very heightened way because Dick Pope and Alison Chitty colluded and used wicker lampshades that created a speckled effect everywhere. Of course, the score is building throughout that scene to a crescendo, which it hits as Johnny finally leaves the house, rushes down the steps and runs across the road. What I love about that exterior shot is that there's a sign up with arrows pointing in two different directions – a great piece of synchronicity.

The music – which is inspired Andrew Dickson, with Skaila Kanga playing the harp – crashes to a final note there. The next section of the film, when Johnny goes into Soho, is played without music, which makes it feel as though it's shot in documentary mode, although it isn't. All the action round Brewer Street and Tottenham Court Road was shot in one night without any crowd control; people are wandering by, cars go past. So there's a definite sense of the real texture of the outside world. It's a stark contrast to the taut and controlled mood inside the house.

Within that whole sequence there's a mixture of two quite different sorts of locations. In a way, there's a sort of shift back and forwards in style. There are the scenes where you see Johnny and Maggie walking in that great wide long shot and there's a fire and dogs and he's talking about the guts of London. Then they walk over a narrow bridge that's lit in a very heightened way, and finally they arrive at the outdoor cafe. It's a strange, barren landscape that is, in fact, the remains of a railway station near Brick Lane that was closed in 1937.

Those scenes, which are all very heightened and for which the music returns, are intercut with the very naturalistic scenes shot around Tottenham Court Road and the West End. When I proposed this, everybody worried that it wouldn't match. But I wanted to create a world that wasn't a world; not a literal world, a poetic world.

And Naked, *of course, is defined by its language more than any Mike Leigh film before it.*

That's not strictly accurate. All my films are defined by their language, in the sense that I've been consistently concerned with achieving accurate, heightened, imaginative dialogue.

Of course, what you mean is that Johnny is given to greater flights of ideas and verbosity than any previous character. And David Thewlis was quite brilliant at doing it. But the dialogue style informed the whole film, and the rest of the cast was well up to it, not least Peter Wight and, when she finally showed up, Claire Skinner, with Sandra's wonderful elliptical utterances.

Let's talk about Johnny and Louise. It seems unlikely they spent a

year going out; she appears to be fairly straight, honest, calm, while he is a wild, angry young man. Was she simply taken in by his charisma and charm?

Well, they did go out for a year. You said yourself that you can imagine getting involved with a guy like that under certain circumstances. Well, that's what happened to her, in a nutshell!

She obviously knows that his heart is in the right place. I know from the back story that when she was going out with him she thought he was redeemable, and she still thinks that now. But she got fed up of him and buggered off to London. She doesn't want to know, but he gets beaten up and there they are in the bathroom . . . Plainly there's real feeling between them, and they both know it.

Desperate for love, Sophie is also taken with Johnny. Louise at least has forged a life for herself in London post-Johnny; Sophie appears to be a lost cause, declaring love for him within hours of meeting him.

What I find interesting about Sophie is that for all her nonsense, she comes out with some very clear thoughts. The most truthful thing she says – and the truth that lies at the heart of the film, certainly in its view of the relationship between men and women – is

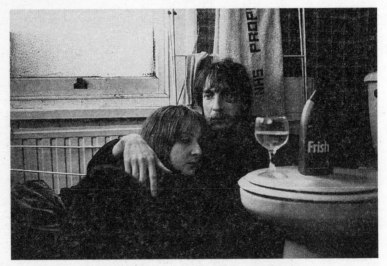

27 *Naked:* Louise (Lesley Sharp) and Johnny (David Thewlis).

this: 'What they start off loving you for they end up hating you for.' It's so true. And I'm as guilty of that as any other bloke.

Again, she's a wasted person. And also, in the context of a film that is about the relationship between the moment we're in and all the moments in time, it's important that here is a woman who is pathologically incapable of doing anything other than feed off the moment. She wants the gratification and the returns in the moment. Yet Sophie's got a sense of humour. Like all needy, insecure people she's capable of forgetting it at times, but it's definitely there.

You became close friends with Katrin Cartlidge during the making of Naked *and were devastated when she died suddenly in September 2002, at the age of just forty-one.*

It's impossible to talk about Katrin, this film and *Career Girls* without simply being overcome by an enormous emotional sense of loss. It's indescribable. Plenty of people have died, and obviously one feels bad and sad about them, but very few have died and left me with such enduring and inconsolable grief. I am one of a whole bunch of people who still say, 'I can't believe she's not going to show up and have lunch.'

I first auditioned her around 1983. She had been a child actress. Alison Steadman had been in a TV play with Katrin when she was a kid, so she'd been around for ages. I'd seen her in various things and thought she was quite interesting. Then I saw Steven Berkoff's production of Oscar Wilde's *Salome*, which was very heightened, extraordinary and funny. I thought she was fascinating in that. She was on tour with it in Japan when I phoned her up and asked if she'd like to be in the film. She said yes instantly.

The great thing about Katrin was that she'd turn up every day and say, 'This is such a gas!' She loved it. She was great company and very easy. Just fun, basically. And funny.

She gives an astonishing performance as Sophie . . .

Well, you can imagine a character like Sophie in the hands of an actress who is even in the slightest way like that herself . . . it would be disastrous. But the great thing about Katrin – and the cool thing about her – was that she wasn't like that at all. She

could get into a character, get into the danger of it, yet not in any way run the risk of being damaged by it and therefore not run the risk of getting it wrong. I remember during the improvisations exploring Sophie's character, and it was just fantastic.

The other major player in this film is the indomitable Lesley Sharp. She was going to be in the film that never happened. She was famously in *Road*, the BBC film of Jim Cartwright's play, directed by Alan Clarke, and in the latter's *Rita, Sue and Bob Too*. She's good, clear, smart. The shared intelligence of that cast informed the film in a very particular way.

Let's not forget Peter Wight: the scene between Brian and Johnny in the empty offices must be one of the best examples of how your method pushes actors to their linguistic limits.

Ah yes, the great Peter Wight. I decided in constructing the elements of *Naked* that we needed to create a situation where we could explore Johnny in debate with somebody about all his preoccupations. I suppose I'd say that the creation and shooting of that material was the toughest I've experienced anywhere along the line. We did the basic improvisations for it in the office block in which we happened to be rehearsing in Marylebone.

I'd set up the woman in the window – played beautifully by Deborah Maclaren – because we actually had that configuration there. We'd opened up the raw premise of the thing. As with all these things, the improvisation is not very interesting when compared to the end product. It's merely a pointer, a sketch, a collection of cartoons in the Raphael sense.

What motivates Johnny to go and see the 'woman in the window'? Does he go to seduce her because he knows Brian will be watching and he wants to prove he can?

This is something I'd rather leave you, the viewer, to decide. But . . . OK. She looks like she might be interesting. Johnny is obviously in some way turned on by the prospect of an early middle-aged woman dancing by herself and being kind of sexy in some way. And yeah, in some ways it is to do with Brian. He's either doing it for Brian or to irritate him. Or to give Brian something to get off on. Beyond that, who knows?

How immersed did David Thewlis become in Johnny?

He was actually living in a Soho bedsit. Whatever you do on this scale of involvement, it gets into your bloodstream. So, plainly, playing Johnny day in, day out for months on end inevitably affected him. But the notion that it took him over completely is simply ridiculous. Of course, he wasn't up for going out on the razz because he was busy working on *Naked*. He was reading constantly, catching up for Johnny.

The myth that he was totally immersed in the character throughout the shoot was further perpetuated by an incident that took place while we were shooting the scene where you see him by himself in central London with crowds of people walking past. The scene was shot outside Leicester Square tube station. We put the 35mm camera with a 1,000-foot magazine in the middle of the road on a traffic island and wrapped it in bin liners. Such techniques are all Dick Pope's. He had massive experience of working as a documentary cameraman on Granada's *World in Action* back in the 1970s. This is a man who's been into the sweatshops of Hong Kong with a camera disguised as a briefcase. So we'd set up the shot of Thewlis outside the tube station specifically so no one would notice he was there. The actor Kenneth Cranham came out of the station, saw David and started chatting to him. What Ken experienced at that moment was David in a mood and a terrible state, but the truth is that he was in character because we were shooting. And that's how the story started.

I've read that Thewlis was very turned on by all the reading and learning he did for Johnny.

Once we'd got the hang of Johnny, David would just go off and read while I was working with the other actors. Amazing things would happen. One day, for example, he rushed in and said, 'You won't believe this! I ran into this nutter in Soho who was handing out these pamphlets.' It was the stuff about bar codes. It was fantastic, crazy, so we used it.

Although it was rewarding, it was also a ludicrously tough assignment. As always, we had to create the action in the location before shooting it. You only have access to a location for a limited amount of time. In the planning meeting before the shoot we

couldn't work out how to rehearse night scenes during the day. Someone very smartly pointed out that we needed to rehearse at night too so that it was the right atmosphere. We spent about ten days or a fortnight in permanent night-time mode rehearsing this fucking thing in the building, with Johnny discussing the entire bloody length and breadth of the meaning of life. It was desperate, it really was.

The shoots were all at night too. And my charming Greek-Cypriot neighbours in north London had a faulty burglar alarm in their house which went off at 10 a.m. every morning while they were at work. I'd arrive home really late and hope to sleep till lunchtime, but never made it.

Why does Brian allow himself to be verbally abused by Johnny and let him stay for so long? Is it simply down to loneliness?

Yes. It's great for Brian: suddenly somebody interesting turns up. Part of the answer comes in the scene in the cafe. He's developed some kind of father-like soft spot for Johnny. He's the only person in the film who has any advice or guidance for Johnny: 'Don't waste your life.' That comes from something somebody said to me once, but I won't go into the details. My films are full of such personal things.

The timing of Brian's advice is everything: you can actually see the power between them shift slightly. Johnny is usually the one asking awkward questions, making demands, dominating the relationship.

For once he's on the back foot. A very important moment for that reason, if no other.

Yet he reverts to type pretty much immediately when he meets Gina McKee's cafe girl.

And she cracks up for her own reasons. He just wants a bed for the night.

She asks if he has a photo of his mum, and he replies that she might find one on the top shelf at the newsagent's across the road. We

understand why he might behave in the way he does towards women, although we do not forgive him.

Absolutely. But some people are disposed to take that comment literally. He doesn't mean his mum is actually a whore or a cheesecake model; he's just being extremely rude about her. Anyway, shortly afterwards we meet the gorgeous Sandra. She shows up in her safari kit in the middle of all this chaos; you couldn't sit in a room and write such a scene.

The juxtaposition of Johnny lying on the sofa, dirty, ragged, in a mess both physically and mentally, with Sandra tidying up the flat, making order out of chaos.

What's great is when she says, 'My wanker boyfriend.' We all know holidays are the best place for relationships to be destroyed (*laughs*). I don't think anyone should underestimate the fact that, in that brief period at the end of the film, Sandra really is as literary an achievement as Johnny. If I were allowed to, I'd say there was particularly good dialogue in that scene.

Following a scene that pleased you so much, you weren't sure how to end the film.

It was certainly a problem for a while. I discussed it at length with David: does he stay? Does he go? Does he return to Manchester or stay in London? Talking about it from my point of view as a film-maker, there's a big difference between the sort of ideas you have before you start shooting a film and what sort of creative process goes on when you've shot 99 per cent of the film, your cinematic juices are flowing and you've got the hang of the film you're making. It's important to remember that I can only make a decision about the ending when I've shot most of the film.

So the question of 'What does he do?' translates into 'How does the film end?' Which in turn translates into 'What is the cinematic image?' I couldn't get it. I couldn't see what the answer was. I could see all the possibilities but no one decision seemed right. Do you see Johnny and Louise getting on the bus and, if so, so what?

Every day I drove to the location from north London all the way down the road where Louise's house was. I could see the house at

the end of the street. I'd turn off and park at the unit base in the school playground. So every day I'd be looking at the house. I knew I enjoyed looking down the road at the house but I wasn't really paying attention; I was thinking about breakfast or the *Today* programme. Then one day – ping! – I suddenly got it. I'd been driving down the shot, in reverse, for weeks. It had been staring me in the face. The minute I realised what the shot should be, I knew what the image had to be: Johnny hobbling down the road, with the house receding behind him. I shared it with David Thewlis and then with Dick Pope. Dick said we couldn't track down the road because it's too long and you'd see the tracks. We couldn't do it handheld because it would be too clumsy. The only way to do it was with a Steadicam, so we hired one for the day. It's the only Steadicam shot anywhere in any of my films. We did bring a guy with a Steadicam up to the prison in Oxford when we shot *Vera Drake*, but we sent him home after twenty minutes with half his fee. We'd changed our minds.

Frankly, the last shot of *Naked* is a joy to watch. Every time I go to a screening I certainly make sure I'm there for it.

Is there a theme that pulls the film together, other than the obvious one of modern isolation? It's probably fair to say that Johnny, irritated with everyone around him, chooses his own company at the end . . .

There are other important things about *Naked*. Brian is guarding an office whose destiny is an unknown function. The 'woman in the window' is in a room with a map of Ireland on the wall that she hasn't even noticed. Why is it there? The waitress is living in a flat owned by two camp gay men who've gone off to America, but she doesn't know who they are. There are books in the flat she hasn't noticed or read. Not to mention all that stuff about Sandra's Buddha, Catholicism and maps of the body. Even in the bathroom, when Johnny and Louise are sitting on the floor, there's a towel behind them inscribed with 'NHS'. In other words, this is an enigmatic world.

Then there's Archie and Maggie. I was hitch-hiking alone from London to Marseille in 1961 in order to catch a Turkish ship to Israel. I hooked up with a guy in the pissing rain on the road from

Boulogne to Paris called Wilson McDougall. His outstanding characteristic was that he was extremely thick. He was from Paisley and he wore a kilt. He was seriously out of his depth and a long way from home. He was paranoid, aggressive and in need of guidance. We were initially picked up by an elderly English lady in one of those half-timbered Morris Travellers. She immediately bawled us out about how hitch-hiking gave the English a bad name and would we stop doing it immediately, please? At which point she turfed us out.

We then got a lift to Paris from an extremely nice guy in a smart Citroën. He insisted on putting us up in his Paris apartment. He had a wife with whom one instantly fell in love, remaining so ever since (*laughs*). She was completely gorgeous. They took us out for a very nice supper, and then Wilson and I slept in a double bed. I was stuck with him. I had to get on the road as I only had six days before the boat left. So I gave him the slip in the Gare St Lazare. He lodged in my head for many years. Goodness knows what happened to him. I hope he went back to Scotland.

Did you pick up hitch-hikers later in life?

Yes. One day in the early 1970s Miss Steadman and I were driving to Liverpool in our Beetle and we picked up a Scottish guy from outside Glasgow who was another version of Wilson McDougall. I picked up hitch-hikers till, sadly and strangely, they ceased to exist. This guy had gone down to London to get a job, had hung around King's Cross for several days, had categorically not had a wash of any sort, and was now going back to Scotland. You just want someone to look after these guys, to tell them to please stay in Scotland. Now you see them having been drawn into the whole crack number, mingling with the tourists in the West End.

Anyway, we're driving up the M6 with this guy, and in no time we were virtually retching at his pong. So I said to Alison, 'We're a bit early, shall we go and see Paul and Jenny in Wolverhampton?' She kept asking, 'Who?' till she finally twigged and we managed to dump our passenger at a service station and continue the journey with our windows wide open.

These are the sorts of sources that informed Archie, with his bleat of 'Maggie!' Interestingly enough, given that we are explaining this

film in a completely unprecedented manner, Archie manifests all received notions of male behaviour towards Maggie, while she is quite bright and sharp. I love it when she says to Johnny, 'How old are you? About forty?' He says twenty-seven, but she thinks it's completely implausible. Johnny and Thewlis were, at that moment, twenty-seven.

Didn't David Thewlis and Ewen Bremner almost get arrested while improvising their scenes together?

One day, in the summer of 1992, there was a late-afternoon rehearsal with David and Ewen. I suggested we go out and they do an improvisation in the street. They went off, so I did as I always do, which is to clock what's happening by keeping close to the actors but out of sight. I'd organised it so that David was sitting on the steps of a church in Marylebone, and Ewen showed up. They were talking, and every so often Ewen would yell, 'Maggie!' He kept shouting at passers-by. All that manic behaviour was going on. Somebody at an upstairs window asked him to stop shouting; he told them to fuck off.

Three minutes later a cop car screeched to a halt. The fuzz jumped out, ready to roll the guys. So I leapt in and said, 'Come out of character!' The coppers were completely bemused. I told them we were rehearsing a film. They wanted to know where the cameras were. They didn't believe me, so I told them I had an assistant round the corner in an office who would corroborate the story. In the end it was all OK.

Something similar happened in *High Hopes*. There was an improvisation with Jason Watkins, who, as Wayne, had to wander around King's Cross with his suitcase trying to find an address. I think my instruction was this: if you see anyone else that you know is a member of the cast, then you know they're in character. So he came across Phil Davis, who was fixing his bike. I had deliberately invented an address that didn't exist so that there'd be no risk that Phil would know where it was and so would have to go inside to find the *A–Z*.

Well, Wayne showed up and they're just standing there wondering where this address might be when – apparently from nowhere – an enormous horse materialised with a uniformed superintend-

ent sitting in the saddle. He asked if everything was OK. They stayed in character, of course. The innocent Wayne asked if he knew where the address was. I thought, 'Oh Christ.' Of course, the copper didn't know the street, so he got on his walkie-talkie. I couldn't stand it any more, so I leapt out shouting, 'Come out of character!' Another confused member of the Metropolitan Police.

At what point did you decide to call the film Naked?

As always, there was a big struggle with the title. I think if Desmond Morris hadn't already written his book, I might have called it *The Naked Ape*, as Johnny makes lots of references to monkeys. At some stage in the proceedings, quite a while after it had been generally released, we had a communication from the distributor in Singapore. The authorities wouldn't allow a poster in the street saying '*Naked*'. Could they have an alternative title? Rather than get into a bother about it – and what happens in Singapore doesn't keep me awake at night – I dredged up a title that I'd previously rejected: *Raw*. I was only inhibited about using it because of the wonderful graphic magazine of that name. So all over the streets of Singapore the posters said *Raw*, but when you went to the cinema the film was still called *Naked*.

Bleak Moments, I discovered after the event, was bought by an American distributor when it first came out and released in the States with this incredible title: *Bleak Moments, Loving Moments*. Bingham Ray, the American distributor, was very keen that I should give *Career Girls* another name – *Hannah and Annie*. As you will immediately realise, I was obliged not to call it that because it sounds like a homage to Woody Allen. Frankly, I never thought about that when we called the characters Hannah and Annie, but there you go. Finally, when I went to Japan to do the press for *Secrets & Lies*, they'd picked up the fact that I had a title for the next film. I said it was called *Career Girls*. 'Oh,' they said, '"Korea Girls".'

I resisted giving *Secrets & Lies* its final title for a long time because Maurice says 'Secrets and lies' at one point in the film, and I hate using something someone actually says in a film. Finally, I suggested 'Lies & Secrets'. Then I gave in. I got over it.

The poster for Naked *attracted a fair amount of attention – mostly negative – showing as it did a still from the scene with Jeremy/Sebastian and Sophie shortly before he rapes her.*

Yes, it was a source of great pain. If there are any scenes that involve nudity in my films, we simply conspire not to take stills at all, because if you do, you can be bloody sure they'll wind up somewhere, the press being what it is. So when it came to that scene, Katrin wasn't actually naked. They both would have been, but at that time you weren't allowed to show male genitals. We decided they'd both have their underwear on. Katrin, being the ultimate trouper, said she wasn't bothered if stills were taken. Of course, that was the bloody shot that got everywhere. Katrin was quite upset in the end. I don't like it, I think it's wrong. And she's not even naked.

Any other regrets about Naked?

Only one. I made a mistake in the casting of the film. In the course of the auditions, one new actor that I met was Marianne Jean-Baptiste; it immediately became clear that she was as sharp as we know her to be. When I was pondering the various women Johnny might run into, she was one of them. For some convoluted reason,

28 *Naked:* Jeremy/Sebastian (Greg Cruttwell) and Sophie (Katrin Cartlidge).

which fourteen years later seems remarkably old-fashioned and retrograde, I had this notion that if one of the women was black it would in some way detract from the real issue. I think it's complete nonsense, even offensive, and I'm embarrassed. It's one of the only things in any of my films that I've regretted, because I know she would have been an interesting, strong character. She wouldn't have been a doormat; she'd have been articulate, strong. It's a shame we didn't get a chance to explore it. I missed it. But there you go. I did, however, get her into the next thing I did, *It's a Great Big Shame!*, and she was really brilliant. I then, of course, got the idea of making her a major player in *Secrets & Lies*.

As an important aside, it would also be true to say that the only thing that made *Naked* really difficult to shoot was the bloody lousy caterers. They were so bad that in a couple of locations, both when we were in the office in Charlotte Street and the house in Dalston on night shoots, people were nipping off to local Turkish and Indian restaurants and paying for their own suppers – something film crews just don't do. The shoot was going well, but as it was coming up to Christmas, people were really depressed about the food. I finally persuaded Simon Channing Williams and Georgina Lowe, the production manager, to sack the caterers and install Set Meals Ltd.

When people showed up on this cold Monday morning in December to shoot yet another depressing scene, they saw this gleaming Set Meals Ltd truck dispensing the most beautifully cooked breakfasts. I saw grown men drop to their knees and weep (*laughs*). If anyone thinks that a discussion about catering is extraneous to the issues of film-making, I can only point out that an army marches on its belly.

Secrets & Lies (1996)

Hortense (Marianne Jean-Baptiste), a young black professional, is at her mother's funeral. She is crying. Maurice (Timothy Spall) is photographing a nervous young bride on her wedding day. His wife Monica (Phyllis Logan) is at home – a spotless new build – doing some decorating.

Later, Maurice and Monica are both at home. Maurice is tender, attentive; his wife is distant, distracted, tense. They talk about his niece Roxanne (Claire Rushbrook), whom they haven't seen for over three years; she will be turning twenty-one in August. They discuss Roxanne's mother Cynthia (Brenda Blethyn); Monica makes it clear she has little time for her, while Maurice gently defends her.

Roxanne is sweeping the inner-city streets, her face dominated by a heavy scowl, while Cynthia works at a cardboard-box factory. Cynthia and Roxanne are in their rented terrace house, bickering. Cynthia mentions not seeing Maurice for a long time. Visibly twitching, she refers to Monica as a 'toffee-nosed cow' and wonders why the childless couple need a six-bedroom house.

Hortense, an optometrist, is giving a child an eye examination. She leaves work and goes to her parents' house. She looks through some of her mother's personal possessions, while her brothers argue downstairs. Back in her modern, ordered flat, she puts a document into an envelope and seals it. She posts it the next day.

Maurice takes a succession of portraits in his studio, including a neurotic dog owner (Alison Steadman) and a cat owner (Liz Smith). When he gets home, Monica is busy with the vacuum cleaner. Again he tries to be kind, but she is edgy, upset, abrasive:

'Since when was hoovering a spectator sport?' She begins to cry. Later, she sits alone on the toilet doubled up in pain, clutching a tampon. When Maurice returns from work, he takes a hot-water bottle to her bed. 'You've drawn the short straw, mate,' he tells her.

Hortense has an appointment with a social worker (Lesley Manville). She says she knew from a young age that she was adopted, and now that both her parents are dead she'd like to know about her birth mother. The social worker leaves Hortense alone with a file. She begins to cry. Her birth mother's name is Cynthia Rose Purley. The social worker returns and, while checking her watch, says she'll get things moving once Hortense has had time to reflect. Hortense is confused: the papers say 'Mother – white'. The social worker says a mistake is unlikely.

Cynthia and Roxanne are at home. Roxanne answers the door to Paul (Lee Ross), her ex-boyfriend. She quickly leaves with him. Cynthia is keen to meet him, but Roxanne yells at her to get back inside. Roxanne and Paul make up in his flat. They kiss. Cynthia is at home alone, looking at herself sadly in the mirror.

Hortense cries as she reads through her file. The next day she goes to the General Register Office to apply for her birth certificate. In her flat she and her friend Dionne (Michele Austin) drink chilled white wine. Hortense says she's got things to sort out. They talk about men, sex and their mothers. A few days later Hortense picks up the birth certificate and looks up Cynthia's address in the map book. She finds the street but drives past the house.

Maurice visits Cynthia. She is surprised but pleased. Cynthia tells him Roxanne's got 'some bloke in tow . . . Shifty-lookin' bleeder. Walks like a crab.' Maurice suggests she brings Roxanne over to the house for a barbecue on her birthday. They talk about how old they were when Roxanne was born: Cynthia was twenty-one, Maurice just seventeen.

Meanwhile, Hortense sits in her flat staring at Cynthia's phone number. She picks up the receiver but can't quite bring herself to dial.

Maurice goes upstairs with Cynthia to look at their late mother and father's room. There's a leak in the roof. He offers to pay for it to be fixed. Cynthia suddenly rushes across the room: 'Give us a cuddle, Maurice . . . please, sweet'eart!!' She hugs him tightly: 'You ain't gonna make me an auntie now, are yer? Sweet'eart?' He

251

pauses, unsure of what to say. He is devastated. He gives Cynthia some cash, reminds her about the barbecue and leaves.

Maurice sits alone in an empty pub.

Back home, Maurice talks to Monica in the kitchen. They speculate about the half-brother or -sister that Roxanne has never met and probably doesn't even know about. In their council house, Cynthia asks Roxanne if she's going to bring her bloke to the barbecue; she says not. A little later, Cynthia asks her daughter if she's on the Pill. She asks to meet Paul again. She says if Roxanne gets pregnant she'll look after the baby. Roxanne loses her temper, pushes her mother onto the bed and rushes out, slamming the front door.

Cynthia is crying on Roxanne's bed. The phone rings; it's Hortense. She slowly introduces herself. Cynthia is in shock. She hangs up and is sick in the kitchen sink.

Hortense redials. Cynthia says, 'You mustn't come round 'ere, sweet'eart.' She is crying. Finally, she takes Hortense's number. A little later, she rings back and they arrange to meet outside Holborn tube station on Saturday.

When they meet, Cynthia doesn't see how Hortense could be her daughter. They go to an empty cafe and sit side by side. Cynthia: 'Listen, I don't mean nothin' by it, darlin', but I ain't never been with a black man in my life. No disrespect nor nothing . . .' Then she remembers. 'Oh, bloody 'ell . . .! Oh, Jesus Christ Almighty!' She thinks Hortense will be disappointed by her. She reveals that when she gave birth she was just sixteen and couldn't face looking at or holding the baby.

The next day Cynthia rings Hortense. They arrange to go for a meal. Maurice takes a photo of a woman whose face has been disfigured by a car crash. Stuart (Ron Cook) turns up out of the blue and complains about Maurice doing well out of his old business.

Cynthia and Hortense have dinner; they get on well. Later, Roxanne and Cynthia sit at the dinner table. Roxanne is intrigued by the change in her mother, who now takes care of her appearance, as well as seeming to be happy for the first time in years. When Cynthia meets Hortense again, she invites her to the barbecue. She tells Maurice she's bringing someone from work.

The barbecue. Cynthia, Roxanne and Paul turn up with beer, sparkling wine and flowers. Maurice's assistant Jane also arrives.

Maurice asks Roxanne when she's going to apply for college. Monica conducts a tour of the house. Hortense arrives. They sit down to lunch. There are some awkward moments when Hortense has to pretend she works in the cardboard-box factory with Cynthia.

They move inside. Hortense goes to the downstairs toilet. Cynthia reveals her secret: 'Maurice . . . it's me daughter.' Chaos ensues. Roxanne is bewildered, angry. 'You fuckin' slag!! Ain't it enough you 'ad to 'ave one bastard, you 'ad to 'ave two an' all?!' She leaves. Paul and then Maurice follow; they sit at the bus stop. Meanwhile, Cynthia and Monica argue. Roxanne, Paul and Maurice return to the house.

Cynthia asks Monica why she hasn't behaved like a wife and given Maurice kids. Maurice tells their secret: after fifteen years of trying, Monica is 'physically incapable' of having children. He breaks down. Cynthia tells Roxanne that she met her medical-student father while on holiday in Benidorm. She isn't ready yet to tell Hortense much, apart from the fact that she got pregnant at fifteen and was sent away by her father to have the baby away from home.

In bed that night, Maurice and Monica talk of their fears and love for one another.

Some time later, Roxanne and Hortense chat and laugh in Cynthia's back garden. Their mother brings out tea and biscuits on a tray.

* * *

AMY RAPHAEL: *Did you have a very personal take on adoption?*

MIKE LEIGH: By 1994, which is when we set about working on what was to become *Secrets & Lies*, the notion of adoption had already been festering in my mind for over twenty years. There are people very close to me who have had adoption-related experiences, although I can't talk about this in detail for obvious reasons. When I started to look into it, I realised that for me the important aspect wasn't so much the relationship between the adoptee and the adoptive parents as the whole issue surrounding the birth parent – and the mother in particular. I was also fascinated by the sense of identity surrounding the person who's actually been given away and adopted. Then, in the course of doing the preliminary

basic research, I hit on the fact that in the 1960s a lot of white girls gave away black babies. Those were the starting points.

The project previous to *Secrets & Lies* wasn't, of course, *Naked* but the stage play *It's a Great Big Shame!* The first act was set in 1893 in a house lived in by white cockneys; the second act was set in 1993 in the same house but everyone was black. With that play came the discovery of Marianne Jean-Baptiste in particular but also Michele Austin; they played sisters in that production.

You had the notion of adoption floating around, but when, for example, did you decide that Timothy Spall and Brenda Blethyn would be brother and sister?

If you want the crude answer: when I cast the film. Those creative decisions are always inherent in the basic scheduling, in a way. So we started with those two and went from there.

No film has ever deviated in its process from the first principle that the actors never know anything beyond what their individual characters would know. But *Secrets & Lies*, given its secrets and lies, was also followed through with an extraordinary degree of military precision. But let's talk about its methods later.

OK. Why do you think Secrets & Lies *was your most commercially successful film internationally?*

There are a number of reasons. Everybody strives for the piece of work that hits a nerve. I'd say two of my pieces have really done so: *Abigail's Party* and *Secrets & Lies*. Some films that you think ought to just bloody don't, like *All or Nothing*, which some people like, but it's a very rarefied coterie of people around the world who even know what it is. But *Secrets & Lies* seemed to get through to people, perhaps because it's about identity.

The second reason is that it won the Palme d'Or at Cannes, which does an amazing amount of good for a film. Then it was nominated for five Oscars, none of which it got. It was snookered by *The English Patient*.

The third reason is quite different. It was immensely successful in a number of countries where it was – and still is – illegal to trace your birth mother. Which is to say, all the Catholic countries, all the South American countries, France, Italy, Spain. Although I

think it's changed in Spain recently. And fifty out of the fifty-two states of America, where it was a big issue for a lot of people.

Did you have a sense of its potential when you were making it?

We did, up to a point. When Maurice goes round to visit Cynthia in her house and they go upstairs to their mother and father's old room . . . if you look at it very carefully, there's a subtle tracking shot in this very small room, where the camera moves in and out. We were setting this up and we knew it was a really powerful, quirky, emotionally charged scene.

In passing, I'm only aware of two people who work on my films who have any kind of ongoing dialogue about the future currency of the film: me and the cinematographer, because we're the only two people constantly looking at the film from the audience's point of view, as it were, apart from the editor. When you're in the mad heat of shooting, no one else is actually at the epicentre of the thing. Anyway, when we were setting up this scene in the bedroom, Dick and I said to each other, 'This is going to earn us some really nice dinners!' – meaning we'd probably go to Cannes. And, of course, we did – rather successfully!

So, yes, one does have a sense, but one isn't always right. Having been encouraged by the success of *Secrets & Lies*, we were able to get a much bigger budget for *Topsy-Turvy* and we were in no doubt that that film would be a massive commercial breakthrough. It was no such thing. It's so tough to tell if art – whether it's a film, a record, a book – will find success. Actually, I suspect that if I'm honest I'd succumb to the received wisdom that the harder you try, the less successful you become.

Does it get easier as you get older to care less about commercial success, or do you simply crave it more because your career is increasingly finite?

Very good question. Both. It actually gets harder in one sense. The more you do, the more you've done; the more you've done, the more you've already done. The more you've already done, the more you're left wondering what to do next. So there's that. It's not a problem. Provided you don't navel-gaze, it's all going on out there in the world; there's still plenty of things to make films about.

One's experience counts for quite a lot. So if I'm worried now about 'Untitled '06', I'm experienced enough to know what I'm up to or not up to. When you're younger, of course, you do things with gay abandon. I've vaguely learned how to cope with getting older, although I'm not a particularly strong person physically.

Your energy levels must change as you get older, which must also make a difference, especially with such a labour-intensive job.

They do change. I invented my way of working when I was twenty-two or twenty-three. I used to rehearse or shoot all day and all night. I never had days off. There always comes a point, particularly with shooting, when you work seven days on the trot for several weeks. You have to spend every moment away from the crew actually rehearsing the scenes. The adrenalin carries you through; you get into the rhythm of it. But as I've said, the rehearsals are a form of purgatory. They can be very enjoyable, and it's very nice working with people and all that, but I grind away for months with nothing to show for it. I still have to get out of bed and be there at 9 a.m. every day. I have to make something happen. If I didn't have that gruelling discipline, you'd basically never have heard of me.

You've talked about 'reading days' before, when you sit around leafing through books and not doing much.

Oh God, I'm without doubt the biggest procrastinator in the history of might-have-been-writers. I still leave everything to the last possible minute.

The real point is that the preparatory improvisational rehearsals are much lonelier. It's all about getting it together, getting the dramatic premise together. Part of my craft is giving actors space, which involves massive amounts of time with them getting into character and staying in character. On the surface, nothing seems to happen. It can be very, very boring. Sometimes I go to sleep in the corner in rehearsals. You are putting it in the oven and letting it cook.

When you hit the shoot, however, it's a whole different experience. At the end of every day you've created something. It's just fantastic. I love it! It's at that point, at the back end of these shoots,

that we have seven-day weeks for weeks on end, but it's not really a problem. I never used to bother about taking days off, but now I'm very disciplined about taking Sunday off during rehearsals.

Secrets & Lies *was internationally successful; do you ever feel that your work is appreciated more abroad than in the UK?*

The films may be appreciated in different ways in different places, but universally they are understood on the same level. The thing that gets people about *Secrets & Lies* has nothing to do with the audience being from South America or Japan or Australia. The question relates back to the 'Play for Today' films, because there's a definite notion that they were very English, or at least very British, and wouldn't really travel. I remember when we made *High Hopes* – which to all intents and purposes was the first feature – it had no distributor when it was finished. Romaine Hart of the Screen on the Green, Screen on the Hill, et cetera, rejected it completely as mere British domestic television. She said it wouldn't travel and had no future. It then went to Venice, where it won a prize, and, to my amazement, the international press was suddenly on our case.

Did Hollywood come calling following the success of Secrets & Lies?

No, not at all. The issue of Hollywood is quite clear. At no stage has anybody begged us – Simon and me – to make a film there. And at no time have we made a film for a Hollywood production company. First of all, everybody knows that nobody in Hollywood ever says no to anything. They are enthusiastic about everything and they pass on virtually everything. Most of what I'd have to say about Hollywood is in Peter Biskind's wonderful book *Down and Dirty Pictures*, in which I figure occasionally.

On the one hand, Hollywood hasn't come crawling because that just doesn't happen. But on the other, we have had discussions with everyone at some stage or another, including a massive number of time-wasting ones. However, we continue to make films with some American money, including 'Untitled '06'.

In *Down and Dirty Pictures* there's the following story: Skouras Pictures distributed *High Hopes* in the States, and the guy in

charge of distribution, Jeff Lipsky, got together with Bingham Ray and they formed their own distribution company, October Films. The first film their company released in the US was *Life Is Sweet*. Simon helped them from the UK to get their finances together so that could happen. They were then very keen to distribute *Naked*, and would have made a fantastic job of it. They were really original, independent distributors. They came to visit us while we were shooting *Naked*. It went to Cannes and went on the open market, but New Line had more dosh, so October Films didn't get it. But our relationship with them continued; they distributed *Secrets & Lies* very successfully. And *Career Girls*. They were involved with *Topsy-Turvy*. At this point they were taken over by Universal, and all kinds of dreadful things happened. Jeff Lipsky had already left, and Bingham Ray was then sacked from his own company – all of which is in that book.

So by the time of *Topsy-Turvy* we were dealing with Universal. They renamed October Films as USA Films. Basically we were dealing with the big boys in Hollywood. It put us in communication with Hollywood, so by that route and independently we have had dealings. When we started on *Topsy-Turvy*, we talked to everyone, including Harvey Weinstein. When we were shooting it, we used to say, 'Thank goodness Harvey turned us down.' He wouldn't have got how we worked. Our special skill is to reinvent constantly the concepts of schedule and budget. We couldn't have made the film without the complete freedom to move the goalposts endlessly. And we certainly wouldn't have had that with him.

Would you ever consider relinquishing the smallest amount of freedom for a considerably bigger budget?

No! Slippery slope. There's no such thing as 'relinquishing a small amount of freedom'. It's the thin end of the wedge, as far as I can see. Look, Simon has endlessly gone to meetings over the years – less so now – where they say they don't mind that there isn't a script or a plot as such, but you must have a name. By which they mean someone like Nicole Kidman. And if I start from that premise, I'm buggered – no disrespect to Nicole Kidman.

This whole thing about Hollywood has a double answer: the basic answer is no, but on the other hand, as I said, we've had

some kind of American backing over the years. And we've had interest. Two very well-known producers from a very well-known independent Stateside company had breakfast with me and Simon two years ago in New York. They said, 'There are three great film-makers in the world: Pedro Almodóvar, Wong Kar-Wai and you. We've worked with the other two and we have to work with you. What do you want to do?'

These particular people have dithered and buggered about and walked away twice. As late as yesterday they phoned up and said, 'Can we assume we're still involved in the next Mike Leigh film?' – long after we've signed and sealed with other people. They live in this egocentric world where everybody else's lives are static and in freeze-frame. It's an ongoing thing.

I was talking recently to Christine Blundell, our make-up designer, who worked on *Casino Royale*. They shot one scene at Shepperton, where they constructed what was supposed to be the interior of a building in Venice. The room goes up and down hydraulically. This one set cost £12 million. What I couldn't do with £12 million . . .

The other really important and fundamental answer to the whole Hollywood question is this: we're not in Hollywood and we're not in America; we're in Europe. We're independent European film-makers. That's why Cannes is such good news. It's the one thing that Hollywood producers cannot get their hands on. They try. They go to Cannes and they try to subvert it, with all their huge bloody billboards blocking out the palm trees. But they can't touch it. It's immune. When I was on the jury at Cannes in 1997, *LA Confidential* was one of the films in competition. It's a perfectly respectable film but the truth is that the entire jury unanimously dismissed it. Harvey Weinstein was furious with us. But there was nothing he could do about it. Nobody nobbles the Cannes jury, despite what people tell you. It's beyond anybody's reach. It's great that Cannes is there. It fulfils an important function in our independence.

The bottom line is that there's no point whinging about Hollywood. Of course, it would be great to go there, take the money in large quantities and do what you like with it. But it doesn't work like that. When you ask about a tiny bit of compromise, you have to remember this is a world where a lot of people earn a lot of

bread and their job is to interfere with everything at every level. Mostly before anyone's even put a roll of film in a camera.

One of the many massive turn-offs about making a film conventionally with a script is that everyone has made the film in their heads before you get on location. For me, the buzz of making a film my way is that you don't know what it is till you've done it. And neither does anybody else, including – and especially – the backers!

What difference would a huge injection of cash make to a Mike Leigh film?

I'd make bigger films. Money would basically enable us to make films that we currently can't make. Bigger canvas. Epic scale.

A few weeks ago I went to talk to students at Newport, Gwent. There's a very strong film department at the university, which is run by a brilliant ex-NFTS student of mine, Coral Houtman. One of the students asked me what the budget would be for 'Untitled '06'. I replied, 'Hold onto your seats because what I'm going to say now you will find obscene and outrageous. The answer is only £6.5 million.'

They all gasped. I went on, 'OK, £6.5 million under your bed in a suitcase is a lot of bread; it would be one hell of a budget if you were to spend it shooting a film on the streets of Newport with your DV camera.' The problem is, making a film in the industrial context in which we work, you have to be incredibly inventive in spreading the money out and making it work. *Vera Drake* was made for a tiny touch more and was a real stretch.

Money would enable me to make period films. It would give me time; there are things I'd like to do on a big scale but time costs money. Money disappears so quickly. For example, there are American backers for 'Untitled '06' and as soon as you sit down to discuss the budget it's a given that the American lawyers take a slice off the top. The bigger the budget, the more you pay people. And the more people there are to pay. But, at the same time, you can start to do other things and you have the luxury of time, space and other production values.

The challenge is to put interesting things on the screen with very limited resources. The difference in cost between a period film like

Topsy-Turvy and *All or Nothing* is ludicrous. *Topsy-Turvy* had a massive costume budget alone. It was sumptuous and theatrical; in *All or Nothing* virtually everyone's costume came from charity shops around Greenwich. If I decide to do a film that is mono-chromatic and generally a downer, which is what *All or Nothing* is perceived as being, then it's cheaper. But if I want to be jolly, it's more expensive.

There is another aspect to this Hollywood discussion: actually going to Hollywood and making a film there. It has no appeal to me at all. I would see it as being a recipe for disaster.

An anecdote to end this rather long discussion: Pierre Rissient, the doyen of the Paris film scene who was active in getting *Naked* into Cannes and who was directly and helpfully involved in *Secrets & Lies* and *Topsy-Turvy*, got in touch the year after *Secrets & Lies* was released. I was at home with my boys on a Saturday night, watching *American Graffiti*, a nice film that you don't want to have interrupted. Pierre calls. He's in Hollywood with some old fart of a producer, whose name I can't remember now. Pierre's very apologetic. He's told the producer I won't be interested, that he's wasting his time, but he insists on talking to me. Pissed off about *American Graffiti*, I agree to have a word. Pierre puts him on.

'Michael –!'

'It's Mike.'

'Michael! I wanna tell you a story . . .!'

He then goes into this very long, ridiculously elaborate and mostly impenetrable story, a large proportion of which seems to have to do with his private library, and ends with: 'So, whaddya say?'

Cautiously, I ask, 'Do I understand that you're asking me to direct a remake of *Uncle Tom's Cabin*?'

'You goddit!'

'Out of the question.'

Long pause. I assume he's dropped dead from shock. People in Hollywood don't say, 'Out of the question.' He'd never heard such a thing. It's not in the Hollywood vocabulary. That's as near as I ever got to working there.

However ambivalent your feelings about Hollywood, Secrets & Lies *undeniably got a great reception in America. Not only was the*

film nominated for five Oscars but you and Brenda Blethyn also won the LA Film Critics Association Best Director and Best Actress awards and she picked up a Golden Globe.

Brenda Blethyn throws herself at the part totally. The great thing about her is that, in a positive sense, she never stops working. She's constantly making suggestions. She's a very complicated character in her own right. She's an extraordinary combination of complete guts and confidence and a massive amount of self-doubt at all times.

Let's talk about the rest of the cast too. Tim Spall is just terrific. He has a great sense of humour. But he's also completely serious about it and he loves the work. He's very versatile.

He turned out to be seriously ill after Secrets & Lies.

No one knew when we were making *Secrets & Lies* that Tim had leukaemia. We wrapped *Career Girls* on a Saturday night and had a party. We had the cast and crew screening for *Secrets & Lies* the next day. Unusually we'd made the two films close up to each other. On the Thursday we were flying down to Cannes for the screening of *Secrets & Lies*, which was the next day. At the cast and crew party Tim felt a bit odd. He went to the doctor the next day – the posh film-insurance doctor, the legendary Dr Gayner in Sloane Square. He diagnosed leukaemia and bunged him straight into hospital. The word was that if he'd gone to Cannes that week they'd have brought him back in a box. He went through a hell of a time and came through the other end.

Phyllis Logan is an important player in this film too. I like her enormously; she's one of the funniest people I know. There's no reason why I haven't worked with her again; you just don't get round to everybody. Claire Rushbrook is also a good actress. I felt it important to pull Michele Austin in because she'd been such a good double act with Marianne in the play. In fact, the scenes where Hortense and Dionne are talking and drinking and where Ron Cook's character visits the photographic studio became the point of a massive stand-off with Ciby 2000, the Parisian backers. They insisted we cut those scenes because they felt them to be redundant to the plot.

This massive stand-off quickly became very acrimonious. They

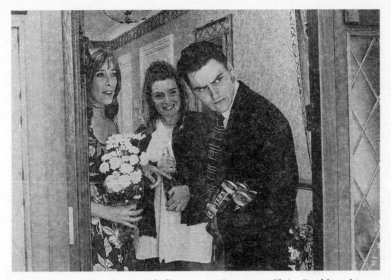

29 *Secrets & Lies*: Monica (Phyllis Logan), Roxanne (Claire Rushbrook) and Paul (Lee Ross).

wanted to wash their hands of the film. They were even keen to sell it and banned us from submitting it to Cannes. This went on for months and months. To cut a long story short, they 'tested' the film in Slough in a three-hundred-seat multiplex – one of only two times I've been subjected to Hollywood-style testing. They showed a work print with no music or mixed sound to a fucking audience in Slough! It cost them £10,000 – money I could have happily wasted on buying caviar and champagne for my friends, I told them.

They then showed it to all the American distributors who were in London for the film market. They were after unassailable support; they were convinced everyone would agree that the two scenes should go. But every single distributor, including the likes of Disney, said it was fantastic, don't touch it. Eventually they backed down and we went to Cannes, where we won the Palme d'Or, thank you very much. They did apologise.

Interestingly enough, I went to a tiny festival in Umbria a few years ago where *Secrets & Lies* was screened. Each year they give the freedom of the town to a film-maker and you get the key. They screened an old Italian distribution print of the film and those

same two scenes were missing. The Italians had done the same thing and I didn't know!

The point is that the scene of the two women in the flat drinking is axiomatic. Without it, you don't get a complete picture of Hortense. Similarly, the scene with the ex-owner shows a stronger side to Maurice, which you don't otherwise see.

Otherwise Hortense is mostly on her own in her flat or at work peering into people's eyes.

Exactly. We needed to see her talking about life with a friend. Dionne asks her what she's been doing, and she says, 'Living,' or something. She doesn't say she's been tracing her birth mother.

Didn't Lesley Manville join the cast late in the day?

Yes. An actor who will remain nameless was playing the social worker. He was useless, dreadful. It wasn't his fault: he was out of his depth. We shot the scene but it was laughable, an embarrassment. Ciby 2000 very reluctantly allowed us to do a reshoot, so I got Lesley Manville in. I hadn't worked with her for quite a long

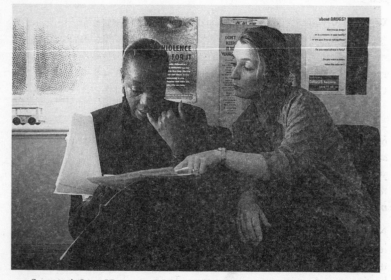

30 *Secrets & Lies*: Hortense (Marianne Jean-Baptiste) and the social worker (Lesley Manville).

time. We wrapped the entire picture, and then a couple of weeks later I worked with her for a week on the character. I went on holiday to France while she did social-worker research. I came back and rehearsed the scene for a week with Marianne, then we shot it over a weekend. It was brilliant. We had all the advantages of having the power and strength of the film behind us.

I blame myself for not spotting how bad this poor actor was. I auditioned him and thought he'd be fine. This has happened maybe four or five times before, but we never usually get as far as filming. Somebody was ditched in the rehearsals of *Vera Drake*; somebody else just before shooting a scene in *High Hopes*. It has happened in the theatre once or twice. It's a terrible thing for anyone to get the sack in any circumstances. The kudos of being in my films is huge, and people have gone round telling all their friends – only then to get the boot. Or occasionally we've cut people out in the editing, though that's more to do with the context and structure and happens on most films.

As always, you did a lot of research for this film. How did you find out about couples who find it hard – or impossible – to conceive?

We went to Professor – now Lord – Robert Winston at Hammersmith Hospital, who gave us a whole morning. A lovely guy. I told my assistant that we needed to talk to someone about IVF treatment, and he was prepared to talk. It was fascinating. Devastating. Of course, I've known people who've gone through it.

Monica and Maurice live in their recently acquired new-build home where everything is just so. Yet they are unhappy, frustrated, angry. Obviously there's the huge issue of being childless, but do you think newly acquired money is often spent badly or that aspirational couples never find the anticipated happiness in property, material goods, etc.?

No, I don't think that. I think it's understandable but wrong to infer that because my films are consistently saying that if you're upwardly mobile and improving your life, I inevitably think you're having a bad time and I disapprove. That would be a misreading. What is true, however, is this: just because you've improved your

material life doesn't mean everything is hunky-dory. When people put a lot of energy into the trappings and the core is not all it could or should be, then all the trappings in the world won't make it any better. This is all terribly obvious . . .

Having said that, it's extremely dangerous and very inaccurate to see Maurice and Monica and such unhappiness as they have – and indeed their relationship with their home – in the same light as Barbara and John in *Meantime*, Valerie and Martin in *High Hopes* or Beverly and Laurence in *Abigail's Party*. Maurice and Monica have integrity, intelligence, sensitivity, taste and some sense of style. It's not an investigation into people who are miserable because they are vulgar. They are unhappy because they can't have children.

Cynthia may think Monica is a snob who has taken all Maurice's money, but it's simply not the case: she discovers the truth at the end. When you see Monica nervously showing everyone around on the day of the barbecue, it's a kind of comic scene and an affectionate view of her. It's been decoded as being in exactly the same territory as Beverly and Valerie. But it very definitely isn't.

Once we learn that they can't have children, we realise why Monica has been diverting all her energies into obsessive hoovering and dusting.

That neurotic behaviour is a function of her condition. She has real problems with her menstrual cycle. If there is a dividing line between the sort of people in their Barratt homes – or whatever you might call them – who suffer from ignorance and vulgarity and those who are simply unhappy, then Monica is on the same side of the line as Barbara in *Meantime*.

When Monica is sitting on the toilet or lying in bed with a hot-water bottle, it's a painful monthly reminder of her inability to conceive.

Totally. She has very painful periods. And all that irritable stuff when Maurice comes home from work . . . My constant problem when I make these films is my reluctance to spell everything out in a crude way. As a result, a proportion of the audience may not

understand what's going on. The less perceptive person could be forgiven for thinking that Monica is a bitch, but she's not.

But it's important to have mixed thoughts about her or else the revelatory scene at the end wouldn't have such impact.

Fair enough. What's important in the context of understanding Monica's journey is that the first time you see her she's dusting the pictures and talking fondly of Roxanne. She is warm, with a dry sense of humour.

Why does it take Monica so long to reveal her secret?

It's not uncommon. It's very painful and private. She's hoping she'll suddenly get pregnant and it'll all go away again. Then nobody needed to have known. And don't forget it's the neurotic Cynthia they haven't told.

When Monica and Cynthia hug it's a pivotal moment in the film; as important as the revelation about Hortense, perhaps?

Yeah. The big question is about Cynthia not telling Hortense who her father is. That's very clear to me. Is it clear to you? What's your reading of it?

That she doesn't know much, if anything, about him.

There is no question about it: when she goes into the cafe with Hortense and says, 'I ain't never been with a black guy,' she totally believes it. And then suddenly something comes back to her. I know exactly what it was because we invented it: she went to a party, got very drunk, shagged a black guy, forgot about it. Whereas Roxanne's father was an American medical student she met on holiday and with whom she had a bit of a fling – a nice time. Plainly she got screwed by a lot of guys. That's obvious. She was vulnerable, needy. The question then is: will she tell Hortense in the fullness of time? Personally, I'm confident she will.

How will Cynthia have processed the fact that she gave a baby away for adoption? Will she have denied it to herself completely or will she have wondered how the child was getting on every now and again?

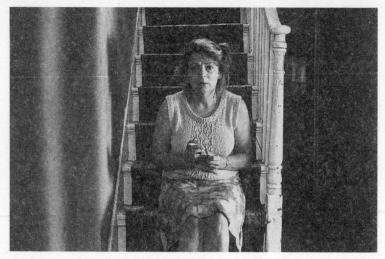

31 *Secrets & Lies*: Cynthia (Brenda Blethyn).

As soon as she picks up the phone and Hortense says, 'Baby Elizabeth Purley,' she knows what's going on. This isn't something she's blanked from her mind. What's happened is this: there were at least two fucks around the same time and as soon as she'd had the baby they took it away. She didn't want to see it, so she had no idea it was black. She will have lived with this secret and she will have hoped never to have to face up to it.

I received a massive amount of letters for many years after *Secrets & Lies* from people saying they'd traced their birth mother or parents as a result of the film. People hoping their child would get in touch with them. But a lot of people hope it will never come back to haunt them. Cynthia probably hopes both of those things deep down somewhere, or she simply wouldn't go and meet her.

The phone call also comes at a critical time, after Cynthia has had a particularly bad row with Roxanne.

Yeah, but that's me telling an interesting story. The phone call would have had the same effect whenever it came. And the rows with Roxanne go on all the time anyway.

Why is Cynthia and Roxanne's relationship so full of anger and resentment?

It's claustrophobic and unfulfilled. It's a life that is unrelieved by the sheer tedium of surviving. And, of course, Cynthia feels bitter towards Monica. She resents her and her affection for Roxanne.

You often focus on people's potential in your films. At a certain point we realise that Roxanne is not fulfilling her potential, that she could, as Maurice suggests, go to college.

Totally the case. There are a lot of kids like that around who simply put up with having a job and surviving. She'll be fine in the end. People have always said that you get more and more out of my films as you watch them a second or third time. If you look at Roxanne right from the word go, although she initially presents as just being surly, even thick, she is quite sunny and sussed. The way she deals with Paul is quite affirmative.

I can't imagine her staying with him.

That's not for me to say. But if you mean she could do better, I'd agree (*laughs*).

The contrast between Cynthia's house and Hortense's flat is interesting: the former is messy, unkempt; the latter spotless, ordered. While Cynthia is so obviously neurotic and on the edge, Hortense seems to be in control most of the time, even when she sees the adoption papers for the first time.

But you do see her crying at that point. It's not unusual for an adopted person to start looking for their birth mother or father when their adoptive mother or father die. It's understandable. It's very important in the scene with the social worker that Hortense says she loved her parents very much, meaning, of course, her adoptive parents.

Hortense is a very self-aware and sussed person. She's gone through the rigours of sorting herself out, of getting a degree; she understands a lot of things and she's disciplined in the way she lives. So in that sense she's not an out-of-control person. But she's not without emotion and she's very affected by the whole thing. It's

tough for her. We see her crying at her mother's funeral. She's emotional. But she is a career girl and she's organised. Cynthia, meanwhile, is all over the bloody show.

Where did you find an empty café in the West End for the celebrated cafe scene?

Cynthia and Hortense meet outside Holborn tube station on what's supposed to be a Saturday evening in summer. They appear to be walking in the direction of Covent Garden. The idea that there would be an empty cafe in that location and at that time demands a massive piece of dramatic licence. The cafe is actually in Moorgate and it was shot on a Saturday; in 1995 there was nothing happening round there. 'Homage to Hopper' again. I love empty pubs and cafes. And, incidentally, all film locations, once you take them over, can be as full or empty as you want to make them.

The other thing of any interest about that scene is that it was covered by several reverses, different sizes. I remember when we shot it thinking it would be nice if it held up as a single two-shot. But the main reason you have to cover such a scene with more than

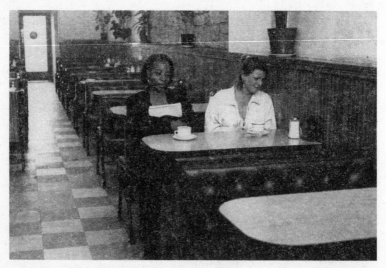

32 *Secrets & Lies*: Hortense (Marianne Jean-Baptiste) and Cynthia (Brenda Blethyn).

one shot is that you might want to shorten or tighten it in the editing. But when we looked at the rushes, everybody said, 'Wow! That take is just amazing.' There were two takes. It runs for something like eight and a half minutes; a roll of film is ten minutes long. It was very, very thoroughly rehearsed. They practised it endlessly, till they could fly with it in the moment.

Did you think it was important to have the two women side by side? The lack of eye contact certainly gives the scene a certain edge.

I did an interview with Howard Feinstein, the New York film writer and critic and a friend. We were having breakfast at the Algonquin Hotel. There's only one thing he didn't quite believe: nobody sits side by side like that. I said, 'Look around. At the Algonquin the restaurant layout is such that everybody sits side by side!' He laughed. But again, if you're worrying about that, you're worrying about the wrong thing.

Actually, in terms of my approach to these things, when the girls started improvising they instinctively sat opposite one another. I asked them to sit side by side instead; they both felt it was OK, and that's good enough for me. The bottom line is that you can't make scenes like that work without very brilliant actors. And both were nominated for Oscars.

Would it be fair to say that Cynthia and Hortense are almost having a love affair? Cynthia is suddenly blooming, dressing up, taking pride in her appearance; they are discovering each other in a way you never get a chance to do with the parents who brought you up.

Yes, absolutely it's a love affair in that sense. And Roxanne's reading of it is that her mum's got a bloke.

The film is obviously about identity, discovering who we are and where we're from. It's about the need to share our thoughts and fears. Would you say there's a fundamental message in the film: we're better off telling the truth?

Of course the film is about identity. There's the whole thing about

the identity of Hortense and Roxanne, but also the individual identities of all the people Maurice takes portraits of, people who are momentarily being corralled into an idealised version of themselves. So there's a conventionally beautiful woman who's had her face mutilated. Then there's a man who believes he still has rights that have long since ceased to be his – the guy who used to own Maurice's shop. And, of course, Hortense is in the business of seeing. So it resonates throughout the film, this whole thing of what we are, what we really are, how we appear to other people, how other people perceive us. As with so many of my films, it's all about the done thing. *Topsy-Turvy* is about mirrors and masks. Specifically, this really is a film about secrets and lies.

It's also a film about a black daughter discovering her white mother, yet race isn't a central issue in the film.

It is an issue but it's dealt with by its implicit absence as an issue. The criticism that I've had from some quarters about the film's failure to deal with race is ridiculous, because it deals with it head on – by not making it an issue, as I say. There are black people and white people in the film, and they get on with it. It's a modern film.

There was also criticism somewhere along the line that the film marginalises black people. 'Why don't you see her family?' came the question. 'You only see her family at the funeral or in a long shot in the house.' The answer to that is simple: that's not what the film was about. And, in fact, those actors were wheeled in at short notice to sketch those characters in. It's very definitely not a film about an adoptive family. As I've said, I felt the real adoption issues are the problems of the adoptee and of the mother who gives her baby away.

Hortense is entering her blood family's lives rather than them entering hers.

Exactly. That's what it's about. The other thing that's widely debated, not least amongst black people, is whether Hortense ought not to look more mixed-race. I was initially concerned, but Marianne knew loads of examples of very dark black people with mixed parents. But it still comes up in discussion now and again.

When Hortense turns up for the barbecue, Monica is initially surprised to see her. Some critics decided that Monica's response brands her a racist.

People either get what's happening at that moment or they don't. Monica thinks Hortense is a Jehovah's Witness, a God botherer. She's certainly not expecting the likes of her to turn up at the house. It doesn't mean she's racist. To borrow from the name of Mikhail Romm's film *Ordinary Fascism*, this is ordinary racism. Which is to say that Monica is simply not expecting a smartly dressed black woman to show up. She doesn't open the door and say, 'Oh hi, come in!' She knows Cynthia's friend is due, but she's not expecting her to be black. Which doesn't make her a racist.

As an aside, I went to Tokyo with *Secrets & Lies*. Marianne Jean-Baptiste had toured Japan with the RSC and she'd found it hard work walking down the street in Tokyo as a black woman. She tells it like it is. I was apprehensive. The film is obviously about a white woman with a black kid. When I got there I said very gently that I was worried about the response; they said there was absolutely nothing to worry about; it's the most Japanese story, secrets and lies. Japanese society is all about face . . . It did very well there.

Let's talk about the mise-en-scène *of the barbecue scene.*

Sure. One question I get asked a lot is about the static shot around the garden table. People want to know why it's like that. Actually, we'd seen the rushes of the scene in the cafe and had a sense that we'd probably hold that single two-shot. The garden-table scene was conceived and shot as a single static shot. If you look at it, it's obvious that it's been scripted and choreographed simultaneously, which is what I do anyway.

From a *mise-en-scène* point of view, the reason I felt it proper to have that static shot – which is preceded by a wide, subtle tracking shot looking down at them when Hortense arrives – is because I knew that when they all moved inside once it's started to rain and finally the shit hits the fan, there would be lots of cuts and the action would become very heightened and intense. In editing terms, fireworks would be going off all over the place. Because I knew the audience would be waiting for everyone to find out who

Hortense really is, I thought if you had it all going on in one frame, it would leave you as the audience to do all the work and the wondering.

There are all sorts of undercurrents on all kinds of levels, but everyone is just getting on with the event really. In practical terms, it took a massive amount of rehearsal to define it. So, for example, Maurice doesn't come and sit in the downstage position, as he'd block our view. Instead, he leans on the wall for a while, which seems very right for his character. Apart from anything else, although actors can learn their lines, food and drink don't always behave predictably . . .

Behind the fence at the back of the garden is a main road. When we did a recce we thought the house was great, apart from the traffic noise from this road. The location guy said it would be fine: we'd clear it with the cops, who would allow us to stop the traffic. But when it came to it the cops didn't want to know. Both the scene when Hortense comes out into the garden as they're having drinks and that very complicated barbecue scene are completely post-synched, also known as additional dialogue recording (ADR).

Way back, I'd never have touched ADR. I was an absolute purist. But when I finally had to do it for various scenes and learned how to do it, I discovered that because the dialogue in my films is so organic and so thorough, even three or four months later when the cast have to come back and do the odd line they are absolutely plugged into it. So there is quite a lot of post-synch stuff in my films, though only when necessary.

The important thing is the relation in this scene between the conception of the shot and what is happening dramatically and narratively at that point. The audience has to make decisions about where to look and who to worry about. It adds to the 'Oh my God, what's going to happen next?' aspect of it. Once you get inside, each moment is a clear progression dramatically and narratively.

So, you get the textural contrast between the wide, static shot and lots of close-up intercutting.

As you say, the audience is anticipating so much by the time they all move inside everyone's position becomes vital; had they sat in different places the dynamics would have changed, however subtly.

Well, of course, that's right. Sometimes things happen in improvisations, and then I reorganise it so it's more conducive to what needs to happen. Which is all any director would do. This is characteristic of all my films, but this film and that location are as good an example as any. As in *Grown-Ups*, the details of the event are informed by the characteristics of the location. For example, when Hortense goes to the loo, the loo happens to be in a certain place – adjacent to the dining room. If there had been no downstairs loo and she'd had to go upstairs, the dynamics – the scene itself – would have been different. The narrative, given time jumps, would still have worked, but the fact is that she could go straight in. I had her going in and sitting on the closed loo seat, but when it came to shooting Dick suggested she lean on the door instead. Therefore, when the door is open, you see everyone in soft focus behind her. In the same massive improvisation, Claire Rushbrook as Roxanne cleared off out of the house completely with her boyfriend. We had to go and find them.

I assume that's because she was upset in character rather than thinking she ought to be upset.

Totally. There could be no other reason; those are the rules of engagement. Although there was a ten-hour improvisation, it never got to the final revelations you see in the film because she'd buggered off. When I structured the dramatic action, it was essential to bring her back into the house. Now, there was a bus stop literally where you see it near the house, and I suggested she'd get a bus. She agreed. So we did another improvisation in which she and Paul went and waited at the bus stop. Maurice went over but couldn't persuade her to come back. We did several improvisations investigating the situation, between which Claire and I discussed Roxanne's motivation rigorously. She very properly insisted there was no way Roxanne was going back. Finally, we discovered that if Paul suggested she return to the house, she would give in. She was impressed by him taking some initiative for once, which was also great for me because it ended his character's journey, gave him a dramatic function. Once we got them back inside, we could tease out the rest of the revelations. Which is just what happened.

Everyone comes out of the barbecue and house scene pretty well, considering what's just been revealed.

They certainly come out of it changed.

Even the audience feels a palpable sense of relief.

Totally.

Career Girls (1997)

Annie (Lynda Steadman) travels from Wakefield to London to stay with Hannah (Katrin Cartlidge), a college flatmate she hasn't seen for six years. They are both smart, single, professional women. Flashbacks to their time as students in London in the late 1980s show what they were once like. Annie is a psychology student, a pretty straightforward young woman prone to eczema and low-level anxiety. Hannah, meanwhile, is the English major with a caustic wit who likes to introduce herself as 'Han-nah'. She is disillusioned and angry; she rages about her alcoholic mother, whom she calls a 'fuckin' bitch'.

They are unlikely friends – Annie is initially sensitive to Hannah's constant teasing and verbal jousting – who over time grow close. They bond over The Cure and discover their fathers left when they were both eight years old. Annie has been crying ever since, while Hannah hasn't cried since she was nine. They move into a flat above a Chinese takeaway when they have grown bored of sharing a flat with Claire (Kate Byers).

Meeting up again at thirty, it quickly becomes clear that Hannah may be a successful retail executive but she has lost nothing of her blunt manner. Showing Annie round her flat, she says, 'Er – there's the bathroom, if you want to have a crap.' Hannah tells Annie she's thinking of buying a flat. Annie is impressed; not brave enough to live alone, she is still at home with her mother. Hannah has suggested they have a look at some overpriced flats for the hell of it.

A flashback shows Ricky (Mark Benton) – a kind, fat, dishevelled psychology student addicted to takeaways – temporarily sleeping on Hannah and Annie's sofa. He soon declares his love for

Annie and is distraught when she rejects his advances. He leaves the flat early one Sunday morning and doesn't return. Hannah and Annie are concerned; they decide to visit him in a bleak, northern seaside town. His grandmother directs them to the seafront, where finally they find him. He asks if they've come to mock him and lead him on. Out of control, he tells them to 'fuck off'.

In the present, Hannah and Annie view some properties. First, a penthouse in which Mr Evans (Andy Serkis) answers the door in his dressing-gown, then repeatedly offers them champagne and drugs. He fails to notice Hannah's sarcasm or Annie's stifled laughs. Next, a flat in a Victorian conversion, where they have an appointment with estate agent Adrian Spinks (Joe Tucker). He turns out to be an old lover of Hannah's from North London Polytechnic whom Annie fell in love with first, but he barely remembers them. Flashbacks show us this trio in their college days.

Later, in a Chinese restaurant, Hannah and Annie wonder what happened to Ricky. Hannah tells Annie she's the only person ever to have appreciated her. The next day, as they walk through a central London park, their old flatmate Claire jogs past them but doesn't notice them. They decide to drive to their old flat and are shocked to find that the distracted man sitting outside, his head buried in a large soft toy, is Ricky. He talks gibberish but seems to recognise them. He says, 'I'm . . . like an idiot savant. Just, er, haven't found any savant yet.' Hannah and Annie are both crying by the time they leave him.

At the station, Hannah gives Annie a copy of Emily Brontë's Wuthering Heights; *they used to use the novel as a playful fortune-telling device when they were students. They hug, promising not to leave it another six years. Both fight tears again as they say goodbye.*

* * *

AMY RAPHAEL: *Why the unusually short gap between* Secrets & Lies *and* Career Girls?

MIKE LEIGH: Around the end of 1993 I got a letter from the BBC producer George Faber. He was commissioning twenty-six films to be shown at the millennium: would I like to write and direct one of them? In spring 1994 Simon and I went and drank a bottle of wine

with George and made a gentleman's agreement that we would make a ninety-minute film – a Thin Man film for the BBC. I asked if ours could be one of the later ones, as we were already committed to what would turn out to be *Secrets & Lies*. This was fine, and we got the green light.

But for some reason – which no one has ever seen fit to explain, much less apologise for – the processes at the BBC by which the contract had to be signed and sealed went to pieces. Letters were lost. There was no communication. We didn't hear a thing. We had no idea what it was about. It became a big issue. When we were doing post-production on *Secrets & Lies* in autumn 1995, for a wheeze I suggested we take the proposed BBC project to Channel 4. There was no film as such, of course – that is, no idea, no treatment, no script, no 'property' – but we suggested that they back it instead and give it the same budget. We went to David Aukin, who was attracted by the wheeze and agreed on the spot; within ten days it was contracted. And if you think you've heard this story before, you're right: see *A Sense of History*.

The press got onto it, and the BBC were outraged. They said we couldn't do it, but of course we could. For some internal Channel 4 reason, it was important that we made it straight away. So, having finished *Secrets & Lies* at Christmas 1995, we went straight into production and made *Career Girls* very quickly. It was shot in five weeks and we only had six characters. I didn't do a long casting process: I just cast people I knew and got on with it. We wrapped it before going to Cannes with *Secrets & Lies* in May 1996 and then came back to edit it.

In that short time you had a lot of locations to find.

Obviously we had the period problem in that respect too, but mostly it wasn't much of an issue. We went to Seaton Carew on the Northumberland coast to do that scene with Ricky. In one shot of the girls we had the whole crew standing on the grass verge, and every time a car went past that wouldn't have been around ten years earlier, someone shouted 'Cut!' It took quite a few takes . . .

We shot it around London, as usual. The flat was in Stoke Newington. We shot in King's Cross. The empty flat where they meet the estate agent was in Fellows Road in Swiss Cottage. The City

boy's flat was in the Isle of Dogs. The obscene mural you see as they walk up the stairs was actually there. The stuff in North London Poly was shot in the poly. The train arrived and left from King's Cross. At one time you could only shoot at Marylebone, but the rules are more relaxed now.

How did Marianne Jean-Baptiste end up writing the score?

We were on a plane in America during a promotional trip for *Secrets & Lies*, and she was saying how much she'd like to write music for films. So I got her to do it for this. It's so unlike the music for my other films – which seemed very right. I love most jazz, and this specific kind works very well in the film. Marianne sings on the soundtrack too. She's got a beautiful voice.

And it's good to hear The Cure too.

They were fans and let us use the music for nothing.

Are you fond of Career Girls?

Yes, very much so. Of course, it's taken on another dimension because of the death of Katrin Cartlidge. But in any case, I'm immensely fond of it. I still find it very moving – and not just because of Katrin. From my point of view, it benefited enormously coming as it did after the weight of *Secrets & Lies*, but it's also true from a commercial point of view that it suffered from coming immediately on the back of that film. I feel that *Career Girls* has a kind of inventive freedom. In the healthy traditions of an experimental short story, it falls between weightier major novels and historical reconstructions – it has a lightness and freedom and fresh air that I'm pleased with.

This may not be for me to say, as it may sound slightly self-congratulatory, but certainly in terms of my intention and feeling about the film when doing it, there's a kind of poetic quality to it. I don't really want to use the word 'ethereal', but that would kind of explain what the film's about. It's something to do with what Hannah and Annie are experiencing. And from a writing point of view, you might consider it alongside *Naked* and *Topsy-Turvy*. It has a dialogue style quite unlike that of any of my other films.

Yet you feel that it remains a neglected film, particularly as it's sandwiched between Secrets & Lies *and* Topsy-Turvy?

Totally. I suspect it's a more rarefied taste. I remember when it opened in downtown New York at the Angelika it was a wow. It played to packed houses. I stood at the back and people were right onto it. Maybe its time will come. Somebody said recently at a Katrin Cartlidge memorial event – which was, incidentally, very jolly – what a great film *Career Girls* is.

But I think, more than any film I've made, people either love it or hate it. It provokes even more extreme reactions than *Naked*. It is quirky. If you don't get what those women are about, you're lost. And there's no causal narrative. I suppose there are two basic sorts of antipathy towards it. The first is a criticism of the acting, because of the way the women behave. Hannah, for example, at both twenty and thirty is doing an elaborate performance – that is, Hannah the character is 'acting', not Katrin. The other thing that irritates people to death is the number of coincidences in the film. People can't believe that Hannah and Annie find Ricky outside the flat, having already run into Adrian and Claire. You can read Ricky's presence, as you must, on one very prosaic level: by complete coincidence he's sitting there clutching a large cuddly toy. But it should operate on another level where it's spooky: he's actually haunting the place. We are not, of course, in the territory of Anthony Minghella's *Truly Madly Deeply* or even *Macbeth*. It is rather to do with the two women revisiting things. I suppose I think there's a sort of metaphorical dimension to the film. Spiritual, maybe.

Personally, I think it's absurd to question such coincidences because everyone knows perfectly well that you can run into someone you haven't seen for forty years and ten minutes later run into someone else who was around the same scene. These things happen. Whether or not you think it's synchronicity or there are forces at work, that's up to you. I have no real truck with either of those criticisms.

There's also, of course, the whole sub-*I Ching* thing of Ms Brontë. They do it at the end when Hannah gives Annie the book; it's perfectly real but there's this other thing going on.

Also, films aren't without dramatic licence.

That's true too. But people forget that when they're criticising my films, because they think, wrongly, that they're always supposed to be naturalistic. If ever there was a film that pushed those boundaries in quite a simple way, it's *Career Girls*.

The other interesting thing about it, I suppose, is this: it is standard procedure in the development of these films that we start way back when with each character and then we build up the years and years of their lives until we reach the present. Then I drop anchor, and the story always takes place in the present. We'd just done it with *Secrets & Lies*, spending three months building up a 'back story'. The investigation into Roxanne's birthday party went on for weeks because there were all sorts of things around it. So there we were in *Career Girls*, discovering Hannah and Annie's lives ten years previously. Normally we work through it and then there are occasional references to the past in the present-day action of the film. But suddenly I had this brainwave: the film could have a double narrative – now and in the past. Once I'd had that idea, it opened the whole thing up.

Did you enjoy using that flashback technique?

Yeah. The present-day stuff is shot formally with fully succulent photography on 35mm. The flashback stuff is shot handheld and on 16mm, using the bleach bypass process we'd used in *Naked*. It was very interesting.

What was your initial idea for Career Girls?

At the end of *High Hopes*, Cyril says, 'From twenty-five to thirty-five are the best years of your life.' This was once said to me when I was thirty-five by a relation from Manchester who's now in his eighties. I also think the journey from twenty to thirty is a long one. At twenty, you're still a kid really, and at thirty you're well into adulthood. That's what this film is about.

How we age and change fascinates you endlessly.

Yeah. Absolutely.

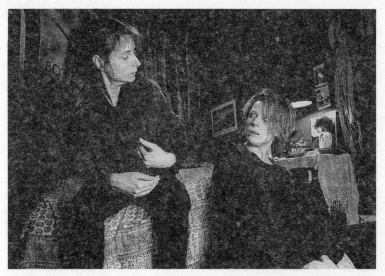

33 *Career Girls:* Hannah (Katrin Cartlidge) and Annie (Lynda Steadman).

Were you looking back on your own life between twenty and thirty with particular nostalgia as you created the film?

No, beyond the fact that in doing the film I must have thought about it. But not especially.

Career Girls gives women two central roles. It's not something you're guilty of in your films, but there is still a dearth of strong roles for women out there.

I couldn't agree more, which is why I do what I do. For exactly that reason.

How long did Katrin Cartlidge and Lynda Steadman hang out together before you shot the film, and what sort of research did they undertake?

Those two, Mark Benton and Joe Tucker all plugged into what was once North London Poly, was then the University of North London and is now the Metropolitan University. We met people that were lecturers and students at the time and pottered round the place. Then, of course, they did the standard things: Hannah was

reading English, and Annie was on a psychology course, so they all did their research.

Didn't Andy Serkis get offered a job in the City while he was doing his research?

Yeah. They said that if the film didn't work out, they'd offer £30,000 a year. What he, they and we didn't realise was that he was destined to become incredibly rich and famous for playing a legendary digitalised character in an epic film classic.

Why would Hannah and Annie want to meet up again? Is it about nostalgia or an emptiness in their lives?

It's what we call friendship. It's what people do. 'Friends Re-united.' I could've called it that.

Hannah and Annie are from a generation of women who are very strong and independent, yet they rely on the attention of men. They use Wuthering Heights *as a fortune-telling device to see when they will next have sex. It's all about blokes.*

They'd both like to be independent. They need to have blokes and

34 *Career Girls:* Mr Evans (Andy Serkis).

they need not to have blokes. Isn't that true about life in general, for men and women?

We've talked about the women being strong, but the men . . .

. . . are more fucked up than ever. You've got one guy who's actually dysfunctional. But Ricky is also intelligent. He's got feelings. You've got a guy who is playing out a role and has blanked out what happened to him in his youth. Then this guy who's beyond the redemption of debauchery.

Is Ricky manic-depressive? It's hard to see how he's become so alienated.

Maybe. He comes from an extremely poor background that is also intellectually and emotionally impoverished. A very provincial background, a seaside place. He derives from a number of people I've known, people who come to London and are way out of their depth in this big city, like Norman, Wayne and those Scottish kids in *Naked*. Not everybody who comes to London from the provinces is escaping. People go to university in London because that's where they got a place. Don't forget, not everyone is interviewed. It's not like Oxbridge.

So here's this guy who's come down on the bus in 1986 to go to North London Polytechnic, but he's certainly not getting anything out of being in the capital. He's not digging the scene. You can see it. It's from one bedsitter to another, from one Chinese takeaway argument to another. Living in the same donkey jacket for ever. Doing a psychology course, yet being screwed up at the same time. Plainly he can do the work. He's got communication problems but he's not incapable of falling in love, and he is desperately in love, which we all know can destroy you.

The two girls play around with him.

Only in the spirit of being friendly platonic friends. They are not winding him up or taunting him. He's not threatening or macho in any way. They perceive him as a friend – harmless – and therefore they can be free-spirited with him. They see him as beyond any need for sexual game-playing.

So he's like a brother instead of a potential fuck.

Exactly. Or a teddy bear. But he's a bloke with feelings. Somebody I know and who I'm very fond of said he thought Ricky was over the top. But he's not. As I've said, I know guys like that.

We've talked about it before and it's one of the most talked about things in relation to my work. The truth is that most plays and films don't portray this type of person. Apart from anything else, it would be very hard to write them by conventional means. Mark Benton, who is now never off the box, is an immensely clever guy. Look how different he is in *Topsy-Turvy*.

The people who don't think Ricky exists have also criticised you for the jerking and twitching that goes on in certain scenes.

These people live in a trendy media world, in an eternal cocktail party. But I don't want to be defensive about *Career Girls*, because it's not a film that needs defending. It stands up perfectly well, as far as I'm concerned. It is infinitely more complex and dense than, say, *Nuts in May*. It's very nicely executed on the part of the performers. It's an original, organic piece of work. Apart from anything else, some of it is very funny.

Let's talk about Katrin Cartlidge.

As I've said and written, she was pretty amazing. First of all, she was terrific at characters, the disciplines of acting and all that. Secondly, she was immensely intelligent, very sharp and sussed about everything and anything. Quick as lightning and always on the case with whatever it might be. She had a huge sense of humour. She was immensely good fun to be with. Never got into a state about anything. Was always there for everyone else. Very generous. A real ensemble actor but an individualist at the same time. She was totally in touch with her own spirit, body, emotions. She could really do anything emotionally.

We did become close friends, and we'd often have lunch. She was always a laugh, every time. But serious too. Then, without warning, she died. Terrifying. We'd been at the film festival in Sarajevo two weeks before. She was there partly because she was massively popular in that part of the world, having been in *Before*

the Rain and *No Man's Land*. They just loved her in Macedonia and Bosnia-Herzegovina. And there was a retrospective of my films in Sarajevo in 2002, so I was there with Charlotte, my partner, Lesley Manville and Katrin. She and I had to introduce a late-night open-air screening of *Naked* to an audience of 2,500. Beforehand, the interpreter asked me what I was going to say. I had no idea, of course. Katrin howled with laughter – she knew I always improvised. I assured the lady I wouldn't say anything she couldn't translate. While we were waiting, Katrin egged me on to say something untranslatable. I suggested ''Twas brillig . . .', et cetera. She said if I'd recite that, she would utter a long Serbo-Croat obscenity she'd picked up while shooting *No Man's Land*. Of course, we didn't actually carry out the dare – just enjoying the idea was enough.

A week or so later she took her parents to Paris with her partner. She felt poorly when she got back and thought she must have food poisoning. She was admitted to the Royal Free and she died. She was forty-one. By this time I was at the Toronto Film Festival with Lesley Manville and Tim Spall. A lot of people at the festival knew her. Everybody was devastated. It was terrible.

Do you find it hard to watch her on screen even now?

At a recent memorial we all watched *Before the Rain*. It is hard and it isn't. It's difficult and delightful . . . I don't know.

I'd only worked with her twice. Then, when it came to *Topsy-Turvy*, she really wanted to be in it: a small part, anything. It became very clear what it would be – the madam in a Paris brothel frequented by Sullivan. She showed up to work on the scene and she'd actually been to Paris and done some research about prostitutes. She really used to enjoy the work. She never went to drama school; she was one of those people who could just do it. She would have gone on to direct. Finally, what can you say about a person? She had a real uniqueness. To say she was a great loss would be a massive understatement. At least we did *Career Girls*, this strange, quirky investigation into women on the cusp of being a grown-up, with all its attendant baggage.

Topsy-Turvy (1999)

London, January 1884. Writer W. S. Gilbert (Jim Broadbent) and composer Sir Arthur Sullivan (Allan Corduner) have enjoyed ten hit operas in a row. Their comic operas, produced by impresario Richard D'Oyly Carte (Ron Cook), have helped pay for the construction of the Savoy Theatre. Sullivan struggles out of his sickbed to conduct the first night of their new comic opera, Princess Ida, *at the Savoy. Gilbert waits anxiously backstage. Sullivan collapses from exhaustion at the end of the performance.*

Princess Ida *fails to impress* The Times's *critic, who refers to*

35 *Topsy-Turvy*: W. S. Gilbert (Jim Broadbent), Arthur Sullivan (Allan Corduner).

Gilbert as 'the legitimate monarch of the Realm of Topsy-Turvydom'. Sullivan, eternally torn between his love of writing serious music and the money to be made from comic opera, tells D'Oyly Carte, 'I have to write a grand opera . . . I cannot waste any more time on these trivial soufflés. D'you know, I haven't written a symphony for over twenty years.'

Gilbert visits his wife Lucy (Lesley Manville) in her bedroom and tells her of his humiliation; he thinks everyone is calling him 'The King of Topsy-Turvydom'. Kitty (her nickname) offers to read to him, but he is distracted. He leaves her room. Sullivan is in his apartment with his mistress, Mrs Fanny Ronalds (Eleanor David). They talk about his imminent trip to Paris and have sex. In Paris, Sullivan visits a brothel.

London is suffering a heatwave. Princess Ida is failing to draw the crowds. Two leading actors, Richard Temple (Timothy Spall) and Durward Lely (Kevin McKidd), decide that Gilbert and Sullivan's career is over. D'Oyly Carte's company manager Richard Barker (Sam Kelly) rings Gilbert and gives him the audience figures in code in case the telephone operator should be listening. Gilbert's father (Charles Simon) dismisses the newly invented telephone as 'A sheer waste of time. It can only result in the further erosion of the written word.'

D'Oyly Carte meets Sullivan in a Paris restaurant, where he sells him the last ten shares in what will become the Savoy Hotel. D'Oyly Carte wants to know if he will continue to collaborate with Gilbert; Sullivan says that although they are under contract, he will not be writing any more operas for the Savoy.

Sullivan, back in London, is visited by Gilbert. Sullivan explains, 'There's so much that I have yet to do for music, for my queen, for my country.' He fears his music is becoming repetitious; they disagree about who is subordinate to whom, librettist or composer. Gilbert presents his latest libretto, set in Sicily and involving a magic potion. Sullivan listens unhappily – Gilbert's magic lozenge plots are precisely what he has objected to. He wants to compose an opera of 'human interest'.

Gilbert, working at home, suffers chronic toothache. He finally visits his dentist, who tells him Princess Ida is too long.

A week or so later, Gilbert goes to D'Oyly Carte's office to complain about Sullivan: he has yet to respond to his reworked

libretto. Although D'Oyly Carte says he is not in the business of revivals, he has withdrawn Princess Ida *in favour of a revival of Gilbert and Sullivan's earlier work,* The Sorcerer.

We see the first act of The Sorcerer. *During the interval, two young leading actresses talk openly. Leonora Braham (Shirley Henderson) smokes and drinks, while Jessie Bond (Dorothy Atkinson) has the varicose vein on her leg bandaged by her dresser.*

Gilbert and Sullivan meet in D'Oyly Carte's office. Helen Lenoir (Wendy Nottingham), D'Oyly Carte's assistant, tries to help the two men come to an agreement, but it's hopeless and they both leave. Their relationship would seem to be over.

Kitty tells Gilbert of two Japanese ladies she has just seen in the street and suggests they visit the Japanese exhibition being held in London. In a gas-lit theatre, they watch a kabuki play in which a supplicant attacks his lord with his sword. Gilbert is inspired. His manservant hangs a Japanese sword on his study wall.

Gilbert's two sisters Maude (Theresa Watson) and Florence (Lavinia Bertram) tell their mother (Eve Pearce) that they bumped into their brother at the Japanese exhibition. She wants to know what he said; she wonders if Lucy is pregnant. The sisters think not.

Gilbert is in his study when the Japanese sword falls off the wall. He is immediately inspired to write The Mikado, *with its Lord High Executioner. He reads it to Sullivan, who warms to it.*

On 12 February 1885 three Savoy actors – George Grossmith (Martin Savage), Durward Lely and Rutland Barrington (Vincent Franklin) – discuss the killing of General Gordon at Khartoum over a lunch of oysters and fish. Grossmith and Barrington both meet D'Oyly Carte to ask for a pay rise. Poisoned by oysters, both men leave before agreement is reached.

In the Savoy Theatre fitting room, the ladies' costumier (Alison Steadman) fits a young actress with her kimono. In his desire for authenticity, Gilbert wants the cast to do without corsets. Lely impetuously says he will find it hard to sing without his corset.

In the theatre, Gilbert asks four Japanese people from the exhibition to help the actors. The three Japanese women walk self-consciously to the music, then teach the actors how to use fans. Some time later, in rehearsal, Gilbert struggles to elicit the performances he desires from Grossmith, Barrington and Jessie Bond. At the full

dress rehearsal, Richard Temple sings the title song of The
Mikado. *The actors are shocked when Gilbert decides to omit the
song. Temple is devastated.*

*The next day chorus members wait for Gilbert on the stairs of
the Savoy and implore him to reinstate Temple's song. He finally
relents.*

The first night of The Mikado. *Gilbert and Sullivan encourage
the actors, Gilbert nervously, Sullivan affably. Grossmith's door is
locked; he is secretly injecting himself with morphine. Despite his
erratic performance, the show is a triumph.*

*Later that night Gilbert sits on the edge of Kitty's bed. He says,
'There's something inherently disappointing about success.' Kitty
says, 'Wouldn't it be wondrous if perfectly commonplace people
gave each other a round of applause at the end of the day?' She
wonders what his next opera might be and suggests an idea that
sounds like a surreal nightmare, in which hundreds of nannies
push empty perambulators around. Kitty is on the verge of tears.
Gilbert is disturbed and confused.*

*Sullivan is in bed, ill. Fanny tells him she is pregnant again; she
has made her own arrangements. She tells him she loves* The
Mikado: *'You've put everything you are into it.'*

*Leonora, alone in her dressing room, is dressed up as Yum-Yum,
her character in* The Mikado. *She is drinking sherry and quoting a
soliloquy from act two. She stands on stage, alone, singing 'The
Sun Whose Rays' from the show.*

* * *

AMY RAPHAEL: *You were taken to the theatre regularly as a child
and the annual treat was, I believe, the visit of the D'Oyly Carte
Opera Company.*

MIKE LEIGH: I remember being interviewed about this film by an
upper-class journalist. He thought it remarkable that someone
from my background – Jewish, provincial – should have been
taken to see Gilbert and Sullivan operas. I told him that had he
gone to the Opera House in Manchester in the 1950s, or indeed
any Hallé concert, he'd have found a massive number of Jews in
the audience.

In the working-class, Jewish East End in the 1920s and '30s everyone knew and sang Gilbert and Sullivan. It was part of the popular culture. Stephen Rea told me how navvies in pubs in west Belfast used to sing Gilbert and Sullivan. I remember being in a pub in Manchester in 1969. After last orders we were going to go for a curry, but someone suggested going to the D'Oyly Carte night at the Press Club in Albert Square. It was an annual gig where the guys from the D'Oyly Carte company would show up – and *only* the guys. All the press men were there and the printers with their newsprint hats on, all eating oversized cheese and onion sandwiches and drinking pints – and all joining in the choruses. In a slightly camp way, the guys from the D'Oyly Carte all gave double-entendre renderings of the songs.

When I was at school, all the teachers were into Gilbert and Sullivan. When I was talking about the film after it had been made, one of the things I consistently said was that the Victorian world hung in the recent air when I was growing up. Not only were we taught by Victorian teachers born in the 1880s and '90s, but we were taught in Victorian schools and lived in Victorian houses. Manchester is, after all, a great Victorian city. So a sense of the Victorian world was all around us in the 1940s and '50s.

There were Victorian institutions. We'd be taken to inter-school musical events in nineteenth-century halls, now long since demolished. You could smell the old Victorian world in the grime, the soot and industrial effluent around you. When I was born, anyone born the day Queen Victoria died would only have been forty-two. On top of that – and something which is really important not only in the spirit of *Topsy-Turvy* but also in terms of the language – from an early age I read everything, from *Tom Brown's Schooldays* to lots of Dickens, which was very much part of my early consciousness. Certainly by the time I was ten I could quote Edward Lear and Lewis Carroll pretty much verbatim – as much as I could quote Gilbert and Sullivan, which is the same territory really.

Through all kinds of reading and from my own life experience an awareness of the Victorian period was just there. My uncured addiction to second-hand bookshops – not helped by recently moving near the British Museum – kicked in at a young age. There were all these second-hand bookshops in Manchester on a steep

street called Shudehill which I started going to before I was eleven. The shops have sadly long since disappeared but I still have many of those books. I used to buy old copies of *Punch* from the 1860s, '70s and '80s that cost sixpence and would be worth a bloody fortune now. They were so three-a-penny back then that I used to cut them up and use them in collages!

Incidentally, when I was working as a director at East 15 Acting School in 1968 they were doing Pinero's play *Dandy Dick*. Since I was around, I was asked if I'd take charge and do a subsidiary project on *Dandy Dick*, which is, in fact, a hilarious farce from the 1890s about a racehorse. I pulled out my old copies of *Punch* and Victorian society cartoons, including George du Maurier's long series called 'Things One Would Rather Have Left Unsaid'. The students and I put together a twenty-five-minute dramatisation of these cartoons, simply going from caption to caption. We even called it *Things One Would Rather Have Left Unsaid*. I was able to whizz that into existence by a knowledge of the period.

I have to say that although I'm not given to spooky preoccupations, I do have a very strong sense of familiarity with that Victorian world in a way that I can't quite put my finger on. I'm not one of those people who goes round thinking that he's reincarnated, but doing a Victorian film came very naturally through what is effectively a lifetime's informal study of and immersion in the period.

It would also be a huge mistake for anyone to assume that what I'm talking about only manifests itself in *Topsy-Turvy*. In a very implicit, personal but probably subtle way what I'm talking about is there across the spectrum of my films.

Your childhood sounds incredibly rich with experience, both in terms of the environment you grew up in and the things in which you immersed yourself.

Well, as I've already said, it was the classic combination of a dreary, dead, bourgeois suburban existence with a philistine diet of safe, middlebrow culture. Some people used to say what an old-fashioned child I was. I was a complicated and possibly bizarre combination of wholesome old-fashioned values and a radical, anarchic reaction to life.

To return to Victorian art, there are pre-Raphaelite paintings that have a kind of innocence, wholesomeness and sense of reality that in a way have been a turn-on for me. Interestingly, and while we're on the general subject of these kinds of influences, I saw a documentary recently about Ronald Searle. He was a massive influence. His first published book of drawings, *Hurrah for St Trinian's*, was given to me as a birthday present when I was a young boy. It was a revelation. Seeing the documentary set me on a train of thought, linking up the tension between reality and flights of fancy in all the films, not least *Topsy-Turvy*. I'd forgotten for a very long time that I was so influenced by Searle. My grandfather used to have *Lilliput* and *Men Only*, which at that time wasn't a dirty magazine but used to have drawings by artists like Searle. A retired relation gave me a whole pile of blank invoice books in which to draw. Paper was rationed. Later I became very disenchanted with journalists, but at this point I was very in love with the whole idea of newspapers and comics, writing articles and drawing cartoons.

Were your mother and father both fans of Gilbert and Sullivan?

Yes. My father used to go and queue for the tickets. We certainly had Gilbert and Sullivan records in the house. I remember being given Leslie Baily's *The Gilbert and Sullivan Book* (1952) for my ninth birthday. In a way it's the genesis of *Topsy-Turvy*. It was a bible really. It's a history. Courtesy of that book, I've always found the backstage aspect of Gilbert and Sullivan interesting. There's also *The Story of Gilbert and Sullivan*, a movie made in 1953 with Robert Morley, Maurice Evans and Peter Finch. It's very amusing comparing it to *Topsy-Turvy*, I have to say.

It's always worth remembering that Manchester has got a big musical tradition, going back to the Hallé, which was founded in 1858 by Charles Hallé himself. When I was a kid there were choirs and operatic societies and brass bands everywhere. Gilbert and Sullivan were part of the popular culture. It's important to understand the context.

This wasn't standard for a lot of kids, but as well as going to endless films, I got taken to all sorts of shows – plays, musicals and variety. I actually saw Laurel and Hardy on stage in 1952 when

they toured the country. It was very strange. First of all, they were in colour and, secondly, when they were doing a railway-station sketch, Oliver Hardy simply couldn't stop giggling. It was the first time I became aware of corpsing. They weren't inspiring; it was just the fact of seeing them.

I assume you were excited by going to see the D'Oyly Carte Opera Company as a child?

Oh yes, but I was excited by a lot of things as a child. For sure. But so far as Gilbert and Sullivan are concerned, I think it's very funny and the music is great, like Offenbach, Donizetti and Rossini, whose work is all related. Over the years a kind of stigma has attached itself to Gilbert and Sullivan. It's all about snobbery, although this is only an English disease, from which the Americans don't suffer.

I learned to shut up about them until it dawned on me during the 1980s that it would be a wheeze to do a film about them that would subvert the snobbery by dealing with them in a realistic way, by looking at the tension between reality and artifice . . . So that became one of a number of ongoing ideas.

As I've said, when we were filming *A Sense of History* in the freezing cold January of 1992, it suddenly occurred to me that Jim Broadbent could play Gilbert. One day some weeks later Jim came round to my place, and I told him my idea. He thought I was joking.

Did Jim Broadbent have any interest in or knowledge of Gilbert and Sullivan?

Not particularly, although he'd been in *The Sorcerer* at the London Academy of Music and Dramatic Art. For seven years he always checked with us before accepting big jobs in case what was to become *Topsy-Turvy* looked likely.

Had it been on your mind to make a period film or was it specifically Gilbert and Sullivan who caught your imagination?

Up to 1992 I'd never done a period play or film, at which point I did *It's a Great Big Shame!*, which was a conscious exercise in

doing a Victorian project. To answer the question: both. Well, one was an excuse for the other. I have three thoughts about the motivation of *Topsy-Turvy*.

One: above all, Gilbert and Sullivan would allow me to take on the apparent genres of the biopic and the lavish costume drama without any risk of losing the very core of my films, which is character.

Two: there's no way I would have considered doing this if it was merely to deal with Gilbert and Sullivan. It could only make sense if it was about something important to me, over and above them and their shows. It was time to turn the camera around and look at what we all do. I felt *Topsy-Turvy* would be an excellent device for exploring matters to do with those of us who are in the business of creating entertainment. Of course, I could make a film about film-makers, but for whatever reason I don't really fancy it.

Three: having read extensively about this world, deciding to make a film about it was the next best thing to getting into a time machine to go back and see what it was like. I think we did that in a way. That was certainly part of the buzz of it. It's a buzz I get anyway when a film starts coming together and a reality starts to exist; in *Vera Drake* and *It's a Great Big Shame!*, when you've suddenly got these 1950 and 1893 scenarios actually happening, it's very exciting. And, of course, I'm fascinated by theatre.

Why did you decide to focus on the mid-1880s in Topsy-Turvy?

I was never going to do a biopic where people aged unbelievably. It's not interesting. I prefer to drop anchor in one place. The only exception to that is *Career Girls*. So it made sense to focus on the period in which Sullivan says he doesn't want any more to do with comic opera; he wants to move on and become serious. Obviously it's a dramatised distillation of what really happened: *Princess Ida* was a relative flop, there was a terrible heatwave, *The Sorcerer* was revived and they wrote *The Mikado*. And the famous Japanese village in Kensington would lend itself to what was clearly going to be a major theme: the tension between the real and the artificial.

It was also an interesting period in terms of advancing technology

and changing attitudes towards women, with Helen Lenoir running the show.

The late nineteenth century, heading towards the Edwardian period and the First World War, experienced a massive period of change. When we were preparing the film, the BFI made a compilation of three hours of footage, all shot in London between 1896 – in other words, the minute the movie camera was invented – to 1901. That was a decade out for us, but it was still very useful.

Helen Lenoir was a revelation for us. It turns out that she really was a career girl and a bachelor woman. She lived in a flat on Buckingham Palace Road that she shared with another woman. She was a prototype twentieth-century working woman. And there's all that stuff about those two actresses. Leonora Braham was a piss artist who had a kid and whose husband had committed suicide. And we read Jessie Bond's 1932 autobiography, a volume that reveals her to be a truly dreadful woman.

Having met Oscar Wilde some time in the 1890s, she reports that she knew by the feel of his hand that there was something wrong. She sounds pretty dim. She had something wrong with her leg, but we didn't know what it was. Dorothy Atkinson and I consulted a specialist, who thought it would probably have been a varicose condition, which they didn't know what to do with at that time.

Once you'd decided upon a specific period, what challenged you next?

Talking generally, the two main challenges of making the film were: to put interesting characters on the screen by creating them organically but at the same time staying true to the real characters; and to be sure that the film didn't fall into the typical biopic trap of not actually showing what Gilbert and Sullivan created. You may watch a film like *Iris* and understand that Iris Murdoch was a genius and a tortured soul, but you don't actually experience what she wrote.

When we had made the film, there was a massive stand-off from the French and German backers. The German backer loved the backstage scenes but wanted to cut all the songs! Unflinchingly I said not only did there have to be a reasonable amount of the

actual music but also everything I had selected was there for a dramatic reason. It was also important that the audience got a chance to savour the treat of Gilbert and Sullivan's work.

Why didn't the French like it?

They hated it. They said only English and American audiences would get it. In fact, they banned us from going to Cannes. They said the French critics would eat me alive; it would be the end of my career. I remain convinced to this day that it would have done very well there. Here's one of their objections to it: they said the scene in the Parisian brothel was fake and unbelievable from a French perspective. Now, when we shot it we had two people from the Institut Français on the set. And when it showed at the Paris Film Festival, I asked if anyone in the audience thought the brothel scene was in any way unbelievable. Not a soul in two screenings thought so.

Another anecdote: in 1997, before making *Topsy-Turvy*, I was on the jury at Cannes. It was the fiftieth anniversary. A lunch was held for Palme d'Or winners. I found myself sitting opposite the president of France, who was flanked by Chen Kaige and Gong Li, a fellow juror. To my left was Martin Scorsese and to my right was Francis Ford Coppola. We were chatting away and I asked Scorsese what he was up to. He said he'd been trying for years to make a biopic about the Gershwin brothers. I told him I was hoping to make a film about Gilbert and Sullivan, whereupon Coppola immediately jumped up with great glee; his dad had been an MD round Broadway theatres and had been a huge fan. At some point during this extremely well-oiled lunch I went to the loo, and there was Francis Ford Coppola singing 'I Am the Very Model of a Modern Major General' from *The Pirates of Penzance* very loudly. Three years later he told our disgruntled French backer that *Topsy-Turvy* was the best film of 1999 and one of his favourite films ever.

How did the Japanese feel about the film?

Even though JVC put a big slice of money into the film, it was never released in Japan, and no one has ever explained why. It wasn't released in Germany either; they didn't think the audience

would like it, although it was at the same time that *The Pirates of Penzance* [*Die Piraten*] played for two years in Berlin. Madness.

Did you ever entertain the idea of an Anglo-Japanese co-production?

Yes. At one stage I had the idea for a really substantial Anglo-Japanese co-production, but plainly it wasn't feasible. There was a Dutchman called Tannaker who went to Japan in 1883 and pulled out a hundred or so men, women and children – most of whom were on the run – and shipped them to London. He installed them in Humphrey's Hall, on the site that is now occupied by Imperial College, and created the Japanese village that Gilbert visited. I wanted to tell the story from the Japanese point of view as well, seeing their journey from Nagasaki. But it wasn't to be.

We also went to Quantel to look at the digital possibilities. We were trying to work out whether it would be cheaper to build a set or digitally create the sequence where Gilbert walks down the Strand with hundreds of people and carriages . . . All pipe dreams.

There were so many versions of the film in my mind. Gilbert on his steam yacht, Sullivan at the races; it was all there in the first draft of my shooting script, but we couldn't afford the time or the money. I think it was for the better. When you are actually dealing with reality as opposed to characters you've created for a metaphor, you tend to get so bogged down in the reality that you can't see the wood for the trees. I think what I finally managed to do was to distil it down so that it became a metaphor. It's still longer than any film I've made, and some people think it's too long. I don't agree, as it happens. It was much longer – there are all sorts of excised sequences.

Long though it is, it must have been very painful to cut, given that it was close to your heart.

Well, it was no closer to my heart than any other film, but I didn't want to cut things that worked. It did reach a point where there was a stand-off about the length. In fact, there was a terrible battle in this very room, with lots of people shouting and screaming. In the end we all agreed on 159 minutes, which was fine for me,

but what was painful was that we were contractually obliged to supply a two-hour version for in-flight screenings. Anyone could have supervised this, but I took the responsibility myself. It was so awful it wasn't even painful. If anyone ever says to me, 'I love *Topsy-Turvy*, I saw it on a plane,' I entreat them to see it again.

You talk about the many versions of the film you had in your head; when you were thinking about making a period film, had you always wanted to subvert the genre?

Yes. That's implicit in the decision to do it. At one time I talked of doing a film about the Irish potato famine; had I done that, I wouldn't have been so concerned about subverting the genre.

Did you feel as though you had to wait until you'd had a certain amount of experience before you could make such an epic film?

Of course, I don't think it's an issue. There had never been an opportunity. I don't think I'd been expecting it to happen at all. It happened naturally when it happened. The truth is that we were only licensed to do it by the success of *Secrets & Lies*. If you were to ask if I thought it was an advantage to have had that amount of experience, the answer is definitely yes.

You may have been brought up with Gilbert and Sullivan, but where did you start when it came to doing the research?

We put an advert in the *Guardian* that said, 'Wanted: researcher for original British feature film. Must have knowledge of nine-teenth-century social history, classical music and Victorian comic opera.' We weren't very hopeful. Guess how many replies we had? A huge amount: six hundred. Out of them, there were fifty-two serious, qualified candidates. It was extraordinary. The person we chose had two music degrees, was ex-BBC library and all the rest of it. These things are essential.

How much Gilbert and Sullivan material did you already own?

I started to collect books and CDs consciously when I eventually had the idea of doing a film. Everywhere I went, I looked.

In terms of research, did you find it more or less of a challenge to work with an existing story?

Neither. It's just a different job. The hard parts weren't to do with it being an existing story but rather working out how to do certain things. It's one thing to get your characters on the go and have them sitting around making tea, scratching their arses and watching the box. But when you've got servants and everyone is speaking a particular kind of language . . . it's just much harder. We did the least amount of preliminary improvisation I've ever done in my films. We were pretty quickly onto the main story.

We rehearsed for six months in the old brewery in Three Mills Island studios in Bow. We had a massive room with a very long table, around which the entire cast would sit, share research and talk their way through the years. There was also a piano which was used every so often. It was like a mini-university. I love it when we can bring in things like it all going wrong with Gordon at Khartoum and Richard Temple saying, 'Oh, the Fenian bomb!'

Did the actors go off and do their own research?

Of course. Copiously. That always happens anyway. There were actors playing characters who existed but also those playing invented characters. Kevin McKidd found out that Durward Lely came from Arbroath, and so when he wasn't needed he took it upon himself to jump on a plane and fly up there. He went into the library, and the woman said, 'Oh, we've got an unpublished autobiography of this guy somewhere in the vaults.' Then he discovered there was a woman in town who had known Durward Lely's son, who'd died in something like 1959. This woman pulled out this tiger's tooth on a chain, a talisman Lely himself had worn around his neck during the Savoy shows. She very kindly gave it to Kevin, and he wore it in the film. Very spooky.

How did you make sure the language was accurate?

First of all, people read books, magazines, newspapers, periodicals. That went into the bloodstream. I'd work in the usual way with the character and, therefore, with the way he or she would speak. Then people would improvise as we were building scenes

and, inevitably, a proportion of what they would come out with would be anachronistic, modern. They'd say things like 'OK', which had yet to be invented.

So I had one shopping trolley and Rosie Chambers, the researcher, had another, both full of reference books. One of the most useful books was, in fact, *The Savoy Operas* by W. S. Gilbert. His dialogue is tremendously useful because it's written in colloquial, late Victorian English and gives us his ironical verbal style. But, ultimately, I simply have a good instinct for the accuracy of spoken language.

I imagine you were distraught to make a mistake, even if it was only one: Gilbert, angry with Sullivan for wanting to write grand operas, says to him, 'I suggest you contact Mr Ibsen in Oslo. I am sure he will be able to furnish you with something suitably dull.' Ibsen was barely known in this country at the time and Oslo was still called Christiania.

We were gutted; it was a stupid mistake. A gaffe. A blunder. Any other mistake is deliberate, by which I mean there's dramatic licence. For example, Gilbert is inspired to write *The Mikado* because the sword falls off the wall. It may be true but it's generally perceived to be apocryphal. I also decided that Gilbert should get the idea for *The Mikado* after going to the Japanese exhibition. In reality, he was already writing the show by the time he visited the exhibition.

If you didn't know that the Japanese exhibition actually existed, you would wonder how on earth Gilbert and Sullivan managed to recreate such a distant, exotic world in The Mikado.

Although the exhibition was a big draw in 1885, an awareness of things Japanese had been going on for well over twenty years.

But many of the Savoy actors are still ignorant about Japanese culture – saying, for example, that they don't want to wear 'dressing gowns' when they are presented with kimonos.

Well, I sort of borrowed that from Charles Ricketts, who redesigned the costumes for *The Mikado* in 1926 for Rupert D'Oyly Carte.

He had initially written to D'Oyly Carte and said he'd have to do proper Japanese costumes and not the 'dreary dressing gowns' that had been used up till then.

Kevin McKidd is very funny in the scene where he complains about having to wear a corset.

I am particularly fond of that pair of scenes about the kimono and the frock, in which everybody, not least Alison Steadman, is just great.

You already had Jim Broadbent on board as Gilbert, but how hard was it to find Sullivan?

It's worth remembering that everything I've ever cast – with the possible exception of knowing I had to find a woman who could play the central character of an abortionist – starts from the premise that you hire an actor and then invent the character. With *Topsy-Turvy* we had to find an actor who could not only play Sullivan but could also look like him. And who could play the piano consummately and had a real grasp of music – classical music at that.

36 *Topsy-Turvy*: the madam (Katrin Cartlidge) and Arthur Sullivan (Allan Corduner).

The casting director Nina Gold and I sat down knowing that if we didn't crack it, we'd be in trouble. We started going through all the possibilities, such as they were. One short, rotund actor with whom I've worked and who theoretically could have looked like Sullivan and who plays the guitar phoned me up and offered his services. He told me he'd started taking piano lessons. Another actor I'd also worked with and knew could play the classical piano said he only played it in private. A very famous actor was very keen and he also played the classical piano, but he happened to be someone I'm extremely unenthusiastic about, to say the least.

Finally, Nina said the only actor she could think of was Allan Corduner. For some reason our paths had never crossed. The problem was that he was in *Titanic: The Musical* on Broadway and therefore wasn't available. So we took him off our list. Then Nina said Allan had three days off in his contract, was coming to London and was keen to meet me. We met in this room and immediately got on. He was going back to New York the following day but I told him he would have to do a bit of practical work with me before I could cast him.

A couple of months later I went to New York to do press for *Career Girls*. I borrowed a rehearsal space with a piano from a friend. Allan turned up and did a bit of character stuff, which he could obviously do very well. I said, 'I believe you can play the piano.' He said he could a bit, what did I want? I suggested jazz, so he sat down and jazz poured out. Followed by Mozart, music hall . . . anything. He is amazing.

I went to see *Titanic: The Musical*, which was a bizarre event. Allan was just brilliant as the first steward. We met afterwards and went round the corner to Joe Allen's. We both had liver and I offered him the job. Two years later Allan, Jim Broadbent and I flew to New York for the premiere of *Topsy-Turvy* at the New York Film Festival. We had supper at Joe Allen's that evening, sat at exactly the same table, and we all had the liver.

What was useful was that Allan had quite a lot of time left in New York doing the rest of the run of *Titanic*. He had a piano in his apartment as he plays all the time. It's very easy in New York to get hold of all sorts of Gilbert and Sullivan material, especially as a lot of the archive is in the Pierpont Morgan library on Madison Avenue. As he didn't know much about Gilbert and Sullivan at

all, Allan had time to absorb a lot. I returned to New York later on that year to see a production of *Goose-Pimples*, and there was Allan, surrounded by CDs and scores and thoroughly enjoying himself. Which was very good news.

Later, at a very early stage of the rehearsals and for a bit of fun, Allan, Jim and I went to dinner at Simpson's-in-the-Strand. You have to wear a collar and tie and they still bring round great racks of beef. It's where Gilbert and Sullivan would actually have eaten.

So Allan Corduner had a perfect musical background, but what about the rest of the cast?

Carl Davis had agreed to compose the incidental music for the film and to conduct the live music that would then be used as a backing track, but he's not really hands-on. Enter Gary Yershon as musical director. He knows Gilbert and Sullivan backwards and is an expert on nineteenth-century music. He has a brilliant capacity to help actors sing. He was later to compose the music for *Two Thousand Years* and is going to do 'Untitled '06'.

Anyone involved in the film had not only to be able to act in this style but also be able to sing for real or play their musical instrument. I had my conventional auditions, where I checked out the acting, and then we had singing auditions. Ideally each actor had to come and sing a piece of Gilbert and Sullivan. Most people got it together to come and give it a go.

Gilbert's company in the Savoy Theatre in the 1880s was always very young; there was nobody much over forty. So we were seeing young-ish actors, a small proportion of whom had come across Gilbert and Sullivan. But most hadn't. Still, they had done their best and managed to find a Gilbert and Sullivan song, and they came and gave their rendering. Gary would put them through their paces. We were very rigorous. Some good actors whom I know well came, but if they weren't up to it, that was it, basically.

Later we made compilation tapes for the cast not only of Sullivan's music but also of related music. There was also a research information starter pack. The stuff their characters would have known about, you name it, it was researched: politics, religion, education, historical background, etiquette, popular literature, gastronomy (we did the same for *Vera Drake*). There was even a small

room in the rehearsal space that Eve Stewart rigged up as the Strand in the 1880s. She found a picture reference for every building on both sides of the Strand and pinned them all up round the wall.

London is a very research-friendly city. On *Topsy-Turvy*, apart from the very good archives at the V&A Theatre Museum in Olympia, we used the massively useful Museum of London and also more specific libraries. Allan went to the Royal College of Music, where he saw Sullivan's piano on a landing. They found Sullivan's baton in a cupboard and lent it to him. We made a replica of it in case of emergency. Later, when we were shooting the first time we see Sullivan conducting, Allan – who's a great worrier – said he couldn't use the baton. I thought he was being spooked by it. I think he probably was in some way, so I suggested he use the replica. Recently he told me the original had become too heavy, which may also have been true. He had been to conducting lessons with an old conductor in Golder's Green . . . there was no end to what people researched.

How was it working with over a hundred actors?

It was a massively complicated thing to rehearse, technically. One of the things that is fundamental to what I do with actors is this: from the word go, they rehearse in some form of costume. If you're in character, you're in costume. On this film this was a big hassle, particularly for the women, who all wore corsets, which take for ever to put on. Assistant directors – who happened to be all women – became very highly skilled at helping actresses put their corsets on – and take them off.

The most remarkable piece of casting and the most courageous acting came from Charles Simon, who played Gilbert's dad. He was eighty-nine at the time we made the film. I do a lot of abstract stuff where people crawl around on their hands and knees – he did all of that. He's dead now but he was a real free spirit. He'd been acting since the year dot. He remembered what the Strand had been like before the First World War. His father had taken him and he remembered the gin palaces. He was also extremely well read and had a very extensive library. He was playing a character who was born at the end of the eighteenth century and he really had a received sense of that. He was terrific.

Another major discovery was Martin Savage, who had been a very obscure actor doing fringe things up north. He was very close to giving up acting to study medicine at this point. I met him through Julia Rayner (who plays Mademoiselle Fromage in the brothel scene), with whom he'd done a play. I realised he was brilliant – and an experienced singer and hoofer. And he could unquestionably look like George Grossmith. He was inspired. Remarkable. His bad cop, alongside Peter Wight's inspector in *Vera Drake*, is terrific.

Casting the part of Fanny Ronalds was more complicated, simply because she was American. One well-known American singing actress actually flew over for an audition. But at the end of the day, Eleanor David can sing, she's a consummate pianist and doing an American accent is no big deal for her.

Shirley Henderson, as Leonora Braham, had never sung anything classical before. She'd sung in nightclubs. She's just one of those people who can do anything.

Did you think the film was 'meant to happen', given that you found all these fantastic actors?

If I'm going to be hippy about it at all, I think that anyway; you could say the same about *Naked* or *Vera Drake*, or anything you like. With *Topsy-Turvy* it was simply a more extraordinary set of circumstances. One of the truths that the whole experience underlined is that we are more than seriously blessed in this country with an amazing community of extremely talented actors of all shapes and sizes. Particularly in the younger department.

I've said this before, but in your films more than in those by other directors it's very hard to imagine other actors playing any of those parts.

That's right. What's important with *Topsy-Turvy*, viewing it in the context of its siblings, is that the actors have all created these characters – irrespective of the fact that they're all drawn from history. They have still taken possession of them. It therefore achieves that status of inevitability to which you refer.

Just following on from that, Lesley Manville and Tim Spall both play people who absolutely existed. But what is virtually

37 *Topsy-Turvy*: Richard Temple (Timothy Spall).

not documented in the case of either Lucy Gilbert or Richard Temple is what they were really like. It's just not logged anywhere. The only clue we ever got about Lucy was that at some point during the First World War, with Gilbert having died in 1911, somebody suggested that she must find life very hard without Sir William. To which she replied, 'Not half as hard as I found it with him!' All we knew was that Lucy was small and pretty but quite bland. We knew the couple were childless. Other than that she's a complete invention – and quite possibly more interesting for it.

Having equally little knowledge about Richard Temple gave us the excuse to create a definitive Victorian 'ac-tor' character. Which, of course, Tim does magnificently. The fact is that Gilbert did cut the Mikado's song, and the chorus did go to him in a posse and persuade him to reinstate it – though how that happened and who said what, we have no idea. There's no way the scene took place exactly as we created it; it was heightened. People who know will also tell you that at the Savoy you go downstairs to the stage, but we shot the scene in a location that put it up a flight of stairs. However, the real point is that the pathos Tim pulls out takes us way beyond the known surface details.

Are you saying that basically you researched the core events and then had the luxury of fleshing out the characters?

Exactly. But it wasn't a luxury; it was a necessity. People constantly ask how on earth we could have made a film such as *Topsy-Turvy* when the facts already exist. Well, of course the facts exist, but the film is a whole series of imaginative leaps. For it to be on the screen at all you still have to bring it to life and particularise it and render every moment organic, or you can't get it on the screen.

The one luxury you didn't have, of course, was a big budget.

It was very tight. As a matter of historical interest, when we calculated what we thought it would cost, it worked out at around £20 million, though ideally we hoped we could get more than that. Then we went into massive negotiations with any number of people. One of the interesting and clever ways in which Simon Channing Williams put it together was by not having one single, dominating backer; there were loads of smaller contributors. Finally, the budget came down to something like £11.75 million.

A few weeks into the rehearsal, when everyone was contracted and it was all finalised, there was the so-called South-East Asian financial crisis. The Korean backers, who'd been very firmly in place for a long time, pulled out, which left us with £10 million. The whole film was a remarkable exercise in finding imaginative solutions. We talked before about the right people being around: the most fortuitous thing was finding the Richmond Theatre.

In what sense?

We rehearsed at Three Mills Island studios and were originally going to build sets and shoot there. But it became rapidly clear that apart from the expense, they didn't have a sound stage big enough. We wanted to find a so-called 'hemp theatre' – that is, an original Victorian theatre where the scenery is still raised and lowered by rope, not wire – and there are only a few around. We discovered that there's a Victorian theatre inside Alexandra Palace, but it was so unsafe that we weren't even allowed to have a look at it, much less film there. Just when things were starting to look dodgy, the discovery was made that the Richmond Theatre was going to be

dark for five weeks – a period that coincided exactly with the relevant actors' contracts. It isn't a hemp house, but it was designed by Sir Frank Matcham, the great theatre architect, and dates from 1899. So, with such a short time, the priority was to shoot all the operatic scenes first and then all the scenes that happened in the auditorium.

For me the most interesting scene in the film – not least for what's known in the movie business as the 'kick, bollock and scramble' aspect of the whole thing – is where Gilbert brings the Japanese folk to the rehearsal. That was created, lit and shot on the last day in the Richmond Theatre. This was July/August and we hit a heatwave like you've never seen – which was ironic given the heatwave in the film. When I look at it now, I have no idea how we achieved that scene. The fact that it had to be put together so fast and shot very simply with two reverse wide shots and a couple of little shots of the guys at the piano informs it with a certain urgency and roughness. I think, in the end, that adds something to it.

Otherwise, we ran into huge difficulties. Firstly, we had all these poor young actors wearing these thick *Mikado* costumes and standing under film lights all day in this bloody heatwave. It was desperate, it really was. There were thirty of them, some of whom were quite distinguished, playing members of the chorus. All they were doing was bowing all the time, so they were very fed up. Their make-up call was at 5.30 a.m. because they had all this stage *Mikado* make-up. A third assistant director slipped inadvertently into the psychological black hole of mistakenly treating the chorus like extras. Which they weren't – they were thirty proper actors. The crunch came when they were all put in a bus to go to lunch at the unit base. They sat there baking in their costumes and nothing happened. They then saw the 'principals' (i.e. the actors playing the principals) come out and get into little mini-vans and be whisked off to lunch, while they sat and waited. They were extremely angry, quite rightly, and Simon and I had to do a lot of ameliorating.

It was really slow for these reasons and others besides, so we only just managed to finish the stuff in the theatre. All the backstage stuff never got shot in that location. We had to create it elsewhere later.

Did you struggle to find other locations?

We were actually very stuck. There's a fantastic oyster bar in the City, near Monument, which is exactly as it was in Victorian times – men standing around eating oysters. Perfect for the scene in the film where they eat oysters. The guys managing the restaurant were very enthusiastic about us. But it turned out the place was owned by a very old lady who had once been told at a cocktail party never to let a film crew anywhere near her house or business. Nothing in the world would persuade her to budge, so we had to shoot the scene in the Institute of Directors in Pall Mall instead.

Gilbert's house is in Harrington Gardens in Kensington. There's a blue plaque and you can visit, have a look around. A lot is as it was. It was leased by an architect's practice, who were very friendly and said we could certainly film in the house, but only at weekends and for £15,000 a day, which Neil Lee, our legendary location manager, said was higher than any facility fee he'd ever heard of for a London location. So it was out of the question, given that the money was already ludicrously tight.

Neil eventually found a place in Kings Langley in Hertfordshire – a decaying old house that had wood panelling and was about to be pulled down. It was in the grounds of a recently vacated comprehensive school (the one where they subsequently shot Lenny Henry's series *Hope and Glory* for TV). We went to see it as a possible for Gilbert's house, and it occurred to us that all our solutions were there. We took the whole place over. It was great, like a mini-studio. The brothel in Paris, Gilbert's house, Sullivan's flat – they were all shot there. The dressing-room scenes that we'd hoped to get shot at Richmond Theatre were all shot there too – and were much more interesting than they would have been in the real theatre's poky dressing rooms.

I think it liberated us in a way because we had to be very inventive to create these worlds. Everything was under control and we didn't have to move the film unit around or anything like that. If we hadn't found the school, I don't know how we'd have completed the film – really I don't. As I said before, I was so glad in the end that Harvey Weinstein or his like didn't get involved, as we were reinventing the film and moving our goalposts every minute of the day.

Had you initially hoped to shoot the brothel scene in Paris?

Of course. Katrin Cartlidge, Julia Rayner and Jenny Pickering had done their research. Julia, who is also a choreographer, had created the naughty Clockwork Doll routine for the scene. Then there was a meeting at which we had to reassess the whole budget, and it was suggested I cut the scene. Lindy Hemming, Christine Blundell and Eve Stewart all said they'd walk off the film if it didn't happen. So we shot it – on the last day!

How did you and Dick Pope prepare for shooting the film?

With *Topsy-Turvy* we had known for so long what we were going to do that we could discuss it in detail, as indeed was the case for the design, costume and make-up. So all sorts of reference were researched, including a day spent looking at the BFI Archive footage. We shot very elaborate tests over a weekend, using various stocks, lenses, filters. Exteriors of people in Victorian costume and domestic interiors. Theatre make-up. Japanese costume and make-up. Natural lighting, gas lighting, stage lighting. The entire spectrum, all shot mute. I think the 'look' we arrived at was tremendous.

Dick Pope had a thousand Victorian-style electric light bulbs made by a firm in the Midlands. Chris Blundell got hold of a little bit of Victorian make-up and sent it off to the labs to be analysed. She then had loads of it made. Francesca Jaynes is a brilliant choreographer. She did not only the choreography but also was very good on etiquette. Everyone did workshops on how to behave socially. We did it meticulously.

As to the shooting style of the film, there's not a whole lot to say: broadly speaking it's in the tradition of how I like to shoot. It's formal and classical, with the freedom to be inventive.

Can you talk me through the first couple of scenes?

The genesis of the first scene in the theatre with the boys doing the seats is actually quite bizarre. At the Savoy Theatre in the 1880s, for an hour or so before each first night, the gallery would fill up with people who'd arrived by omnibus from areas such as the East End and Islington. This working-class audience would sing rous-

ing choruses from the previous operas. The title sequence of *Topsy-Turvy* was going to start with this singing and then cut to Sullivan waking up on his sickbed.

In order to shoot this – in the gorgeous summer of 1998 – we decided to round up members of amateur operatic societies, put them in Victorian costumes and get them to sing. Which is exactly what we did. They did very well; they knew all the operas. They were singing from *The Pirates of Penzance*, so we constructed this shot where you see seats and you see the guys with white gloves checking the seats. You hear this solo soprano singing 'Poor Wandering One'. The camera cranes up and gets to the top, where the crowd breaks out into a rousing chorus of 'Hail Poetry!'

We shot it on a Saturday and thought it was really great. But when we saw the rushes on Tuesday, we were horrified. Inevitably, the members of an amateur operatic society that does Gilbert and Sullivan operas are well-fed, modern, middle-class people. Not only that, it was summer and they were all bronzed. They'd all been on holidays in the sun. They bore as much resemblance to Victorian working-class people in January 1884 as you and I do to the Muppets. The footage was mawkish, embarrassing and smug. The camera doesn't tell lies. It was unusable.

How did you salvage anything from that shoot?

It was the inspiration of Robin Sales, the editor, to use the shot without the woman's voice and just to crane up and cut out. Therefore, you get an interesting shot. I wouldn't have thought of it. In the next scene, with Sullivan getting out of bed and so on, I decided to shoot it off the perpendicular, 'Dutch', as it's known. So all the shots are on an angle and there's something jagged about it. When he bursts through the stage door, it's a handheld shot. The camera pans round on the stage-door keeper.

Were you keen on the ending of Topsy-Turvy *being in the theatre too?*

It was always going to end with Yum-Yum singing 'The Sun Whose Rays' from *The Mikado*. But the preceding scene, where Leonora Braham is pissed and looking in the mirror, was a completely spontaneous extra scene. I suddenly suggested to Shirley

Henderson that it might be good to see her reciting Yum-Yum's speech about artifice, beauty and modesty in rather a real way, pissed and to herself. And it worked very well.

It seemed right that the film should end by looking at these relationships in a wider context.

Despite the budget, the film ended up looking sumptuous. It's rather strange, then, to see your recurring themes – growing old, not having children, relationships, et al. – addressed in a 'glossy' film. I'm thinking of something like the scene with Gilbert and Kitty at the end, as she sits in bed feeling dejected, hurt and unloved, which perfectly illustrates what you're saying about Topsy-Turvy *as a film about people.*

Yes, yes. And that scene was a creative flight of fancy. I worked with Lesley Manville and pushed a long way to get to that. What she's coming out with has got a damn sight more to do with Fellini than Gilbert and Sullivan.

Gilbert is terribly repressed, which becomes increasingly understandable with the random glimpses of his family.

Plainly his family was barking mad. Without going into too many details, there was a very rancorous break-up between the parents. What I don't deal with in the film is the fact that W. S. Gilbert's father was a novelist who wrote what we discovered rather painfully to be impenetrable, lengthy tomes, which Gilbert junior illustrated. It's an interesting family tree. One of the descendants – though not, of course, from the childless Gilberts – is the journalist Polly Toynbee.

So yes, by seeing his family you begin to understand why he was a bit nutty himself. In that context, it was useful, I think, to imply Gilbert's relationship with his awful mother, as it provides an insight into his relationship with his wife. In turn, Sullivan was very close to his mother, but she'd kicked the bucket by this time, so I didn't deal with that.

Do you think either Gilbert or Sullivan were particularly likeable?

I think Sullivan was extremely likeable; accounts suggest that

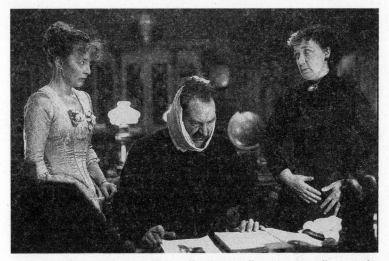

38 *Topsy-Turvy*: Lucy (Lesley Manville), W. S. Gilbert (Jim Broadbent) and Mrs Judd (Kate Doherty).

Gilbert wasn't. I've been around plenty of creative people who some like and others don't. My close friend and colleague David Halliwell, who sadly died recently, was an acquired taste and not everyone could get on with him. But, underneath all the aggressive stuff, he was an incredibly nice, lovable guy.

Were you conscious of wanting to do Gilbert and Sullivan justice? Did you hope to challenge people's snobbery towards them?

To answer the first part: there is that, yes. Except I'd also have to say that the film is a journey of discovery, so it's not only what Gilbert and Sullivan are but what *Topsy-Turvy* is. To me, making the film wouldn't have been remotely interesting or valid as an exercise if I hadn't succeeded in introducing original, personal, idiosyncratic, dark elements about the reality of these people's lives in contrast to the chocolate-box world of the operas. And the second part: up to a point. Like a lot of different kinds of art, things become obscured by prejudice and fashion and snobbery. So in that context, yes.

It was suggested after Topsy-Turvy *came out that you might enjoy directing an opera.*

Not true. I couldn't be bothered with it. I wouldn't be able to get opera singers to do my sort of acting. I worked in conjunction with Gary Yershon as musical director and Francesca Jaynes as choreographer. In fact, Fran did the donkey work of getting the old prompt books and reconstructing the blocking. I didn't in any sense direct any scenes from the opera; I refined them a bit when I saw them. The only time I did direct in any shape or form is the scene in which they are rehearsing a scene. Even then, it really came down to me directing the scene in the film and not the opera.

Despite having to cut it and the budget being slashed, are you happy with the way Topsy-Turvy *turned out?*

Yes, hugely. I'm very proud of it. It's a massive achievement by a great team of people on both sides of the camera. It's just a tragedy about Oslo.

Were you disappointed not even to be nominated for Best Director at the Oscars?

Not really. We got well-deserved craft awards. The only Oscars we've ever won were those two, for costume and make-up for *Topsy-Turvy*. It should have got the design award too, but that went to *Sleepy Hollow*. And why no best actor award?

I've been nominated a few times for Best Director but never won – you just don't. Commercially, though, nothing is better in the world than getting an Oscar or a nomination – not for me personally but for the film.

All or Nothing (2002)

Rachel (Alison Garland) works in an old people's home. Her father Phil (Timothy Spall) is a minicab driver. He hears Ron (Paul Jesson), his co-worker and neighbour, lie to their boss: he accidentally backed his car into a post but pretends to have been hit by another car. Ron takes his car to the garage, and Phil gives him a lift home.

Rachel's mother Penny (Lesley Manville) works in a supermarket; she appears to be sad and tired. Another neighbour, Maureen (Ruth Sheen), also works there; she is chatty and outgoing. Penny cycles home from work. Her son Rory (James Corden) is hanging around the communal courtyard of the housing estate where they live; like his sister Rachel, he is overweight. He is unemployed, angry and rude. Also hanging around in the courtyard are Samantha (Sally Hawkins) and Craig (Ben Crompton).

Penny is annoyed with Rory for not working. In the flat, he verbally abuses her, then sprawls on the sofa. In the pub, Phil and Ron discuss the damage done to Ron's car. Phil, an armchair philosopher, says, 'You're born, you die. That's it.' When he gets home, Penny tells him about Rory's behaviour. Sulking, the boy sits at the table with his back turned, his plate balanced on his knee, watching television. Penny, the only thin member of the family, says she'd like to go for a walk. Phil offers to take her to the pub instead, but she declines.

When Ron gets home, he finds his wife Carol (Marion Bailey) drunk. Their daughter Samantha comes in and they all start arguing. Meanwhile, Maureen banters with her daughter Donna (Helen Coker). Jason (Daniel Mays), Donna's aggressive boyfriend, comes to pick her up.

Phil, short of cash to pay for the rental of his taxi radio, is looking for coins down the back and sides of the sofa. He asks Rachel, who is reading in her room, to lend him some money. He then asks Penny; she agrees but not before berating him for failing to start work earlier. She does the crossword in bed and Phil tries to help. Unable to sleep, she goes downstairs in the night and sits alone on the balcony.

The next morning Rachel is talking to her co-worker Sid (Sam Kelly) at the old people's home. She is a teenager and he is almost an old man, but it doesn't stop him from flirting with her; she is clearly uncomfortable and compromised. Back at the flat, Phil is still in bed. When he makes it into work, he gives his boss Neville (Gary McDonald) the pile of money he has begged and borrowed from his family.

Donna and Jason have sex in her bedroom. When she tells him that she's pregnant, he is immediately abusive: 'I don't want to be a dad . . . I don't even want a relationship with you.' She is hurt, confused, scared.

Penny, Maureen and Carol go to a karaoke night at their local pub. Penny says that she and Phil aren't married; Carol is very drunk and collapses as Maureen is singing. They leave.

Wandering around the estate at night, Samantha bumps into Craig. She knows he likes her; she isn't interested but taunts him and pushes him away. Rory is also outside, smoking.

Doing a night shift, Phil picks up a passenger who then refuses to pay. He is philosophical and tells himself life's too short. When he gets home, Penny has fallen asleep on the sofa, waiting up for Rory.

Maureen finds Donna at home crying and with a mark on her face. Donna shouts at her mother, scared to admit that she is letting history repeat itself by becoming pregnant so young. Jason turns up at the flat and is aggressive. Maureen sees him off. Samantha, who has been watching him coming and going, follows him to his car and later has sex with him.

The next day Sid suggests that Rachel comes back to his flat to sit on the bed and watch a video. She doesn't respond but, again, is threatened. She feels there is no one to talk to back at home.

Phil picks up a well-dressed Frenchwoman, Cécile (Kathryn Hunter), who is returning to her central London hotel with an antique vase. Initially she is critical of the route he is taking but

then she asks him questions about his family. He talks fondly of his children and becomes reflective. They agree that life is lonely.

Rory is kicking a ball around on the estate. His short fuse well established by this point, he loses it with some other boys. They run away and he is alone. He is breathless, clutching his chest. He falls to the ground. Maureen sees him from the balcony and runs down to help. She instructs Carol to ring an ambulance; she is paralytic, so Samantha takes over. She is calm, controlled. She also rings Penny at work.

Phil drops off the Frenchwoman. He is deep in thought. He turns off his taxi radio and mobile and drives off.

Penny tries to get hold of Phil but can't; Rachel, who is walking alone along wasteland by the river, is out of contact as well. Penny phones the minicab office and they send Ron to pick her up from work. Another car crashes into his and Penny runs the rest of the way.

Maureen, who went with Rory to hospital in the ambulance, watches as he's examined by a doctor. Phil stands on a bleak, empty expanse of beach, staring out to sea. Penny arrives at the hospital and hugs Rory. Rachel arrives a little later. The doctor informs them that Rory has a heart condition that surgery will not fix; he will be on permanent medication and will have to go on a diet and stop smoking.

Phil makes his way back to London. Penny finally gets through to him; angry yet relieved, she shows her despair by saying, 'For fuck's sake.'

Back on the estate, Maureen and Donna talk, then hug. Ron and Carol are drunk. Samantha leaves them to it. She bumps into Craig, who shows her the letter 'S' he has carved into his chest. He says he loves her. She is shocked; she hugs him, runs off and cries in her room.

Phil arrives at the hospital while Rory is asleep. Penny is angry with him for switching off his phone. Rory wakes up and tells her to stop having a go at his dad. Phil promises Rory he'll take the four of them away to Disneyland. When Phil and Penny walk down the corridor, he tentatively puts his arm round her, but she breaks free from him.

Back at the flat, Phil sits in his armchair drinking a beer. He vows to work hard, get up early, fulfil his promise to Rory. Penny

thinks it's too little, too late: 'You make me sick.' She asks where he's been all day; he tells her he's had enough. 'You don't love me no more,' says Phil. When he then asks if she loves him, she doesn't answer. He starts to cry and says he should leave. Penny discovers Rachel on the stairs; her daughter tells her that she speaks to Phil with disrespect.

Penny returns to Phil and takes his hand. 'We ain't a family,' says Phil. They both admit to feeling lonely. They hold each other long and hard, kiss tenderly and go to bed.

Phil, Penny and Rachel visit Rory a few days later. Phil has shaved and washed his hair; Penny is wearing make-up. Rory is on an open ward, by a huge window. For the first time he and Penny and Phil are happy and relaxed together. Only Rachel is still a little withdrawn and anxious. She says she hasn't been sleeping much, but no one really hears her.

* * *

AMY RAPHAEL: *Your first film of the twenty-first century was another film that divided people.*

MIKE LEIGH: I don't think it divides real people, as opposed to media wankers. Some journalists took against it, the most famous of whom is Jonathan Ross. In both his television film show and in his film-review column in the *Daily Mirror*, he went out of his way to implore people not to go and see the film. The general criticism is that *All or Nothing* is a complete downer, but the fact is that it has an optimistic ending. The point is – with all due respect to everybody – that this can only really be discussed in the context of the film being released quite commercially by UGC in multiplexes, where it didn't do particularly well. Anyone who has watched it without prejudice – and I've sat in on enough screenings to know this for myself – simply gets involved in it without being cluttered with the baggage of commercial considerations.

They get involved with a film that is an emotional roller coaster, that has many highs and lows, that illustrates goodness and badness. It explores central issues to do with families and responsibilities, to do with communication and lack of communication between people. It's about love and passions and coping on a low

income. There are also philosophical aspects to the film. But if someone decides to approach all those elements of the film with an irrelevant set of preoccupations, then I have nothing serious to say to them about it.

All or Nothing marks the beginning of your collaboration with Alain Sarde; what was his direct involvement as producer?

It was a collaboration with Alain Sarde and StudioCanal, the film-making arm of Canal Plus. We knew from various sources in Paris that Sarde had started to be interested some time before. He brokered a three-picture deal with them, the first being *All or Nothing*. We also made *Vera Drake* as part of this agreement, but there will be no third film; StudioCanal wriggled out of that deal.

Working with Alain Sarde has always been excellent. With both *All or Nothing* and *Vera Drake*, his reaction on first seeing the films in Paris was fantastic. He had no comments or criticisms to make, which is as it should be. And which is very different from the behaviour of most backers. My editors on those films, Lesley Walker and Jim Clark respectively, are both veterans who found it deeply refreshing and entirely remarkable. On conventional films they're often used to finding themselves still cutting months after the movie was supposed to have been delivered. They invariably end up with films that bear no resemblance to anything, simply because endless armies of backers, producers and other meddlers confuse the thing out of existence.

To cut a long story short, what I'm saying is this: the main backers were impeccable, they didn't interfere and they left us to get on with it. The money was tight, but it always is; there wasn't a brief, but there never is.

As usual you chose to do something strikingly different from the previous film, going in this case from a period drama to working-class domestic drama. Did you feel a need to get back to your grass roots?

Having done *Topsy-Turvy* I felt it was the perfect time to do a working-class, warts-and-all film. I was very clear about that. And yes, in some ways I suppose I did feel the need to get back to my grass roots.

Is there a connection between the disaffected, oppressed youth of the 1950s, when you grew up, and the cynical, disenfranchised and similarly disaffected youth of the early twenty-first century depicted in All or Nothing?

All the disaffected youth in my films – *Bleak Moments, The Kiss of Death, Meantime, Life Is Sweet, Secrets & Lies, Naked, Career Girls* – relates back to my own experience. But specifically *The Catcher in the Rye, East of Eden, Rebel Without a Cause* world in which I grew up: a suburban middle- to lower-middle-class world of post-war respectability. It was awful. Brylcreem, collar and tie, repression, good behaviour and the done thing, out of which our entire generation broke loose, memorably, in what is known as the swinging '60s.

The desolation of the disaffected, working-class, unmotivated young people of *Meantime* and *All or Nothing* is really a different territory. It was interesting, in this context, doing *Vera Drake*, because that was the post-war world in which people were putting their lives back together. There's a sense of honour and respectability about them. The young guys in *Vera Drake* – at the centre of which is Sid, Danny Mays' character – are a little bit naughty and scurrilous but basically good boys with morals.

I said this earlier, but when I was making *Vera Drake* I suddenly understood the world in which I grew up. It made me realise – properly at last – that our parents had been through what seemed like the end of the world. They'd fought for respectability and dignity in some way, which is why we had to put up with such a bland, scrubbed and squeaky clean world in the 1950s.

However, by the time you get to the age of Margaret Thatcher and the state of the nation with which *Meantime* deals, the world has fallen apart at the seams. And by the turn of the century, people are living in a decaying environment, like they do in *All or Nothing*. In my opinion, it's got even worse in the five years that have now elapsed since we made that film. I watched the news last night and every item was about someone being stabbed or murdered. That's new. So it would be very hard to relate what is going on now to my own youth, beyond the ordinary experience of feeling oppressed as you grow up. I have to say that nothing embodies learning from your own experience more than how I have behaved

as a parent as opposed to how I was parented, the result of which being that I have two sons I get on with like a house on fire (he said, rather smugly, and repeatedly . . .)

What was your initial idea for All or Nothing? *Did you have 'a feeling' about wanting to make a film about love and the breakdown of communication in a relationship?*

To answer the second part of the question, probably. I don't really know. What I certainly had in mind was the whole thing of fatalities amongst offspring. It's a constant fear. Some of my films – and this is definitely one of them – just come from an emotional feeling about things. I wouldn't have been able to pin down what that was straight after making the film, never mind several years later.

Obviously you'd separated from Alison Steadman a few years previously.

Yeah, that's there in the film. Definitely. Since you mention it, there are some quite direct aspects of that in the film, about women and men not understanding one another.

Have you experienced what Phil is going through, in terms of feeling lonely, isolated, depressed? Is that coming from the heart?

Yes. I've felt those things plenty of times. I still do.

In that sense is All or Nothing *one of your more personal films?*

I don't know about that. Not particularly. The things we are talking about now are all over my films, including *Topsy-Turvy*. *Bleak Moments, Hard Labour* – they are both about isolation. Elements of relationship stuff are even in *Nuts in May*. One of the silliest criticisms is that Tim Spall played the same character in both *All or Nothing* and *Secrets & Lies*. Those kind of comments are unbelievably stupid – in *All or Nothing* he's very clearly a different character with a different sense of responsibility. But I will concede that at the core of both characters is that sense of loneliness and isolation, which is personal to me. But those feelings don't only manifest themselves in Phil. Penny and the kids feel that way too. Also Samantha and Craig.

You found the perfect location to illustrate such personal isolation too: an empty housing estate in Greenwich.

Apart from casting a film, the first task is to find a place within the confines of Greater London – because budget won't allow us to travel – which we can use as a rehearsal base. Long ago I stopped trying to be specific about where it should be; it just became a case of finding somewhere, wherever we could. There has to be complete freedom, absolute exclusivity. For *All or Nothing* we could only find a primary school that was about to be abandoned, which was next to the Greenwich Hospital. We duly acquired it and took it over for a while.

So we were based in Greenwich. Sometimes it makes sense, as it did for this film, to drop anchor in the fiction of the film in the place where we actually were. I did it in *Grown-Ups* and *Home Sweet Home*. We decided the characters should live on a local, actual housing estate. When I got together with the location manager and production designer and told them we needed to film on the bleakest one we could find, the immediate response was: 'This will bring nothing but headaches. It will be a disaster. Housing estates are almost impossible to film in.' I then said I wanted it to be in Greenwich. They thought I was being even more ridiculous.

But after a few weeks Neil Lee, the location manager, rushed in and said he'd found a complete estate right in the middle of Greenwich. It had three hundred flats and was empty. It was shortly going to be demolished but in the meantime we could get in there and do what we liked with it. We went to see it, and not only was it available and empty, but it also had this extraordinary atmosphere and visual quality to it. So we took it over and put a security fence around it. There was one couple still living there who refused to move out. They were fine; they weren't interested in us.

All the graffiti and things like the red car we see in the garage at one point, were they all there already?

Pretty much.

Because you found such a natural location – with its own identity – did it allow the film to breathe?

Yeah. Totally. It was yet another moment of serendipity – something we keep on coming back to. It made everything so much easier. Dick Pope just knew how to shoot the estate. It helped us both. We knew how to see it. A central factor was being able to maintain the sense of isolation, because there was genuinely nobody around. The dynamics of the place were extraordinarily evocative. It was so bleak that there was just that one desolate tree in the middle of it all.

The physical bleakness is enhanced by the costume: all those washed-out, muted colours, all those second-hand clothes . . .

Yes, it was a consistent style. This was my first film to have the brilliant Jacqueline Durran as costume designer. She had been Lindy Hemming's assistant on *Topsy-Turvy* and she would go on to win the BAFTA for *Vera Drake*. She had more charity-shop clothes than we knew what to do with.

Many of the scenes feel claustrophobic – the bedroom scene in which Donna tells Jason she's pregnant, for example – which is evocative of living in a cramped high-rise.

The interesting and weird thing about the film – and we had the same experience with *Home Sweet Home* – is that we shot the same scene in different places, as all the flats were replicas of each other. They were very standard. The space was tight, but then it always is. When there's a lot of shouting in a scene, it's a terrific advantage to do it in a disused estate.

We worked very hard before we shot the scene where the truth comes out in *Secrets & Lies*. There was Roxanne shouting 'fucking' this and 'fucking' that at the top of her voice and slamming toilet doors. The next-door neighbours went bananas. They simply heard the same thing over and over again for days. The same swearing, door slamming . . . it drove them nuts so they made a terrible fuss about it. It was, therefore, as I say, a great bonus to be on an empty housing estate for this next film.

Let's talk about the title scene of the film, in which we see Rachel slowly mopping the floor in a gloomy corridor in the old folks' home. It's reminiscent of Ozu, though perhaps not consciously.

There are also elements of Beckett and Pinter in the film . . .

Yes, I think that's right. Ozu is probably a more conscious refer-
ence than Beckett and Pinter. It goes without saying that pastiche
is not my thing. I hardly go round thinking, 'I'm doing an Ozu.'
However, I always try to find an opening title scene that will be
interesting but not distracting. *All or Nothing* had to start with
Rachel and establish her situation, start to tell her story.

More so than your other films, All or Nothing *has a documentary
feel to it which makes the viewer feel like a voyeur. It almost feels
as though you're intruding into other people's lives.*

Does it? I don't know about that. Maybe I had a conception that
had something to do with that feeling. I don't really know. But I
think you're right in the sense that I wanted to do something very
grainy and real. Certainly that informed how we made it. Obvi-
ously the people in the back of minicabs are descendants of the
people having their photographs taken in *Secrets & Lies*. And
ancestors of the girls having abortions in *Vera Drake*.

Incidentally, I like cars, car culture. Not everything to do with
them but a lot. I loved the cars in *Vera Drake* because they
reminded me of when I was a kid and really into cars. I used to live
on the corner of two main roads in Salford, so there was traffic
going past all the time. I used to sit at my bedroom window with
friends and we'd see who could name the makes first: Austin, Ford,
Wolseley, Rover, Jaguar and the occasional Fiat or Citroën. Later,
as an adult, I had a Citroën Deux Chevaux for about five years. So
I like the clapped-out old minicab aspect of this film, driving
around London. I find it very stimulating.

*It's not your style to indulge in big action scenes, yet there are two
car crashes in* All or Nothing.

People do genuinely complain that there are no car crashes in my
films. I thought we'd better have one to shut them all up. And as
for two car crashes, a man who drives like Ron might well have
two in succession.

A small detail, but I believe one of your favourite lines in the film

is the scene in the minicab office, where Neville tells his sister Dinah that he will dock her wages if she leaves early, to which she replies that she will 'tell Mummy'.

Lesley, the editor, wanted to cut it because she thought it held the scene up. I insisted we keep it. Every time it got a laugh at screenings, which it often did, I'd look at Lesley and wink victoriously.

Going back to the minicab vignettes: there are some interesting actors.

Well, there's Joe Tucker, who had just been the estate agent in *Career Girls*. Alex Kelly shows up being a very paranoid girl in a very low-cut dress getting the wrong end of the stick. She was to be Ethel in *Vera Drake*.

But of course the real star turn is the legendary Kathryn Hunter, she of Théâtre de Complicité and sometime collaborator with Peter Brook. She does a French antique dealer who's rather incongruously travelling around with this Chinese vase. She sat in this very room and said, 'I hate film.' She'd been in Peter Greenaway's *The Baby of Mâcon*. What could I say? Only that her views were fair enough, but it would be nice for her to do it. She really doesn't like filming at all; she regards herself as a theatre person. Virtually that whole scene was filmed on a low-loader driving round Clapham and Bloomsbury. But she delivered the goods perfectly. And she enjoyed herself.

And for the central roles you returned to Timothy Spall and Lesley Manville once more.

There's a short list of actors whom I always want to work with. I have to be careful or I'd always use the same people. I felt it was time for Lesley Manville to take centre stage, as it were. Tim was up for it too. During the casting I saw young actors lined up by Nina Gold, two of whom were Alison Garland and James Corden. You'd have to be seriously dumb not to spot that they could be brother and sister. I already knew Mr Spall was involved, and he's not the most svelte of collaborators!

Ruth Sheen, Paul Jesson and Marion Bailey are all old hands at my stuff. Marion Bailey is a great participator in my films and a big

character in her own right, as it happens. A very sharp woman, very dry, very thorough. But frankly that's a description of all these actors. And then there's Gary McDonald, a mad, brilliant, black actor who was particularly extraordinary in *It's a Great Big Shame!*

Vitally, this is where Danny Mays, Helen Coker and Sally Hawkins came on the scene for the first time, all of whom went on to give further memorable performances in *Vera Drake*. All extremely bright, all extremely talented. Sally Hawkins is doing ever more remarkable things, including the new Woody Allen film, *Cassandra's Dream*, and she's going to be in 'Untitled '06'.

Apparently she hated wearing the low-cut tops required of Samantha and felt very exposed.

She only hated them when she wasn't in character. But she's very up for whatever needs to be done. And very versatile.

When you use a number of young actors, do you feel as though you need older, more experienced actors to anchor them?

No. There's no such consideration. I could make a film entirely with young actors. It's a purely dramatic choice.

Although Timothy Spall had already taken on a decent role in Topsy-Turvy *and had experimented with Hollywood in* Rock Star *and* Vanilla Sky, *this was really the first role to which he brought the experience of having had – and survived – cancer. He's so raw, so vulnerable, so desperate. Yet, as Spall would say, it's 'acting without strings'. What I'm trying to say is that his experience brought another dimension to his acting, best shown in* All or Nothing.

Yes, I agree. That's fair enough. It's certainly there in what he does. To return to what we were talking about earlier, there is no question that when someone like Jonathan Ross talks about this film in those dismissive terms, it shows no understanding about what Tim is contributing. All these people know his work from *Auf Wiedersehen, Pet*, and not to spot that this particular performance is extremely courageous, special, imaginative and profound is stupid to say the least. I sometimes think there remains, remarkably, an English embarrassment about emotions.

It is an emotional film, sure, but it's also life-affirming. When we see the Bassett family at the start of the film, they are in disarray; by the end there is something approaching hope, a future.

Yes. As I said earlier, it has an optimistic ending.

How did Phil become so sad? What sort of back story did you work through in rehearsals?

Phil and Penny got together very young. Actually, Phil answers your question. As a young guy he felt very unlovely, very much the sort of guy nice girls wouldn't look at. Suddenly this pretty girl goes for him. He couldn't believe it. She went for some kind of sense of security. Both children, each in their own way, were very slow. The boy was quite volatile. Nonetheless, it was a very happy family. At some point it started to go sour for Penny. It's bound up with the time when things started to feel humdrum and difficult for Phil.

Are Phil and Rory depressed?

Sure. The whole family is. As much as anything, Phil suffers from being a romantic and a person with an imagination.

Meanwhile, Penny is cycling to work, wants to go for walks, feels the claustrophobia of the flat acutely. She ends up nagging . . .

She doesn't know she's a nag. By nature she isn't one, but she can't help having become one. Phil is totally uninspired by what he's doing.

It's very frustrating watching Phil and Penny failing to communicate until Rory's heart attack acts as a catalyst.

Sometimes you can't talk in a relationship, for a variety of reasons. It's just how it is.

Penny is unhappy in her relationship, yet, when she goes to the karaoke night in the pub with Maureen and Carol, she mentions the fact that she's not married.

Well, she isn't. They never bothered. It's the twenty-first century.

The karaoke night is tragicomic: we see the dynamics between these three very different women who are friends despite their differences. One is married; one is unmarried with kids; one is a single mother with a grown-up daughter. One is drunk; one is fed up and sad; one is making the best of her situation.

These are three women who don't especially know each other; they just happen to be neighbours. One has given up and spent a very long time getting pissed; one is weighed down by life's burdens and is trying to cope; one could be weighed down but has a big sense of humour and knows how to deal with things. All different and all lonely. As we've already mentioned, most of my films are about loneliness.

But what's also going on in that scene is something I love and which *Topsy-Turvy*, of course, is full of: when an actor performs a skill of which they are very capable. Ruth Sheen is actually a rather good singer. So when she gets up to sing you think it's going to be awful, but actually it's rather gorgeous.

Did you go to many karaoke nights?

Ruth and I went to a few, yes. She actually won a competition one night. It was good fun.

39 *All or Nothing*: Ruth Sheen (Maureen) with Mike Leigh.

Returning to your point that your films often have loneliness as a central theme: the most awkward embodiment of it in All or Nothing *is surely in the relationship between Rachel and Sid.*

I wouldn't call it a relationship as such. He's around at work, he's someone to talk to. I don't think she's doing anything to encourage him. He, meanwhile, is hugely interested. He's a lonely old man. He wants to have a cuddle, at least, with an ample young lady.

Even if she was 'very slow' when growing up, it seems as though Rachel should be doing more with her life. In that sense, the film is also about the wasted potential of the younger characters.

Yes. The metaphor for all that is what happens to Samantha, who hangs around looking for trouble the whole time and hasn't got a job. She's bored shitless. Yet when the crisis happens, when Rory has the heart attack, she's in there sorting it out. You can see that she's someone who could make a serious contribution to society, given the right opportunity and motivation. She sorts it all out, while her mother goes to pieces.

Do you think even Donna has potential?

Yes. Again, I think she's quite intelligent really. She's angry. She's got the wrong bloke. She's got a job, but what a job. Not fulfilling at all.

It's very easy to think she will have the child as a single mother, never find the right bloke and the cycle will just continue.

Yes. She and her mother are up against it. They're having a tough time.

The cafe scene where the three girls meet up – which acts as a mirror for the three mothers meeting up at the karaoke – turns from the bitchy and frivolous to the serious as soon as Rachel starts talking about death.

They don't want to confront it. They're scared. Rachel's in there to be part of the gang. She isn't one of the girls but she wants to be. The other two aren't threatened by her because she's not sexy; they

are instead disturbed by uncomfortable stuff she has to deal with. Throughout the film, Rachel is in the background, on the edge of things. But she's sensible and together; at least she's got a job. She gets on with life. She is less a cause for concern than Rory, certainly.

Did Rory's heart attack come out of improvisation or did you manipulate it?

It's no big deal. I'm a storyteller, a writer, a dramatist. All writers manipulate. That's what we do. I make things up. That's the job. From a practical point of view, I've got to set things up and point them in the right direction, and so on. There are things that happen where I set up the dramatic premise and the story then comes out of how the characters interact. That is the substance of the story, though it may be reworked and developed further.

In the narrative causal sequence of events that happen in *All or Nothing* – as was the case with *High Hopes*, where the old lady is locked out – I simply invented what happens and then told the actors individually what was going to happen. Just as I had thought of Laurence having a heart attack in *Abigail's Party*, I had conspired way back with James Corden that he would have a heart attack and, indeed, worked with Rob Wilfort on the doctor character accordingly.

It is not unduly clairvoyant to think of a seriously overweight lump of a boy having a heart attack. We'd researched and even practised the whole process of the heart attack from a medical and practical point of view, just like we did in *Abigail's Party*. Then, when we made the film, we set about breathing life into the scene. In a strict sense, it was structured before we shot it. It's simply another way of building the story, and there's always a combination of various approaches to these things in my films. To grasp a random example, the breakdown scene in *Grown-Ups* evolved more organically: although I obviously set up all the extant elements that led to what happened, what actually happened was worked out by negotiations in improvisations and rehearsals.

But given the nature of what happens in *All or Nothing* – and given the fact that my number-one rule is that nothing should happen that isn't organic – nothing was imposed that wasn't feasible.

Did you have a specific idea of how to shoot the heart attack?

All we need to know is that it's happened. So there's one high shot of the event taking place that helps the pace of the narrative. Again, what was great about having the empty estate was that you could shoot from any angle, do anything.

You may be interested to know that when we were shooting the heart attack, Steve Buscemi was in town and he brought his family along on set. I don't normally allow anyone on set, but he's a friend.

The shots around Rory's hospital bed are in contrast to Phil arriving at the expanse of land and sea around Dungeness.

Finally, having had that significant conversation with the French lady, Phil needs to get away, to break out. He finds himself heading out of London. He turns off the car radio and the mobile. He needs the head space as well as the physical space. He finds himself at Dungeness. It was an extraordinary shoot. The weather was incredible, warm and fresh. There was wonderful clear light; it was fantastic. We shot in the very early morning and in the late afternoon. Maybe it's kind of arty in a way, but it has its own emotional meaning.

Dungeness has a very American feel to it.

In fact, when we showed it in America, somebody thought Phil had actually gone to the States, while someone else thought he was in a dream sequence about being in the States. To me, it feels more like Dungeness.

40 *All or Nothing*: Phil (Timothy Spall).

The close-up of Timothy Spall's face as he looks out to sea is quite astonishing: it simultaneously captures a great depth of emotion and an absolute numbness.

That was good to shoot, but the really amazing thing was capturing the space. Some people spend their entire lives shooting films in extraordinarily exotic places. In a way, although you could say *All or Nothing* is shot in an amazing space – given that the housing estate was a real find – I don't often get the opportunity to be in a place that is a natural phenomenon. *Topsy-Turvy*, for example, allowed me to explore a sense of interior space.

So Dungeness was this incredibly evocative, eerie place whose emotional and poetic currency is further informed by the enduring presence of Derek Jarman; we were only a few hundred metres from his house and inspiring garden. It was a very special shoot. The close-up was great, but it was familiar territory to me. There are three scenes in my films where we deal with the sea, and it's always a dramatic sea: *Nuts in May*, *Career Girls* and this scene. I felt in some way that the dramatic North Sea at Seaton Carew wasn't cinematically investigated in *Career Girls*. You get much more of a sense of that environment in *Nuts in May*. But I think we deal with it best here.

What's on Phil's mind at this point, or is it blank?

He's quite literally all at sea. He's escaping. He doesn't know what's going on.

The scene cuts to Rachel walking on wasteland in east London, with the Millennium Dome sitting forlornly in the background.

The river at Greenwich is another evocative place. She's just walking about, spending time on her own. At another point in the film you see Rory sitting outside, alone, smoking a cigarette. Penny sits on the balcony alone earlier on.

After the relative lull of Phil and Rachel wandering alone, we see a frantic, desperate Penny finally getting hold of Phil.

It is the only time she swears in the whole film: 'For fuck's sake.'

The climax of the film is not in fact Rory's heart attack but Phil and Penny at home after the hospital visit, forced to face truth and reality.

The bubble is burst. It's all part of the ongoing investigation in my films into the bursting bubble: will it or won't it? In *Bleak Moments*, as we know, the bubble never bursts. So at the end of the film it's status quo. Here, the bubble well and truly bursts. There's a massive shift. Phil and Penny connect.

You asked me earlier about the autobiographical element: when Phil accuses Penny of not loving him, of treating him like a piece of shit, she genuinely finds it incomprehensible and outrageous. From her point of view she does no such thing.

It takes Rachel to tell her mother that she does indeed treat him with barely concealed contempt.

Which absolutely focuses Penny on the truth.

The shot that tracks across the room is an incredibly long, intense scene. I imagine it was very hard even for actors as experienced as Timothy Spall and Lesley Manville to create something so intimate and emotional in one shot, even with just a small crew filming them.

They had to concentrate hugely. The scene starts off as a wide shot of the room and ends up as a tight close-up. Boards were put down across the floor so the dolly could move smoothly; we couldn't use rails as they'd have been visible before the camera moves in. The action takes place around an armchair. Next to the armchair, in the wide shot, is a coffee table with a can of beer on it. You see carpet. For the camera to get near enough for the close-up – given that it's very organic and we use fixed lenses rather than cheating by using zoom lenses – the two prop guys had to remove the table and beer can during the shot, very quietly and unobtrusively. The carpet was also folded back. This plainly had to be done not only in the utmost silence but subtly, in order not to distract the actors.

We all rehearsed it together, rigorously. Sure as hell Tim and Lesley really had to concentrate, but they can do it. I try to set up working conditions for actors to be able to do this sort of thing. It's

very disciplined and very sensitive. And, of course, all credit to those prop guys!

After Phil and Penny kiss, the scene fades to black to suggest the passage of time.

Otherwise, you could be forgiven for thinking the following scene was the next morning. But it can't be, as Rory is now convalescing.

The next time we see Phil and Penny, he's washed his hair, she's smiling and wearing make-up, and they've both made an effort with their clothes.

However, a doubt hangs over Rachel. She's got to go back to work. Don't forget, she's been off for a while; we know that's got something to do with Sid. She hasn't told Penny and Phil about him; they've got enough to worry about. She probably won't tell them or, indeed, anyone.

The final hospital shot is filled with colour and light, a stark contrast to the muted colours of the flat and the preceding scenes. The world is apparently theirs for the taking.

41 *All or Nothing*: Penny (Lesley Manville) and Phil (Timothy Spall).

We chose very deliberately not to have Rory in the same ward as before. He would have moved anyway. We wanted them to be able to see the outside world. So the bed is right by the window.

It's a shame that the film was given an '18' certificate on account of the use of the word 'cunt'.

In a film like this the language has to be appropriate, real. I had a letter the other day from a woman who'd been to the National to see *Two Thousand Years*. She had taken an overseas relation to the National but had been shocked by the use of swear words. She was surprised by a 'playwright of my standing' resorting to swear words to get cheap laughs. I really don't know how to reply to such archaic philistinism.

Penguin Books went to the front line [with *Lady Chatterley's Lover*] in 1960 and started the battle by winning. The first use of 'fuck' in any of my films is in *Meantime*. Until that point all my films had been made for the BBC, and there was no way anyone could say 'fuck' on the BBC. We calculated how far into *Meantime* the first swear word ought to be, given that there was a 9 p.m. watershed. When Mark says 'fuck' at the dinner table, it was a major breakthrough. Even so, they are remarkably well-mannered in *Meantime*. Look at Coxy: he doesn't say 'cunt' once. In reality he'd probably say little else.

Vera Drake (2004)

London, 1950. Vera Drake (Imelda Staunton) lives in a small flat with her husband Stan (Phil Davis) and their two grown-up children, Sid (Daniel Mays) and Ethel (Alex Kelly). Vera works as a cleaner for several upper-class families, while Stan works as a mechanic in his brother Frank's (Adrian Scarborough) garage. Ethel works in a light-bulb factory and Sid is an apprentice tailor. They are a happy, loving family making a living in post-war London.

Vera is devoted to helping other people. In her spare time, she

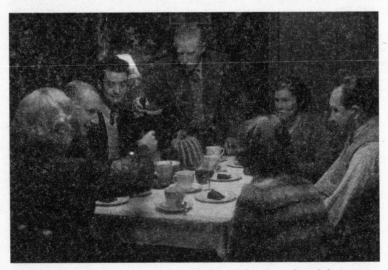

42 *Vera Drake*: before the storm, the Drakes celebrating – from left, Joyce (Heather Craney), Frank (Adrian Scarborough), Sid (Daniel Mays), Stan (Phil Davis), Vera (Imelda Staunton), Reg (Eddie Marsan) and Ethel (Alex Kelly).

visits sick friends and relatives, offering kind words, cups of tea and even – in this world of ration books – biscuits. She invites a desperately shy neighbour, Reg (Eddie Marsan), to eat with them because she doesn't like to think of him alone in his flat. As she goes about all these 'duties', Vera is to be found singing or humming to herself.

One day Vera visits a nervous young woman. She hums a tune as she puts the kettle on and then, without a fuss, produces a syringe, rubber tubing, a grater and a bar of soap from her bag. Offering gentle words of reassurance, she performs an abortion. 'Just put this little tube in . . . you'll be as right as rain.'

Vera has been 'helping girls out' for more than twenty years. Leading a secret life as an illegal abortionist, she doesn't view what she does as being in any way out of the ordinary. These girls need help; she helps them. We see her perform a further half-dozen abortions: there's a mother of six with an abusive husband who knows she can't feed another child; a young black woman with no family terrified of having her baby alone.

The appointments are made through Lily (Ruth Sheen), a childhood acquaintance who operates a lucrative service for black-market products such as tea and sugar. Lily is as self-serving and cynical as Vera is kind and trusting; it doesn't occur to Vera to ask the young girls for money, and she has no idea that Lily charges two guineas.

Susan (Sally Hawkins), the daughter of one of the families Vera cleans for, becomes pregnant after she is date raped. She seeks advice from a disinterested older friend (Fenella Woolgar), sees a physician (Nicky Henson) and a psychiatrist (Allan Corduner) – she has to prove she's unstable – and, finally, visits a private clinic for an illegal abortion. She tells her parents nothing.

Back at the Drakes' flat, Reg has become a regular visitor. He asks Stan for permission to marry Ethel. 'Have you asked her?' says Stan. 'Yes,' replies Reg sheepishly. Sid, meanwhile, has a good time with his friends, going dancing, flirting with different girls.

Stan's brother Frank lives in a semi-detached house in the suburbs with his wife Joyce (Heather Craney). Frank and Stan are very close, but Joyce is materialistic, snobby and desperate for her first child.

Vera performs an abortion on a young girl, who quickly becomes

very sick. She is rushed to hospital and her mother is forced to give the police information about Lily and Vera.

Oblivious to these dramatic events unfolding, Vera lies in bed with Stan. He tells her a personal story about the war for the first time. We learn that Vera's mother brought her up alone.

Frank and Joyce go to Vera and Stan's flat on the Sunday to celebrate Ethel and Reg's engagement and to announce that Joyce is pregnant. A knock on the front door interrupts celebrations. Stan answers the door, and the police ask for Vera. Detective Inspector Webster (Peter Wight) and his colleagues accompany Vera into her small bedroom. 'I know why you're here,' she says. 'Because of what I do. I help young girls out.' They ask if she performs abortions. 'That's not what I do, dear. That's what you call it, dear.' She shows them her abortion kit.

Vera doesn't look at anyone as she leaves the flat. She is taken away in a police car. The family are given no explanation. Stan follows her to the police station and is forced to wait. DI Webster is kind but firm. Vera swears she would never take money from the young girls. She is shocked to find out that Lily has been charging them without her knowledge. Vera is asked to take her wedding ring off; she's been wearing it for the past twenty-seven years, since the day she got married.

Vera – the woman with a heart of gold – is formally charged. She is uncomprehending, distraught. Once a loving mother and wife, she is now a criminal. Stan is allowed to see Vera so she can explain the situation herself. She whispers her story in his ear.

Stan goes home. He is angry but understanding, confused but compassionate. Ethel is distressed and confused; Sid is initially furious: 'She's let us down . . . it's little babies, innit?' Stan asks Sid to forgive her. Frank talks of Vera being like a mother to him, while Joyce, her moment ruined, spits out, 'Stupid cow, how can she be so selfish?'

After a night in the cell, Vera appears before the magistrate and is released on bail. Just before Christmas, she is brought back before the magistrate and committed to trial in January.

Christmas at the Drakes' is awkward. Joyce would rather be anywhere else, although Reg, at least, is happy: 'This is the best Christmas I've had in a long time. Thank you very much, Vera. Smashing!' Earlier he had said: 'It's all right if you're rich, but if you can't feed 'em, you can't love 'em.'

Vera's solicitor informs her that none of her employers are willing to appear as character witnesses. The best she can hope for is an eighteen-month sentence.

At the trial, Vera's defence lawyer emphasises her strong moral character and points out that she didn't profit from the abortions. The judge (Jim Broadbent), determined to make an example, sends her to prison for two years and six months.

In prison, a hunched-up Vera meets other abortionists. They are serving longer sentences as both their clients died. They assure her that she will only have to serve half her sentence.

At the Drakes' flat, Stan, Sid, Ethel and Reg are bereft. They sit round the table in silence.

* * *

AMY RAPHAEL: *Making a film around the issue of abortion had been on your mind for some time.*

MIKE LEIGH: Of all my films, with the possible exception of *Topsy-Turvy*, this is one of the longest in gestation. When I was a kid, there was a nurse who lived in a house next to where I went to school. She knew my parents. I'd see her around, sometimes in our house. She used to potter round in a very small car. At some stage I picked up that she had been to prison. Eventually I discovered why.

When and how did you discover what she was doing?

In a way the question is: when did I know about abortions? I'm not sure. But I do know that growing up in that environment and going to Salford Grammar School, which was a tough, rough place . . . you didn't spend much time shielded from reality. Everyone knew what went on in the world.

Did you not learn or at least pick up things from your mother and father?

That's an open question. I put a little homage, 'To my parents, a doctor and a midwife,' at the end of the film. So people have automatically and quite wrongly assumed that I spent a massive

amount of time discussing abortion issues with them. I didn't. Knowing my father, I think it's extremely unlikely that he ever encouraged abortions, though he would obviously have known when to advise a termination if it was appropriate. But he never came in at the end of the day, sat down to supper and said, 'Well, Mrs X had an abortion today.' Although he did talk about most other medical matters.

Would you have talked to your father about the subject matter of Vera Drake *had he still been alive?*

Yeah, of course, but the fact is he's been dead for over twenty years.

Actually, the other personal thing is this: we lived in a very working-class area, in a custom-built Victorian doctor's house with a surgery attached to it, and in the attic space there were a couple of spare rooms. My folks used to have unmarried mothers with babies living there to help out. There was a whole stream of them. The last mother was a young woman who came from Aberdeen and was mad. They eventually had to take her away. So the concept of an unmarried mother and an unwanted child was in my awareness from an unusually early age.

Apart from your experiences at home, did you bring any particularly personal experiences of abortion to the film?

I was never personally responsible for an unwanted pregnancy, which is just good luck. But I was around and in some ways involved with other people's illegal abortions. It was always traumatic and bad news. I had such an experience when I was twenty; don't forget the Abortion Act didn't make it legal here till 1968. I was out of work and, because no one else was around, I volunteered to go and keep an eye on an abortion that had been set up in a provincial town. She was somebody else's sister. A doctor had been lined up to fly in and out. It was a very concentrated and very traumatic experience. I wrote it up in diary form and for a while I had a notion of making the film I talked about earlier.

But it sat on the back burner for a long period, during which time all sorts of issues and aspects related to having or not having children, not being able to have children, having abortions or

unwanted children cropped up right across the board in my films. I have to tell you that I never mentioned the idea of making a film about illegal terminations to a single person. I never mention such ideas, not even to a partner.

When I finally decided to make this film, it seemed the right time to deal with abortion, not least because it became clear that the film would be released around the time of George W. Bush's second presidential election. In that context alone, it seemed very relevant. The whole debate around abortion has certainly changed direction in a very worrying way over the last few years.

Do you consider Vera Drake *to be an overtly political film?*

It certainly is. I am used to talking about my films as being implicitly political. If it has anything to say, it does boil down to the important statement that if you outlaw abortion, these appalling things will happen again. As we know, the film has been criticised in some quarters for not discussing the moral questions of abortion. That is because, frankly, it starts from the premise that abortion is inevitable in an overcrowded world. It's going to happen. In this context, I had no reason to get into the morality of abortion.

Which in itself fits in with your whole desire to make the audience work, to make them think about the issues in question.

Absolutely. That's why there are a couple of abortions where Vera is less than enchanted by the women concerned. There's the character played by Elizabeth Berrington who is very cynical and dismissive and blows cigarette smoke in her face. There's the woman who gets into a right old state after finding herself pregnant by another man while her husband is away on active service in Korea. In both cases Vera is manifestly less than sympathetic. She just gets on with it.

Why did you decide to set Vera Drake *in 1950?*

Well, obviously it had to be a film set before the abortion law changed in 1968.

At this point I can declare that there's another film I have not yet made, which I can only talk about in a very vague way: an auto-

biographical film set in the 1940s or 1950s about the world in which I grew up. That film may or may not ever be made; in some ways I've dealt with that putative idea in *Vera Drake* and *Two Thousand Years*. So it felt good and proper to set a film in the 1950s, to deal with that world but without it being at all autobiographical.

In the event, it made more sense for the film to be set in 1950 rather than in the later 1950s. Once you get to 1953 and beyond, England changes. The new Elizabethan era is upon us, and in no time you're into the age of rock'n'roll. It's a whole new world. I didn't want to set the film in 1947 but I did want there to be a sense of the post-war world. In the end, 1950 seemed just right because it was on the cusp. There's a real sense of the impending, consuming 1950s. Look at Joyce, Vera's sister-in-law.

Although abortion had been legal for almost forty years by the time you made Vera Drake, *it is still a subject that is rarely discussed with any frankness, even in this country. And yet it affects so many people in one way or another.*

The most disappointing thing pertaining to any of my work is the fact that *Vera Drake* did not do better commercially worldwide, although it's my highest grossing film in the UK. Our intelligent and far from romantic assumption was that it would speak to so many people on so many levels that it would simply take off. The American distributors, Fine Line, who are tough customers, thought precisely that. It remains a mystery to me.

You already had a certain amount of personal experience, but what did you learn when you came to do the research?

We found out about the law and how it worked. I unearthed the fact that there was one route for rich girls and another for everyone else. That abortion wasn't a crime at all until 1801. That a lot of women carried out abortions unaware other people were getting paid for them.

To reiterate, an important thing about all my work is that it's about looking at the world in such a way that you see every character as being rounded and at the centre of his or her universe. So we looked at it from the point of view of the people having abor-

tions, of the abortionist, of the police, of the medical profession, and so on. Although we don't state this in so many words, one of the things that was important about the police and their activities in this area is that they had a massive workload of rapes, murders, et cetera, and yet they had to waste their time dealing with abortionists. Which underpins the spirit of the film.

Given the meticulous nature of your research, how did you feel when the film's authenticity was questioned?

There was a ludicrous and offensive assertion from a retired midwife – in the *Guardian* no less – that the method shown in the film was implausible and would simply have killed a person. No one could walk around with all that liquid inside them. Well, any number of obstetricians and gynaecologists, some of whom I know, were outraged by those comments.

Quite apart from the fact that the procedure we showed was the most common in use, the assertion that everybody would have been infected and died was simply not true. But there was a risk of infection, which is why somebody gets infected in the film. We happened to show a back-street abortionist who chose to visit the women where they were – be it at home or at a friend's place – to set up the device, do the job and clear off. But plenty of girls actually went round to the abortionist's house, then got on the bus and went home, which makes nonsense of the thing of not being able to walk about.

Unfortunately, I was stupidly so incensed that I couldn't be bothered to respond. That was a big mistake: the story just proliferated and other journalists picked up on it.

It may be common sense that the girls undergoing abortions would keep quiet about their experience, but how did Vera Drake manage to keep her work a secret from her family for two decades?

Well, we're back to *Secrets & Lies*. Of course there were people who kept it a secret. The real truth of it is that it was an illegal, nasty business, and someone like Vera Drake is responding to something that happened in her past. It is already a secret before keeping it from Stan ever becomes an issue.

I could, of course, have made a very different film: there were

lots of stories of working-class housing estates where the abortionist would go off to prison and she would be cheered by crowds as she left. She was performing a service and being wrongly treated. To me, this scenario wouldn't have allowed me to say what was needed. By contrast, having a woman of great and wholesome purity who is discovered by her own family to be a criminal is far more meaningful. Of course, she's only a criminal in the eyes of the law.

I asked if Cynthia in Secrets & Lies *always felt the burden of having given away a child; does Vera Drake carry a similar burden? We see her whistling and just getting on with her life, yet she must worry that the police will one day knock on her door.*

Yes, of course. I thought you were going to ask if she carries the burden of guilt for the abortions. She doesn't; she sees it as something that has to be done because this is what those girls need to stop their lives from being ruined. However she may articulate it to herself, she would simply think it shouldn't be like this, it shouldn't be illegal. She doesn't say that, of course.

When she's arrested there is no issue of her work as an abortionist being political or humanitarian; she just does it because someone has to.

Exactly. She thinks, 'If I don't do it, then who will?' Those girls have no one to turn to. Going back to the previous question, of course she carries the burden of being discovered: as soon as you see her face in the scene where the cops show up, you can see this is the moment she has been dreading for years. She knows exactly why they are there.

Given that the title role was such an exhausting, exacting task, how did you decide whom to cast?

Once I'd decided to make a film about an illegal female abortionist in the early 1950s, the question was who to get. After much consideration I decided to approach Imelda Staunton, with whom I had not previously worked. We knew each other a bit and I'd auditioned her at some stage, but that was it. On an instinct it felt

very right, and of course it was. The normal deal is to tell an actor nothing about the project at all. But in this instance that would have been impossible. I had to know that she would feel all right about playing an illegal abortionist.

As for the rest of the cast being unaware of her secret . . . As usual I explained to the whole cast at the beginning that there was very little I could tell them about the film except that it would be set in the 1950s. Some people were subsequently told they were going to play a judge or a doctor or a nurse. And it was essential that Vera's family didn't know it was a film about abortion until they found out in character.

Were you at all concerned with the fact that the actors might be pro-choice or pro-life?

No, actually, I wasn't. To be honest, it hadn't occurred to me until you asked the question. Certainly nobody at any stage in the proceedings ever raised any questions about what they were doing. But then I suppose I instinctively gravitate towards kindred spirits.

This was your fifth collaboration with Phil Davis. Whereas this was the first time you'd worked with Imelda Staunton, you'd grown up with Phil Davis and watched one another mature.

Yes, absolutely. In *Who's Who* he plays a cheeky young chappy, and here he is playing a middle-aged guy who's been through it. Phil Davis is a unique actor and person. He's completely open, completely able to get inside the narrative. He's also a sometime director. I'm resistant to some actors who become directors because they lose an ability to get on with the job from an actor's point of view, but he suffers from none of that. He's been through the mill a bit in his life one way or another. He brings massive sensitivity and reserves of emotional depth. He's a stylist who has a genuine capacity to be real.

And, of course, Ruth Sheen had appeared alongside Phil Davis in High Hopes *back in 1988.*

Ruth Sheen is enormously talented and massively underused. When I started working with her on this film, I said she had always

done goodies with me but this time she should do a baddie. And she was really up for it.

To return to what we were talking about earlier in terms of *Vera Drake* being an evocation of the grown-up world I remember as a child: nowhere in the film does that happen more palpably, tangibly and evocatively than in the moment when Lily is around at their flat and Ethel comes in. Lily turns round with her hat on, her cigarette and those specs and just looks at her. It reminds me of all sorts of people from childhood, circa 1948 to 1951, who wore specs, smoked and would always look at you in rather a judgemental way. It's massively evocative for me. Ruth really taps into something. And like Imelda Staunton and Phil Davis, she has a genuine sense of the real working-class world, and that's what she brings to her character.

You were well into your fourth decade of directing by 2004, so it's no surprise that you keep returning to favourite actors – another of whom is Peter Wight.

He is also a unique actor. All actors in all parts in all plays and films take possession of the character and make it their own. In my films the received wisdom is that actors play characters who aren't them. Good as anyone is, it's always vital to identify the dividing line between the character and the actor. As I've said, I'm very strict about making sure actors refer to the characters in the third person when talking about them.

I love working with Peter. I swear by what he does and he's impeccable, but he's also virtually incapable of talking about his character in the third person. Like no one else I've ever worked with, he manages to put his personality into the characters. The council employee in *Meantime* who comes about the window, Brian the night security guard in *Naked* and the Detective Inspector in *Vera Drake* are all different characters but they all have something in common beyond the mere fact that Peter Wight is playing them. They all have a spirituality. Which adds up to the fact that he is a kind of genius: with great compassion, commitment and involvement, he takes possession of a character and it becomes part of him.

Sally Hawkins puts in a startlingly different performance here to her role in All or Nothing.

She's remarkable. Extraordinarily versatile. She just gets into a character and lives in its skin. As an actor she takes remarkable risks. She's one of the wittiest people I know. She's a gifted writer and she's very visual; she draws beautifully, which very much informs her approach to acting. She was in *Twenty Thousand Streets Under the Sky* with Phil Davis – a fairly remarkable pair of performances. I spoke to her just this morning. She's just been to see Woody Allen. She's had her hair dyed blonde for an American film she's in; she says she's progressed from looking like Jimmy Savile to Jane Asher.

Nicky Henson, who plays the private doctor Sally Hawkins's character Susan goes to see about an abortion, was at RADA at the same time as me. He ASM'd on my first ever production, *The Caretaker* by Harold Pinter. He was a big-time heart-throb actor when he was young and appeared in all sorts of romantic films. It was very nice to drag him, kicking and screaming, from the conventional world of the other form of acting. He did rather well, I think.

Danny Mays is another remarkable actor, there's no question. Essex background. Went to a secondary drama school for kids and then to RADA as well. A really sophisticated actor. Very intelligent, very funny. In all, they were a very funny collection of people.

It is to Nina Gold's credit that she spotted that Adrian Scarborough could play Phil Davis's brother. They do look remarkably alike. I love that kind of thing. We did it with the kids in *All or Nothing*, we did it in *Meantime* and we managed to contrive, with a little help from certain devices, to make Jane Horrocks and Claire Skinner look as though they could be twins in *Life Is Sweet*. Heather Craney, who plays Joyce, is a force to be reckoned with. She was one of the principal chorus people in *Topsy-Turvy*. She's very sharp indeed.

Then there's Gilbert and Sullivan again . . . Allan Corduner went to talk to psychiatrists. He is remarkable in that scene with Sally, served magnificently by brilliant set and costume designs. There's wonderful detail in that scene: ribbings on Sally's costume and also

on the details of some artefacts of an art-deco nature. And Jim Broadbent spent time with a judge or two.

When it came to the cinematography and design of Vera Drake, *did you want to make a film that looked as though it was not only set but also made in the 1950s?*

No. People always ask me if I looked at lots of films from that period, and the answer is no. I didn't need to, frankly. They are in my head. They are part of my reference. To have made a film that looked like it was made or shot in 1950 would have necessitated it being in black and white or very crude colour. We wanted to create the feeling that it was 1950, which isn't the same thing.

Inherent in the whole issue of how *Vera Drake* looks is the important fact that, like the next film we're going to make, the budget was more than usually tight. We looked at the possibility of shooting it digitally but decided that was simply not an option. We looked at other options and discovered that Kodak had just introduced this Super-16mm stock that was designed to blow up to 35mm and look impeccable. We were so impressed by the tests that we decided to use it. What Dick Pope was able to achieve photographically was of a really rich and profound quality. We had a cast and crew screening to which a number of cinematographer friends came, not knowing that we'd used this 16mm Kodak stock, and no one spotted that it wasn't shot on 35mm.

As always, we shot elaborate tests and made a lot of decisions about colour and palette, texture and filters, with a view to it evoking the period but not in any way creating a pastiche of the films of the period.

Vera Drake *is a good example of your ability to see the bigger picture but also to pay great attention to the smallest of details. So much so that I personally felt the need to watch it once as a thriller and then a second time to luxuriate in the detail.*

One of my preoccupations and habitual objectives comes under the heading of what I call 'treats' for the audience. On one level, the film has to be a continuous run of treats. But it also operates on a level in which particular scenes are treats, whether it's a joke or a specific event. You could argue that the scene where the cops

show up to arrest Vera Drake is a treat. But if you're talking about detail, then the chocolates on Christmas Day are a treat.

What was it like working with the legendary editor Jim Clark for the first time?

Great. He's been around for a thousand years, as you know. He's seventy-five now. He's cut everything, from *The Pumpkin Eater* to *Marathon Man*, *The Killing Fields* and *Honky Tonk Freeway* . . . his CV is endless. I've known him socially for a long time and I taught with him at the London Film School in the 1970s. It was with some trepidation that I approached him, because my natural inclination was to get a young editor who was exciting and whose career would be helped by the opportunity. I wasn't entirely sure how Jim would react to making a film in such an unconventional manner. But he loved it. And if you were to talk to him, he'd tell you that he loved it more than anything he's done. He loved being liberated. He comes out in the middle of winter on location and looks at rushes . . . he's great, he really is. He's a complete film buff. He sees everything and he's got an amazing film and music library. He's a great free spirit. Terrific. A great editor.

Can you be specific about what he brought to the film?

A huge sympathy with the material. He also brought a great clarity of vision to it. He made perceptive, sensitive observations. I dare say most of the editors I've worked with would have done a great job with *Vera Drake*, but Jim is still unique. He's going to cut the next film.

Let's talk about Vera Drake the woman: where would she have learned to do back-street abortions?

When the Detective Inspector asks her if this happened to her when she was young, her reaction is such that you can only come to the conclusion that it did. That is the only answer to the question. Plainly somebody did it to her . . . That's all you need to know.

When the Detective Inspector asks her if it happened to her, it's

important that she answers not with words but by the expression on her face.

It has to work the way it does. Some people have said they didn't spot it. They're not being very bright. If you pay attention, you get what's happening in that moment.

Despite being a back-street abortionist for so many years, she still can't bring herself to say the word 'abortion'.

Because she doesn't really see it as that. She sees it as helping girls to start bleeding again. Obviously she knows what abortion is, but that's how she copes with it.

Vera and Stan have a very strong relationship – perhaps one of the best in any of your films – yet here she is withholding a major part of her life from him.

In my films there are lots of explorations of the kind of relationship that is a universal experience for a very large number of people: one that is not easy, that has negative aspects to it. Apart from anything else, it would have been ludicrous to have had a bad relationship between these two people; it wouldn't have told the story

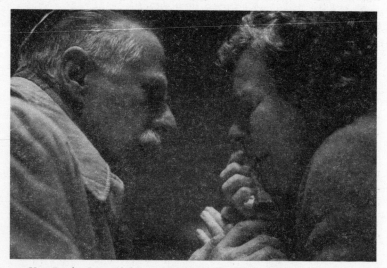

43 *Vera Drake*: Stan (Phil Davis) and Vera (Imelda Staunton).

in terms of the morality of what it's about. They have to be a happy family. But life is not perfect for them. In that context, the job was to investigate and explore a positive, loving relationship.

And so we see them in bed the night before she's arrested. He's telling her a story from the war, confiding in her, being honest; there's a moment when she could have reciprocated and revealed her secret.

It just so happens that he tells her something he'd never got round to telling her before. The point is that at that moment you know what she's holding on to. But she has no idea what you as the viewer know: that the shit is hitting the fan at an alarming rate and that her whole world is about to implode.

The build-up to the arrest is tense and compelling; Vera's collapse is almost too much to bear.

It all begins when the girl who's had an abortion is at home with her mother and she's got a fever. By now you've seen some six or seven abortions. You have been lulled into thinking it's just what Vera does, and it never goes wrong. I worried slightly that having this inevitable sequence of events – involving the hospital, the police and the stuff with Lily – juxtaposed with Vera being very happy. I worried about it being too obvious. But I didn't worry for very long. Its strength is that it *is* obvious, making it very hard to watch. Unbearable, I hope.

Did you have a clear idea of how to shoot the build-up to the arrest?

Yes. First of all, it's important that you get implied point-of-view shots: Reg walking through the snow past the Wolseley police car; the cops alighting from the police car; the cops walking towards the Drakes' flat. For me, quite apart from the form and content of the film, there's always the parallel buzz of: 'Hey! We're making a 1950s cops and robbers movie with a Wolseley police car!' Or just: 'Hey! We're making a movie!'

The police turn up, a sequence which, apart from anything else, was shot in two different places: in the actual location and, later,

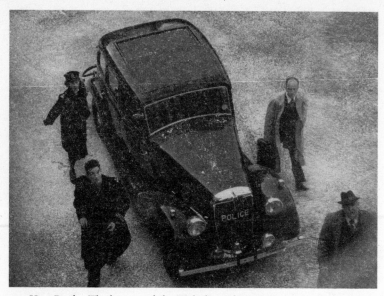

44 *Vera Drake*: The law – and the Wolseley police car.

because we'd run out of time, on a built set replicating the flat at the disused Hornsey Central Hospital, where we shot a substantial proportion of the action, including all the abortions and, of course, the hospital sequence.

But shooting a location scene involving eleven actors and a complete film crew in a very, very, very small flat was not easy. There's a tracking shot that starts inside the corridor of the flat when the police come out of the bedroom. It then tracks back as we see the Detective Inspector telling Stan he can come to the police station, before tracking back even further, out of the door of the flat. Rehearsing and organising that shot was a painstaking nightmare because it was so bloody cramped.

The flat was on the top floor, which made it much more difficult for Dick from a lighting point of view. There was a scaffolding tower for the lights out the back, behind the sofa.

Were the logistics of it more of a challenge than capturing the memorable moment when we see Vera's face?

No, because the logistics of capturing that moment were hard too.

She is looking towards the door to where the police are crowded round. They are filling up the doorway. If you think about where the camera is for the shot of her, with the rest of the family in the background – it has to be with them, but they have to be adjacent to the camera, giving off-camera motivation and eye-lines for her and for the others round the table. It's a real place and the walls are in the way. It's very difficult but it can be done and it's always worth it. You have to do these things without compromising.

When Vera is led out of the flat, there's no eye contact between her and her family.

She can't look at anybody. She's anaesthetised and stunned by the whole thing. And it is more than massively humiliating. And she's spoilt their day.

At what point did the rest of the cast find out what Vera had been up to all these years?

At the same time we find out. When we got to this scene in the development of the material, in the rehearsal period, it was a truly

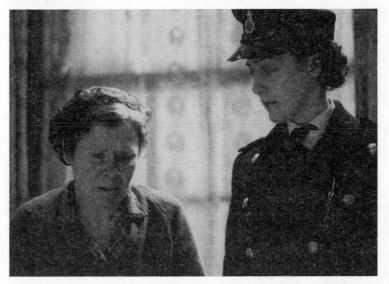

45 *Vera Drake*: Vera, 'anaesthetised and stunned', with WPC Best (Helen Coker).

unbelievable, memorable, devastating, remarkable experience which I will never forget. We've already talked about the equivalent climax in *Secrets & Lies*, but it has to be said that, technically, the improvisation in *Vera Drake* was no different to any improvisation that leads to any event large or small in any of my films or plays. It's how it always works; this one just happened to be an elaborate manifestation of it.

It's misleading to talk about this event in isolation from all the detailed preparation that led up to it. If you count the number of characters directly involved – not to mention quite a lot of characters indirectly involved – you'd be talking about six members of the family plus Reg, which makes seven. Four members of the police force. A doctor and two nurses. The girl whose abortion goes wrong and her mother. Which adds up to sixteen in that immediate scenario. Not to mention Lily. Then there are all the other abortions . . .

All these characters have their own evolutionary stories, not least of which is Frank and Joyce's elaborate, detailed back story. All those things had been constructed over a very, very long period, including things like an improvisation in which all of a sudden, having not been seen for the whole war, Frank comes back from Burma. For all intents and purposes, they thought they were never going to see him again.

Did Adrian Scarborough have to pretend to be in Burma as part of his back story?

What nobody apart from Adrian Scarborough and I knows (until now) is that one day during rehearsals he spent a whole day in character in a very large room in the disused hospital in which we were rehearsing humping a large piece of furniture round and round on his back. This simulated the arduous physical ordeal those guys experienced in Burma. Every couple of hours I'd go and see how he was getting on. Alongside the research he did, and with the help of the Imperial War Museum, he got a very clear sense of what Frank had lived through.

To go back to the improvisation, when the police show up it's not simply about the events that led to the abortion but also about the back stories of all the characters. That moment is resonant

with layers and layers of stuff. Stan is substantially older than Frank and looked after him when he was a kid; Frank was part of Stan and Vera's family. So when there's a suggestion on the go that he shouldn't spend Christmas with them, it's nothing short of devastating. When Reg says this is the best Christmas he's ever had, we learn he's a man with a very lonely background. He'd been admitted into this loving, warm environment. There are thousands of things on the go.

In addition to the life experience of the characters we created in this fictitious world, nobody from Vera Drake's extended family even knew there were any actors playing police. A few days before the arrest scene the actors playing the policemen had spent a whole day with a retired senior police officer who was around in the 1950s, just as endless numbers of lawyers, judges, nurses and doctors were involved. Not to mention those guys at the War Museum.

So you were absolutely prepared for the day itself?

Yes. The actual day had to be planned with military precision. Apart from anything else, you're calling actors to this one rehearsal place that they've all been coming to in a very familiar way for ages but setting things up so that they don't see each other or know certain other actors are on the premises. Sometimes it's a bloody nightmare. It's why we make such a fuss to get the right place to rehearse in. It so happens that Hornsey Central Hospital was terrific for this particular operation, to such an extent that I actually wonder if we could have made it work in any other environment – or in any of the places in which we had previously rehearsed.

We had access to the whole hospital, and the grounds were quite extensive too. It was all going to seed; they are about to build a new NHS community hospital on the site. There was a massive ward with lots of side rooms at one end and a whole other section that became the art department. At the other end were more modern wards and attached to them a very old part of the hospital, upstairs from which were all these little flats and rooms where the doctors and nurses used to stay when on call. One of those became the Drakes' flat. Another became where Frank and Joyce lived. It

was all set out with furniture and props so they could do improvisations – the usual procedure.

In the morning of that day, starting very early, we had all the cops in their police station in one of the wards. There was a room where Vera Drake – if she was arrested – was going to be interrogated. We had a fingerprint room. Working with our researcher we actually rehearsed technically how the fingerprint procedure should happen. The whole thing was set up with a cell and everything. The procedure was rigorously rehearsed in a technical sense, but not in terms of the dramatic action, which is, of course, unpredictable in an improvisation.

The actors playing the cops checked out what would happen in the event of someone being arrested and brought in. They then had to be locked away. When the family actors turned up, we lied to them and told them they couldn't go through a certain door because the art department had taken it over. No one thought to question such a statement; why would they?

By now the extended Drake family had done hundreds of improvisations just sitting around in the flat talking. Frank had been round for tea with Joyce any number of times. It was routine really. What they didn't know was that Frank and Joyce were going to tell them she was pregnant. Otherwise it was just another improvisation.

The actors playing the police were going to get a stand-by cue to warm up and get into character, which takes quite a lot of time. Then there would be another cue to go through the grounds of the hospital on a prescribed route and to knock on the door (they'd been shown which door earlier). I was going to send a message from my mobile to an assistant, who would go and give them the cue.

Normally I don't cue things during improvisations and I could have left it to work in a random way, but it would've been terrible if the cops had shown up when the Drakes were out or Vera wasn't there. As long as people know they can be in character and then take a very simple cue without it getting in the way, it makes it all possible.

No one else from my production team was there because I keep the numbers down to an absolute minimum in that sort of situation. Therefore, I was the only non-combatant there. Eventually I gave the go-ahead, but I was so tense that it seemed to take for ever

to take effect. All of a sudden there was a knock at the door. If you asked the actors sitting around in the Drakes' flat who it could be, they'd say the only person who could be at the door was Lily or somebody they wouldn't know at all.

But it was the cops. It was remarkable. I think it's pretty fantastic to make films. It's pretty fantastic to experience what you experience in front of a camera and on the screen. But this was three months away from shooting the damn thing. This was make-believe in a clapped-out hospital on a grey Saturday afternoon. It went flawlessly. Everyone was so far down the line in terms of being those characters that nobody was acting badly or saying things they wouldn't say.

You could in theory have pointed cameras at it and shot it . . . but you couldn't really, because all sorts of things changed when we actually came to shooting on location. For example, the logistics of the temporary flat we were in were such that the cops took her into the kitchen to question her; when we got to the real flat, we had to re-explore it and ended up moving the scene to the bedroom. It seemed much more meaningful and it was also, of course, where she was hiding her abortion equipment.

Improvisations are just that. Key things happen and you distil those into the final material, while other things happen that deviate from the point or are red herrings and you just chuck them out. An improvisation is only an improvisation.

So when Sid's response to his mother's illegal activity is initially one of negativity, are we to assume that reaction comes completely from Sid or from Daniel Mays?

The former. It's a very important point to make. At that moment Dan would have been Sid. While we're talking about Sid, I can tell you that at one point, after this discovery about his mother, he actually went out and prowled around at night. Later I discarded this. It would still have happened, but we didn't need to see it. What we distilled from that came from the feeling of the response, not the actual logistics of it.

Was it important for there to be one dissenting voice in the family, someone who takes a moral position?

This is very hard for me to quantify, but inevitably what you're talking about is what's in the film. What I've just been talking about – and this is why I'm generally reluctant to talk about it at all – is not what's in the film but part of the investigation out of which either directly or by default what is in the film is arrived at. So you very appropriately say it's important to have someone who takes a moral position, and implicit among many of the decisions we made was a character who would behave like that.

But it would also be dishonest for me to say I anticipated exactly how Sid would respond or, indeed, any of them. Instead, the whole job for me is taking a journey of investigation during which I discover the truth. It's a combination of all the things I feed in through, for example, definition of character or the juxtaposition of characters. It's how the characters respond and how I then respond to them. It's how I reorganise or reinvestigate the material and, indeed, challenge it in a creative way to arrive at what is dramatically coherent to me. And it's how I allow my imagination to be stimulated by what happens.

Because hopefully you would have worked with the actors in such a way that would . . .

. . . have pointed them in the right direction, yes. But ultimately the right answer is what I arrive at, irrespective of whether I've already thought of it or when or how each decision is made.

I believe the real police station was an experience in itself.

We shot the magistrates' court and the police station in the same building: a disused, listed, clapped-out building in Bow where the Kray twins and their accomplices were banged up any number of times. Those cells were grim in the extreme, rat-infested and filthy. But knowing the ghosts of Ronnie and Reggie were walking tall did add to the flavour of the experience.

When Vera is told to take off her wedding ring for the first time since Stan put it on her finger twenty-seven years earlier, it's not only terribly moving but also symbolic of a new distance from her husband, from her family.

Helen Coker had got her head round all the procedures her WPC would have to carry out in this situation. At the point when she asked her to take off her jewellery there were several different things going on in the improvisation in different parts of the police station. Since my job is obviously to clock everything, I tend to scuttle about like a little movie camera. But I was there in the room when that ring came off. It was devastating. Such inspiring moments are a joy. I think, 'Wow! This is going to be a great movie!'

I couldn't have anticipated what Peter Wight would do in character, thinking on his feet. It was very intelligent. Stan had followed them to the police station under his own steam in the improvisation and then hung around. Every time the Detective Inspector came out, Stan would ask what was happening but be told nothing. Peter, realising that Stan genuinely didn't have a clue about what Vera had been up to, actually had the idea during the improvisation that she should tell Stan. Could I have thought of that? I don't know.

What is the fundamental difference between those improvised scenes and the shoot proper, apart from the changes to detail you mentioned earlier? Is it a matter of making it more stylised?

Yes, absolutely. For example, in the improvisation Stan came in and Vera spent ages telling him her story. But when it came to the film, you don't hear what she tells him, given that she whispers it in his ear. Which is for one fundamental storytelling reason: the audience does not want to hear it all over again. They know the story. So we worked out the briefest version of what she could say to him. And then I had her whisper it. As a result, what you see in the film is actually far more poignant than what happened in the improvisation, which took ages.

Once you've reached a certain point, you can play with the material and make it work on camera.

Totally. No improvisation of Johnny and Brian in the office block in *Naked* was ever as remarkable as any moment you see in the actual film simply because it was only the improvisation. The ten-hour improvisation that I've just described in *Vera Drake* – at the

end of which everyone was exhausted, not least Imelda – was traumatic, remarkable, moving and mind-blowing. But if it were in some way put directly onto continuous film and projected, it would be confused, repetitious, unfocused. Because it's not a piece of art; it's research, it's raw material, it's a found object.

You comment on how exhausted Imelda Staunton was at the end of that improvisation; she must have been completely shattered and all cried out by the end of the shoot, given that she would have been repeating that scene a number of times. A rather trivial question, but did she ever use a tear stick in order to bring on the tears artificially?

Imelda's remarkable ability is to be able to tap into that emotion. She reminded me at some stage after we'd finished the film that the day before the ten-hour improvisation I'd advised her to get an early night as it could be quite a big day. It was more than I should have said really – although, of course, she still had no idea of what was going to happen.

As for the tear stick, she didn't need one in the improvisation, but when we shot the proper scene and did several takes we used drops then. Nobody can cry with empty tear ducts.

How did you decide the key to the Christmas scene, when Vera is home on bail?

It's one of those scenes which are dotted around these films; I construct the action to serve the shot, as well as the shot to serve the action, such as the scene in *Naked* where the camera pans back and forth between the kitchen and the living room and then up the stairs before Johnny leaves the flat, or the scene in *Meantime* where you can see down the corridor of the flat and they're all walking in and out of the bathroom and the toilet.

So, in the Christmas scene, you get an exposition of each character and a clear sense of the atmosphere just by following the chocolates around the room. And Reg rounds off the journey with his famous speech. Incidentally, the scene is covered in one shot, with the camera panning and counter-tracking simultaneously.

The judge wants to make an example of Vera Drake. I presume you

found out how many women were actually arrested and sent to prison?

Not so many people were put away for abortion as you might expect. But they'd make an example of people, no question. The sentence could have been longer or shorter, depending on the judge. By the way, the actor that was going to play the magistrate had to pull out, so, at very short notice, Paul Jesson took over. I think what he does is amazing. It's such a good character. And again, great period specs.

So we get to the crown court with Jim Broadbent. I filmed the whole event with a view to editing it down, which I don't normally do. In the cutting room we realised it would only work by fading in and out, a device I very seldom use. Obviously you couldn't put the whole thing on screen, as it would be boring. There was no way of doing what I normally do with ordinary behavioural action, which is to distil it in the construction and the writing, because we were dealing with formal proceedings. Anyway, it was an open and shut case, so it didn't take too long to film. We wanted to shoot in the Old Bailey but couldn't, so we ended up in Kingston Crown Court.

Were you able to tell Jim Broadbent that he would only have a small role?

Of course. He's my friend. I told him he'd be playing a judge in a film about an abortionist.

The prison scene with the two abortionists who have reoffended make the viewer wonder if Vera herself will reoffend.

I thought it was important to see a couple of women in prison who were regulars. As you say, they are there to raise the question of what is going to happen to Vera when she gets out. I know what I think. What do you think?

I think she'll do it again. I don't think she'd be able to help herself.

It's debatable, but I don't think she will, for the sake of the family. In fact, I'm sure of it. But I can quite see where you're coming from. Fortunately, if she gets out after eighteen months, then she's

only got another sixteen years to go before abortion is made legal, in 1968.

The prison scene cuts to the family sitting round the table in silence. This is the final scene of the film, so the audience is left wondering . . .

. . . or even discussing. That's the important thing.

I'd like to ask some random questions about the film. Were you influenced by any films from the 1950s when you shot it?

As I've said, hundreds of films I've seen and remember sit in my head as references. But I couldn't cite any 1950s film as a particular influence. I did think about how abortion hadn't been dealt with absolutely seriously in British films. Even in Karel Reisz's splendid *Saturday Night and Sunday Morning* the abortionist was played by the comedienne Hylda Baker, and you weren't really confronted.

Did you see Maurice in Secrets & Lies *as a precursor to Vera?*

No. Never thought of it until this moment. I can see immediately what you mean, but it had never occurred to me. You could retrospectively list a run of characters who are in one way or another sympathetic and take responsibility . . .

You could say that Vera Drake *and* Naked *are the only films in which you focus the narrative on a single character: Vera is a modern-day saint, while Johnny is dark and tormented.*

Yes, that's true. For what it's worth, *Naked* focuses far more exclusively on the central character. There are far fewer scenes in *Naked* that don't involve Johnny than scenes in *Vera Drake* that don't involve Vera. You see other people's worlds from other perspectives much more in *Vera Drake*, though ultimately it's about one woman's journey. But then you could argue that all of the films could be perceived as one or two people's journeys.

Reg and Ethel have been criticised by some journalists as characters who aren't real or credible.

I can't discuss that because it's so stupid. Not to mention infuriating. The point is this: if that was the only film of mine they'd ever seen, it probably wouldn't occur to them to make such comments. But because, as we know, there's a popular received notion about the existence of implausible caricature in my films, people make sure it doesn't get missed out of the equation.

At one point Reg makes a sudden revelation: 'Six of us in two rooms; if you can't feed them, you can't love them.'

Again, this completely came out of the world we built for him, Eddie Marsan and I. What's interesting and important about Reg is that he's a perfectly intelligent guy who simply needs security, context and motivation.

It would be easy to see Reg and Ethel as a bit daft, but is it not a case of shyness?

They are shy. Reggie is an honest guy. I don't think it's worth discussing further. If you are going to bend over backwards to find a character on whom you can pin the sin of being over the top, it would be Joyce. But she's not over the top at all. I remember women like that in the 1950s. I can even remember the stink of their perfume. They are still around.

We talked earlier about the scene in which Frank talks about Vera having been like a mother to him and having known him since he was six, whereas Joyce calls her a 'silly cow'.

In the back story we discovered that here's a guy who's been through a lot, who meets this woman serving in a pub in the West End. An explanation of why they were attracted to one another lies outside my remit in that men and women are given to remarkable attractions.

Is there genuine love there?

Of course. But Joyce is distracted by material considerations. She is also, as we know, a member of something of a dynasty in these films. Upwardly mobile with attitude.

365

It's almost a surprise to see how strong and persuasive Stan is with Sid, asking him to forgive his mother.

Well, first of all you see Sid sounding off about Vera. It's interesting that you should talk about Stan being strong and persuasive. He may indeed be being both of those things, but the important thing is that he is simply being dead honest. Stan is totally gutted by what Vera's done. He totally disapproves. But he has the honesty to avoid the shackles of his own prejudices to see where she is coming from and why she's done it. He's loyal to her, but it's not blind loyalty. He knows what motivates her, even if it is seen by the law as a crime.

Are you having a dig at the rich when none of the upper-class women who employ Vera as their cleaner will appear as a character witness?

No. I'm not having a dig at anybody. They would simply regard it as not their affair. If she's going to break the law, it's not their problem. One woman is unable to give a reference but does send her blessing. A Catholic.

You were once asked in a Q&A session why Vera never confronted Lily.

They could, of course, have arrested and prosecuted Lily. If the film has a flaw at all, it's that the black-market stuff with which Lily is involved is perhaps too implicit and therefore not clear enough. The cops have obviously done a deal with her, got information out of her and found Vera as a result. They tended to prosecute the perpetrators rather than the facilitators. We unearthed loads of cases where the procurers got away with it.

When Vera Drake reads out her address in court she says, 'Oslo Street'; is that a reference to the mistake you made Topsy-Turvy?

Yeah. We always work out proper addresses. The Drakes lived in Copenhagen Street, near King's Cross. I decided that since the flats we actually filmed in and around bore no resemblance to Copenhagen Street, it would be distracting to anyone who knew the street if we named it. It's a famous spot too. So I decided to give it

a name that doesn't exist in Islington. At which point I thought it would be a good in-joke to call it Oslo Street.

How many people actually noticed?

Not sure if anyone really did. But I've met people who swear blind that they know Oslo Street.

What sort of discussions did you have with Andrew Dickson about the music?

You only really discover what sort of film you want to make by actually making it. One of the things we had discussed before we shot it was using popular songs of the period. We even put aside £100,000 for copyright, which is always a very expensive game.

Normally, during the improvisations characters listen to the radio and watch television for real. Plainly this wasn't something they could do in *Vera Drake*. Nobody would have had a television and there was no way of playing 1949 radio programmes. As a substitute, we had a whole lot of compilation CDs of songs from the period. Lucy the researcher put them together, grouped by year. It created a useful atmosphere. Then I started to come to the conclusion that the film wasn't going to be an exercise in nostalgia. As it happens, Simon Channing Williams and our film accountant, Will Tyler, were simultaneously coming to the conclusion that we couldn't afford that £100,000 anyway.

So I showed the film to Andrew Dickson and suggested children's voices. He recorded some stuff but the trouble with kids' voices is the lack of dynamic. So he suggested doing it with grown-up, professional female singers, which really worked.

It must have been tough for Eve Stewart to do such effective production design on a relatively small budget.

As ever, Eve was very inventive. She creates these environments – recycling every bit of wood and repainting every last inch. We recycled that hospital every which way to create places, just as we'd done in the old house and school in *Topsy-Turvy*. Every abortion you see was shot somewhere in that hospital. When you make a period film, you can't just go leaping around the streets; it's not

like *Naked*, where you can just have Johnny standing outside Leicester Square tube station.

We bought a 1937 Ford 8 for Phil Davis and Adrian Scarborough to work on in character during the rehearsals. It was a clapped-out old thing and the engine didn't work. They tinkered about with it in the garage improvisations. It makes three appearances in the film in different places. When Vera is either arriving or leaving from doing that first abortion, it actually drives through the shot. It had to be pushed by the guys. That's low budgets for you.

Jacqueline Durran had to get every detail of the period costume right, again working with a small budget.

Jacqueline was Lindy's assistant on *Topsy-Turvy* and then did *All or Nothing*. She's since done the film adaptation of *Atonement*.

Vera Drake was the second film in the three-picture deal with Alain Sarde for StudioCanal.

We did the first film, *All or Nothing*, which Alain Sarde liked a lot. We told him over dinner in Paris what the idea was for the next one, which he also appreciated. But *All or Nothing* did not meet with StudioCanal's commercial expectations, so they wanted to walk away from the deal, even though a contract is a contract, even in Paris. Finally, it was agreed that they would do the second film in return for being let off the third film, a decision that I wasn't wildly enthusiastic about.

Why didn't the film go to Cannes?

We finished the film and, as with *All or Nothing*, took it to Paris and showed it in a screening room off the Champs-Elysées. Alain Sarde was blown away by it. He, along with others who were there, thought it would do well at Cannes; they even said it had Palme d'Or written all over it. And these Parisians don't say these things lightly.

We were a little bit late with the final edit. I spoke to Thierry Frémaux, who was in his third year as artistic director of Cannes. I had already met him when we'd taken *All or Nothing* there in his

first year. He was very accommodating and suggested I prepare a tape. We did the subtitles and hit a difficult deadline to get a good presentation version of the film, which was sent to Paris. In my experience the routine when a film goes to selection for Cannes is this: they look at the film straight away and the artistic director then personally phones up and invites you.

So we sent it to Paris, and twenty-four hours, forty-eight hours, a week went by. Nothing. It had plainly started to be an issue. I had it on excellent authority that most of the people on the panel were amazed that Thierry Frémaux was in any way equivocating. He dithered and dithered. It slowly came out that he was saying Cannes couldn't always have a Mike Leigh film, nor should they always feature established film-makers, although several were already in the competition – Wong Kar-Wai, Walter Salles, Ethan Coen and Emir Kusturica. We then heard that he didn't want lots of British films. The only other British film was *The Life and Death of Peter Sellers*. I doubt that even the extremely nice people who made that film would compare it to *Vera Drake*. I hope that's not too arrogant.

Anyway, it dragged on for ten days. It became clear that a serious doubt hung over *Vera Drake*. Even the former artistic director of Cannes, Gilles Jacob, who was still involved with the festival, wanted it. Finally, after ten days, Simon Channing Williams did a very smart thing. He had a word with Marco Müller, the new artistic director of the Venice Film Festival, and told him off the record what was happening. Müller asked to see it straight away. He immediately invited it into the competition. And that was the end of that.

It did well at Venice, of course.

Yes; it won the Golden Lion, Sophia Loren made the presentation and I had to give a speech. I decided to end with a gag about the Cannes Film Festival rejecting the film, which meant that we could instead be in Venice. It brought the house down; they loved me having a go at Cannes. Marco Müller later told me that he'd phoned Thierry Frémaux to ask if he was taking it or not, and he'd said, 'Well, you take it if you want.' So they claim in France never to have turned it down. But they certainly didn't invite it. Nor did Frémaux ever communicate with us.

My personal opinion may sound arrogant, but I think he thought *Vera Drake* would probably stand a good chance of winning the Palme d'Or. Maybe he just didn't want the same old people winning. I can't see what else it could be.

You received Oscar nominations in both the Achievement in Directing and Original Screenplay categories, and Imelda Staunton was nominated for Best Performance by an Actress in a Leading Role. Did you feel optimistic about winning at least one of these?

As always we were encouraged massively to believe in the possibilities, not least that Imelda would win. Those of us who traipse across the Atlantic, squeeze into tuxedos and evening dresses and attend this ludicrously tacky event can't help buying into the fantasy that we're going to win. But we are quickly reminded of the fact that it's not actually our gig. We're beyond even being outsiders: in fact, a low-budget, serious, European film like *Vera Drake* makes us *rank* outsiders. In the end Clint Eastwood's *Million Dollar Baby* cleaned up because it's a film by a local boy.

I've been at the Oscars three times and the only time we won anything was for the make-up and costume for *Topsy-Turvy*, which was great. Not winning at the Oscars may be predictable but I get really angry when we don't even get nominated at the BAFTAs and American films do. So when I got Best Director for *Vera Drake* at the BAFTAs – when it was as plain as the nose on your face that Scorsese was going to get it for *The Aviator* – the only person more surprised than me was Scorsese himself.

What do you do with all your awards?

They're in the back room here at our office. I certainly don't have them at home, that's for sure.

Epilogue
by Amy Raphael

31 October 2006

A gloomy, cheerless day in Soho. The cast of 'Untitled '06' meet in the large upstairs room of a private members' club. Also present are key crew members, from the head of costume design (Jacqueline Durran) to the script supervisor (Heather Storr). They all sit in a large circle. Some lean into each other, chatting or giggling; others sit stiffly, silently. Positioned slightly outside the circle, I recognise some of the actors at a glance: Sally Hawkins, Eddie Marsan, Alexis Zegerman, Sylvestra Le Touzel, Stanley Townsend. Mike Leigh takes his seat. He talks fluently and easily; he is funny and warm. He mentions the list he keeps of all the characters' names from both his films and plays: there have been four hundred and eighty-four characters so far and, with sixteen in this new film, 'we'll hit the five hundred mark.'

He looks round the room. 'I'm particularly excited by you as a group of actors. There's no excuse not to do something humorous, if not funny.' He says that only four of the cast have already worked with him (Hawkins, Marsan, Zegerman, Le Touzel), while the others are 'new to this esoteric experiment'. He rubs his beard. 'Everyone knows these films of mine are made without a script. Which is true but not true. There's always a shooting script that I write at the last moment, just before we go on location and start filming. You as an actor may or may not be privy to it; it's purely a practical matter.'

He pauses, looks round the room. 'Contrary to some myths, I really don't know what we're going to be doing. Of course, it would be ludicrous to suggest I have absolutely no idea, but it is only a vague sense. I'm not withholding information to be arty,

enigmatic or obscure.' Everyone laughs. By turn, he is a little more serious. He talks of secrecy, of the cast not discussing their characters with one another. 'You have to keep your gob shut on a big scale.' Another ripple of laughter, but with a nervous edge: here is a formidable director whom everyone wants to please.

Formidable but also empathetic. 'It will be impossible for you not to feel paranoid at some stage: "Why haven't I been called? Why aren't I in this film? He hates me!" But it's only because we aren't ready for you.' He looks at Zegerman and smiles. 'Lexi, you experienced that big time in *Two Thousand Years*; it took for ever before your character was even born.' He discusses creating a character via lists of real people the actors know and then researching the character. 'My commitment to all of you is that you'll have good stuff to do. However, I won't promise the number of scenes in which you'll appear. It may be one, it may be twenty. Either way, it will be worth it.'

Leigh jokes about his nodding off in rehearsals, blaming it on being 'an old geezer'. He says this is 'not an esoteric cabal up a mountain, but a film'. He says they may suffer a terrible winter during the preparation of the film, but they will be ready to shoot in time for 'those gorgeous spring days and nights'. Finally, he reminds the assembled actors that some of them may hardly see each other from now until the wrap party next summer. A round of applause, followed by tea and coffee. Most of the cast barely know one another, but already there is a sense of intimacy, of camaraderie. If anyone in the room is prickly with anxiety, they are doing a good job of hiding it.

15 February 2007

I exchange the odd email with Leigh, mostly about the progress of this book. I ask how rehearsals are going, how the film is coming along. He writes back: 'It's a fucking bollocks – so far behind, and with so little to show as to be utterly ludicrous.' It makes me laugh; I remember that he almost always feels like this before shooting starts.

10 April 2007

A warm day anticipating spring. A corrugated-iron building hid-

den at the back of an industrial estate in Tufnell Park. Another circle of people looking at Mike Leigh, only this time it's the crew – and no actors are present. Again I join the group, feeling like an impostor despite everyone's friendliness. We are each handed a shooting script for 'Untitled '06'. On the front is a gentle yet serious warning: 'This is a working script. It will change as the filming progresses. It is top secret. Please don't show it to anyone.' I glimpse inside: 'Scene 1: Streets TBA (Day Ext. Saturday Week 1). Poppy on her bicycle.' I turn to the final page: 'Scene 50: Streets (Day Ext./Int. Saturday Week 6). Poppy's fifth driving lesson. Scott.'

Filming, announces Leigh, is to start the following week. 'This particular film does not, at this moment, exist. We are all going on a journey . . . Virtually all the action centres round one character, Poppy, played by Sally Hawkins. She is nutty, zany, mobile, funny. In one way she is all over the place, but she's also quite grounded.' As he talks, Leigh seems tired and weary but full of anticipation too. 'We are using this new, state-of-the-art Fuji film stock called Vivid, which does colour in an extreme way. We shall shoot widescreen for the first time too.' He says Poppy is a schoolteacher, as is her flatmate Zoe, played by Alexis Zegerman.

Everyone laughs when Leigh talks of sitting in the back of the car during rehearsals while Poppy had driving lessons with instructor Scott (Eddie Marsan). He has no idea what will happen beyond scene 50 of the shooting script. 'What I've told you is all I know. The film needs to zip along. The spirit of the thing will be very much about that. We can start to have fun now. It will be nice weather and, apparently, there's a jolly good caterer.'

It is a short, instructive meeting. The crew quickly disperse. For many of them, this is where the real work starts.

23 April 2007

The film crew are packed into a small book shop round the back of Waterloo station. Leigh finds a corner and is watchful. He talks to cinematographer Dick Pope about various angles and possible shots. I stay for a while, trying unsuccessfully to keep out of everyone's way. The scene is a simple one but, it later turns out, crucial in setting up the viewer's relationship with Poppy: she wanders

into the shop, talking to herself as she looks at various books. She tries to engage the shop assistant (Elliot Cowan) in conversation, but he studiously ignores her.

On the pavement outside, Hawkins drinks mineral water. She is fizzing with energy and excitement. Yet, knowing that she will be in almost every scene of a film that has to come together as it's being shot, she is also terrified.

11 *July 2007*

A cold, damp autumnal day. A residential road in Tufnell Park. The last few days of the 'Untitled '06' shoot. Dick Pope is wearing four layers and is still chilly. Leigh wears a fleece, leather jacket and hat. So much for gorgeous summer days. The action centres on Poppy having a driving lesson with Scott. Poppy is dressed in red fishnet tights, brown boots, a cheap gold necklace, a lurid dress and a red cardigan with sleeves so long she can hold them in her fists. Scott wears unfashionable black jeans, a denim jacket, a small gold hoop in one ear and a goatee beard. His tension quickly builds to fury: he yells at her to get out of the driving seat, saying he is going to take her home. She seems surprised.

I ask Leigh how it's going. He allows a small smile then raises his eyes to the heavens. He sits next to Pope on a low black wooden stool. They gently bicker for a moment, then both look up and grin. Between shots, various vehicles drive past, apparently oblivious to the film set. One merely crawls past, the learner driver behind the wheel staring at the road ahead. Leigh shouts, 'Look! Life imitating art!' The crew, usually lost in concentration, laugh.

13 *August 2007*

Leigh and editor Jim Clark are in a darkened room in Soho. This is the start of the fifth week of editing and Leigh appears more relaxed than on set the previous month. Clark's calm, methodical editing is impressive, but this should come as no surprise; as Leigh has pointed out elsewhere in this book, Clark is, at seventy-six, the veteran of such films as *Marathon Man*, *The Killing Fields* and *The Mission*. They run through a scene filmed at Koko in Camden, where Poppy, Zoe and some girlfriends are dancing to Pulp's 'Common People', and the following scene, where the young

women are seen walking home through north London. They look through other material: Poppy trampolining; Poppy and Zoe in their flat, messing around while preparing for a lesson; Poppy and Scott out driving. Leigh slides down his chair and nods off for a moment.

A little later, I ask if Leigh is pleased with the film. 'It's come out of its shell big time. It was the classic problem of finding the film.' Clark joins in. 'We have a lot of fun in here; if we didn't, it'd be a lousy film.' Leigh: 'We make the film in here.' Clark: 'We remake it!' It seems a long time since the cast met up on that gloomy day in November last year. Leigh flinches. 'I have *never* felt more insecure about a film than when I talked to everyone that day. Never.'

30 August 2007

A private screening of a cutting copy of 'Untitled '06' is held at De Lane Lea in Soho. The backers have already seen it and approve; now is the turn of various members of the crew and Gary Yershon, who is composing the score over the coming months. Leigh may argue that each of his films is unlike the last, but I can't think of any two films that are more different than *Vera Drake* and 'Untitled '06', not even *Topsy-Turvy* and *All or Nothing* or *Naked* and *Secrets & Lies*. Like *Naked*, it is character driven, but Hawkins takes centre stage to an even greater extent than David Thewlis before her.

It is not an easy film to describe. There is no particular plot and, on this early viewing at least, no climactic, defining moment. On a simplistic level, it's about two young women living together, having fun, looking for love but getting on with life. The opening scenes show Poppy cycling through London, wind in her hair, smile on her face, before visiting the book shop with the silent sales assistant. Her apparently carefree approach to life is slowly seductive, and as the film progresses and she becomes more three-dimensional, so her character becomes more fascinating. Hawkins carries the film: she gives a brilliant, open performance, judging Poppy perfectly and allowing her a vital warmth.

Although Leigh's films are always humorous, this is the most obviously funny film he's ever made. There is, unsurprisingly, a dark side too: driving instructor Scott is deeply troubled and, over

the course of the film, reveals himself to be a confused, deluded, bitter and angry man. He is furious when Poppy starts a relationship with Tim, a nice social worker, and finally accuses her of having come on to him. He completely loses his head in the middle of a lesson, which she deals with calmly and sympathetically. This is not, however, one of Leigh's 'difficult' works. In fact, when Poppy and Zoe sit chatting in a rowing boat at the end, it is arguably the most uncomplicated, open and life-affirming finale of any of his films.

The following month, Leigh rings one afternoon to say that the film now has a name: *Happy-Go-Lucky*. In a moment, it becomes very real. Not a work in progress but the follow-up to *Vera Drake*. It might, he says, go to the Berlin Film Festival the following February. I arrange to meet him again to discuss the film, but in the interim he suggests I talk to Dick Pope, Sally Hawkins and Eddie Marsan.

Pope insists that all Mike Leigh films differ from one another, and *Happy-Go-Lucky* is no exception; they all have a unique look, he says, and tell a very different story. He then explains how they decided to go widescreen. 'We tested it before, but always finally rejected the format for not being appropriate. When Mike told me that he wanted this film to be very free, for it to be very light on its feet and employ a fluid visual language, I thought it would be a great opportunity to combine vibrant colours and a constantly moving camera along with widescreen to achieve something exciting and completely different to what we've done before.'

I say that *Happy-Go-Lucky* is very natural looking, and he laughs. 'Some people think that whenever we work together Mike and I just go out and wave a camera around a group of improvising actors. In fact, I used to work on documentaries, and working with Mike is the polar opposite: everything is really structured and incredibly disciplined. Yet he's a genius at making things appear spontaneous and natural, and I endeavour to achieve this for him visually. Working with Mike is unique in my experience because his films are 100 per cent character driven; he adores cinema and the cinematography is never treated as an also-ran, but, crucially, everything we do services the actors and the acting. This always leads and the camera always follows and observes. The acting rules.'

Which is why it's so tough – but ultimately rewarding – for actors to work with Leigh. Hawkins, however, didn't stop to think about how hard it was being in almost every scene of a Mike Leigh film. 'Had I done so, I probably would have burst under the pressure. I just took every day as it came; I couldn't really do anything else. And every day was a different challenge. When working on a Mike Leigh film, you never really know what's going to happen – or, perhaps more accurately, *how* it's going to happen. And what's so clever about the way Mike works is that it stops you from end-gaming. If you do, you just trip yourself up. And it's not our job to be the writer or editor or anything; we simply have to exist in the moment and do exactly what our character would do.'

The process was particularly rigorous for Hawkins. 'It felt at times like I just had to keep running, to keep going from scene to scene with lines learned only days – and, sometimes, minutes – before the camera started rolling. Mike never stops pushing and searching, looking in every corner at every detail. As an actor you are constantly being tested and going to places you never thought you could go to. I think Poppy's spirit and energy helped me through. She's always laughing, always happy. It was a joy to jump into her skin; she is light and funny, with a very twinkly, naughty sense of humour. She just adores people – all people – and relishes finding out about them, seeing the world through their eyes.'

Hawkins says that finding a character with a 'sparky nature' was Leigh's aim from the start of rehearsals. She remembers exploring Poppy as a lively three-year-old and, that night, sleeping like a baby. 'Although she has this incredible energy, I never felt drained by her. She was enlivening. She just keeps going. Once we finished filming I was shattered, but funnily enough I now miss Poppy. She was such a huge part of my life for all those months.'

While Hawkins was creating Poppy with Leigh, Eddie Marsan was often working on Scott on his own. 'It was hard because, apart from one scene when he briefly meets Tim, Scott only appears in scenes with Poppy. So I spent a lot of time alone, creating this mad bloke. I sat in on loads of driving lessons, picking up the vernacular. I trawled through conspiracy theories, researched stalkers and people who have imaginary love affairs, who misconstrue what people are communicating to them. Scott has incredible issues about women. Of course, I had no idea what anyone else

was doing, of what Poppy had been up to. Mike took me right out of my comfort zone.'

When I meet with Leigh again, he is initially reluctant to discuss *Happy-Go-Lucky*. He feels too close to it, has yet to develop a perspective on it. I push him on the 'vague sense' he had of the film a year ago. 'Well . . . I had a notion to make a film with Sally which would be, in some shape or form, about a woman coming through a lot of things. Poppy is a healthy combination of being a bit of an anarchist but also being incredibly responsible and capable. It's a film about love: Poppy is a naturally loving person, while Scott is obviously starved of love. It's also a film about needs. But in a way you could say all my films are about these things.'

He cast Hawkins ahead of everyone else. 'I'm particularly able to deal with an actor with whom I've worked before, whom I've therefore got the hang of. Sally is very special. Very funny. Creative. We communicate, we have a rapport. And, like other people I've worked with, she's a highly imaginative, creative person, over and above being an actor.'

Although it's a very different film, it's hard not to think back to *Career Girls* when watching *Happy-Go-Lucky*. 'All these two films have got in common is this: women who are of a similar age, around thirty. The women in each film are in contrasting places emotionally, psychologically, socially. You could say *Vera Drake* has something in common with *Happy-Go-Lucky* in the sense that both have a female character who is a good person.' He pauses. 'Those who've seen *Happy-Go-Lucky* say it's a departure from my other work but . . . I just haven't got the hang of it yet.'

I remind Leigh of what he said in the edit suite about never having felt more insecure talking about a film than he did in the cast meeting almost a year ago. 'It's true. I absolutely felt that. And don't forget, I had been secure about *Vera Drake* – although, of course, I was apprehensive about pulling it off.' He admits that during *Happy-Go-Lucky* he did, at times, think he was too old, the whole process was too hard, he wouldn't make it. Mostly it is the relentless, endless rehearsals that wear him down. 'Once upon a time, a million years ago, everything in rehearsals was exciting.

Now they are my eternal albatross. Whereas I can still get up at 5 a.m. every morning on a shoot and never get knackered, because it's continuously stimulating.'

On occasion, Leigh even thought this might be his last film. But not for long. 'I love it. I love making films and I love the films I make. I love working with the cast, the crew. I anticipate that *Happy-Go-Lucky* will be one of my favourite films. Yet, at times, while making it, I also felt that it would rank as one of my least favourite films. I was talking to a friend just the other day who reminded me that I always say a film's crap or a disaster when I'm making it. But then, months later, I sit and watch it and think, "Wow!" And, at that point, I know it's been worth everything.'

Acknowledgements

With thanks to Ian Bahrami, Abbie Browne, Walter Donohue, Jonny Geller, Joanne Glasbey, Edie Kähler, Doug Kean, Richard Kelly, Simon Mein and Jonathan Rutter.

Filmography

Bleak Moments (1971)
Autumn Productions/Memorial Enterprises/BFI Production Board. Produced and edited by Les Blair, photography by Bahram Manocheri, designed by Richard Rambaut, sound by Bob Withey. With Anne Raitt (Sylvia), Sarah Stephenson (Hilda), Eric Allan (Peter), Joolia Cappleman (Pat), Mike Bradwell (Norman), Liz Smith (Pat's Mother), Malcolm Smith, Donald Sumpter (Norman's Friends), Christopher Martin (Sylvia's Boss), Linda Beckett, Sandra Bolton, Stephen Churchett (Remedial Trainees), Una Brandon-Jones (Supervisor), Ronald Eng (Waiter), Reg Stewart (Man in Restaurant), Susan Glanville (Enthusiastic Teacher), Joanna Dickens (Stout Teacher), Christopher Leaver (Wine Merchant). 111 mins.

Hard Labour (1973)
BBC TV. Produced by Tony Garnett, photography by Tony Pierce-Roberts, sound by Dick Manton, edited by Christopher Rowlands, designed by Paul Munting, costumes by Sally Nieper. With Liz Smith (Mrs Thornley), Clifford Kershaw (Mr Thornley), Polly Hemingway (Ann), Bernard Hill (Edward), Alison Steadman (Veronica), Vanessa Harris (Mrs Stone), Cyril Varley (Mr Stone), Linda Beckett (Julie), Ben Kingsley (Naseem), Alan Erasmus (Barry), Rowena Parr (June), June Whitaker (Mrs Rigby), Paula Tilbrook (Mrs Thornley's Friend), Keith Washington (Mr Shore), Louis Raynes (Tallyman), Alan Gerrard (Greengrocer), Diana Flacks (Mrs Rubens), Patrick Durkin (Frank). 75 mins.

'The Five-Minute Films' (1975; broadcast 1982)
BBC TV. Produced by Tony Garnett, photography by Brian Tufano, sound by Andrew Boulton, edited by Chris Lovett. *The Birth of the 2001 FA Cup Final Goalie* with Richard Ireson (Father), Celia Quicke (Mother); *Old Chums* with Tim Stern (Brian), Robert Putt (Terry); *Probation* with Herbert Norville (Arbley), Billy Colvill (Sid), Anthony Carrick (Mr Davies), Theresa Watson (Secretary), Lally Percy (Victoria); *A Light Snack* with Margaret Heery (Mrs White), Richard Griffiths (Window Cleaner), Alan Gaunt (Talker), David Casey (Listener); *Afternoon* with Rachel Davies (Hostess), Pauline Moran (Teacher), Julie North (Newlywed). 25 mins.

Nuts in May (1975)
BBC TV. Produced by David Rose, photography by Michael Williams, sound by John Gilbert, edited by Oliver White, designed by David Crozier, costumes by Gini Hardy. With Roger Sloman (Keith), Alison Steadman (Candice-Marie), Anthony O'Donnell (Ray), Sheila Kelley (Honky), Stephen Bill (Finger), Richenda Carey (Miss Beale), Eric Allan (Quarryman), Matthew Guinness (Farmer), Sally Watts (Farm Girl), Richard Ireson (Policeman). 80 mins.

The Kiss of Death (1976)
BBC TV. Produced by David Rose, photography by Michael Williams and John Kenway, edited by Oliver White, designed by David Crozier, costumes by Al Barnett, music by Carl Davis, sound by John Gilbert. With David Threlfall (Trevor), Clifford Kershaw (Mr Garside), John Wheatley (Ronnie), Pamela Austin (Trevor's Mum), Angela Curran (Sandra), Phillip Ryland (Froggy), Kay Adshead (Linda), Elizabeth Hauck (Shoe-shop Customer), Karen Petrie (Policewoman), Frank McDermott (Mr Bodger), Christine Moore (Mrs Bodger), Eileen Denison (Mrs Ball), Marlene Sidaway (Christine), Brian Pollitt (Doctor), Elizabeth Ann Ogden (Bridesmaid). 80 mins.

Who's Who (1978)
BBC TV. Produced by Margaret Matheson, photography by John Else, edited by Chris Lovett, designed by Austen Spriggs, costumes

by Robin Stubbs, sound by John Pritchard. With Simon Chandler (Nigel), Adam Norton (Giles), Richard Kane (Alan), Jeffrey Wickham (Francis), Souad Faress (Samya), Phil Davis (Kevin), Graham Seed (Anthony), Joolia Cappleman (April), Lavinia Bertram (Nanny), Francesca Martin (Selina), David Neville (Lord Crouchurst), Richenda Carey (Lady Crouchurst), Geraldine James (Miss Hunt), Sam Kelly (Mr Shakespeare), Catherine Hall (Samantha), Felicity Dean (Caroline), Angela Curran, Roger Hammond (Couple in Window). 80 mins.

Grown-Ups (1980)

BBC TV. Produced by Louis Marks, photography by Remi Adefarasin, edited by Robin Sales, designed by Bryan Ellis, costumes by Christian Dyall, sound by John Pritchard. With Phil Davis (Dick), Lesley Manville (Mandy), Brenda Blethyn (Gloria), Janine Duvitski (Sharon), Lindsay Duncan (Christine), Sam Kelly (Ralph). 90 mins.

Home Sweet Home (1982)

BBC TV. Produced by Louis Marks, photography by Remi Adefarasin, edited by Robin Sales, designed by Bryan Ellis, costumes by Michael Burdle, music by Carl Davis, sound by John Pritchard. With Timothy Spall (Gordon), Eric Richard (Stan), Tim Barker (Harold), Kay Stonham (Hazel), Su Elliott (June), Frances Barber (Melody), Sheila Kelley (Janice), Lorraine Brunning (Tina), Heidi Laratta (Kelly), Paul Jesson (Man in Dressing Gown), Lloyd Peters (Dave). 90 mins.

Meantime (1983)

Central Television/Mostpoint Ltd for Channel 4. Produced by Graham Benson, photography by Roger Pratt, edited by Lesley Walker, designed by Diana Charnley, costumes by Lindy Hemming, music by Andrew Dickson, sound by Malcolm Hirst. With Marion Bailey (Barbara), Phil Daniels (Mark), Tim Roth (Colin), Pam Ferris (Mavis), Jeff Robert (Frank), Alfred Molina (John), Gary Oldman (Coxy), Tilly Vosburgh (Hayley), Paul Daly (Rusty), Leila Bertrand (Hayley's Friend), Hepburn Graham (Boyfriend), Peter Wight (Estate Manager), Eileen Davies (Unemployment Benefit Clerk), Herbert Norville (Man in Pub), Brian Hoskin (Barman). 90 mins.

Four Days in July (1984)
BBC TV. Produced by Kenith Trodd, photography by Remi Ade-
farasin, edited by Robin Sales, designed by Jim Clay, costumes by
Maggie Donnelly, music by Rachel Portman, sound by John
Pritchard. With Bríd Brennan (Collette), Des McAleer (Eugene),
Paula Hamilton (Lorraine), Charles Lawson (Billy), Brian Hogg
(Big Billy), Adrian Gordon (Little Billy), Shane Connaughton
(Brendan), Eileen Pollock (Carmel), Stephen Rea (Dixie), David
Coyle (Mickey), John Keegan (Mr McCoy), John Hewitt (Mr
Roper), Ann Hasson (Midwife). 96 mins.

The Short and Curlies (1987)
Film Four/Portman. Produced by Victor Glynn and Simon Chan-
ning Williams, photography by Roger Pratt, edited by Jon Gre-
gory, designed by Diana Charnley, costumes by Lindy Hemming,
music by Rachel Portman, sound by Malcolm Hirst. With Alison
Steadman (Betty), Sylvestra Le Touzel (Joy), David Thewlis
(Clive), Wendy Nottingham (Charlene). 18 mins.

High Hopes (1988)
Film Four International/British Screen/Portman. Produced by Simon
Channing Williams and Victor Glynn, photography by Roger Pratt,
edited by Jon Gregory, designed by Diana Charnley, costumes by
Lindy Hemming, hair and make-up by Morag Ross, music by
Andrew Dickson, sound by Billy McCarthy. With Phil Davis (Cyril),
Ruth Sheen (Shirley), Edna Doré (Mrs Bender), Heather Tobias
(Valerie), Philip Jackson (Martin), Lesley Manville (Laetitia), David
Bamber (Rupert), Jason Watkins (Wayne), Judith Scott (Suzi),
Cheryl Prime (Martin's Girlfriend), Diane-Louise Jordan (Chemist-
shop Assistant), Linda Beckett (Receptionist). 110 mins.

Life Is Sweet (1990)
Thin Man/Film Four International/British Screen. Produced by
Simon Channing Williams, photography by Dick Pope, edited by
Jon Gregory, designed by Alison Chitty, costumes by Lindy Hem-
ming, hair and make-up by Carolyn Walsh, music by Rachel Port-
man, sound by Malcolm Hirst. With Alison Steadman (Wendy),
Jim Broadbent (Andy), Claire Skinner (Natalie), Jane Horrocks
(Nicola), Timothy Spall (Aubrey), Stephen Rea (Patsy), David

Thewlis (Nicola's Lover), Moya Brady (Paula), David Neilson (Steve), Harriet Thorpe (Customer), Paul Trussell (Chef), Jack Thorpe Baker (Nigel). 102 mins.

A Sense of History (1992)
Thin Man/Film Four International. Written by Jim Broadbent, produced by Simon Channing Williams, photography by Dick Pope, edited by Jon Gregory, production and costume design by Alison Chitty, music by Carl Davis, sound by Tim Fraser. With Jim Broadbent (23rd Earl of Leete), Stephen Bill (Giddy). 28 mins.

Naked (1993)
Thin Man/Film Four International/British Screen. Produced by Simon Channing Williams, photography by Dick Pope, edited by Jon Gregory, designed by Alison Chitty, costumes by Lindy Hemming, hair and make-up by Christine Blundell, music by Andrew Dickson, sound by Ken Weston. With David Thewlis (Johnny), Lesley Sharp (Louise), Katrin Cartlidge (Sophie), Greg Cruttwell (Jeremy), Claire Skinner (Sandra), Peter Wight (Brian), Ewen Bremner (Archie), Susan Vidler (Maggie), Deborah Maclaren (Woman in Window), Gina McKee (Cafe Girl), Carolina Giammetta (Masseuse), Elizabeth Berrington (Giselle), Darren Tunstall (Poster Man), Robert Putt (Chauffeur), Lynda Rooke (Victim), Angela Curran (Car Owner), Peter Whitman (Mr Halpern), Jo Abercrombie (Woman in Street), Elaine Britten (Girl in Porsche), David Foxxe (Tea-Bar Owner), Mike Avenall, Toby Jones (Men at Tea Bar), Sandra Voe (Bag Lady). 126 mins.

Secrets & Lies (1996)
Thin Man/Ciby 2000/October Films. Produced by Simon Channing Williams, photography by Dick Pope, edited by Jon Gregory, designed by Alison Chitty, costumes by Maria Price, hair and make-up by Christine Blundell, music by Andrew Dickson, sound recordist George Richards. With Brenda Blethyn (Cynthia), Marianne Jean-Baptiste (Hortense), Timothy Spall (Maurice), Phyllis Logan (Monica), Claire Rushbrook (Roxanne), Elizabeth Berrington (Jane), Michele Austin (Dionne), Lee Ross (Paul), Lesley Manville (Social Worker), Ron Cook (Stuart), Emma Amos (Woman with Scar), Brian Bovell and Trevor Laird (Hortense's

Brothers), Claire Perkins (Hortense's Sister-in-Law), Elias Perkins McCook (Hortense's Nephew), June Mitchell (Senior Optometrist), Janice Acquah (Junior Optician), Keeley Flanders (Girl in Optician's), Hannah Davis (First Bride), Terence Harvey (First Bride's Father), Kate O'Malley (Second Bride), Joe Tucker (Groom), Richard Syms (Vicar), Grant Masters (Best Man), Peter Wight (Father in Family Group), Gary Macdonald (Boxer), Alison Steadman (Dog Owner), Liz Smith (Cat Owner), Sheila Kelley (Fertile Mother), Angela Curran (Little Boy's Mother), Linda Beckett (Pin-Up Housewife), Wendy Nottingham (Glum Wife), Anthony O'Donnell (Uneasy Man), Ruth Sheen (Laughing Woman), Annie Hayes (Mother in Family Group), Jean Ainslie (Grandmother), Daniel Smith (Teenage Son), Lucy Sheen (Nurse), Frances Ruffelle (Young Mother), Felix Manley (Baby), Nitin Chandra Ganatra (Potential Husband), Metin Marlow (Conjuror), Amanda Crossley, Su Elliott and Di Sherlock (Raunchy Women), Alex Squires, Lauren Squires and Sade Squires (Triplets), Dominic Curran (Little Boy), Stephen Churchett, Phil Davis, David Neilson, Peter Stockbridge and Peter Waddington (Men in Suits), Rachel Lewis (Graduate), Paul Trussell (Grinning Husband), Denise Orita (Uneasy Woman), Margery Withers (Elderly Lady), Theresa Watson (Daughter), Gordon Winter (Laughing Man), Mia Soteriou (Fiancée), Jonathan Coyne (Fiancé), Bonzo (Dog), Texas (Cat). 136 mins.

Career Girls (1997)
Thin Man/Channel 4/October Films. Produced by Simon Channing Williams, photography by Dick Pope, edited by Robin Sales, production and costume design by Eve Stewart, music by Marianne Jean-Baptiste and Tony Remy, hair and make-up by Christine Blundell, sound recordist George Richards. With Katrin Cartlidge (Hannah), Lynda Steadman (Annie), Kate Byers (Claire), Mark Benton (Ricky), Andy Serkis (Mr Evans), Joe Tucker (Adrian), Margo Stanley (Ricky's Nan), Michael Healy (Lecturer). 87 mins.

Topsy-Turvy (1999)
Thin Man/Newmarket Capital Group/October Films. Produced by Simon Channing Williams, photography by Dick Pope, edited by Robin Sales, designed by Eve Stewart, music by Carl Davis from

the works of Arthur Sullivan, hair and make-up by Christine Blundell, costumes by Lindy Hemming, sound recordist Tim Fraser, casting by Nina Gold, musical director Gary Yershon, choreography by Francesca Jaynes, research by Rosie Chambers. With Jim Broadbent (W. S. Gilbert), Allan Corduner (Arthur Sullivan), Lesley Manville (Lucy Gilbert), Ron Cook (Richard D'Oyly Carte), Wendy Nottingham (Helen Lenoir), Timothy Spall (Richard Temple), Kevin McKidd (Durward Lely), Shirley Henderson (Leonora Braham), Dorothy Atkinson (Jessie Bond), Martin Savage (George Grossmith), Vincent Franklyn (Rutland Barrington), Cathy Sara (Sibyl Grey), Louise Gold (Rosina Brandram), Eleanor David (Fanny Ronalds), Sam Kelly (Richard Barker), Andy Serkis (John D'Auban), Charles Simon (Gilbert's Father), Alison Steadman (Madame Leon), Jonathan Aris (Wilhelm), Stefan Bednarczyk (Frank Cellier), Nicholas Woodeson (Mr Seymour), Mia Soteriou (Mrs Russell), Dexter Fletcher (Louis), Sukie Smith (Clothilde), Kenneth Hadley (Pidgeon), Kate Doherty (Mrs Judd), Togo Igawa (First Kabuki Actor), Eiji Kusuhara (Second Kabuki Actor), Akemi Otani (Dancer), Naoko Mori (Miss 'Sixpence Please'), Kanako Morishita (Shamisen Player), Roger Heathcott (Stage-door Keeper), Geoffrey Hutchings (Armourer), Francis Lee (Butt), William Neenan (Cook), Adam Searle (Shrimp), Keeley Gainey (Maidservant), Gary Yershon (Pianist in Brothel), Katrin Cartlidge (Madam), Julia Rayner (Mademoiselle Fromage), Jenny Pickering (Second Prostitute), Philippe Constantin (Paris Waiter), David Neville (Dentist), Matthew Mills (Walter Simmonds), Nick Bartlett and Gary Dunnington (Stage Hands), Amanda Crossley (Emily), Kimi Shaw (Spinner), Toksan Takahashi (Calligrapher), Theresa Watson (Maude Gilbert), Lavinia Bertram (Florence Gilbert), Eve Pearce (Gilbert's Mother), Neil Humphries (Boy Actor), Michael Simkins (Frederick Bovill), Angela Curran (Miss Morton), Millie Gregory (Alice), Shaun Glanville (Mr Harris), Neil Salvage (Mr Hurley), Matt Bardock (Mr Tripp), Bríd Brennan (Mad Woman). Ladies and Gentlemen of the Chorus: Mark Benton (Mr Price), Heather Craney (Miss Russell), July Jupp (Miss Meadows), John Warnaby (Mr Sanders), Kacey Ainsworth (Miss Fitzherbert), Ashley Artus (Mr Marchmont), Richard Attlee (Mr Gordon), Paul Barnhill (Mr Flagstone), Nicholas Boulton (Mr Conyngham), Lorraine Brunning (Miss Jardine), Simon Butteriss

(Mr Lewis), Wayne Cater (Mr Rhys), Rosie Cavaliero (Miss Moore), Michelle Chadwick (Miss Warren), Debbie Chazen (Miss Kingsley), Richard Coyle (Mr Hammond), Monica Dolan (Miss Barnes), Sophie Duval (Miss Brown), Anna Francolini (Miss Biddles), Teresa Gallagher (Miss Coleford), Sarah Howe (Miss Woods), Ashley Jensen (Miss Tringham), Gemma Page (Miss Langton-James), Paul Rider (Mr Bentley), Mary Roscoe (Miss Carlyle), Steve Speirs (Mr Kent), Nicola Wainwright (Miss Betts), Angie Wallis (Miss Wilkinson), Kevin Walton (Mr Evans). 152 mins.

All or Nothing (2002)
Thin Man/Les Films Alain Sarde. Produced by Simon Channing Williams, photography by Dick Pope, edited by Lesley Walker, designed by Eve Stewart, casting by Nina Gold, costumes by Jacqueline Durran, hair and make-up by Christine Blundell, music by Andrew Dickson, sound recordist Tim Fraser. With Timothy Spall (Phil), Lesley Manville (Penny), Alison Garland (Rachel), James Corden (Rory), Ruth Sheen (Maureen), Marion Bailey (Carol), Paul Jesson (Ron), Sally Hawkins (Samantha), Helen Coker (Donna), Daniel Mays (Jason), Sam Kelly (Sid), Kathryn Hunter (Cécile), Robert Wilfort (Doctor), Gary McDonald (Neville), Diveen Henry (Dinah), Timothy Bateson (Harold), Edna Doré (Martha), Georgia Fitch (Ange), Tracy O'Flaherty (Michelle), Jean Ainslie (Old Lady), Badi Uzzaman and Parvez Qadir (Passengers), Russell Mabey (Nutter), Thomas Brown-Lowe, Oliver Golding, Henri McCarthy, Ben Wattley (Small Boys), Peter Stockbridge (Man with Flowers), Brian Bovell (Garage Owner), Michele Austin (Care Worker), Alex Kelly (Neurotic Woman), Alan Williams (Drunk), Peter Taylor (MC), Dale Davis (Singer), Emma Lowndes, Maxine Peake (Party Girls), Matt Bardock, Mark Benton (Men at Bar), Dorothy Atkinson, Heather Craney, Martin Savage (Silent Passengers), Joe Tucker (Fare Dodger), Di Botcher (Supervisor), Valerie Hunkins (Nurse), Daniel Ryan (Crash Driver). 128 mins.

Vera Drake (2004)
Thin Man/UKFC/Studio Canal/Ingenious Media. Produced by Simon Channing Williams, photography by Dick Pope, edited by

Jim Clark, designed by Eve Stewart, costumes by Jacqueline Durran, hair and make-up by Christine Blundell, music by Andrew Dickson, sound recordist Tim Fraser, casting by Nina Gold, research by Lucy Whitton. With Imelda Staunton (Vera), Phil Davis (Stan), Peter Wight (Det. Inspector Webster), Daniel Mays (Sid), Alex Kelly (Ethel), Adrian Scarborough (Frank), Heather Craney (Joyce), Eddie Marsan (Reg), Ruth Sheen (Lily), Sally Hawkins (Susan), Leo Bill (Ronnie), Gerard Monaco (Kenny), Sandra Voe (Vera's Mother), Lesley Manville (Mrs Wells), Simon Chandler (Mr Wells), Sam Troughton (David), Fenella Woolgar (Susan's Confidante), Nicky Henson (Private Doctor), Allan Corduner (Psychiatrist), Lesley Sharpe (Jessie Barnes), Anthony O'Donnell (Mr Walsh), Martin Savage (Det. Sergeant Vickers), Helen Coker (WPC Best), Paul Jesson (Magistrate), Jim Broadbent (Judge), Richard Graham (George), Anna Keaveney (Nellie), Marion Bailey (Mrs Fowler), Chris O'Dowd (Sid's Customer), Sinéad Matthews (Very Young Woman), Sid Mitchell (Very Young Man), Tilly Vosburgh (Mother of Seven), Alan Williams (Sick Husband), Heather Cameron, Billie Cook, Billy Seymour (Children), Nina Fry, Lauren Holden (Dance Hall Girls), Elizabeth Berrington, Emma Amos (Cynical Ladies), Joanna Griffiths (Peggy), Wendy Nottingham (Ivy), Angie Wallis (Nurse Willoughby), Judith Scott (Sister Beech), Vinette Robinson (Jamaican Girl), Rosie Cavaliero (Married Woman), Liz White (Pamela Barnes), Lucy Pleasance (Sister Coombes), Tracey O'Flaherty (Nurse), Tom Ellis (Police Constable), Robert Putt (Station Sergeant), Craig Conway (Station Constable), Jake Wood (Ruffian), Vincent Franklin (Mr Lewis), Michael Gunn (Gaoler), Paul Raffield (Magistrate's Clerk), Philip Childs (Clerk), Jeffrey Wickham (Prosecution Barrister), Nicholas Jones (Defence Barrister), Stephen Dunbar (Usher), Angela Curran, Jane Wood (Prisoners), Eileen Davies (Prison Officer). 125 mins.

Happy-Go-Lucky (2008)
Thin Man/Summit Entertainment/UKFC/Ingenious Media/Film4. Produced by Simon Channing Williams, photography by Dick Pope, edited by Jim Clark, designed by Mark Tildesley, casting by Nina Gold, hair and make-up by Christine Blundell, costume by Jacqueline Durran, music by Gary Yershon, sound recordist Tim Fraser. With Sally Hawkins (Poppy), Eddie Marsan (Scott), Alexis

Zegerman (Zoe), Sylvestra Le Touzel (Heather), Stanley Townsend (Tramp), Kate O'Flynn (Suzy), Caroline Martin (Helen), Oliver Maltman (Jamie), Sarah Niles (Tash), Samuel Roukin (Tim), Karina Fernandez (Flamenco Teacher), Nonso Anozie (Ezra), Sinéad Matthews (Alice), Andrea Riseborough (Dawn), Joseph Kloska (Suzy's Boyfriend), Elliot Cowan (Bookshop Assistant), Anna Reynolds (Receptionist), Trevor Cooper (Patient), Philip Arditti, Viss Elliot, Rebekah Staton (Flamenco Students), Jack MacGeachin (Nick), Charlie Duffield (Charlie), Ayotunde Williams (Ayotunde). 118 mins.

Stage Plays
(with commentary by Mike Leigh)

The Box Play
Midland Arts Centre, Cannon Hill, Birmingham, 18 December
1965. Designed by Mike Leigh.
A family lives in a box. Outside the box the world goes by, but the
family stays inside. Only the teenage son ventures forth, at one
point bringing home a girlfriend. Chaos. Fast-moving. Height-
ened. Climactic. Hilarious. A strip-cartoon play. Bright, bold, clear
design. In one act.

With hindsight, I realise that this was the prototype Mike Leigh
work, all about being trapped in a claustrophobic domestic envi-
ronment. The amateur cast included Les Blair, who was working
for a Birmingham advertising agency before enrolling at the Lon-
don Film School.

My Parents Have Gone to Carlisle
Midlands Arts Centre, 13 May 1966. Designed by Mike Leigh.
While her parents are away for the weekend, a teenage girl throws
a party. Chaos. In two acts.

More embryonic stuff. I was aching to make films in this period,
but it was to be five years before that happened . . . At one point in
this play, I froze the action and went to a blackout. When the lights
came up, the entire event – large teenage cast, furniture, props and
all – was now visible from the reverse angle; that is, I'd swung it all
through 180 degrees. It was a powerful cinematic moment – even
shocking! And it worked dramatically. But the idea of doing that
now would be preposterous!

The central character had a number of stream-of-consciousness soliloquies – filmic interior monologues, really. There had been a couple of these in *The Box Play*. This was to feature for some time to come.

The Last Crusade of the Five Little Nuns
Midlands Arts Centre, 2 July 1966. Designed by Mike Leigh.
Five comic nuns, Sister Dunlop, Sister Sampson, Sister Paddy, Sister Capone and Sister Bournville, in a rowing boat, eating bananas on the high seas. In Act Two, they land on a desert island (tiny, with one palm tree, as in cartoons), where they encounter a man and a monkey. Chaos.

Surely my most superficial piece, but still a lot of fun. However, it was not really about anything – certainly not nuns! It was criticised by some local teachers for exploiting its teenage female cast: they all took off their habits in the tropical heat. More soliloquies.

NENAA
RSC Conference Hall, Royal Shakespeare Theatre, Stratford-upon-Avon, Summer 1967. With Gerald McNally (Gerald), Peter Rocca (Luigi), Edward Lyon (Delivery Boy), Mike Billington, C. G. Bond, Robert Davies, Peter Gordon, Roger Lloyd Pack, Louis Mahoney, Matthew Roberton, Richard Williams and David Weston (Customers).
Gerald works in a London cafe. He fantasises about going back home to Tyneside to found 'NENAA' – the North-East New Arts Association. The cafe owner, Luigi, tolerates this at first but eventually loses his patience and sacks him. Hungry working men come and go. A lad delivers supplies. In one act.

This was my first improvised play with professional actors, which was very satisfying and exciting. I was the Assistant Director for Peter Hall's last RSC season. There had been a huge cast for *Coriolanus*, but *All's Well That Ends Well* needed far fewer spear-carriers. So I was allowed to cook up this piece with some of the surplus actors during the *All's Well* rehearsals. It had one lunchtime performance in the rehearsal space that later became the Swan Theatre.

Again, the central character stepped out of the action several times and launched into soliloquies – unexceptional for the in-

house audience of theatre workers at this venue! The piece in general was realistic, although its mode of production was crude – few props, basic costumes, performed with no lighting or effects in broad daylight.

The title was a bit of naughtiness on my part. The word was out amongst the Stratford company that we were hatching some 'experimental drama'. So I gave it a title that sounded like an abstract, meaningless word, threatening the kind of arty, impenetrable rubbish so fashionable at the time – and which I knew our audience was expecting! In fact, I had the whole cast come on out of character at the beginning and chant: 'Nenaa! Nenaa! Nenaa!' putting the stress on the first syllable, then the second, then the first.

Then the audience was treated to forty minutes of blokes in a greasy spoon! (Not to mention the strange word turning out to be nothing more exotic than the initials of a putative provincial committee!)

Individual Fruit Pies

E15 Acting School, Loughton, Essex, 3 July 1968. Designed by Mike Leigh, lighting by Paul Braithwaite. With David Atkinson (Ronald), Jane Briers (Mrs McAuley), Robert Putt (Andy), Sarah Stephenson (Betty), Gwen Taylor (Mrs Briddon), Peggy Goodson (Mary Brent), Edward Caswell (Gerald Swann).

Ronald lets out rooms. His mother lies dying in her bed. They are visited by relations. Tenants come and go, paying their rent, complaining. Alone, Ronald plays classical LPs, conducting with a knitting needle. His mother dies. Real. Heightened. Climactic. In one act.

This was my first fully fledged, grown-up piece. All my themes were on the go, not least birth and death (one of the tenants was pregnant). It was the first time I got each actor to start off with a number of people he or she knew. Sarah Stephenson was to develop her mentally handicapped Betty into Hilda in *Bleak Moments*.

The play was performed in a double bill with *A Night Out* by Harold Pinter, the cast of which included Alison Steadman.

Down Here & Up There

Theatre Upstairs, Royal Court Theatre, London, 1 August 1968. Designed by Mike Leigh. With Gerald McNally (Gerald), Robert Putt (Gus), Amaryllis Garnett (Kit), Gwen Taylor (Pat), David S. Boliver (Bert).

Gerald is a Catholic teacher from up north. He works in London and lives in a flat. He has lost his faith. He talks to God, in whom he no longer believes. He gets no reply. He assumes the role of the priest he once toyed with the idea of becoming and hears his own confession. He goes back home and has altercations with his married sister. A crisis play in one act. The title refers to London and up north, as well as to Earth and Heaven.

My second collaboration (see *NENAA*) with Gerald McNally, sort of playing himself in a way that I abandoned after this. More soliloquies. This was the last production to be performed in the English Stage Club Bar, before it was turned into the Theatre Upstairs; you played late on Thursdays, Fridays and Saturdays, and had to compete with late-night drinkers, the pub next door having closed. Squaddies from the local barracks were often in attendance.

The cast included Amaryllis Garnett as a mad cellist. She was beautiful, talented and special; tragically, she committed suicide in 1973.

Big Basil

Manchester Youth Theatre, Lesser Free Trade Hall, Manchester, 4 January 1969. Designed by Janet Payne.

Basil is a small working-class teenager in a fictional comprehensive school in Manchester. The play was a study of the eponymous hero, both at home and at school. Lots of short scenes. In two acts.

This was the first of two plays for the Manchester Youth Theatre, which was run by the inspired Geoffrey Sykes. Massive cast; rehearsed during the Christmas holidays. Soliloquies again for Basil.

The cast included the sixteen-year-old Steven Pimlott as the form master. Steven was to become one of our greatest theatre directors. Sadly, he died of cancer in 2007.

Epilogue

Sedgley Park College and De La Salle College joint drama depart-
ment, Manchester, 27 June 1969. Designed by John Coupe and
Mike Leigh.

A Roman Catholic priest, Father Blackburn, hears confessions
from a wide variety of penitents. But he himself has doubts, which
he airs to a God he is no longer sure he believes in. As he reaches a
crisis, he has to put up with cynical abuse from his housekeeper's
son and the pious platitudes of a visiting nun.

In retrospect, I realise that through *Down Here & Up There,* this
play and *Hard Labour* I was finding ways of expressing my own
deep-seated atheism, through Roman Catholics who were strug-
gling with their own faith. I guess my natural tendency was – and
remains – to see religion as the vulnerable human folly it is. This is
what I was still doing thirty years later in *Two Thousand Years.*

The circumstances of this production were fortuitous. I hap-
pened to land a job as drama lecturer to a group of extremely tal-
ented Roman Catholic teaching students. Although these actors
weren't professional, this was undoubtedly my most ambitious,
sophisticated and accomplished work to date, in terms of its form
and content.

Each performance was followed by a heated Q&A. Half the dis-
cussion concerned the then befuddled question of how such a
meticulously structured play could possibly have come out of
improvisation. The other half, encouraged, interestingly, by a
Mother Superior very much of her post-ecumenical time, was all
about the central crisis of faith.

Some people were understandably angry with me personally for
staging what they saw as an anti-Catholic piece in a Faithful Com-
panions of Jesus college. Others appreciated its open humanism
and my quest for truth. The cast were unequivocally enthusiastic
about the project.

Glum Victoria & The Lad with Specs

Manchester Youth Theatre, Renold Theatre, Manchester, 5 Sep-
tember 1969. Designed by Mike Leigh.

The unhappy eponymous heroine, fed up with her bickering fam-
ily at home and alienated at school, strikes up a putative relation-

ship with her eponymous co-hero at the daily bus stop. Lots of scenes. Two acts.

The companion piece to *Big Basil,* this time rehearsed over the summer holidays. Another huge cast. Higher production values than on *Basil* and rehearsed for longer! By now I was keen to get back to London and to move the work on with professional actors. And I was desperate to make a film . . . Some very cinematic moments in this piece: a maths teacher sits in an empty classroom, as we hear an off-stage chorus sing 'All Things Bright and Beautiful'.

Bleak Moments

Open Space Theatre, London, 16 March 1970. Designed by Mike Leigh. With Anne Raitt (Sylvia), Sarah Stephenson (Hilda), Eric Allan (Peter), Joolia Cappleman (Pat), Mike Bradwell (Norman). As in the film, but with only the five central characters, played by the same cast. The action all takes place in Sylvia and Hilda's living room. In one act.

This was my most advanced piece to date, created intensively with a small, first-rate professional cast. No money from the Open Space – no wages, no production or design budget; all somehow funded from my own very empty pocket!

It was the first of my plays without any soliloquies, but of course it was all going on under the surface, suppressed, unspoken.

Having given me a late-night slot for nine performances, Charles Marowitz, the founder and artistic director of the Open Space Theatre, and his administrator, Thelma Holt, tried as hard as they could to sabotage the show – indeed, to cancel it. They watched a crude run-through of the first draft and paid no heed when I told them that what we would present to the public in less than a week would be polished and precise – which it was.

They were appalled. They weren't interested in the characters or their problems. In fact, they didn't get it. It wasn't arty enough for them. Yet Marowitz, an American, was a major player on the radical alternative London cultural scene in the 1950s, '60s and '70s. A critic and director, he had run actors' improvisation workshops around town for years and had written a reasonable treatise on acting, *The Method as Means* (1961). He had assisted Peter Brook

at the RSC, including during the Theatre of Cruelty season, which was based on the works of Antonin Artaud and which was a great influence on me, and he had directed loads of shows. To this day he remains at large in the States, where he continues as a critic, playwright and director.

Doubtless his negative reaction to *Bleak Moments* derived from his clear but simplistic and narrow notion of what experimental drama should be – or, more precisely, of what it should look like. You had to see all the wheels going round. Everything had to be transparent – self-conscious deconstruction, self-referential verbal tricks, affected abstraction, actors talking and behaving in an obvious, physical, 'experimental' way. Anything else was bourgeois, reactionary and philistine.

But in my humble opinion it was Marowitz who was the philistine: 'Tea, coffee, sherry,' he proclaimed, 'that is not what improvisation is all about. This piece has no intellectual basis or justification. It eschews all Artaudian principles of theatre.'

I couldn't bring myself to argue with such pretentious nonsense, preferring to put all my energy into fighting for the show not to be cancelled, for Marowitz and Holt were very keen indeed to stop it. But why? Why were they so desperate to cancel nine performances at 10.45 p.m. of an obscure experimental play by an unknown twenty-seven-year-old? Not because *Bleak Moments* failed to conform to Marowitz's definition of experimental, but because of an 89-minute American cult movie that vaguely did. This was *Flesh* (1968), directed by Paul Morrissey, produced by Andy Warhol and starring Joe Dallesandro as a male hustler, selling his body to support his heroin habit and that of his lesbian wife, and to pay for her lover's abortion.

Radically anti-classical in style and technique, this was the first film to feature both an erection and the word 'cunt'. When it was refused a certificate by the British Film Censor, Marowitz and Holt had screened it under club conditions at the Open Space, where it had enjoyed a mixed reception. However, while we were preparing *Bleak Moments*, thirty-two members of the Metropolitan Police raided the theatre and seized the print and the projector. They also interrogated the audience. Marowitz and Holt were fined £220, which was paid by Warhol!

The film censor, John Trevelyan, then intervened and, remark-

ably, defended the film. Questions were asked in the House of Commons, the case was dropped, there was massive coverage in the press, and within days the film was showing again at the Open Space, around the clock, with long queues all down Tottenham Court Road.

Yet *Bleak Moments* went on. On the first night there was a full house. One could have heard a pin drop for 75 minutes. You can get a clear idea of what the play was like by watching the film: charged, taut, tense, long silences, comic moments, lots of laughs, organised, very precise.

Marowitz had warned me that the critics would slaughter it. Several very definitely didn't, especially Benedict Nightingale in the *New Statesman*, who was very enthusiastic: he called it 'amusing, touching, unpretentious and good'. But *The Times*'s critic, Irving Wardle, whom I later realised Marowitz had encouraged to pan it, wrote the stupidest review ever, for which, to be fair to him, he has since apologised on many occasions. Michael Coveney, in his book, writes that Wardle 'mistakenly thought that the stuttering and stumbling was a consequence of Leigh's improvisational methods. Indeed, he mistakenly thought that the actors were making it up as they went along. He interpreted the halting atmosphere as one derived from actors' embarrassment.'

The cast was originally to have included Derrick O'Connor, a brilliant Londoner who long ago defected to Hollywood. He let me down, as did the late George Colouris, then about seventy, a veteran of dozens of British and Hollywood movies, notably *Citizen Kane,* in which he played Thatcher the lawyer. He had been in Orson Welles's Mercury Company and was wildly enthusiastic when I described what we were to do. He had always wanted to be part of this kind of experiment. He lasted four days of rehearsal. He hated it, and walked. He didn't trust me an inch.

Two afterthoughts: for the record, I have something of a soft spot for the Warhol/Morrissey films *Flesh, Trash* and *Heat,* although my original reaction to all of them was that they certainly helped to define for me what it wasn't all about.

And a factoid I find irresistible: it turned out that the film's distributor, Jimmy Vaughan, accurately judging the publicity value of a police raid, had got some mates to lodge an obscenity complaint at the local cop shop.

A Rancid Pong
Basement Theatre, Greek Street, London, 26 July 1971. Designed by Mike Leigh. With Joolia Cappleman (Marilyn), Reg Stewart (Arnold).
A grotty couple in a grotty double bed in a grotty room, with a large grotty potty, sporting a turd in piss. In one act.

Delightful. Horrible. Funny. Sad. Nothing much happened, yet it was all going on. A bit of light relief after we'd finished *Bleak Moments*, the film. Depressing light relief!

The Basement Theatre, formerly the folk club Les Cousins (referred to by Norman in *Bleak Moments*), ran lunchtime plays. The audience would eat their sandwiches as they sat on three sides of the action. I positioned the potty so that you couldn't miss it as you entered the auditorium.

The venue was next door to L'Escargot in Greek Street. It no longer exists. Nor does the famous Magic Shop in Tottenham Court Road, where I brought the plastic turd.

Wholesome Glory
Theatre Upstairs, Royal Court, London, 20 February 1973. Designed by Mike Leigh. With Alison Steadman (Candice-Marie), Roger Sloman (Keith), Geoffrey Hutchings (Dennis).
Keith and Candice-Marie at home in their flat. Keith's brother, Dennis, comes round on a Sunday afternoon. They berate him about eating meat and smoking and other vices; and they sing him their zoo song and make him join in. Then he leaves. They are very pleased with themselves. In two acts.

Whereas *Bleak Moments* opens out for the screen but keeps the same central action, and therefore maintains the same theme, with *Nuts in May* I took the dreaded couple out of their *Wholesome Glory* safety zone, where nothing threatened them, and threw them into an alien and dangerous environment.

This makes the film far more ambiguous and complex than the play. Of course, the main action of Act Two, the zoo-song sequence, had to be recycled in the film – it was too good to waste. Ray obviously replaces Dennis as Keith and Candice-Marie's victim.

The Jaws of Death
Traverse Theatre, Edinburgh, 4 September 1973. Designed by Mike Leigh. With Alison Steadman (Brenda), Richard Ireson (Hack), Adrian Shergold (Young Man).
Hack is a private detective with no cases. He sits in his office, procrastinating. From time to time he goes out on mystery missions. His secretary, Brenda, has nothing to do. She is permanently tired and dozes off frequently. A young guy wearing shades delivers a parcel. Nobody knows what it contains. In one act.

Performed at 1.20 a.m. for three weeks, this offering played to packed houses! We concocted it in Edinburgh specifically for this Festival slot. A comic – indeed, hilarious – play about nothing happening. It had *film noir* undertones but owed more to Samuel Beckett than to Raymond Chandler.

I put in the dozing-off gags because I thought the audience would be a-slumber at so late an hour. But there was too much loud mirth and jollity for anybody to manage forty winks.

Dick Whittington and His Cat
Theatre Upstairs, Royal Court, 26 December 1973. Designed by Diz Marsh. With Paul Copley (Dick Whittington), Philip Jackson (His Father/Stephen), Lavinia Bertram (His Mother/Alice), Tim Stern (The Cat), Joolia Cappleman (The Cat's Mother/Kim/Jackie), Peter Godfrey (Father Christmas), Roger Sloman (Mr Fitzwarren/Her Majesty's Constabulary/Motorist).
Dick is an innocent Yorkshire lad who makes model aeroplanes and wants to be a pilot. He has left school and is unemployed. His dad works down the pit. His mum grumbles. He hitches down to London to go to Heathrow to get a job as an airline pilot. He meets all kinds of people on his travels, including a spiv with a tail – the Cat – who sells wind-up mice on Oxford Street and who takes Dick home to his council flat in the East End. There, the Cat's Mother serves up Kit-e-Kat. Eventually, he goes home to his loving parents. In two acts.

A Christmas show, subverting one of the panto classics by telling a completely different story while still referring to the original elements, as well as keeping the title.

Heath and the Tories were in power, disastrously. That year,

we'd seen the miners' strike, the three-day week and petrol rationing. Unemployment was becoming an issue. I was up to my usual trick of viewing the gritty, real world through a comic, poetic prism; confronting the audience's expectations by juxtaposing different levels of reality. The cats, for example, were played as completely human cockneys, except that they had tails, they occasionally made mewing sounds that appeared merely to be part of the way they spoke and they ate cat food. And the character called Her Majesty's Constabulary was played as a policeman, complete with moustache, but was dressed as a WPC, the only example of cross-dressing in my oeuvre, essential here in this pantomime parody.

Father Christmas was the Chorus. He sang much of his narration, accompanying himself on a concertina. He occasionally joined in the action and he supervised the scene changes. This was the only time I've had a narrator. The piece was also the last of the soliloquy plays: Dick had some.

The play opened on Boxing Day 1973. It was far more complex and ambiguous than some people gave it credit for. A few critics were positive, and it played to packed houses until *Time Out* panned it viciously, whereupon business slumped and the whole thing was quickly forgotten.

Babies Grow Old
The Other Place, Stratford-upon-Avon, 27 August 1974; ICA, London, 4 February 1975. Designed by Judith Bland, lighting by Brian Harris. With Anne Dyson (Mrs Wenlock), Sheila Kelley (Elaine), Eric Allan (Geoff), Matthew Guinness (Charles), Sidney Livingstone (Barry).
Mrs Wenlock lives alone in Birmingham. A lower-middle-class woman in a small semi-detached house, she is very old and is riddled with rheumatoid arthritis. She has taken to sleeping downstairs on the fold-up sofa bed. Nobody knows this, including her pregnant daughter, Elaine, and her doctor son-in-law, Geoff.

Elaine and Geoff visit Mrs Wenlock. They live out of town. They have left their dog in the car because it is too energetic for Mrs Wenlock. So, having popped in to say hello, they go off to another part of town to park the beast on Geoff's parents.

While they're away, Mrs Wenlock's nephew, Barry, drops in. His

leg is in plaster and he's on crutches. He's a squaddie and has been injured on active duty in Northern Ireland.

When Elaine and Geoff return, they are accompanied by Charles, another doctor. They have run into him somewhere. Charles is posh. He was in practice some years ago with Geoff, locally. Elaine worked there as the receptionist.

Barry leaves. Charles stays for quite a while and gets drunk with Geoff. There is much talk about many things, including medical matters. Eventually, Charles goes home.

Mrs Wenlock goes up to bed, with great difficulty, and Elaine and Geoff stay the night. They sleep on the sofa bed, which they think hasn't been used for ages. As they lie in bed, Elaine says to Geoff, 'I hope this baby appreciates me. It'll have nothing to thank you for.'

In the middle of the night, Mrs Wenlock comes downstairs for a glass of water. Elaine wakes up, thinking she is seeing a ghost.

The next morning, Elaine and Geoff get up and fold away the bed. When they have finally left, Mrs Wenlock proceeds to open it again, but runs out of strength and will power. She slowly grinds to a halt, and the play ends. In two acts.

My first major play, mostly well reviewed. It was very popular at Stratford, and played to packed houses at the ICA the following year.

It had a ten-week rehearsal period and was the first stage play I had ever done for which everybody was paid proper wages and there was actually a production/design budget. All courtesy of Trevor Nunn and the late lamented Buzz Goodbody, the young female director who founded the Other Place and who was tragically to commit suicide the following year at the age of twenty-seven. The last time I saw her was at the first night of the ICA revival.

The Silent Majority
Bush Theatre, London, 24 October 1974. Designed by Mike Leigh. With Stephen Bill (Mr Clancy), Julie North (Mrs Clancy), Yvonne Gilan (Mrs Duffy).
A young couple have altercations with their landlady. In one act.

A sketch, really, put together in a week at short notice to replace

another piece, the identity and nature of which I can no more remember than the reason for its late departure. We shared the bill with *Hitting Town*, an early work by Stephen Poliakoff.

Abigail's Party

Hampstead Theatre, London, 18 April 1977 (revived 18 July 1977). Designed by Tanya McCallin, costumes by Lindy Hemming, lighting by Alan O'Toole. With Alison Steadman (Beverly), Tim Stern (Laurence), Janine Duvitski (Angela), John Salthouse (Tony), Thelma Whiteley (Susan). Harriet Reynolds played Susan in the revival.

What can I say? This was the Mother of All Breakthroughs. The rest is history.

Too Much of a Good Thing

BBC Radio 3, 1979 (broadcast July 1992). Produced by Liane Aukin, sound by Cedric Johnson and Julian Walther. With Lesley Manville (Pamela), Phil Davis (Graham), Eric Allan (Mr Payne).
An overweight working-class girl lives with her rat-catcher father. She works in an office and is preoccupied with food. She takes driving lessons and begins a relationship with the driving instructor. They have sex, and she loses her virginity, whereupon the instructor immediately ceases to be interested in her.

My only radio play. I had always wanted to do one: every time I made a film I would be very excited by the possibilities of sound and sound editing. I hate most radio drama, and I deeply mistrust the convention of the actors all standing round the studio microphone, holding their scripts.

For this one, we rehearsed for three weeks, doing my normal thing, and then recorded it all entirely on location with a brilliant BBC quadraphonic sound team. We did it just like a film. The actors wore costumes and used real props (no quirky boffins with coconut shells!), and they learned their lines. We rehearsed fully, action and words. As it was radio, the slim Lesley Manville could effortlessly play a fat girl.

The head of radio drama, Ronald Mason, loved it. So did all the staff drama directors and editors. But it wasn't broadcast for thirteen years. When it had first been commissioned, the controller of

Radio 3 was a very enlightened man called Stephen Hearst, who allocated what for a play was an unusually large sum of money, taken from a so-called Experimental Programme Fund. However, by the time we had made the play, Hearst had been replaced by a deeply conservative Scottish Presbyterian called Ian McIntyre. He hated it and refused to allow it to be broadcast, on the grounds that it was totally without literary merit and simply too banal for Radio 3.

This caused an uproar at the BBC. The entire drama department went into pitched battle in the play's defence; one staff director wrote an essay on the piece, comparing it (favourably) with Samuel Beckett. The story even got into the press.

But McIntyre was adamant. Interestingly, he never owned up to objecting to the sex scene, which had to include the important moment of climax and orgasm so that you could hear how instant was Graham's loss of interest.

Most people assumed that this moment was what really lay at the centre of his objections. Personally, I think he was just a philistine with an illiberal notion of high culture, entirely unsuited to the great innovative tradition of Radio 3. The mystery is why he was in the job at all.

Ecstasy

Hampstead Theatre, 29 September 1979. Designed by Alison Chitty, costumes by Lindy Hemming, lighting by Alan O'Toole. With Sheila Kelley (Jean), Ron Cook (Roy), Julie Walters (Dawn), Stephen Rea (Mick), Jim Broadbent (Len), Rachel Davies (Val).

Jean lives alone in a Kilburn bedsit. She works as a petrol-pump attendant. She is abused by men, such as Roy, a married decorator. He drops in on her for casual, loveless sex.

Her close friend is Dawn, with whom she grew up in Birmingham. Dawn is married to Mick, an Irish labourer. They have three little girls.

Roy pays an unscheduled visit just as Jean is preparing to go out on a Saturday night with Dawn and Mick. Dawn arrives to collect Jean, at which moment Val, Roy's wife, storms in and attacks him. Their fight results in the bed collapsing and the room being trashed. The warring couple leave.

Rummaging through the debris, the girls find Val's purse. Jean

decides to keep the money and spend it on their night out. They go off, chucking away the empty purse somewhere near by. Later that night, they return with Mick. Also with them is Len, a gentle guy whom they haven't seen for ages. Years ago, when they were all first in London, the four of them hung out together. Dawn and Jean shared a room; Mick and Len worked on building sites. Jean and Len were at Dawn and Mick's wedding.

Len, originally from Lincolnshire, has been working in Corby all this time. He has been very hurt by a woman. Now he wears spectacles. Mick ran into him in an Irish pub the other day and took him home. Dawn and Mick have conspired to tell neither Jean nor Len that they're going to reunite.

Once Mick and Len have fixed Jean's bed (by removing its remaining two legs), the four of them settle down to a long and riotous night of laughing, crying, talking, drinking, smoking, remembering, arguing, joking, dancing and, above all, singing.

Their repertoire covers a wide variety of songs, ranging from Jean's beautiful 'Danny Boy' to Dawn's hilarious 'Roll Me Over in the Clover' and Mick's robust rendering of an Irish republican classic.

Dawn and Mick eventually leave. To his surprise, Jean has asked Len to stay, if he wants. He does so. She cries and tells him how she now drinks and how she's had abortions. He cries too. She tells him she regrets not responding to him in the old days, when he loved her. She just wanted a good time.

They settle down for the night, Jean in the bed, Len in a chair. In two acts.

This is my favourite of these plays. Some people still think it's the best. It was my second show at Hampstead. I knew everybody would expect another *Abigail's Party*, so I did what I've often done: I dished up something completely different.

Goose-Pimples
Hampstead Theatre, 3 March 1981, transferred to Garrick Theatre, 29 April 1981. Designed by Caroline Beaver, lighting by Alan O'Toole. With Jim Broadbent (Vernon), Marion Bailey (Jackie), Paul Jesson (Irving), Jill Baker (Frankie), Antony Sher (Muhammad).

Jackie is a croupier in the West End of London. She lodges with Vernon, who has invited fellow car salesman Irving and his wife Frankie to supper at his flat. Vernon and Frankie are having an affair behind Irving's back. When Vernon opens the packet of steaks he is about to cook, he finds they have gone off, despite not being past the sell-by date. Furious, he takes his guests out to a local steakhouse.

Jackie comes home with Muhammad, whom she has picked up at her casino. Vernon has invited her to join him and his guests for a drink when she comes off duty.

She thinks Muhammad is an oil sheikh. He isn't. He's a simple guy from Jeddah, Saudi Arabia. He speaks no English and has no idea what's going on, except that he is quite convinced that he's in a brothel and that Jackie is a prostitute.

She is deeply offended by his sexual advances but is attracted by an enormous wodge of paper money he is carrying. The result of their total lack of communication is that, at the precise moment his £500 has been accidentally strewn all over the room, Vernon, Irving and Frankie return.

The night degenerates into chaos. Vernon and Irving bully Muhammad and fill him with booze. They all interrogate him. Irving makes lewd advances towards Jackie; Vernon is abusive to Frankie; Jackie tries to keep up the pretence that Muhammad is a millionaire; and Muhammad fails to read any aspect of the situation. He becomes more and more befuddled and confused. He gets drunker and drunker, and finally collapses on the floor.

Irving accuses Vernon and Frankie of 'having it off'; to which Vernon replies, 'Irving, I wouldn't stoop so low.'

Irving and Frankie leave. Vernon refuses to put Muhammad in a taxi, saying, 'Look at the size of him – I can't shift him down two flights of stairs.'

Kissing Jackie voraciously, Vernon persuades her to spend the night with him in his room, on the grounds that she'll be safer if Muhammad wakes up in the night. They retire to the bedroom, leaving the poor visitor from Jeddah snoring on the floor.

I call this an anti-farce. In farce, all confusion is finally sorted out, order is restored and everybody's happy. Here, it all gets worse and worse, until it's an utter disaster.

It is a play about greed, money, sex, lying, cynicism, lust, communication, materialism and, above all, racism. Muhammad is the good guy, a total victim.

It was immensely popular. After its initial run at Hampstead, it ran for six months in the West End. It was a sell-out at both venues. Nevertheless, it was grossly misunderstood by certain people, most of whom never actually saw it.

Some time before *Goose-Pimples*, a controversial documentary, *Death of a Princess*, about the stoning to death of a Saudi Arabian royal, had been shown on Independent Television, resulting in the Saudi government immediately cutting off diplomatic relations with the UK.

Just before we opened at Hampstead, Thatcher had gone to Riyadh to mend fences. Diplomatic relations were restored, and the two governments decided that King Khaled would make a state visit to London the following year.

During the course of his research for Muhammad, Tony Sher had spoken to all sorts of Saudis and Muslims, including at the Central Mosque in London, where they had been very helpful. But when the word got out that the play depicted a Muslim drinking and whoring, Dr Syed Azid Pasha, of the Union of Muslim Organisations of the UK and Eire, wrote and demanded that the offending parts of the play be cut.

This was, of course, a request that we could not possibly fulfil. Quite apart from the fact that it was not an attack on Islam, the play's concern was to show sympathetically a man being terrorised by racists.

But the issue escalated. In fact, it got somewhat out of control. Just before we transferred from Hampstead to the Garrick, the Saudi government joined in. They warned that if the British government didn't demand that the play be pulled, King Khaled would cancel his state visit and diplomatic relations would again cease.

We now found ourselves at the centre of a massive cause célèbre, a big media story. The press had a field day, I was on prime-time television and advance ticket sales at the Garrick soared.

Of course, we refused to withdraw the play, and as this is a democracy, there was no legal process by which the authorities could force us to do so.

Press cuttings from the Hampstead opening were sent by diplo-

matic bag to the British ambassador in Riyadh. The Foreign Office arranged to have armed men in the audience on the first night, and my poor actors were terrified. But on the day of the first performance, the Foreign Office returned their tickets, the armed men stayed away, and we went ahead and did the show, to great acclaim.

The play enjoyed a successful run. There were no incidents, and King Khaled went ahead with his state visit, which he doubtless enjoyed thoroughly.

Smelling a Rat

Hampstead Theatre, 6 December 1988. Designed by Eve Stewart, lighting by Kevin Sleep, sound by John Leonard. With Eric Allan (Rex), Timothy Spall (Vic), Bríd Brennan (Charmaine), Greg Cruttwell (Rock), Saskia Reeves (Melanie-Jane).

Rex Weasel owns a very successful pest-control company. He has gone to Lanzarote for Christmas with Mrs Weasel, but returns home unexpectedly early without her, late at night.

He unpacks his toilet bag and puts his golf clubs away. His enormous double bed is covered with Mrs Weasel's extensive collection of soft cuddly toys. He throws these on the floor and proceeds to go to bed.

Suddenly, he hears voices. He turns off the light, grabs an air gun from his bedside drawer and hides in one of the many built-in wardrobes in his sumptuous bedroom.

Vic Maggott works as a rodent operative for Rex's firm. He has been instructed by Rex's second-in-command to drop in at the flat over the Christmas period to make sure all's well. Accordingly, he has been given the key. He is with his wife, Charmaine. They are on their way home from a family party at her sister's place.

Vic and Charmaine are in good spirits. They explore the flat, roll around on the bed and are generally jolly and ribald. They chatter about this and that, and Vic philosophises a bit. He talks about Rex's wealth and greed, and is mildly rude about his aggressive behaviour towards his employees. He also reports that Mrs Weasel is said to be a 'slag'.

They discuss the fact that Vic has never told Rex, for whom he has worked for three years, that he has a criminal record. In his teens he was framed for something he didn't do.

Charmaine uses the en-suite loo. Vic hides in a wardrobe and jumps out and gives her a shock when she comes back into the bedroom. They are both highly amused. As their mirth subsides, they hear voices, so they hide in two other wardrobes.

Rex's son Rock arrives with a young lady called Melanie-Jane Beetles. She is garrulous, and he is on the whole monosyllabic. He doesn't say much, although from what he does say it becomes apparent that Rex has no time for him and has treated him extremely badly over a long period.

Rock is mainly concerned with getting Melanie-Jane into bed, but the more he tries to seduce her, the more talkative and frenetic she becomes, darting all over the room. Eventually, she starts opening and closing the wardrobes, one after the other. Charmaine's appears to be locked because she is holding it shut from the inside. But when Melanie-Jane opens Vic's wardrobe, there he is. At this, she becomes extremely fraught and locks herself in the bathroom. Vic and Charmaine emerge. They are very polite and not a little nervous.

Once they have explained everything to Rock, Melanie-Jane comes out of the bathroom, cautiously. Rock's main concern is that Vic shouldn't tell his father that he was here, and Vic promises him he won't say a word. With that resolved, Rock proceeds to see the Maggotts off the premises, while Melanie-Jane quietly slips back into the bedroom and sits on the bed to put her shoes on.

Wrongly thinking the coast is clear, and badly in need of the loo, Rex pops his head round the wardrobe door, holding the gun.

Instantly traumatised, Melanie-Jane now utterly flips her lid and rushes back into the bathroom, locking the door.

Rock, Vic and Charmaine run in, and are equally shocked and amazed to see Rex. End of Act One.

The second act is a long journey through a jungle of misunderstandings, accusations, threats, recriminations, violence, philosophising and general chaos, with some charming singing by Charmaine of 'Charmaine' thrown in.

Vic and Charmaine sail very close to the wind of Rex's wrath. But he does promise that a token of his appreciation will be found in Vic's wage packet at the end of the month. They eventually leave.

Rex, having bawled Rock out mercilessly throughout the act,

now repacks his overnight bag, throws £100 in cash on the bed and clears off, leaving Rock and Melanie-Jane to it. But Rock leaves, without taking the money, and the play ends as Melanie-Jane rushes out after him.

Although farcical, *Smelling a Rat* really isn't an anti-farce like *Goose-Pimples*, as the action doesn't simply disintegrate into chaos and disaster. Nor is it a farce. Actually, it's more of a play of morals, ambiguous though its morality may be.

It is, of course, about capitalism, fascism, power, love, parenting, having a good time and controlling other people. It is also an elaborate gag about animals, insects and humans. Its comic use of the wardrobe allows for pure slapstick, and our experiments with language, especially in my collaboration with Tim Spall in the creation of Maggott, are achievements of which I am extremely proud.

Greek Tragedy
Belvoir Street Theatre, Sydney, 13 June 1989; Edinburgh Festival, Church Hill Street Theatre, 13 August 1990; Theatre Royal, Stratford East, 3 September 1990. Designed by Stephen Curtis, costumes by Edie Kurzer, lighting by Mark Shelton. With Evdokia Katahanas (Kalliope), Stan Kouros (Alex), Nicholas Papademetriou (Perri), Christina Totos (Vicki), George Spartels (Larry), Zoë Carides (Toni). Adam Hatzimanolis played Alex in the Edinburgh/Stratford East revival.
Kalliope is from a small island in Greece. She is married to the aggressive Alex. Kalliope is quiet, gentle, homesick and pregnant. Alex is first-generation Australian, as is his successful cousin Larry, for whom Alex works as a machine cutter in his garment factory.

Kalliope spends her lonely days sitting at a sewing machine in her little house in Marrickville, Sydney. She is an outworker. From time to time, her consignments of piecework – the garments she sews – are delivered and collected by Perri, a Greek Cypriot. Unhappily married, he is a nice guy with a gentle sense of humour – a pleasant change for Kalliope from her surly husband. She looks forward to Perri's short visits.

One day, when Alex is working on the machine, Larry bawls

him out, momentarily distracting him, and Alex accidentally cuts off his thumb.

Coincidentally, Larry's vulgar wife, Vicki, finds herself very near Kalliope's house when her car breaks down, so she drops in on Kalliope to use her phone to call Larry, only to discover that Larry has taken Alex to the hospital.

Kalliope is fraught. She tries calling the hospital, but she gets no joy.

Eventually, Larry arrives with Alex, who has his arm in a sling. Larry has a row with his wife, and Alex is impatient with Kalliope.

Now Perri innocently shows up for his routine pick-up and drop-off, and, finally, Toni, Vicki's good-humoured younger sister, who is a Qantas flight attendant, visits unexpectedly. She is on her way to the airport to work a flight to Los Angeles.

Much family mayhem and chaos. Jumbo jets fly low overhead (we're very near Sydney airport).

Everybody leaves, and Alex beats Kalliope. In one act.

Some time in the mid-1980s, an official fund was set up in Canberra to bring artists to Australia to commemorate the 1988 Bicentenary, and I was approached by the radical Belvoir Street Theatre to come to Sydney to make a play. We agreed that such a piece obviously wouldn't be a celebration of the 'WASP' experience, and I went over in 1988 to cast half a dozen actors for a show to be created the following year.

I auditioned over three hundred actors. The theatre was keen to be seen to be giving everybody a chance. Geoffrey Rush was among the candidates. Actually, my assumption was that I would find six very talented and sophisticated indigenous Australian actors, with whom I would be able to explore the Aboriginal experience. This was a world of which I'd had a few tiny glimpses on my travels Down Under, three years earlier.

However, such a cast didn't exist at that time, although a brilliant Greek Australian cast did emerge. There is an enormous Greek community in Sydney, and an even bigger one in Melbourne. There was a huge Greek migration to Australia after World War Two, and for the most part these actors were their children or grandchildren. It seemed to make perfect sense to go for this group and to explore their world.

In fact, the play I arrived at was, of course, very much related to my own immigrant background, with its yearning for other places and the bilingual talk – much Greek was used in the play, just as my grandparents would drop in and out of Yiddish when I was a kid. Not to mention how very reminiscent Marrickville's rag trade was to me of Jewish north Manchester in the 1950s, added to which was the fact that I had been living in Greek Cypriot north London for fourteen years, with Greek Cypriot next-door neighbours, all of whose female family members took in sewing outwork. Shouted Greek and the low drone of sewing machines were sounds my two boys were growing up with.

These personal aspects aside, however, the play was very much about matters Hellenic – 'Greekness', as such. But it was also specifically a picture of Australia. 'Overseas' is a word you hear endlessly Down Under. The place is 17,000 kilometres away, at the other end of the planet, and it feels like it, even to native Australians. But to European immigrants who yearn to go home, or to those who wish to visit, the distance is painful.

The sense of yearning for one's roots and a sense of distance and travel pervade the piece. Planes continually fly low over the house; Kalliope plays tapes of mournful, nostalgic Greek songs; and Toni is bound for the distant shores of the USA. Finally, on another level, I had fun with the Greek-tragedy aspect of this tragicomedy: augury, fate, coincidence, inevitable consequences, mortal wounds, birth, death, recrimination, argument and accusation.

The play was successful, if controversial, in Sydney. It was brought to the UK the following year by Philip Hedley, the artistic director at the Theatre Royal, Stratford East, and Frank Dunlop, who ran the Edinburgh Festival.

It's a Great Big Shame!
Theatre Royal, Stratford East, 13 October 1993. Designed by Alison Chitty, lighting by Jon Linstrum, music by Katherine Aughton, research by Leonie Gombrich. With Kathy Burke (Nellie Buckett), Ruth Sheen (Fanny Clack), Michael Gunn (Eli Finch), Paul Trussell (Jim Short), Joe Tucker (Jack Skegg), Wendy Nottingham (Ada Ricketts), Gregor Truter (Sholto Babbington, Esq./Policeman), Katherine Aughton (Hon. Augusta Grabisham), Gary McDonald

(Amos Churchill/Barrington), Michele Austin (Joy), Clint Dyer (Randall), Marianne Jean-Baptiste (Faith).

1893. In the East End of London, Nellie Buckett, a poor waif, falls in love with a tall young brewer's drayman called Jim Short. But he marries a small woman called Ada Ricketts, who works in a hardware shop.

Once married, Ada bullies Jim, and finally he strangles her and chops her up. Not having seen him around for a while, Nellie goes to visit him at No. 13 Manby Street, Stratford East.

Through the letterbox, she asks him to come out. He says he can't because he 'has to clean the windows and the knives'. Then he lets her in. To her horror, he and the whole place are covered in blood and guts.

One hundred years later, in 1993, in exactly the same house, a small, weedy black guy called Randall is bullied by his very large black wife, Joy. She wants him to take out a 1930s fireplace to make more room. They are visited by Barrington, with whom Randall has just played football, and by Faith, Joy's patronising, snobbish, upwardly mobile sister. There is much talk about various things, including the possible presence in the house of a 'doppie', West Indian patois for a ghost.

But the main issue is the proposed removal of the fireplace – the 'ting' (thing). Barrington is a builder and is happy to see to it here and now, as he's otherwise booked up. But, unknown to Randall, Joy has arranged for her and Faith's dad to take a day off work to do it. Much conflict arises out of this and Randall's ability to go through life irritating everybody, especially his long-suffering wife; not to mention Faith's capacity to wind everybody up.

At the height of the row, Barrington nearly throttles Randall. After which everybody calms down, and Faith leaves.

It is now agreed that Barrington will sort out the fireplace, and the task begins of getting all the furniture and other effects out of the living room. But while Barrington is getting his tools and tackle from his car, Joy reaches the end of her tether with Randall and strangles him to death.

She hides his body quickly, and Barrington comes back. Telling him that Randall is 'calmin' down upstairs', she sets about getting the rest of the furniture out, with Barrington's help. Before tackling the 'ting', Barrington asks for a cup of tea.

At the dead of night, Joy can't sleep. She comes downstairs and sees the ghost of Ada Short.

This two-act musical play came out of several initially unrelated notions. Firstly, there was the Theatre Royal, Stratford East, itself, where two years earlier I had staged the revival of *Greek Tragedy*. Built in 1884, the theatre had just reached the end of a major restoration to its original glory when we opened the show.

Secondly, there were at this time two strong and important traditions at Stratford East: music hall and plays that reflected the fact that 40 per cent of the theatre's local community was Afro-Asian. The Theatre Royal had been a music hall at various times – Marie Lloyd certainly appeared there – and they still hosted a monthly music-hall night on Sundays. Successful black and Asian plays had included the musical *Five Guys Named Moe,* which transferred to the West End, *Black Tulips*, about black guys in the British armed forces, a show by The Posse, a talented gang of black actor/writers, and, just before our show, *Moti Roti.*

Next, I had become particularly interested in the great cockney comedian Gus Elen (1862–1940), most famous for the song 'If It Wasn't for the 'Ouses in Between'. I was especially taken with a piece of 1932 film of him singing 'It's a Great Big Shame!'. This had been shown by Jimmy Perry on his BBC TV music-hall and variety archive programme.

And finally, I wanted to explore the idea of diverse people occupying the same dwelling at different times, which has always fascinated me. And, since Stratford is now very much an area where black people live, it seemed to make sense to set a play in both the Victorian era and the present day, with events linked by one house.

I was also attracted by the possibilities of the juxtaposition of styles – a preoccupation that has cropped up regularly in this book. Here, Act One consisted of a fluid, episodic period piece, interspersed with songs, whereas Act Two was mostly a fourth-wall piece. Yet, paradoxically, Act One contained more naturalistic acting than Act Two.

Obviously, Gus Elen's song 'It's a Great Big Shame!' was the inspiration for the Act One story. The tune was by George LeBrunn, the words by Edgar Bateman, who also wrote 'The 'Ouses in Between'. Here they are:

414

I've lost my pal, 'e's the best in all the tahn,
But don't you fink 'im dead, becos 'e ain't;
But since 'e's wed 'e 'as 'ad ter knuckle dahn,
It's enuf ter wex the temper of a Saint!
'E's a brewer's drayman, wiv a leg-o-mutton fist,
An' as strong as a bullock or an 'orse;
Yet in 'er 'ands 'e's like a little kid.
Oh! I wish as I could get 'im a divorce.

(Chorus) *It's a great big shame, an' if she belong'd ter me,*
I'd let 'er know who's who.
Naggin' at a feller wot is six foot free,
And 'er not four foot two!
Oh! They 'adn't been married not a month nor more,
When underneath her fumb goes Jim.
Isn't it a pity as the likes ov 'er
Should put upon the likes ov 'im?

Now Jim was class – 'e could sing a decent song,
And at scrappin' 'e 'ad won some great renown;
It took two coppers for ter make 'im move along,
An' annuver six to 'old the feller dahn.
But today when I axes would 'e come an' 'ave some beer,
To the door-step on tip-toe 'e arrives;
'I daren't,' says 'e – 'Don't shout, 'cos she'll 'ear –
I've got ter clean the windows an' the knives.'

(Chorus)

On a Sunday morn, wiv a dozen pals or more,
'E'd play at pitch-and-toss along the Lea;
But now she bullies 'im a-scrubbin' o' the floor –
Such a change, well I never did see.
Wiv an apron on 'im, I twigged 'im on 'is knees
A rubbin' up the old 'arf-stone;
Wot wiv emptyin' the ashes and a-shellin' o' the peas,
I'm blowed if 'e can call 'isself 'is own.

(Chorus)

I dramatised and fleshed out the song's central relationship, in
the form of Jim and his shrewish bride. But I replaced Gus Elen's

elderly, cantankerous cockney male with Nellie Buckett, ungainly, unwanted and in love with Jim. Kathy Burke's brilliant character wore a version of Elen's cap and suit, and even carried his hammer, and the show began with her singing the whole song, imitating Elen's gestures, in a tiny proscenium that was an exact copy of the newly restored real one surrounding it.

Ada and Jim's courtship is mostly seen from Nellie's perspective, which of course involves a very free interpretation of the relationship between Jim and his 'pal', the song's narrator.

Apart from the newlyweds' home, the Act One action included scenes in the Cock & Bull pub, where Jim delivers beer; out by the River Lea, where Jim and pals (including Nellie) play the illegal pitch-and-toss; and the hardware shop where Ada works and where she and Jim meet when he comes in to buy a kettle. There was also an ambitious scene in a dray, complete with a horse.

One of the pub scenes consisted of an extended sing-song, in which five other Gus Elen numbers were performed by various characters: 'The 'Ouses in Between', "Arf a Pint of Ale', 'The Coster's Mansion', 'The Coster's Mother' and 'Catch 'Em Alive, Oh!' The music was ingeniously supervised by Katherine Freeman (then known as Katherine Aughton), who composed the original score and researched and collated the Gus Elen material. Her line-up in the pit was violin, trombone, euphonium and piano.

In another of the pub scenes, Gary McDonald, who also played Barrington in Act Two, supplied a beautifully performed old black drunken sailor, such as would be found in the merchant navy in the nineteenth century. This afforded me the opportunity to explore Victorian racial attitudes to negroes. I had at one stage intended the show to include caricature realisations of these attitudes, with all the black actors from Act Two appearing in jungle scenes full of missionaries being boiled in pots, etc. But I very properly abandoned this bizarre notion, partly because the show was too long anyway, but mostly because the one scene with the old black sailor said it all. But I return to this idea, albeit implicitly, in the oyster scene in *Topsy-Turvy*, not to mention certain echoes in *Goose-Pimples*.

This was, of course, the first time I had attempted to apply my methods to a period piece. I had no reason to suppose that it wouldn't work, and in the event it did. But I had realised we would

need a full-time researcher, which was a radical departure, and Leonie Gombrich did this brilliantly. Of course, what I was secretly doing was testing the possibility of a Victorian film, as I already had *Topsy-Turvy* in mind.

The show was brilliantly designed by Alison Chitty and was mostly well received, although some critics were stupid enough to insist that it was a double bill of two plays!

However, after a successful run, it was quickly forgotten by everybody, not least those responsible for the Olivier and *Evening Standard* Awards. And since I now entered my period of international movie success, not least at Cannes and at the Oscars, I decided once and for all that I could no longer be bothered with the theatre.

It was to be twelve years before I relented . . .

Two Thousand Years

Cottesloe auditorium of the National Theatre, London, 15 September 2005. Designed by Alison Chitty, lighting by Paul Pyant, music by Gary Yershon, sound by John Leonard, research by Yael Luttwak. With Caroline Gruber (Rachel), Allan Corduner (Danny), Ben Caplan (Josh), Adam Godley (Jonathan), Alexis Zegerman (Tammy), John Burgess (Dave), Nitzan Sharron (Tzachi), Samantha Spiro (Michelle).

Summer 2004. Josh is twenty-eight. He has a First-Class Honours degree in mathematics, but he doesn't work. He just reads. He still lives at home with his parents, Rachel and Danny, in a semi-detached Victorian house in Cricklewood, north-west London.

Danny is a dentist and a compulsive teller of Jewish jokes. Rachel has never worked, although she has a sociology degree. Josh's younger sister, Tammy, is a successful interpreter, specialising in Spanish. She shares a flat with a girlfriend and has just visited Venezuela for the first time since she was there during the 1997 earthquake.

Rachel's father, Dave, an East Ender, has retired from his removals business. He has emphysema and smokes heavily. An old socialist, he is highly critical of Blair and New Labour.

Dave is also an ex-kibbutznik: that is, he emigrated to Israel in 1950 and went to live on a kibbutz, where he met his wife, Naomi, a Liverpudlian. Disillusioned with the kibbutz way of life, they

returned to London when Rachel was a little girl. We don't see Naomi in the play. To begin with, we gather that she is unwell. Later, she dies.

Rachel's younger sister, Michelle, also known as 'Mash', is single, a successful corporate banker and estranged from the family. They haven't seen her for over a decade, and she is never in touch.

All three generations of this family have been at different times members of Habonim. This is a real, British, secular, socialist, Zionist, Jewish youth movement. It was founded in 1929 and is linked to several kibbutzim in Israel, including Dave's. '*Habonim*' is Hebrew for 'the builders'. The object of the movement was traditionally to persuade young Jews to go and be kibbutzniks, as Dave and Naomi did. Rachel and Danny met each other in the movement; Mash was a keen member in her day, as, later, was Tammy. Josh wasn't really interested.

In her teens, Mash had a boyfriend in the movement, Jonathan, but when she went to Leeds University, she dumped him. These days, he is a housing officer, happily married to a social worker. He drops in to see Rachel and Danny from time to time. He lives in the area and often brings them gifts of fruit and vegetables from his nearby allotment.

The play begins with just such a visit. He, Rachel and Danny reflect on Yasser Arafat and the Israelis, and ponder whether Ariel Sharon will pull out of Gaza next year. They reminisce, particularly about Mash, whom Rachel suddenly remembers is about to hit forty. Josh is uncommunicative.

Danny and Rachel go on holiday to Gozo. While they are away, Josh turns to Orthodox Judaism. He experiments with putting on phylacteries, covers his head, prays in Hebrew and stops eating bacon and ham.

On their return, his liberal, secular, atheist parents are horrified and bewildered by this strange turn of events. They discover that Josh has actually been visiting a rabbi.

Tammy returns from Venezuela. She is positive, upfront and outgoing. She is intrigued by her brother's religious turn. She, Danny and Rachel try to talk to Josh about it rationally, but he is defensive, argumentative and evasive.

Jump to ten months later, May 2005, a couple of days after the

general election in which Blair has been returned to power for the third time.

Dave comes round. He is furious with Blair and is both outraged and amused by Josh's religiousness, which has been kept from him till now and which Danny and Rachel have during the year learned to tolerate.

When Tammy shows up on the same afternoon, the talk is about politics, Jewishness, doubts about Zionism and much else. Again, everybody tries to talk to Josh, and again he is defensive.

Act Two takes place in September 2005. Naomi has died, and Dave is coping by himself, although Rachel is devoting much of her time to him.

Nobody has heard a word from Mash, and Dave in particular is deeply upset by this.

Tammy introduces the family to her boyfriend Tzachi, a pleasant Israeli philosophy graduate, whom she met on a trip to New York City. He grew up in a kibbutz and is surviving in London by working in a photocopier factory. The couple have just been on holiday together in Spain.

Dave arrives. There is more talk about Israel, Palestine and other matters; there are jokes, arguments, shouting and rows.

Then Mash shows up. She is defensive, neurotic, disingenuous, lonely, sad, insecure and ridiculous. And she is deeply bitter about her late mother. She has been away by herself to Africa to 'celebrate' her fortieth birthday. And she is complicated and inconsistent about how and when she found out about Naomi's death.

There is more arguing, bickering and high emotion. At one point, Mash insensitively suggests that Dave ought to have somebody looking after him. Rachel takes offence at this, as she has been doing precisely that. Mash observes that Rachel has nothing else to do with her life, and Rachel concedes that she has indeed achieved nothing: all she has to show for her years is a loving family.

Josh becomes angry with Mash and storms out, and eventually, at the climax of the ultimate family row, Tzachi wades in, Israeli commando-style, and calms them all down.

Somewhere along the line, Josh comes back into the room, having removed his skullcap.

Just after Tammy and Tzachi have left, Jonathan drops in with some vegetables. Mash finds seeing him again very difficult, espe-

cially when he announces that he and his wife are expecting a baby. At this, Mash suggests that when she returns from the loo, they should all have a drink to celebrate. But Rachel and Danny are adamant that she mustn't be allowed a single drop.

Jonathan leaves immediately. Dave gets Danny to run him home there and then, and Josh disappears into the garden. When Mash reappears, Rachel has nothing to say to her, so she takes a swig of their whisky and leaves in a huff.

A few evenings later, Danny and Josh are playing chess. Rachel reads out an item in the *Guardian* about Hurricane Katrina. Peace reigns.

When Laurence Olivier ran the National Theatre, I wrote to Ken Tynan and got no reply.

In 1976, I wrote to the newly appointed Peter Hall, whom I had assisted at Stratford-on-Avon. I was immediately invited to see him. He was complimentary about my work and enthusiastic about the prospect of my doing a piece for the National. But I never heard from him again.

When Richard Eyre took over, he made promises he didn't keep – at least, not for nine years! When I asked him after all that time why he had broken those promises, he replied that they had 'been made in bad faith'. The slot he now offered me would have been the very last show of his tenure. As it happened, I was busy with *Topsy-Turvy*, but I have to admit that I didn't find this invitation very inspiring.

Next came Trevor Nunn, whom I had also assisted at the RSC and for whom I had, of course, made *Babies Grow Old*. Just after he had taken the job at the National, I ran into him at the Telluride Film Festival in Colorado. He asked, 'Will you come and create a play at the National Theatre?' I replied, 'Yes, absolutely.' I never heard from him again.

Finally, Nick Hytner, even before he'd begun the job, took me out to lunch and invited me to come and do whatever I wanted. I was excited and delighted and honoured, and I accepted immediately.

Then he went back to the theatre and told people. Very impressed, they asked how on earth he'd managed to pull it off. 'Oh, it's simple,' he said. 'I asked him.'

Just after I'd accepted Nick's commission, I saw Kwami Kwei-Armah's excellent *Elmina's Kitchen* at the Cottesloe. I realised that now was the time to follow his lead, and that of many other Afro-Caribbean and Asian writers, and finally to come out, to do a personal piece hewn from the seam of my own specific ethnic, social and political background. The National Theatre had become a healthy forum for ideas and discussion, and now was the time to do what I'd been procrastinating about for years.

*

I only ever directed nine stage plays other than my own. Here they are:

The Caretaker by Harold Pinter
RADA Little Theatre, 1962. Designed by Mike Leigh. With Richard Kane (Davies), Roger Hammond (Aston), Terry Taplin (Mick).

Little Malcolm and His Struggle Against The Eunuchs by David Halliwell
Unity Theatre, London, 1965. Designed by Mike Leigh. With David Halliwell (Scrawdyke), Philip Martin (Wick), Michael Cadman (Ingham), Ron Cream (Nipple), Julian Burberry (Ann).

Endgame by Samuel Beckett
Midlands Arts Centre, 1966. Designed by Mike Leigh. With a teenage cast. Hamm was played by a young Joseph Seelig, founder and now director of the London International Mime Festival.

Julius Caesar by Shakespeare
The Assassination Scene. Toured schools in the Potteries with actors from the Victoria Theatre, Stoke-on-Trent, while we were performing *Twelfth Night*.

The Knack by Ann Jellicoe
RSC Theatregoround, 1967. Designed by Mike Leigh. With John Shrapnel (Tolen), Derrick O'Connor (Colin), Peter Geddis (Tom), Lynn Farleigh (Nancy).

Romeo & Juliet and *Measure for Measure* by Shakespeare
Webber Douglas Academy, 1968. With student casts, including
Sharon Duce as Juliet.

The Honest Whore by Thomas Dekker
East 15 Acting School, 1968. With a student cast.

The Life of Galileo by Bertolt Brecht
Bermuda Arts Festival, 1970. Designed by Mike Leigh. With a very
large local amateur cast. The only professional was the Bermuda-
born British actor Earl Cameron, who played Galileo.

This production was such an atrocious experience that I swore I
would never again direct anything other than my own material.
And with the exception of *A Sense of History* and a handful of
commercials, I haven't.

MISCELLANEOUS

Commercials:
Exchange & Mart (1989), Kleenex (1991), Macdonalds (1994),
Transport for London (2002), British Telecom (2003), Breast Can-
cer Care (2006).

Four miscellaneous pieces, developed with actors using my usual
methods:

A Mug's Game
BBC Schools Television, 1973. Produced by Andrée Molyneux.
With Gillian Joyce (Carol), Eric Allan (Martin), Keith Washington
(Steve).
A short, rather worthy study of the effects of gambling.

'Plays for Britain', Titles
Thames Television, 1976. Produced by Barry Hanson, music by
Carl Davis. With Tim Stern (Man), Theresa Watson (Woman).
A couple whinge about everything British. Cut to Union Jack.

Hanson promised me a slot if I did the titles. He broke his promise.

The Improvised Play
Created as part of *Arena: Mike Leigh Making Plays*, BBC TV, 1982. Produced by Alan Yentob, photography by Remi Adefarasin, sound by John Pritchard. With Alison Steadman (Miranda Bromley), David Threlfall (Mick Leeming), Sam Kelly (Merton Savoy).
Mick Leeming is a deeply pretentious young assistant theatre director, all talk and no talent. He devises an experimental drama of no merit, working with two unlikely repertory actors, Miranda, a humourless feminist, and Merton, an old-school theatrical queen.

This was my way of solving the problem of never allowing anybody to film my 'rehearsal process'. I did it myself, setting up this preposterous piece and directing us working on it as it evolved, shooting as we went along.

The names are interesting. Mick Leeming is obviously a subtle reference to guess who. Ms Bromley was so called because I'd had to shoot my *Exchange & Mart* commercial in Bromley, due to the fact that Leslie Grantham was appearing in panto there. (By the time we came to shoot, Grantham had been sacked by *Exchange & Mart* and replaced by Mark McGann!) And Mr Savoy anticipated *Topsy-Turvy*.

London Film Festival Trailer (1991)
Produced by Simon Channing Williams, photographed by Dick Pope, designed by Jim Clay, costumes by Lindy Hemming, make-up by Christine Blundell, music by Rachel Portman, graphics by Chris Allies. With a large cast, including Ewen Bremner, Jim Broadbent, Ken Campbell, Ron Cook, Greg Cruttwell, Phil Davis, Martin Duncan, Janine Duvitski, Gina McKee, Ruth Sheen, Megumi Shimanuki, Marlene Sidaway, Alison Steadman and Tim Stern.
Shown before every film at the 1991 Festival, and used for several editions subsequently, this was commissioned by the then LFF director, Sheila Whitaker.

Dick Pope and I had always wanted to make a film with a vertical frame. We still do. This was a chance to practise it. A series of single-shot scenes in black and white. All unrelated, lots of charac-

ters, caught moments. Then, from vertical to horizontal: wide screen, bright colours. All the same characters troop by, with Big Ben and the Houses of Parliament behind them. Then they're in a cinema, watching a movie. Dissolve to LFF graphics and logo.

Some loved it, others loathed it.

Finally, a mention is deserved for the tragic case of *Knock for Knock*. This thirty-minute studio play was scurrilously wiped by a fatuous BBC committee whose job it was to decide what programmes were worthless enough to scrap – all in the interest of saving storage space! Thus, to my knowledge, no copies exist at all of this very funny, unique and popular play.

Time Out said it was 'the funniest thing on the box for months – and certainly the funniest thing on six legs anywhere. Sam Kelly gives the performance of the decade. So does Anthony O'Donnell. Bliss to be daft.'

Knock for Knock
BBC TV 'Second City Firsts', 1976. Produced by Tara Prem, designed by Myles Lang. With Sam Kelly (Mr Bowes), Anthony O'Donnell (Mr Purvis), Meryl Hampton (Marilyn).
Mr Purvis has been done for driving while over the limit on his stag night. He desperately needs car insurance, so he spends a terrifying half-hour with the deranged insurance broker Mr Bowes, to no avail.

Index

Figures in italics indicate captions.

$8^{1}/_{2}$, 13–14
1984, 232
À bout de souffle, 12
Abney Park cemetery, Stoke Newington, London, 42
Abortion Act (1968), 342, 343
About a Boy, 135
Academy cinema, Sydney, 158
ACTT (Association of Cinematograph, Television and Allied Technicians), 51
additional dialogue recording (ADR), 274
Adefarasin, Remi, 35, 135, 140, 151, 177
Adshead, Kay, 100, *105*
Aherne, Caroline, x
Aldermaston march (1960), 46
Aldwych Theatre, London, 15
Alexandra Palace, north London, 309
Algonquin Hotel, New York, 271
Allan, Eric, 43, 45, 55, 62, 97–8
Allen, Woody, 9, 247, 328, 349
Almodóvar, Pedro, 259
American Graffiti, 261
Amos, Emma, 41, 42
Anderson, Lindsay, 13
Anderson, Sarah Pia, *167*
Angelika Film Center, Greenwich Village, New York, 281
Annie Hall, 9
Antonioni, Michelangelo, 14–15, 48
Artaud, Antonin, 15
Arts Theatre, London, 15
Association of Cinematograph, Television and Allied Technicians (ACTT), 51
Atkinson, Dorothy, 290, 297
Atonement, 368
Auf Wiedersehen, Pet, 328
Augustus Carp, Esq., by Himself (Bashford), 221
Aukin, David, 113, 124, 221, 279
Austin, Michele, 251, 254, 262
Australia, 184, 197, 219
Autumn Productions, 50
Aviator, The, 370

Baby of Mâcon, The, 327
Baddiel, David, 6
BAFTAs, 370
Bailey, Marion, 155, 162, *165*, 317, 327–8
Baily, Leslie: *The Gilbert and Sullivan Book*, 294
Baker, Hylda, 364
Bamber, David, 190
Bapty, 176
Barber, Frances, 147
Barker, Richard, 289
Barker, Tim, 146, *146*, 152
Baron Cohen, Sacha, 6
Barrington, Rutland, 290
Bartók, Béla, 16
Bateman, H. M., 5
Batman, 14
BBC, xix, 47, 135, 159, 229–30, 240, 337
 Abigail's Party, 110, *111*, 149–50
 and *A Sense of History*, 220, 221, 222, 279
 Arena special on ML's work, 84

cinematographers, 160–61
and expenses, 74
Maida Vale, 126
a main outlet for films, 75
ML fails to get on directors' training
 course, 47, 65
ML on making BBC films, 69
ML's last film for the BBC, 170–73,
 175, 178, 182
Pebble Mill, 38, 75, 76, 97
'Play for Today' films, xiii, 38, 47,
 66, 67, 68, 74, 90, 112, 137, 144,
 163, 174, 257
proposed Thin Man film, 278–9
ratings, 67
schools television, 78
'Second City Firsts', 75
The Kiss of Death aired, xvii, 102
Wednesday Plays, 47, 50
wipes *Knock for Knock*, x
writers' complaints about *Hard
 Labour*, 70–71
BBC Birmingham, 96–7
BBC Club, 136
BBC Radio 3, 120, 143
BBC1, 67, 83
BBC2, 113
 Late Review, 119
Beatles, 16, 46
Beckett, Linda, 64
Beckett, Samuel, xiii, 16, 21, 48, 326
 Endgame, 15
Before the Rain, 286–7
Bellow, Saul, 16
Benson, Graham, 159
Benton, Mark, 277, 283, 286
Beresford, Bruce, 51
Bergman, Ingmar, 12
Berkoff, Steven, 239
Berlin Film Festival, 218, 376
Bermuda Arts Festival, 51
Berrington, Elizabeth, 343
Bertram, Lavinia, 125, 290
BFI (British Film Institute), 51, 297
 Archive, 312
 Imax cinema, 194
Bill, Stephen, 88, 222
Billy Liar (Waterhouse), 16
Billy Trilogies, The (TV series), 174
Biographic Films, Dean Street, Lon-
 don, 18, 19
Biskind, Peter: *Down and Dirty Pic-
 tures*, 257–8
Blain, Janey (ML's great-aunt), 139, 140

Blain, Sid (ML's great-uncle), 139
Blair, Les, 50–51, 207
bleach bypass, 232
Blethyn, Brenda, 25, 41, 42, 132, 135,
 142, 250, 254, 262, 268, 270
Blow-Up, 15
Blundell, Christine, 232, 259, 312
Bond, Jessie, 290, 297
Bosnia-Herzogovina, 287
boulevard plays, 124
Boulting Brothers, 14
Bow Street Magistrates' Court and
 Police Station, London, 360
Boyd, William: *Good and Bad at
 Games*, 153
Bradwell, Mike, 45, 55, 60
Brady, Moya, 209
Braham, Leonora, 290, 291, 297, 307,
 313
Branagh, Kenneth, 174
Brecht, Bertolt, 16
 The Caucasian Chalk Circle, 167
Bremner, Ewen, 225, 246
Brennan, Bríd, 169, 174, 175, 176, 180
British Film Institute *see* BFI
British Museum, London, 16, 292
British Screen, 208, 222–3
Broadbent, Jim, 205, 208, 209, 210,
 212, 212, 220, 221, 222, 288,
 288, 295, 304, 305, 315, 341,
 350, 363
Brontë, Emily: *Wuthering Heights*,
 278, 281, 284
Brook, Peter, xiii, 15, 73, 327
Brunning, Lorraine, 146
Bullets over Broadway, 9
Buñuel, Luis, 7, 12
Buscemi, Steve, 333
Bush, George W., 343
Byers, Kate, 277

Café Royal, Regent Street, London,
 171
Cagney, Jimmy, 14
Calder, Alexander, 16
Camberwell School of Art, London, 3,
 17, 22
Canal Plus, 321
Cannes Film Festival, 223, 228, 254,
 255, 258, 259, 261, 262, 263,
 279, 298, 368–9
Canterbury, 135, 136–7, 141, 151
Cappleman, Joolia, 36, 45, 55, 125,
 131

Carey, Richenda, 125
Carlton-Browne of the F.O., 14
Carnarvon, Lord, 222
Carrick, Anthony, 82
Carroll, Lewis, 292
Carry On films, 14, 69
Cartlidge, Katrin, xx, 224, 229, 230, 234, 239–40, 248, 248, 277, 280, 281, 283, 286–7, 312
Cartwright, Jim, 240
Casey, David, 83
Casino Royale, 259
Cassandra's Dream, 328
Cassavetes, John, 13
Catcher in the Rye, The, 61, 322
Cathy Come Home (television play), 47
Central School of Art and Design, London, 17
Central Television, 127, 161
Cerne Abbas, Dorset, 96
Chamberlain, Chris, 22
Chambers, Rosie, 302
Chandler, Simon, 125, 130
Channel 4, xi, 113, 138, 159, 171, 184, 207, 208, 221, 222–3, 279
Channing Williams, Simon, 257, 259
 and *Grown-Ups*, 135–8
 proves his organisational genius, 136–7
 and *Naked*, 40
 and film names, 67
 co-producer of *The Short and Curlies* and *High Hopes*, 207
 and caterers for *Naked*, 249
 and October Films, 258
 and George Faber, 278–9
 and *Topsy-Turvy*, 309, 310
 and *Vera Drake*, 367, 369
Charlton, Bobby, 8
Charnley, Diana, 161, 184
Chekhov, Anton, 123
 The Cherry Orchard, 15
Chen Kaige, 298
Chicago International Film Festival, 54
Chitty, Alison, 222, 232–3, 236
Chopin, Fryderyck François, 60
Churchill, Caryl, 112
Churchill, Sir Winston, 173
Ciby 2000, 262–3, 264
Citizen Kane, 14, 55
Clair, René, 12
Clarins Group, xv
Clark, Jim, 13, 321, 351, 374, 375

Clarke, Alan, 161, 240
Clay, Jim, 104–5
Clayton, Jack, 13
Clonard monastery, Belfast, 174
CND (Campaign for Nuclear Disarmament), 46
Coen, Ethan, 369
Coker, Helen, 317, 328, 355, 361
commercials, 85–7
Connaughton, Shane, 169, 176, 181
Conservative Party, 194
Cook, Ron, 252, 262, 288
Coppola, Francis Ford, 298
Corden, James, xvii, 317, 327, 332
Corduner, Allan, 140, 288, 288, 304–5, 306, 339, 349
Coronation Street, 80
Corrie Hotel, Swanage, 97
Cotton, Elizabeth, 60
Coulouris, George, 55–6
Coveney, Michael: *The World According to Mike Leigh*, 41, 118, 209, 227
Cowan, Elliot, 374
Coyle, David, 178
Craney, Heather, 338, 339, 349
Cranham, Kenneth, 241
Crimes and Misdemeanors, 9
Crompton, Ben, 317
Cruttwell, Greg, 225, 231, 234, 248
Cure, The, 277, 280
Curran, Angela, 100, 105

Daniels, Phil, 155, 161, 165
David, Eleanor, 289, 307
David, Elizabeth, 173
Davies, Rachel, 77, 83
Davis, Carl, 105, 107–8, 148, 167, 182, 222, 305
Davis, Julia, x
Davis, Miles, 16
Davis, Phil, xvi–xvii, 125, 129, 131, 132, 132, 189, 192, 200, 203, 246–7, 338, 338, 347, 348, 349, 352, 368
de Hadeln, Moritz, 218
De La Salle Brothers, 170
De Niro, Robert, 208
De Sica, Vittorio, 10
Depression, 61
Deserto Rosso, Il, 14–15
Diana, Princess, 236
Diary of a Nobody, The (Grossmith), 221

Dickens, Charles, 292
Dickson, Andrew, 167, 237, 367
Diplock trials, 112
Disney, 263
Doherty, Kate, 315
Doré, Edna, 189, 192, 198, 198, 203
Dougherty, Mervyn, 176
D'Oyly Carte, Richard, 162, 288, 289–90
D'Oyly Carte, Rupert, 302–3
D'Oyly Carte Opera Company, 291, 292, 295
Drama Amongst Puppets (drama cartoon), 124
du Maurier, George: 'Things One Would Rather Have Left Unsaid' series, 293
Dublin, 174
Duncan, Lindsay, 132, 133, 135, 136, 141
Durran, Jacqueline, 167, 325, 368, 371
Duvitski, Janine, 109, 120, 120, 133
Dylan, Bob, 16, 60

Ealing comedies, 14, 127
East, Irene, 73–4
East 15 Acting School, Loughton, Essex, xiii, 20, 21, 53, 55
East of Eden, 322
Eastwood, Clint, 370
Ebert, Roger, 54, 58
Eisenstein, Sergei, 10, 12
Elizabeth, 135
Elliott, Su, 147
Emmett, Rowland, 60
Eng, Ronald, 56
English, John, 18
English Patient, The, 254
Equity, 51, 68, 144
Evans, Maurice, 294
Eyre, Richard, 167

Faber, George, 278, 279
Faithful Companions of Jesus Sisters, 170
Feinstein, Howard, 271
Feliciano, José, 111, 112, 150
Fellini, Federico, 12, 14, 314
Ferris, Pam, 155, 162
Feuillade, Louis, 14
Field Day Company, 172, 174
Finch, Peter, 294
Fine Line, 344

Finney, Albert, 3, 15–16, 51, 52
First World War, 139
Fisher King, The, 195
Fitzgerald, Scott, 16
Fitzroy Tavern, Charlotte Street, London, 24
Ford, John, 14
Forman, Milos, 70
Formby, George, 80
Fort, Matthew, 217
Forum hotel, Belfast, 172
Fougasse (Cyril Bird), 32
Francis, Karl, 158
Franklin, Vincent, 290
Frears, Stephen, 51
Free Trade Hall, Manchester, 46
Freedland, Jonathan, 6
'Freight Train' (song), 60
Frémaux, Thierry, 368–9
Frenzy, 53
Fugard, Athol: *Boesman and Lena*, 172

Gance, Abel, 182
Garland, Alison, 327
Garnett, Tony, 47, 50, 65–9, 73, 74
Gaunt, Alan, 83
Gayner, Dr John, 262
Gdansk, Poland, 193
Germany, 298–9
Gershwin brothers, 298
Gervais, Ricky, x
Gielgud, Sir John, 15
Gilbert, Florence, 290
Gilbert, Lucy (Kitty), 289, 290, 291, 307–8, 314
Gilbert, Maude, 290
Gilbert, Sir W. S., 101, 222, 288–90, 291, 299, 302, 303, 308, 310, 311, 314, 315
 The Savoy Operas, 302
 see also Gilbert and Sullivan
Gilbert and Sullivan, 291, 292, 294–8, 300, 304–5, 314, 315
 The Mikado, 290–91, 296, 302–3, 308, 310, 313–14
 The Pirates of Penzance, 298, 299, 313
 Princess Ida, 288, 289–90, 296
 The Sorcerer, 290, 295, 296
 see also Gilbert, Sir W. S.; Sullivan, Sir Arthur
Gilliam, Terry, 195
Ginsberg, Allen, 16

Gloria, 13
Glynn, Victor, 207
Godard, Jean-Luc, 13
Godfrey, Bob, 18
Gold, Jack, 84
Gold, Nina, 304, 327, 349
Golden Hugo award, 54
Golden Leopard award, 54
Golden Lion award, 369
Gong Li, 298
Gordon, General, 290, 301
Gorki, Maxim: *Lower Depths*, 15
Granada Television, 37, 75, 106, 241
Greenaway, Peter, 327
Grido, Il, 14
Griffiths, Richard, 83
Griffiths, Trevor, 81
Grindley, David, 112
Grossmith, George, 290, 307
Grosvenor Square anti-Vietnam War demonstration (1968), 46
Grotowski, Jerzy, 15
Guardian newspaper, 53, 236, 300, 345
Guardian Weekend magazine, 217
Guinness, 85
Gumshoe, 51

Habonim Dror Zionist youth movement, 6, 7, 46
Hall, Sir Peter, 15
Hallé, Charles, 294
Hallé Orchestra, 6, 291, 294
Halliwell, David, 18, 207, 315
Hamilton, Paula, 169, *180*
Hampstead Theatre, London, 27, 112, 113, 119, 120, 124, 127, 167
Hannah and her Sisters, 9
Hardy, Oliver, 10, 294-5
Hare, David, 107
Hart, Romaine, 257
Harty, Russell, 125
Harvey, Laurence, 13
Hatton, Maurice, 138-9
Hawkins, Sally, xx, 317, 328, 339, 349, 371, 373-8
Heery, Margaret, 82-3
Hemingway, Polly, 64
Hemming, Lindy, 119, 166-7, 215, 232, 312, 325, 368
'hemp theatre', 309
Henderson, Shirley, 290, 307, 313-14
Henry, Lenny, 208, 234, 311
Henson, Nicky, 339, 349

Hewitt, James, 236
Hewitt, John, 169
Highgate Cemetery, London, 93, 190, 193, 199, 204
Hill, Bernard, 64
Hitchcock, Alfred, 53
Hoffman, Dustin, 208
Holdich, Charlotte (ML's partner), 287
Honky Tonk Freeway, 351
Hope and Glory (television series), 311
Hopper, Edward, 143, 270
Hornchurch Rep, 116
Hornsey Central Hospital, Haringey, London, 354, 357-9, 367
Horrocks, Jane, 205, 209, 210, 214, 216, 349
Horrocks, Tim, 48-9
Hoskins, Bob, 208
House of Commons, London, 172, 178
Houtman, Coral, 260
Hunter, Kathryn, 318, 327
Husbands, 13
Hutchings, Geoffrey, 89

Ibsen, Henrik, 302
ILEA (Inner London Education Authority), 234
I'm All Right, Jack, 14
Imperial College, London, 299
Imperial War Museum, London, 32, 198, 356, 357
In Loving Memory, 51
Innocents, The, 13
Institut Français, London, 298
Institute of Directors, Pall Mall, London, 311
Ireson, Richard, 82
Iris, 297
Irish potato famine, 300
Isaacs, Jeremy, 159
Israel
 ML's stay in kibbutzim, 6-7
 ML attends the Jerusalem Film Festival, 219
It's a Mad, Mad, Mad, Mad World, 85
ITV, 113

Jackson, Philip, 190
Jacob, Gilles, 369
James, Geraldine, 126
Janáček, Leoš, 107
Japan, 247, 273, 298
Jarman, Derek, 334

Jaynes, Francesca, 312, 316
Jean-Baptiste, Marianne, 41–2, 248–9,
 250, 254, 264, 265, 270, 272,
 273, 280
Jennings, Humphrey, 203
Jerusalem, 7
Jerusalem Film Festival, 219
Jesson, Paul, 150, 317, 327, 363
Jewish Chronicle newspaper, 5
Jews for Justice for Palestinians, 8
Jones, Morgan, 153
Jones, Tom, 109, 112, 150
Jordan, Neil, 160
Jules et Jim, 12, 60

Kanal, 7
Kane, Richard, 125, 130, 131
Kanga, Skaila, 237
Keaton, Buster, 14
Keegan, John, 179
Kelley, Sheila, 43, 88, 147, 150, 167
Kelly, Alex, 327, 338, *338*
Kelly, Sam, 126, 132, 133, 138, 140,
 289, 318
Kensington & Chelsea Conservative
 Association, 128
Kerouac, Jack, 16
Kershaw, Clifford, 64, 71, 93, 100,
 106, 107
Kidman, Nicole, 258
Killing Fields, The, 351, 374
Killing of a Chinese Bookie, The, 13
Kingsley, Ben, 64, 72, 73
Kinnock, Neil, 228
Klee, Paul, 16
Kleenex, 86, 87
Kodak Super-16mm stock, 350
Krakow, 193–4
Kray twins (Ronnie and Reggie), 360
Kurosawa, Akira, 12
Kusturica, Emir, 369
Kwei-Armah, Kwame: *Elmina's
 Kitchen*, 8

LA Confidential, 259
Labour Party, 158, 194
Lady Chatterley's Lover (D. H.
 Lawrence), 337
Lassally, Walter, 13
Last Tango in Paris, 215
Last Year in Marienbad, 14
Lauder, Harry, 84
Laudyn, Stefan, 194
Laughterhouse, 167

Laurel, Stan, 10, 294–5
Lawson, Charles, 169, 176
Le Touzel, Sylvestra, 183, 185, *185*, 371
Lear, Edward, 292
Lee, Neil, 311, 324
Leigh, Dr Alfred Abraham (ML's
 father), 14, 61
 war service, 1
 and ML's RADA scholarship, 3
 relationship with ML, 3–4
 medical career, 4, 5, 65, 68, 341–2
 personality, 4
 attitude to art, 4, 5
 and ML's marriage, 9
 love of Gilbert and Sullivan, 294
 premature death (1985), 4, 184,
 196, 197–8
Leigh, Leo (ML's younger son), 86,
 183, 218, 261, 323
 birth (1981), 151
 Jewish background, 8, 9
Leigh, Mike, *viii*, 35, 330
 birth (20 February 1943) in Salford,
 Lancashire, 1
 childhood, 1–2, 65, 68, 70, 151,
 170, 291, 292–5, 341, 342, 348
 education, 2, 3, 4, 12, 16, 60, 170,
 292
 artwork, 4, 5
 writes and directs his first play, 3
 grandfather's death, 1, 11, 102
 in the Habonim youth movement,
 6–7, 46
 relationship with his father, 3–4
 Jewish influence, 5, 6–9, 138–9, 291
 atheism, 7, 141
 and early television, 9–10
 film and theatre influences, 10–16,
 21, 48
 London Film School, 17, 49, 52, 351
 RADA, 3, 7, 12, 13, 15–18, 46, 51
 foundation-year art course at Cam-
 berwell, 3, 17, 22
 first directs (*The Caretaker* at
 RADA), 18, 131, 349
 world view, 46, 48–9, 193
 fails to get on BBC directors' train-
 ing course, 47, 65
 forms Autumn Productions, 50
 and East 15 Acting School, xiii, 20,
 21, 53, 55, 293
 working titles, 66–7
 drama lecturer in Salford (1968–9),
 170

meets Alison Steadman, xiii, 72, 293
marriage to Alison Steadman
(1973–2001), xiii, xiv, 9, 211, 323
first major stage play (*Babies Grow
Old*), 15
on studio plays, 78–9
commercials, 85–7
and corpsing, 106–7, 144, 222, 295
on budgets, 96, 258, 260–61, 324,
350, 367
forms Thin Man Films, 138
on extras, 143–5, 211–12
a political film-maker, 157–8
shoots first film with Roger Pratt,
160–61
in Northern Ireland, 172–7
enforced break (1986), 183, 208
teaches and travels abroad, 184
father's death, 184, 196, 197–8
in Poland (1989), 193–4
first proper feature film (*High
Hopes*), 195
first Thin Man film, 207, 213
directs *A Sense of History*, 220–23
on casting etiquette, 234
rule-breaking, 235
friendship with Katrin Cartlidge,
239, 280, 286
on film titles and posters, 247–8
on catering, 249
on Hollywood, 257–60, 261
on use of flashback, 282
love of reading, 292–3
love of cars, 326
on swearing in his films, 337
awards, 370
love of film-making, 379
acting
off-screen characters, 26
Two Left Feet, 17, 51–2, 144
West, *11*, 52
films
abandoned film (1986), 183, 191,
207, 208, 240
Abigail's Party, x, xiv–xx, 8, 50,
59, 99, 109–13, *114*, 120, 201,
227, 254, 266, 332
All or Nothing, ix, xvii, xix, xx,
161, 203, 210, 254, 261,
317–37, *330*, *333*, *336*, 349,
368, 375
Bleak Moments, x, 11, 12, 13, 21,
35–6, 45–63, 57, 62, 65, 68–9,
73, 79, 89, 90, 98, 101, 103,

131, 134, 151, 156, 160, 184,
188, 193, 195, 196, 207, 227,
228, 247, 322, 323, 335
Career Girls, xx, 79, 226, 239,
247, 258, 262, 277–87, *283*,
284, 296, 304, 322, 327, 334,
378
'The Five-Minute Films', 82–5,
184
Four Days in July, 67, 70, 129,
157, 169–82, *180*, 183, 213,
234
Grown-Ups, xii, 36, 60, 67, 79,
98, 128, 132–45, *148*, 151,
196, 275, 324, 332
Happy-Go-Lucky ('Untitled '06'),
xx, 33, *185*, 256, 260, 305,
328, 371–9
Hard Labour, xiii, xvi, 8, 50,
64–76, 71, 79, 90–91, 98, 99,
101, 106, 143, 149, 170, 182,
196, 323
High Hopes, 24, 67, 93, 138, 157,
158, 161, 163–4, 189–204,
197, *198*, *200*, 207, 213, 214,
228, 246, 257, 265, 266, 282,
332
Home Sweet Home, xvii, 36, 67,
95, 108, 146–54, *146*, 156,
167, 186, 202, 210, 324, 325
The Kiss of Death, xvii, 60, 67,
93, 98, 100–108, *105*, 144,
151, 159, 322
Life Is Sweet ('Untitled '90'), xviii,
34, 67, 98, 159, 191, 192, 195,
205–19, 210, 212, 214, 216,
226, 233, 258, 322
Meantime, xi, 36, 38, 40, 59, 67,
69, 127, 138, 155–68, *164*,
165, 193, 195, 213, 266, 322,
337, 348, 349, 362
A Mug's Game, 78
Naked ('Untitled '92'), xx, 23, 36,
38–41, 63, 72, 90, 124, 128,
129, 162, 163, 166, 179, 186,
188, 192, 197, 209, 213, 218,
223, 224–49, 229, 231, 235,
238, 248, 258, 261, 280, 281,
282, 285, 287, 307, 322, 348,
361, 364, 368, 375
Nuts in May, ix, x, xiii–xiv, xvi,
13, 38, 49, 50, 58, 67, 75, 76,
79, 88–99, *95*, 101, 121, 158,
159, 222, 227, 286, 323, 334

Secrets & Lies, xvii, xviii, xix, 15,
25, 26, 37, 41–2, 55, 80, 93,
95, 98–9, 102, 124, 143, 192,
210, 211, 212, 227, 233, 247,
249, 250–58, 261–78, 263,
264, 268, 270, 278, 279, 281,
282, 300, 322, 323, 325, 326,
345, 346, 356, 364, 375
A Sense of History, 220–23, 295
The Short and Curlies, 183–8,
185, 207, 209
Topsy-Turvy, 37, 41, 79, 85, 124,
128, 158, 161, 166, 186, 198,
210, 226, 255, 258, 261, 272,
280, 281, 287, 288–316, 288,
303, 308, 315, 323, 325, 334,
341, 349, 366, 367, 368, 370,
375
'Untitled '06' see Happy-Go-
Lucky
Vera Drake, x, xv–xvi, xix–xx, 15,
23–4, 32–3, 43, 59, 61, 87,
128, 129, 140, 162, 198, 203,
218, 244, 260, 265, 296, 305,
307, 321, 322, 325–8, 338–70,
338, 352, 354, 355, 375, 376,
378
Who's Who, xvi, 67, 98, 105, 112,
113, 125–31, 134, 140, 151,
191, 347
plays
Abigail's Party, xiv, 50, 110–24,
126, 127, 167
Babies Grow Old, 15, 43, 75, 78,
113
Bleak Moments, 49, 50, 51
The Box Play, 19
Dick Whittington and His Cat, 78
Ecstasy, 27, 120, 124, 167, 171,
210
Epilogue, 71–2
Goose-Pimples, 150, 162, 210, 305
Individual Fruit Pies, xiii, 20, 55
It's a Great Big Shame!, 87, 186,
203, 249, 254, 295–6, 328
The Jaws of Death, 78
Knock for Knock, x, 67, 159
The Life of Galileo, 51
Little Malcolm and his Struggle
Against the Eunuchs, 17–18,
21, 207
Muddled Magic, 3
The Permissive Society, 67, 74–5,
77–81, 101, 103, 159

The Silent Majority, 78
Too Much of a Good Thing
(radio), 67, 143
Two Thousand Years, 7, 8, 15, 26,
61, 186, 233, 305, 337, 344,
372
Wholesome Glory, 75, 78, 89
style
the antithesis of Hollywood gloss
and sheen, 70
bleakness, x, 59, 325
caricature issue, 163, 191, 217,
234, 365
dialogue, 237, 280
focus on detail, 59–60
humour, x, 58–9
realism, x, 59
satire, 191
spontaneity, 96, 98, 376
three-dimensional, interesting
characters, 54
themes
abortion, xv–xvi, 43, 326,
339–40, 341–7, 349, 351–4,
356, 359, 363, 364, 368
adoption, 251–5, 267–8, 269, 272
class, 46, 139
death, 102, 153
education, 141
family secrets, xi, 251–3, 267, 268
having/not having children, xi, 65,
77, 80, 125, 129, 130, 133,
134, 139, 141, 152–3, 156,
186, 189, 190, 196, 199, 217,
250, 253, 265, 266, 267, 318
identity, 271–2
modern isolation, 244
parenting and the needs of chil-
dren, 148
private, alternative, interior world,
2
received behaviour, 48, 60–61, 91,
101, 129, 179, 201, 210
relationship breakdown, xi, 11,
149, 189, 323
religion, 71, 141
tension between real and artificial,
296
unemployment, 155–8, 164, 213
youth, 101, 213, 322
working process, xi–xii, xviii–xix, 6,
162
Alison Steadman on, xiii–xv
buzz and excitement of making

films, 44, 296, 353
character-driven films, 376
establishing characters, 25–8
exploration of the unknown, 22–3
importance of each actor's confidence in his/her role, 19
improvisation, xii–xvi, xviii, xx, 13, 19, 20, 22–5, 30, 37, 39, 40, 41, 43, 49, 53, 55, 68, 72, 93, 127–8, 140, 142, 168, 176, 202, 236, 240, 246, 256, 275, 301–2, 356, 358–9, 361–2, 368
method at work in films, 38–43
method enjoyed by the actors, xii
ML's reluctance to talk about what he does, 21, 23, 26
notional film, 28–30
plot kept from the actors, xii, xv, xiv, 13–14, 20, 30–31, 40, 41–2, 152, 232, 254, 347, 357, 358, 372, 377–8
privacy issue, 31–2
rehearsals, 30, 256, 378–9
shooting script, 30, 74
soliloquy, 21
Spall on, xvii–xix, 38
structure and discipline, 376
support of his actors, 24–5
technical side of film-making, 33–4
'treats' for the audience, 350–51
use of zooms, 98–9
widescreen, 373, 376
working atmosphere, 34
Leigh, Phyllis Pauline (née Cousin; ML's mother), 6, 9, 61, 65, 66, 187, 196–7, 294, 341–2
Leigh, Toby (ML's elder son), 86, 135, 183, 218, 261, 323
birth (1978), 126
Jewish background, 8–9
studies illustration at Manchester Met University, 8
Lely, Durward, 289, 290
Lenoir, Helen, 290
Lenya, Lotte, 16
Levin, Bernard, 116
Levy, Ruth (ML's sister), 2, 8
Life and Death of Peter Sellers, The, 369
Lilliput magazine, 294
Lipsky, Jeff, 258
Littlewood, Joan, 15
Liverpool Everyman Theatre, xiii

Loach, Ken, x, 47, 66, 67, 68, 86, 161
Locarno International Film Festival, 54
Logan, Phyllis, 250, 262, 263
London Academy of Music and Dramatic Art, 295
London Double Bass Ensemble, 167
London Film Festival, 53, 138–9, 194, 218
London Film School, 17, 49, 50, 52, 351
Long Day Closes, The, 10
Long Good Friday, The, 160
Lord Chamberlain, 15
Loren, Sophia, 369
Los Angeles Film Critics Association, 262
Los Angeles Times, 191
Lowe, Georgina, 249
Lowry, L. S., 70, 104–5
Loyalism, 178
Lulworth Cove, Dorset, xiii, 93

McAleer, Des, 169, 174, 175, 176
McDonald, Gary, 318, 328
McDonald's, 86, 87
McDougal, Wilson, 244–5
McKee, Gina, 225, 242
McKenna, Paul, xix
McKidd, Kevin, 289, 301, 303
Maclaren, Deborah, 225, 230, 240
McShane, Ian, 16
Made in Britain, 161
Major, John, 228
Malcolm, Derek, 53
Manchester, 1, 6, 8, 12, 13, 65, 68–71, 91, 144, 175, 292, 294
Manchester Film Society, 10
Manchester Grammar School, 3, 5
Manchester Met University, 8
Manchester Polytechnic, 106
Manchester United FC, 8
Manchester Youth Theatre, 106
Manhattan, 9
Manocheri, Bahram, 35, 36, 50, 52
Manvell, Roger: Film and the People, 10
Manville, Lesley
meets ML at the RSC, xi
in Too Much of a Good Thing, 143
appears in six of ML's films, xi
on the length of time allocated to the films, xi–xii
on how actors love working with ML, xii

in *Grown-Ups*, 132, 132, 143
in *High Hopes*, 190, 192
in *Secrets & Lies*, 251, 264–5, 264
at Sarajevo, 287
at the Toronto Film Festival, 287
in *Topsy-Turvy*, 41, 289, 307, 314, 315
in *All or Nothing*, xix, 317, 327, 335, 336
Marat/Sade (Weiss), 15
Marathon Man, 351, 374
Marks, Louis, 135
Marowitz, Charles, 50
Marsan, Eddie, 338, 339, 365, 371, 373, 376, 377–8
Marx, Karl, 190, 193, 199, 204
Mason, Bob, 77, 80
Mason, James, 14
Match Point, 9
Matcham, Sir Frank, 310
Matheson, Margaret, 112, 127
Mays, Daniel, 317, 322, 328, 338, 338, 349
Medwin, Michael, 51, 52
Melly, George, 53
Memorial Films, 51
Men Only magazine, 294
Mercury Theatre, 56
Metropolitan Hospital, Kingsland Road, east London, 161
Midlands Arts Centre, Birmingham, 18
Millennium Dome, Greenwich, 334
Miller, Jonathan, 113, 123
Miller, Rachel, 123
Million Dollar Baby, 370
Minghella, Anthony, 281
Mission, The, 374
Molina, Alfred, 155, 162, 164
Mona Lisa, 160
Monk, Thelonious, 16
Monroe, Marilyn, 14
Monty Python, 160, 195
Morahan, Christopher, 69, 83, 84
Moran, Pauline, 83
Moreau, Jeanne, 12
Morley, Robert, 294
Morris, Desmond: *The Naked Ape*, 247
Müller, Marco, 369
Munden, Marc, 204
Murdoch, Iris, 297
Museum of London, 306
music
in *Bleak Moments*, 60

in *The Permissive Society*, 80
title music for 'The Five-Minute Films', 84
in *The Kiss of Death*, 60, 105, 107–8
in *Home Sweet Home*, 108, 148, 150, 167
in *Abigail's Party*, 109–12, 149–50
in *Who's Who*, 130
in *Meantime*, 167
in *Four Days in July*, 182
in *High Hopes*, 192, 202
in *A Sense of History*, 222
in *Naked*, 237
in *Career Girls*, 280
in *Topsy-Turvy*, 297–8, 303, 305, 313
in *Two Thousand Years*, 305
in *Vera Drake*, 367
in 'Untitled '06' (*Happy-Go-Lucky*), 305, 374, 375
My Left Foot, 181

Nagasaki, 299
Napoléon, 182
National Film and Television School (NFTS), 260
National Film Theatre, London (NFT), 14, 194
National Gallery, London, 16
National Theatre, London, 8, 15, 233, 337
Neville, David, 125
New Wave, 13
New York, 218–19, 304, 305
New York Film Festival, 63, 304
News Theatres, 10
No Man's Land, 287
North, Julie, 83
North Grecian Street Primary School, Salford, 3
North London Polytechnic (later University of North London, then Metropolitan University), 280, 283, 285
North Middlesex Hospital, Edmonton, London, 151
Northern Ireland, 157, 170–77
Norville, Herbert, 82
Norwegian Film Festival, 218
Nottingham, Wendy, 183, 185–6, 290
Nouvelle Vague, 12
Nunn, Trevor, 15, 73

O'Brien, Flann, 16
Observer newspaper, 53
October Films, 258
O'Donnell, Anthony, 88, 95, 97
Old Bailey, London, 363
Oldenburg, Claes, 60
Oldman, Gary, 155, 161, 162, *164*, 168
Open Space Theatre, London, 50
Opera House, Manchester, 291
Ordinary Fascism, 273
Oscars, 370
Other Place, Stratford-upon-Avon, 15, 43, 75
Ozu, Yasujiro, 12, 325, 326

Paisley, Rev. Ian, 174
Palace, 195
Palme d'Or, 99, 254, 263, 298, 368, 370
Paris, 16, 245, 261, 287, 321, 368, 369
Paris Film Festival, 298
Parker, Alan, 85
Parkinson (chat show), 209
Patterson, Dan, 6
Pearce, Eve, 290
Penguin, 117, 337
People Show, The, 167
Peters, Lloyd, 148
Picasso, Pablo, 16
Pickering, Jenny, 312
Pinero, Arthur Wing: *Dandy Dick*, 293
Pinter, Harold, xiii, 48, 84, 326
 The Caretaker, 16, 131, 349
Plays of the Year anthology, 117
Pope, Dick, 34–8, *35*, 98, 99, 195, 209, 222, 232, 236, 241, 244, 255, 275, 312, 325, 350, 373, 374, 376
Portman, Rachel, 182
Portman Productions, 138, 207
post-synch, 274
Potter, Dennis, 119–20, 123
Praise Marx and Pass the Ammunition, 138
Pratt, Roger, 35, 38, 49, 153, 160–61, 184, 188, 195, 202, 209
pre-Raphaelite art, 294
Prem, Tara, 75, 78
Presley, Elvis, 111–12, 150
Press Club, Albert Square, Manchester, 292
Prime, Cheryl, 190

P'*Tang Yang Kipperbang*, 171
Pulp, 374
Pumpkin Eater, The, 351
Punch magazine, 293
Purple Rose of Cairo, The, 9
Putt, Robert, 82

Quadrophenia, 161
Quantel, 299
Quatre cents coups, Les, 12, 20
Questions of Leadership (documentaries), 161
Quicke, Celia, 82

RADA (Royal Academy of Dramatic Art), xvii, xix, 3, 7, 12, 13, 15–18, 46, 51, 131, 349
Radio Days, 9
Radio Times magazine, 178
Raitt, Annie, 45, 55, 62
Ray, Bingham, 247, 258
Ray, Satyajit, 12
Rayner, Julia, 309, 312
Raynes, Louis, 64, 70
Rea, Stephen, 27, 169, 171, 172, 174, 178, 181, 205, 211, 212–13, *212*, 234, 292
Rebel Without a Cause, 61, 322
Reisz, Karel, 13, 364
Relph, Simon, 208
Renoir, Jean, xi, xiii, 12
Reynolds, Harriet, 109, *120*
Rialto Cinema, Great Cheetham Street, Salford, 13
Richard, Eric, 146, *146*, 150
Richardson, Tony, 13
Richmond Theatre, Surrey, 309–10, 311
Ricketts, Charles, 302–3
Rio Cinema, Dalston, London, 158, 193
Rissient, Pierre, 261
Rita, Sue and Bob Too, 240
Road, 240
Robert, Jeff, 155, 162
Roberts, Veronica, 77
Robinson, W. Heath, 5, 60
Rochdale Youth Theatre, 80
Rock Star, 328
Roget's Thesaurus, 195–6
Rohauer, Raymond, 14
Rolling Stones, 16
Romm, Mikhail, 273
Ronalds, Fanny, 289, 291, 307

Room at the Top, 13
Roose-Evans, James, xix
Rose, Chris, 40
Rose, David, 75–6, 101, 105, 107, 159, 184, 208
Rosenthal, Jack, 171
Ross, Jonathan, 320, 328
Ross, Lee, 251, 263
Roth, Tim, 40, 155, 161, 164, 168
Roussos, Demis, 109, 112, 150
Rowley, Paul, 15
Royal College of Music, London, 306
Royal Court Theatre, London, 15, 75
 Theatre Upstairs, xiii, 75, 89
Royal Free Hospital, London, 287
Royal Shakespeare Company (RSC), 15, 55, 89, 98, 99, 113, 143, 273
 early improvisation (1967), 19, 53
 Manville meets ML (late 1970s), xi
 ML as assistant director, 62, 73
Royal Ulster Constabulary (RUC), 176, 177
Rudkin, David: *Afore Night Come*, 15
Rudman, Michael, 113, 123, 124
Rushbrook, Claire, xvii, 26, 250, 262, 263, 275
Russell, Bertrand, 46

St Thomas of Canterbury church, Salford, 170
Sales, Robin, 313
Salford, Lancashire, 13, 72, 175, 326
 ML born in, 1
 cinema in, 10
 Hard Labour set in, 64, 69–70
 a Catholic city, 170
Salford Grammar School, 3, 16, 170, 341
Salles, Walter, 369
Salthouse, John, 109, 120, 121
Sarajevo Film Festival, 286, 287
Sarde, Alain, 321, 368
Saturday Night and Sunday Morning, 15–16, 364
Savage, Martin, 290, 307
Savoy Hotel, London, 289
Savoy Theatre, London, 288, 290, 291, 301, 302, 305, 308, 312
Scarborough, Adrian, 338, *338*, 349, 356, 368
Schlesinger, John, 151
Scofield, Paul, 15
Scorsese, Martin, 298, 370
Scott, Judith, 190

Scott, Sir Nicholas, 128
Screen on the Green, Islington, London, 230, 257
Screen on the Hill, Haverstock Hill, London, 257
Screen International (magazine), 67
Scum, 161
Searle, Ronald, xiii, 294
 Hurrah for St Trinian's, 294
Second World War, 1–2, 61, 198, 203
Sedgley Park College, Manchester, 170
Seed, Paul, 174
Sellers, Peter, 20
Serkis, Andy, 278, 284, *284*
Set Meals Ltd, 249
Shadows, 13
Shakespeare, William, 15, 21
 Hamlet, 1
 Macbeth, 281
 A Midsummer Night's Dream, 73
 The Taming of the Shrew, 73
 Twelfth Night, 55
 A Winter's Tale, 106
Shakespeare Memorial Theatre, Stratford-upon-Avon, 5, 6, 15
Shameless (BBC television sitcom), 106
Sharp, Lesley, 224, 230, 234, 238, 240
'She Belongs to Me' (song), 60
Sheen, Ruth, xv, 140, 189, 192, 200, 203, 317, 327, 330, 339, 347–8
Short Cuts, 85
silent cinema, 14
Simon, Charles, 289, 306
Sinatra, Frank, 147, 149, 150, 195, 196
Singer, Isaac Bashevis, 8
Singing Detective, The (BBC television mini-series), 186
Sinic (magazine), 49
Skinner, Claire, 205, 209, 212, 214, 226, 230, 234, 235, *235*, 237, 349
Skouras Pictures, 257
Sleepy Hollow, 316
Sloman, Roger, xiii–xiv, 88, 93, 95
Smith, Bessie, 16
Smith, Liz, 56, 64, 71, 73, 250
Smith, Roger, 50
Solidarity, 193
Some Like It Hot, 14
South-East Asian financial crisis, 309
Southampton University, 54
Spall, Timothy
 first works with ML, xvii
 friendship with ML, xvii, 153–4

attitude to acting, xvii
in *Home Sweet Home*, 146, *146*, 153
on ML's working method, xviii–xix, 38
in *Life Is Sweet*, 205, 208, 209, 210, 212, 214
in *Secrets & Lies*, 93, 212, 250, 254, 262, 323
leukaemia, xvii, 262, 328
at the Toronto Film Festival, 287
in *Topsy-Turvy*, 289, 307, 308, *308*, 328
in *All or Nothing*, ix, xvii, 317, 323, 327, 328, *333*, *334*, *335*, *336*
Spencer, Stanley, 16
Spriggs, Austen, 130
'Squidgy tapes', 236
St-Denis, Michel, 15
Stage, The (newspaper), 68
Staunton, Imelda, xv–xvi, xix–xx, 338, *338*, 346–7, 348, *352*, *355*, 362, 370
Steadicam, 244
Steadman, Alison (ML's ex-wife), xi, xx, 8, 245
meets ML, xiii, 72, 293
marriage to ML (1973–2001), xiii, xiv, 9, 211, 323
improvisations, xiii–xiv
in *Hard Labour*, 64, 73
in *Nuts in May*, 88, 92, 93, 95, 121
in *Abigail's Party*, xiv, 109, 112, 114, 118–21, *120*
and extras, 144–5
in *The Short and Curlies*, 183, 185, *185*
in *Life Is Sweet*, 98, 205, 208–11, 212, 216, 217
at the Norwegian Film Festival, 218
and Katrin Cartlidge, 239
in *Secrets & Lies*, 250
in *Topsy-Turvy*, 290, 303
Steadman, Lynda: in *Career Girls*, 277, 283, *283*
Steinberg, Saul, 16
Stephenson, Sarah, 45, 55
Stern, Tim, xiv, xv, 82, 109, 114, *120*, *121*
Stewart, Eve, 86, 306, 312, 367
Stonham, Kay, 146
Storr, Heather, 230, 371
Story of Gilbert and Sullivan, The, 294
Strangeways prison, Manchester, 70

Streep, Meryl, 208
StudioCanal, 321, 368
Sullivan, Sir Arthur, 288–91, 296, 299, 302–6, *303*, 311, 313, 314
see also Gilbert and Sullivan
Summers, Jeremy, 70
Sunset Boulevard, 14
Swanage, Dorset, 97
Sydney, 184, 193

Tannaker Buhicrosan, 299
Tate Gallery, London, 16
television, arrival of, 9–10
Temple, Richard, 289, 291, 301, 307–8
Thames Television, 107
Thatcher, Margaret, xi, 114, 125, 130, 157, 158, 194, 228, 322
Thatcherism, 157, 213
Théâtre de Complicité, 327
Theatre of Cruelty, 15
Theatre Royal Stratford East, London, 15, 87
Thewlis, David, 27, 183, 185, 186, 187, 206, 209, 211, 224, 229, 230, 231, 234–7, *238*, 241, 243, 244, 246, 375
Thin Man Films, 138, 207, 213, 279
Third Man, The, 14
Thomas, Dylan, 24
Three Mills Island studios, Bow, London, 301, 309
Three Stooges, 10
Threlfall, David, 93, 100, *105*, 106
Time Out magazine, 102
Tin Pan Alley (Denmark Street), London, 153
Titanic: The Musical, 304
Tobias, Heather, 189, 202
Tom Brown's Schooldays (Hughes), 292
Tom Jones, 13, 51
Tomlinson, Ricky, 68
Toronto Film Festival, 287
Townsend, Stanley, 371
Toynbee, Polly, 314
Trodd, Kenith, 171
Troubles, the, 170, 171
Troughton, Sam, 43
Truffaut, François, 12, 13
Truly Madly Deeply, 281
Tucker, Joe, 278, 283, 327
Tunney, Paddy: *The Stone Fiddle*, 173
Twenty Thousand Streets Under the Sky (BBC drama), 349

Two Left Feet, 17, 51–2
Tyler, Will, 367

UDA (Ulster Defence Association), 173
UGC, 320
Umbria, 263–4
Uncle Tom's Cabin, 261
Universal, 258
USA Films, 258

Vampires, Les, 14
Van Gogh, Vincent, 23, 110
Vanilla Sky, 328
Venice Film Festival, 257, 369
Vermeer, Jan, xiii
Victoria and Albert Museum, London (V&A), 16
 Theatre Museum, Olympia, London, 306
Vidler, Susan, 225
Vietnam War, 46
Vigo, Jean, 12
Vision On (BBC children's programme), xix
Vivid (Fuji film stock), 373
Vosburgh, Tilly, 155

Wajda, Andrzej, 7
Wakes Week, 144
Walesa, Lech, 193
Walker, Lesley, 321, 327
War of the Roses, The (play), 15
Warsaw, 193
Warsaw Film Festival, 194
Watkins, Jason, 189, 246–7
Watson, Theresa, 290
Weill, Kurt, 16
Weinstein, Harvey, 258, 259, 311
Weldon, Fay, 70
Welland, Colin, 171
Welles, Orson, 56

Wells, H. G.: *The Bulpington of Blup*, 2
Wenham, Brian, 83
Wesker, Arnold, 6
West, 11, 52
Wheatley, John, 100, 105
Whitaker, Sheila, 218
White, Oliver, 107
Whitehead, E. A.: *The Foursome*, xiii
Whose Line Is It Anyway? (television programme), 6
Wickham, Jeffrey, 125, 129
Wight, Peter, 155, 162–3, 225, 237, 240, 307, 340, 348, 361
Wigmore Hall, Wigmore Street, London, 108
Wilde, Oscar, 297
 Salome, 239
Wilder, Billy, 14
Wilfort, Rob, 332
Williams, Bridie, 65–6
Williams, Kenneth, 119
Wilson, Harold (Baron Wilson of Rievaulx), 157
Winner, Michael, 52
Winston, Professor (later Lord) Robert, 265
Wong Kar-Wai, 259, 369
Wood, Victoria, 208
Woolgar, Fenella, 339
Workers' Press, 50
Workers' Revolutionary Party, 50
World in Action (Granada television documentaries), 37, 241

Yentob, Alan, 221
Yershon, Gary, 305, 316, 375

Z Cars (television series), 105
Zegerman, Alexis, 371, 372, 373
Zelig, 9
'zig' (comedy sketch), 6